TCM
THE ESSENTIALS

VOL. 2

52

MORE

MUST-SEE

MOVIES

and WHY THEY
MATTER

JEREMY ARNOLD
foreword by
BEN MANKIEWICZ

RUNNING PRESS
PHILADELPHIA

Running Press
Hachette Book Group
1290 Avenue of the Americas, New York, NY 10104
www.runningpress.com
@Running_Press

Printed in China
First Edition: October 2020

Published by Running Press, an imprint of Perseus Books, LLC, a subsidiary of Hachette Book Group, Inc. The Running Press name and logo is a trademark of the Hachette Book Group.

The Hachette Speakers Bureau provides a wide range of authors for speaking events. To find out more, go to www.hachettespeakersbureau.com or call (866) 376-6591.

The publisher is not responsible for websites (or their content) that are not owned by the publisher.

Photography credits
page 269: Courtesy Barbara Kopple; page 238: Shutterstock; all other images courtesy Turner Classic Movies.

Print book cover design by Susan Van Horn.
Print interior design by Corinda Cook.

Library of Congress Control Number: 2020935110

ISBNs: 978-0-7624-6939-0 (hardcover), 978-0-7624-6940-6 (ebook)

1010

10 9 8 7 6 5 4 3 2 1

Joel McCrea, Robert Warwick, and Porter Hall in Sullivan's Travels *(1942)*

CONTENTS

FOREWORD BY BEN MANKIEWICZ

When TCM launched *The Essentials* in 2001, our mandate was clear: we wanted to create a dedicated time slot—8 p.m. Saturday—to present a single movie that we believed film lovers needed to know. For those not well versed in the Golden Age of Hollywood, it might be a picture they hadn't yet seen. For our more film-centric viewers, it might be a chance to see a classic in a new way, with a fresh perspective from a professional dedicated to this emotionally expansive art form.

Selecting that professional was key. Robert Osborne had been introducing movies on the channel since 1994—and doing it as only Robert could, with his singular and seemingly incompatible combination of sophistication and folksiness. But we wanted *The Essentials* to feel different. To do that, we thought it had to look different. Writer/director Rob Reiner was the first host for a couple of years, followed by director Sydney Pollack, then Peter Bogdanovich, not only a seminal director himself, but a living link to classic cinema, a product of his extensive work interviewing the great directors who emerged out of the studio system: Ford, Welles, Hawks, Hitchcock, and so many more.

Each host provided valuable insight, but something was missing. And you didn't have to be a math major or a film student to complete the equation. *The Essentials* needed Robert. So we made a change. We'd continue to bring in an *Essentials* host, but they would sit with Robert, who would lead a conversation about the movie. Over the next decade, Molly Haskell, Carrie Fisher, Rose McGowan, Alec Baldwin, Drew Barrymore, and Sally Field joined Robert.

After Robert's death in 2017, we had to change again. And it wasn't easy. Alec Baldwin helped get us through it, hosting three distinct guests in a single season, each of them lending their unique perspective to the conversation: David Letterman, William Friedkin, and Alec's *30 Rock* costar, Tina Fey.

That led to our current incarnation, where I try, with limited success, to channel my inner Robert Osborne in conversation with a filmmaker. For the return of *The Essentials* in the 2019 season, we welcomed writer-director Ava DuVernay, who challenged us to think differently about what constituted an essential film. Ava worked with us to include movies previous hosts had likely never considered: *Claudine* (1974), with Diahann Carroll and James Earl Jones; Barbara Kopple's

6

documentary, *Harlan County U.S.A.* (1976); and
Gillo Pontecorvo's *The Battle of Algiers* (1966)
were all released more than forty years ago, yet
each struck me as particularly relevant to the
world we live in today. Ava turned *The Essentials*
into a forum for exposing viewers to movies
they'd never seen before. And then she'd passion-
ately and convincingly argue that those films were
critical to a full understanding of the power of
cinematic storytelling. Even when Ava discussed
a more traditional film, like *Dog Day Afternoon*
(1975), she brought a vibrant and fresh perspec-
tive to the conversation.

By the way, four of Ava's picks, including
Harlan County and *Battle of Algiers*, are included
in this *Essentials* book. And please remember, this
compilation is a delicious sampler. We are not
claiming these are the definitive fifty-two essential
films. It's merely a collection of delights, culled
from more than three hundred movies we've
featured on *The Essentials* since 2001, from Rob
Reiner to my cohost for the 2020 season, director
Brad Bird, who has four of his titles included.

Finally, as I look over the list, I see so many
of my favorite films, movies that move me on
a visceral level: *The Battle of Algiers*, *Sweet Smell
of Success*, *The Sting*, *Network*, *One Flew Over the
Cuckoo's Nest*, *Ride the High Country*, *Sullivan's
Travels*, *The Producers*, *Notorious*. I mean, if we'd
included *Paths of Glory*, this might have been
a perfect book.

Photo by Jeremy Freeman

INTRODUCTION

One of the delights of TCM's *The Essentials* series has always been the sheer breadth of its films. Epic or intimate, American or international, serious or escapist, the only thing that has mattered has been whether a film made enough of an impact to stand as one that all dedicated movie enthusiasts should see. Every film may not be to everyone's taste, but each is important in the history of Hollywood or world cinema, whether for content, visual technique, acting, directing, cultural impact, or myriad other reasons.

Through 2020, Turner Classic Movies has shown 318 movies on *The Essentials*, some more than once. The first *Essentials* book showcased fifty-two of them, and in this volume are fifty-two more. As before, this is not meant as a list of the fifty-two "best" (or second-best) movies ever made, although many of these titles could legitimately land on such a list. It is, rather, another sampling of the movies that have been shown in the series, chosen to represent a wide variety of genres and talents. (The full list of 318 films can be found on page 287, and I hope you will refer to it as a guide to help you explore other worthwhile titles.)

The Essentials has had many hosts since 2001, and each entry in this book once again includes excerpts of their on-air introductions, from Rob Reiner in 2001 to Ben Mankiewicz and Brad Bird in 2020. The late Robert Osborne hosted the series for ten years with various cohosts, and it was a special joy to revisit his insights, especially for films that he always said were among his top favorites, such as *Dodsworth* and *A Place in the Sun*.

If this book inspires you to seek out and watch these films (that is, after all, the goal), you might consider a few illuminating and occasionally oddball double features, the result of connections, patterns, and contrasts that I noticed while writing. For instance, several actors appear more than once, making for interesting looks at their talent over the years. *Dodsworth* and *The Maltese Falcon* afford a chance to appreciate the terrific versatility of Mary Astor; Burt Lancaster shows drastically different sides of himself in *Sweet Smell of Success* and *Field of Dreams*; and William Holden moves from the jungles of *The Bridge on the River Kwai* to the New York offices of *Network* twenty years later with his persona just the same.

To compare two of the all-time famous movie kisses, take a look at *Notorious* and *The Quiet Man* (you could also throw in *Vertigo*). Watch *Brief Encounter* and *The Apartment* to see how Billy Wilder was inspired by the former to create the latter. Enjoy Charles Laughton's performance in *Mutiny on the Bounty* and then marvel at his sole piece of directing with *The Night of the Hunter.* Take in *A Face in the Crowd* and *Network* to see how much was predicted, and how little has changed, in the worlds of television and celebrity.

For some more offbeat pairings, try *Pather Panchali* and *One Flew Over the Cuckoo's Nest* for their different approaches to humanism. *The Battle of Algiers* uses documentary-like narration to increase its realism, even though everything is staged, and *Harlan County U.S.A.* avoids narration for the same reason, even though nothing is staged. *2001: A Space Odyssey* and *Hannah and Her Sisters* might sound completely off the wall as a duo, but consider: both films say something resonant about what makes us human, even though one goes outward, using the entire universe as its canvas, and the other goes inward, to the human heart, using only the setting of Manhattan.

Laura, The Ghost and Mrs. Muir, Vertigo, and *Field of Dreams* are four quite different films that nonetheless all explore yearning, loneliness, and a love for someone who is presumed dead.

Two of them are fantasies with ghosts or spirits appearing on-screen, and three contain scenes in which a character believes (or wants to believe) that a loved one has come back to life. They are all so skillfully made that they make the audience believe, too, sweeping viewers to a place of transcendence and wonder. That sense of wonder is something the movies can give like no other entertainment medium. What follows are fifty-two examples to prove it.

—Jeremy Arnold

TCM ESSENTIALS HOSTS

2001–2002: Rob Reiner

2003–2004: Sydney Pollack

2005: Peter Bogdanovich

2006: Robert Osborne and Molly Haskell

2007: Robert Osborne and Carrie Fisher

2008: Robert Osborne and Rose McGowan

2009–2011: Robert Osborne and Alec Baldwin

2012–2014: Robert Osborne and Drew Barrymore

2015: Robert Osborne and Sally Field

2017: Alec Baldwin and William Friedkin, Tina Fey, David Letterman

2019: Ben Mankiewicz and Ava DuVernay

2020: Ben Mankiewicz and Brad Bird

SUNRISE

Fox Film Corporation, 1927
B&W, 94 minutes

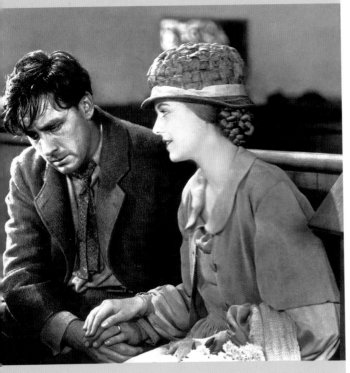

In a church, Janet Gaynor finds that forgiveness might be possible.

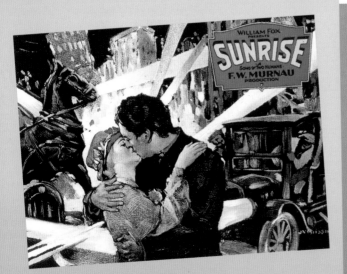

DIRECTOR

F. W. Murnau

PRODUCER

William Fox (uncredited)

SCREENPLAY

*Carl Mayer, from an original theme
by Hermann Sudermann*

STARRING

GEORGE O'BRIEN THE MAN

JANET GAYNOR . THE WIFE

MARGARET LIVINGSTON. . . THE WOMAN FROM THE CITY

BODIL ROSING . THE MAID

J. FARRELL McDONALD THE PHOTOGRAPHER

RALPH SIPPERLY.THE BARBER

**AFTER A FARMER
IS TEMPTED BY A
SEDUCTRESS TO KILL
HIS WIFE, THE MARRIED
COUPLE GO ON TO
RENEW THEIR LOVE
TO THE POINT
OF TRANSCENDENCE.**

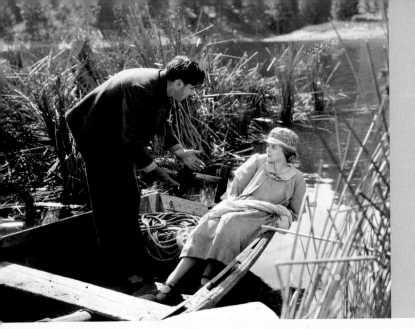

Janet Gaynor shrinks back in fear from husband George O'Brien.

ROBERT OSBORNE

"If anybody wants to see what a silent film is like, they really should watch this one. Because it's a great beginning to see how powerful a film can be without words. . . . You never quite know where it's going. It does keep you kind of in suspense."

WHY IT'S ESSENTIAL

Made at the apex of the silent era, just two years before talkies would fully take over, *Sunrise* turns a simple, melodramatic plotline into visual poetry. A rural man is spurred by his lover to kill his wife; he comes to his senses just in time, but now his wife is terrified of him and tries to run away. They end up in a nearby city and begin an unlikely reconciliation so intensely conveyed that the real substance of the film becomes emotion itself. Longing, anger, fear, guilt, remorse, love—the audience feels them all, deeply. The movie's subtitle, "A Song of Two Humans," and the fact that husband and wife are never named give *Sunrise* the feel of a parable. The characters' wounded souls and capacities to heal, the film suggests, are part of our shared humanity.

George O'Brien and Janet Gaynor display the highest levels of dramatic silent-film acting, using their eyes and body movements to express nuances of thought and emotion. Director F. W. Murnau accomplishes the same with his extraordinary, innovative technique, starting with the opening shot. The high-angle image of a locomotive steaming through a station, with street life visible through a massive glass wall, was achieved by a train model in the extreme foreground, a real street image in the middle-ground, and a miniature of buildings and an elevated train inserted into the background by use of a mirror. It was all done in-camera: a single strip of film negative was reexposed to shoot each of the three elements, with the appropriate area of the frame carefully masked each time.

*"I love how the two leading ladies are so brilliantly juxtaposed.
You have the dark jezebel, the city woman who [wears] very provocative
clothing . . . , and then you have this beautiful, delicate porcelain
doll in Janet Gaynor. . . . This is the perfect gateway into [silent movies]."*

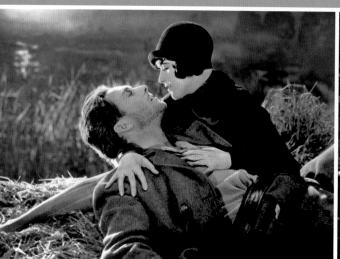

*Margaret Livingston as the temptress, holding
George O'Brien with clawlike hands*

*The city was constructed on the Fox lot in perspective,
to give the illusion of vastness and depth.*

Karl Struss, one of the film's two cinematographers, along with Charles Rosher, later said his biggest challenge on *Sunrise* was the stunning traveling shot as O'Brien walks through a marsh to meet his lover. Accomplished inside a sound stage, the camera was mounted to a curved dolly track hanging from the ceiling, with the complex movement creating significant lighting problems.

The sets were built in forced perspective—larger in the foreground, smaller in the back—to create the illusion of depth, an effect most striking in shots of the massive-looking city. Constructed

entirely on the Fox lot, the buildings were just twenty-five feet high, and some of the doors just three. Even the extras became smaller, with dwarfs and children acting in the far background. That blend of realism and fantasy gives *Sunrise* a mysterious, dreamlike quality, reflecting the experience of husband and wife as they fall in love to an almost ethereal level. Murnau's elaborate techniques are all in service to the emotional journey of the characters—and the audience.

He brought those techniques from Germany, where he had used them on several masterpieces

of German expressionism, such as *Nosferatu* (1922), the first vampire movie, and *The Last Laugh* (1924). The latter inspired American mogul William Fox to import Murnau to Hollywood with a promise of carte blanche for *Sunrise*. He even permitted Murnau to bring along key technicians such as Struss, the British-born Rosher (who had worked in Germany), and the brilliant art director Rochus Gliese. The result was one of the most expensive American features yet made.

The film was unable to recoup its cost but was acclaimed as a visionary achievement. At the first Academy Awards, honoring movies from 1927 and 1928, *Sunrise* won the Oscar for Unique and Artistic Picture, a category that was dropped the following year. (Best Picture went to *Wings* [1927].) Janet Gaynor won Best Actress for *Sunrise*, *7th Heaven* (1927), and *Street Angel* (1928) combined; Rosher and Struss won Best Cinematography; and Gliese was nominated for Best Art Direction.

Fox signed Murnau to a new contract, but he only directed three more films before dying in a 1931 car accident at the age of forty-two, cutting short one of the most promising directing careers in history. Fellow director Fritz Lang eulogized him as "a man to whom the cinema owes its fundamental character, artistically as well as technically."

Sunrise remains one of the great achievements of American silent cinema, an embodiment of Murnau's belief that "real art is simple, but simplicity requires the greatest art."

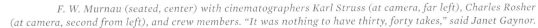

F. W. Murnau (seated, center) with cinematographers Karl Struss (at camera, far left), Charles Rosher (at camera, second from left), and crew members. "It was nothing to have thirty, forty takes," said Janet Gaynor.

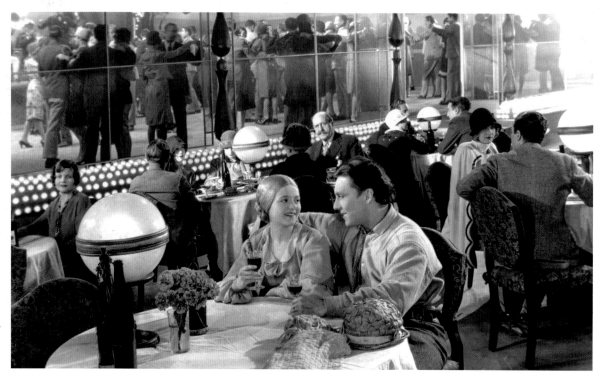

Janet Gaynor and George O'Brien renew their love in the city, in a complex composition.

WHAT TO LOOK FOR

In the extraordinary trolley sequence that follows O'Brien's aborted plan of murder, Gaynor sits in fear, unable to look at her husband, and he stands in remorse, silently pleading for a forgiveness that seems impossible. Meanwhile, the trolley winds through a landscape slowly shifting from rural to urban. Murnau conjures a striking mix of realism and dreaminess here. He had a mile-long track constructed for the scene, as well as every inch of the urban sets, but he keeps the camera—and the audience—inside the trolley, with the sets visible through the windows. The image of this couple trapped in silent, crushing emotions, as if in a cocoon, is made dreamlike by the glimpses of the outside world transitioning around them. When they finally disembark, the entirely constructed cityscape feels indifferent and overwhelming.

—

For O'Brien's early scenes, Murnau had the actor's shoes weighted with lead to make his body movements look heavier and more threatening. The effect is especially vivid in the rowboat, as O'Brien steps ominously toward Gaynor.

—

Sunrise was the first Hollywood feature to have an optical soundtrack; it contains a synchronized musical score and sound effects.

.............

STEAMBOAT BILL, JR.

United Artists, 1928
B&W, 71 minutes

DIRECTOR

Charles F. Reisner

PRODUCER

Joseph M. Schenck (executive producer)

SCREENPLAY

Carl Harbaugh (story)

STARRING

BUSTER KEATON. WILLIAM CANFIELD, JR.

ERNEST TORRENCE . WILLIAM

"STEAMBOAT BILL" CANFIELD

TOM LEWIS TOM CARTER

TOM McGUIRE JOHN JAMES KING

MARION BYRON KING'S DAUGHTER

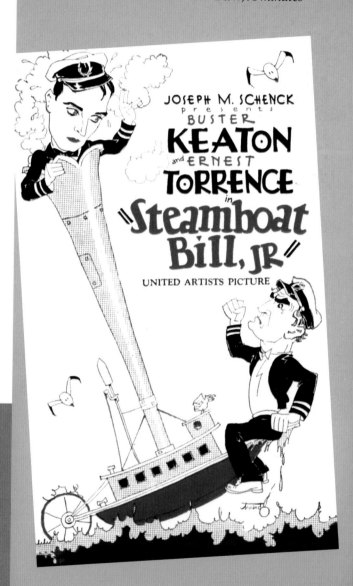

THE TIMID SON OF A CRUSTY RIVERBOAT CAPTAIN TRIES TO PROVE HIMSELF WHILE FALLING FOR A RIVAL CAPTAIN'S DAUGHTER.

WHY IT'S ESSENTIAL

Buster Keaton's last independent silent comedy is a gem, full of charming and ingenious comedy routines that grow physically grander as the story progresses, culminating with the single most renowned—and most dangerous—stunt of Keaton's career.

In a beautifully choreographed early sequence, the imposing Steamboat Bill, played by arch silent-movie villain Ernest Torrence, ventures to a train station to welcome his son, whom he expects to be a strapping lad able to help resuscitate Bill's steamboat business. He hasn't seen Junior since infancy but knows he will be wearing a white carnation; inevitably, every man who disembarks is wearing a carnation, and father and son each in turn generate comedy out of an entertaining series of misidentifications. Finally, they meet, with the captain dismayed to find that Junior seems not only far from "strapping" but as effete as they come.

Steamboat Bill, Jr. milks the contrasting attitudes of father and son through several amusing set pieces, such as a visit to a hat shop and a scene in which Keaton tries to bust his father out of jail by smuggling in tools hidden inside a loaf of bread—only to find his dad refusing the bread because he wants nothing to do with his disappointing son.

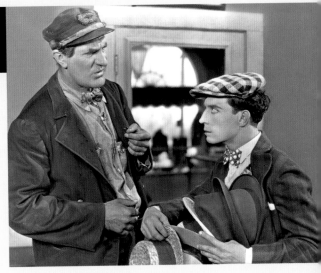

Ernest Torrence, Buster Keaton, and an armful of hats in a classic sequence

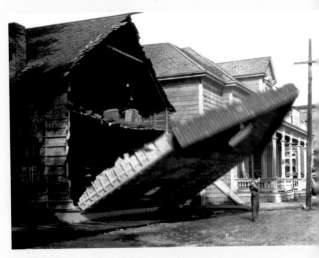

Side view of the most famous— and dangerous—stunt of Keaton's career

But the film truly shines when Keaton has a chance to devise elaborate stunts. The most acrobatic of the silent film comedians, Keaton blended laughs with a sense of breathless danger like no other artist. *Steamboat Bill*'s final fifteen minutes are a classic case in point. A cyclone

strikes the town: buildings rip apart, facades crumble, and an entire hospital detaches and flies away, leaving Keaton in bed in a now wide-open room. He struggles in the wind, at one point almost parallel to the ground as a truckload of boxes fly into him. "I took a pretty good beating," Keaton later told historian Kevin Brownlow.

The most eye-popping moment, and still one of the most spectacular stunts ever filmed, comes when the facade of a house falls toward an unsuspecting Keaton—who just so happens to

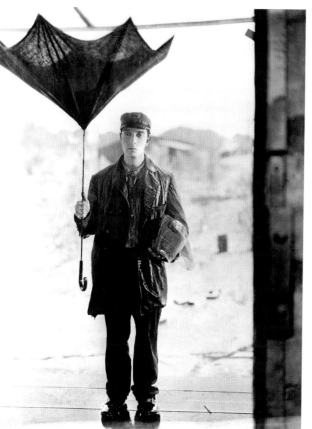

Keaton creates comedy with a simple umbrella.

be standing in the one spot where he won't get crushed, as a small window opening falls around him. Keaton had filmed an earlier version of this gag in his 1920 two-reeler *One Week*, but this rendition upped the ante considerably. The stunt was done for real, with a heavy wall and with two nails driven into the ground to mark Keaton's placement. He later explained to *Sight and Sound* magazine, "We built the window so that I had a clearance of two inches on each shoulder, and the top missed my head by two inches and the bottom my heels by two inches." He only planned a single take: "You don't do those things twice."

Originally, *Steamboat Bill, Jr.* was not even supposed to feature a cyclone. It had been scripted as a flood, and Keaton had already begun preparing the sequence when production supervisor Harry Brand informed producer Joe Schenck that a flood would be inappropriate: deadly real floods had lately been in the news, and Brand believed that so many people died from floods each year that the audience wouldn't find the scene funny. Keaton later said he knew that windstorms actually caused more deaths than floods, but he went along with the change, even though it cost him $35,000 to reconstruct the sets. He created the intense wind by means of six airplane engines with attached propellers.

The result looks at once absurdly over the top and astoundingly real, a dichotomy that encapsulates much of Keaton's appeal. Comedy

............

ROBERT OSBORNE

"This film is now considered one of Buster Keaton's masterpieces, but in 1928 it was the latest Keaton film [to do] very poorly at the box office—which was especially hard on him because at that time, Buster was financing his films with his own money. . . . After this he signed a contract with MGM, [where] he basically got lost in the factory mentality of the studio system . . . and soon realized he'd made the worst mistake of his life. He never again enjoyed genuine creative freedom. . . . But this film was made when he was very much at peak form. . . . When you see [the house stunt], you'll understand why even the cameraman said he had to look the other way!"

Buster Keaton and Marion Byron, who at sixteen was in her first film

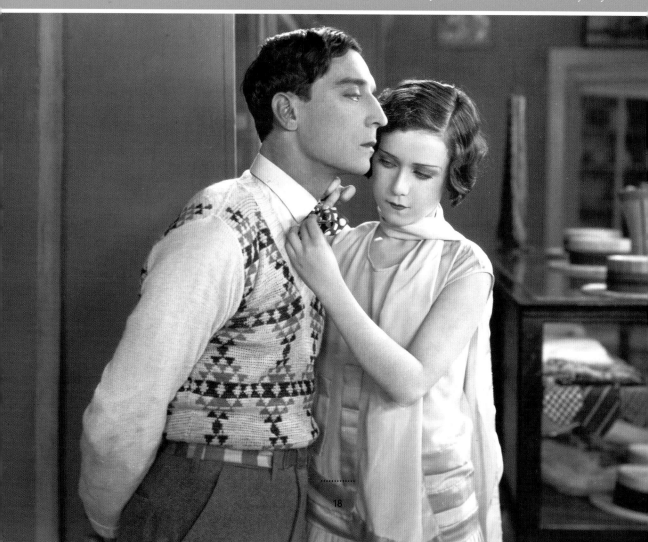

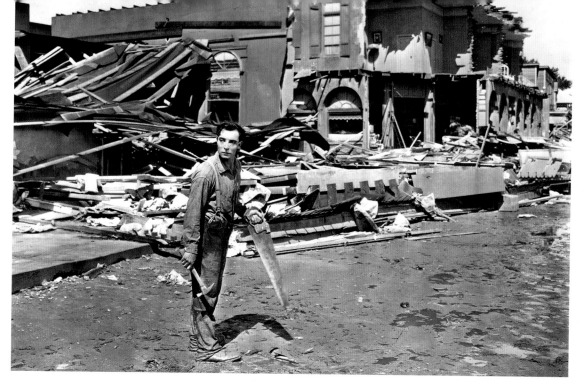

Publicity photo of Buster Keaton posing against the destroyed set

and suspense, laughs and fears, are often divided by a very fine line, and it can be easy to take for granted the perilous nature of Keaton's gags because he was so skilled at keeping them on the side of laughter.

WHAT TO LOOK FOR

When Steamboat Bill takes his son to a haberdasher to find the ideal hat, Keaton's perfectly timed reactions create brilliant comedy as he tries on more than a dozen of them. There's also an amusing in-joke: one of the hats is a flat porkpie variety, Keaton's trademark from previous films. Here he takes one quick look at himself and discards it immediately.

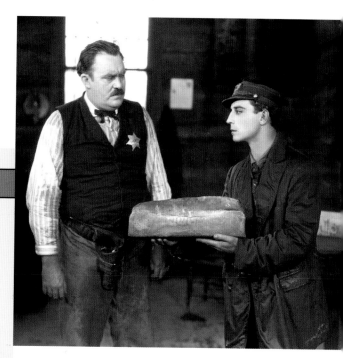

Buster tries to get a suspicious loaf of bread past the sheriff (Bud Marshall).

FREAKS

MGM, 1932
B&W, 62 minutes

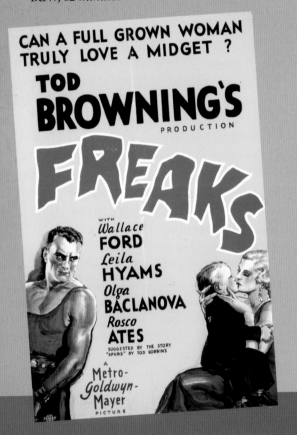

CAN A FULL GROWN WOMAN TRULY LOVE A MIDGET?

TOD BROWNING'S PRODUCTION

FREAKS

WITH Wallace FORD
Leila HYAMS
Olga BACLANOVA
Rosco ATES

SUGGESTED BY THE STORY "SPURS" BY TOD ROBBINS

A Metro-Goldwyn-Mayer PICTURE

PHYSICALLY DISABLED CARNIVAL PERFORMERS EXACT REVENGE AGAINST A TRAPEZE ARTIST AND A STRONGMAN AFTER DISCOVERING THAT THE COUPLE PLANS TO KILL ONE OF THEIR OWN FOR HIS MONEY.

DIRECTOR

Tod Browning

PRODUCER

Tod Browning (uncredited)

SCREENPLAY

Willis Goldbeck and Leon Gordon (uncredited), suggested by Tod Robbins's story "Spurs"

STARRING

WALLACE FORD	PHROSO
LEILA HYAMS	VENUS
OLGA BACLANOVA	CLEOPATRA
ROSCO ATES	ROSCOE
HENRY VICTOR	HERCULES
HARRY EARLES	HANS
DAISY EARLES	FRIEDA
ROSE DIONE	MADAME TETRALLINI
DAISY HILTON	SIAMESE TWIN
VIOLET HILTON	SIAMESE TWIN
SCHLITZE	HIMSELF
JOSEPHINE JOSEPH	HALF WOMAN—HALF MAN
JOHNNY ECK	HALF BOY
FRANCES O'CONNOR	ARMLESS GIRL
PETER ROBINSON	HUMAN SKELETON

Once seen, never forgotten, *Freaks* still packs a punch, but not in the way some might expect. The picture was so badly received in 1932 by audiences, critics, and even the studio that made it (the unlikely MGM), that *Freaks* virtually destroyed its director's career and developed an unfair reputation for hideousness that even today can obscure its real content. Classified as a horror film, it doesn't actually contain much horror—until the climax. For the majority of its brief running time, the tone is not one of dread or fear, but one of compassion.

With the buildup created by its opening scene of a carnival barker promising "living, breathing monstrosities," much of the story is surprisingly sedate as it looks behind the scenes of a traveling circus. Little appears to happen at first, but audience attention is riveted on the carnival performers—the disabled, so-called "freaks": conjoined twins, hermaphrodites, microcephalics, a bearded lady, limbless people, and, most prominently, two little people, Hans and Frieda, who are very much in love. (They are played by brother and sister Harry and Daisy Earles.) That love is put to the test as a trapeze artist, Cleopatra, schemes with her boyfriend, Hercules the strongman, to marry Hans and murder him for his inheritance. When Hans's friends

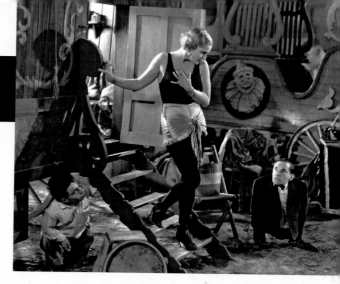

Cleopatra (Olga Baclanova) steps outside as "freaks" Angeleno (Angelo Rossitto) and Half Boy (Johnny Eck) eye her ominously.

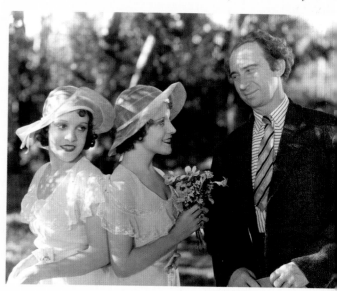

Roscoe (Rosco Ates) woos one of the Siamese Twins (Violet Hilton) as her sister (Daisy Hilton) watches.

discover the plot, they exact horrible revenge.

At its core, *Freaks* is really about challenging the audience's reactions to people with these real-life disabilities. As written, directed, and performed, they are essentially warm, noble souls with the same day-to-day concerns as anybody

else. They are never shown performing in the circus ring but are kept humanized. The real "living, breathing monstrosities" are Cleopatra and Hercules—and anyone who would not treat the "freaks" with human dignity.

This is best illustrated in the movie's most unforgettable and bizarre sequence: the wedding feast. It begins as a celebration of Hans and Cleopatra's marriage with the "freaks" reveling around a long dinner table. They don't yet notice that Cleopatra and Hercules are laughing at the sham they've perpetrated. But when the "freaks" start their memorable chant, "Gooble gobble/ gooble gobble/we accept her/one of us," Cleopatra turns stone-cold. Revulsed by the idea of being one of "them," her true self comes out with the venomous, classic retort: "Dirty, slimy, freaks!" The looks of hurt as the "freaks" suddenly realize they've been tricked and belittled are remarkably affecting, underscoring how successfully Browning has made the audience empathize with them.

At the end of the picture, as they crawl through mud and rain with knives to inflict terror upon their tormentors, the audience may well be caught between sympathizing with them, finding satisfaction in their action, condemning it, enjoying the horror-film atmospherics, and feeling unsettled watching these real people with real conditions now presented as a macabre spectacle.

Freaks is based on a short story, "Spurs," published in 1923. Tod Browning, a director whose career stretched back to 1915 and included several horror classics starring Lon Chaney, had wanted to adapt it since at least 1927; he had joined a circus as a teenager and felt an affinity toward the performers. Only after the success of Universal's *Dracula* (1931), which Browning directed, and *Frankenstein* (1931), did MGM production chief Irving Thalberg finally agree the time was right to cash in on the horror craze.

Wallace Ford and Leila Hyams as sympathetic carnival performers who stand up for the "freaks"

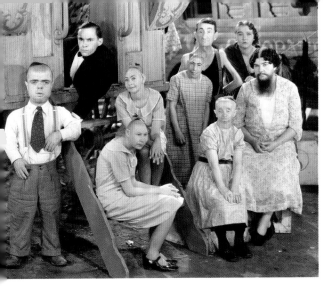

Some of the disabled cast of Freaks: *(front) Jerry Austin, Jenny Lee Snow, Koo Koo, and Olga Roderick; (middle) Elvira Snow and Schlitze; (rear) Johnny Eck, Peter Robinson, and Josephine Joseph*

Cleopatra (Olga Baclanova) seduces Hans (Harry Earles).

Screenwriter Willis Goldbeck later recounted that Thalberg told him to write something "more horrible" than those Universal classics. After Goldbeck submitted his script, which contained extended horror sequences originally included in the finished film, he found Thalberg slumped at his desk. "He looked at me sadly, shook his head, and sighed, 'Well, it's horrible.'"

The public controversy began with the first preview. Reportedly, audiences were sickened, people ran out of the theater, and one woman attempted to sue the studio for causing her miscarriage. MGM cut the film way down, eliminating the gruesome, now-lost, final scenes, and released it in small cities with a gradual expansion in hopes that the controversy would die down. It didn't. Several cities banned the picture, and the United Kingdom did so for thirty years. *Freaks* was a disaster, and Browning's career never recovered. He made just a few more films before retiring to a life of seclusion.

In 1962, the movie was revived at the Venice Film Festival and reassessed as a classic, though the controversy surrounding it has never really disappeared. Ultimately, *Freaks* is an unclassifiable work by a talented artist whose intended result was significantly modified beyond his control. But it stands nonetheless as a humane morality play, one that critic Andrew Sarris said "may be one of the most compassionate movies ever made," and which *Time Out* magazine has deemed "cinema's boldest statement on the dichotomy between outer appearance and inner life."

WHAT TO LOOK FOR

Its climactic violence aside, *Freaks* is also strongly pre-Code for some entertainingly racy moments that would have been forbidden two years later. In one scene, Wallace Ford appears to be naked in a bathtub as Leila Hyams walks in, leans over the edge of the tub, and carries on a casual conversation; only a minute or two later does Browning reveal that Ford is wearing pants and not actually taking a bath. At another point, Olga Baclanova is preparing to cook eggs for Henry Victor when she unties her robe, sticks out her chest, and asks, "How do you like them?" Cheekiest of all is the moment where one of the twins kisses her fiancé, and her conjoined sister registers pleasure on her face.

ROBERT OSBORNE

—

"It's not really a horror film. It's about life just being lived at a different level with a different kind of people. . . . It's such a bizarre film for MGM. They were all for glamour, and to be able to create a movie with this atmosphere I think is kind of amazing."

Filming the wedding feast. Director Tod Browning stands at far right.

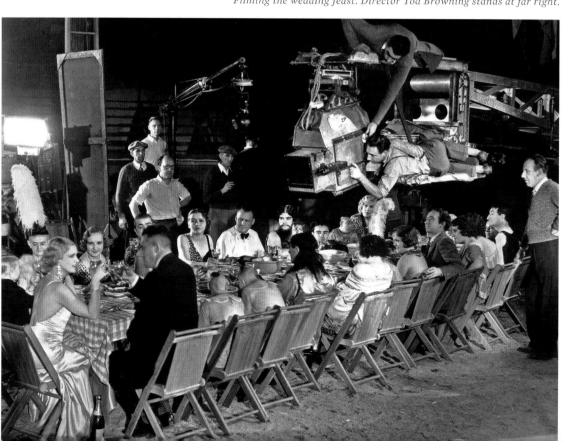

GOLD DIGGERS OF 1933

Warner Bros., 1933
B&W, 97 minutes

DIRECTOR

Mervyn LeRoy

PRODUCER

Robert Lord (uncredited)

SCREENPLAY

Erwin Gelsey, James Seymour,
David Boehm, and Ben Markson,
based on a play by Avery Hopwood

STARRING

WARREN WILLIAM LAWRENCE

JOAN BLONDELL . CAROL

ALINE MacMAHON TRIXIE

RUBY KEELER . POLLY

DICK POWELL . BRAD

GUY KIBBEE . PEABODY

NED SPARKS . BARNEY

GINGER ROGERS . FAY

STERLING HOLLOWAY MESSENGER BOY

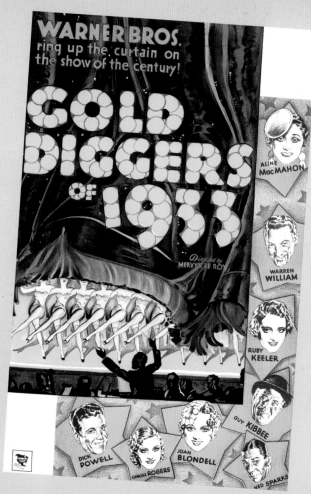

**THREE OUT-OF-WORK CHORUS GIRLS BEFRIEND
AN ASPIRING, MYSTERIOUSLY RICH SONGWRITER WHO
MIGHT BE ABLE TO FUND A NEW BROADWAY SHOW.**

When Warner Bros. completed *42nd Street* in early 1933, studio executives were so sure they had a hit on their hands that they delayed its release by several weeks so that *Gold Diggers of 1933*, then in production, could open hot on its tail. The confidence was striking because musicals were practically considered passé at the time. Talkies were only a few years old, but a glut of early musicals—many of which were tediously photographed—had wearied audiences of the genre. *42nd Street* turned things around spectacularly. A backstage musical with wildly imaginative production numbers choreographed by Busby Berkeley, it gave Depression-era audiences a jolt of sheer escapism while acknowledging their daily struggles. With *Gold Diggers of 1933*, Berkeley struck again.

His genius opened up new possibilities for musicals by obliterating the proscenium arch. In a Busby Berkeley number, no topic, set, costume, or activity is too fantastical or off-limits. The number is devised completely for the camera, which can go anywhere and shoot from any angle, even on its side, without ever jarring the audience—in fact, the crazier the better. The opening of *Gold Diggers of 1933* sets the audience up for this, as Ginger Rogers sings "We're in the Money" straight to the camera, and literally *in* money: she is costumed in coins, as are dozens

Joan Blondell, Aline MacMahon, and Ruby Keeler in a pre-Code moment. Director Mervyn LeRoy brought comic precision and flair to the nonmusical sequences.

of other women who soon appear. When Ginger sings a reprise in Pig Latin—and the camera pushes in for an extreme close-up of her mouth that lasts for twelve priceless seconds—the audience understands that anything goes.

Wilder images are yet to come. In "Pettin' in the Park"—one of four numbers with catchy words and melodies by tunesmiths Harry Warren and Al Dubin—cops chase a baby played by dwarf Billy Barty, all on roller skates; the baby hands Dick Powell a can opener to pry open Ruby Keeler's metal outfit; a snowball fight leads to a horde of pretty girls creating kaleidoscopic

ROBERT OSBORNE
—

"The Busby Berkeley numbers in this movie are so wild . . . and it makes a stinging statement at the end: a song about the forgotten man and how guys that fought in the First World War are now standing in breadlines. It's not something they're looking back on, it's what was going on at that moment. But they do it in such a merry way, and you've got this wonderful cast—all kinds of young, bright talents as well as some great old-timers."

A trademark Busby Berkeley overhead shot in the "Shadow Waltz" number. Ruby Keeler with violin is surrounded by twenty-four of Berkeley's girls with violins.

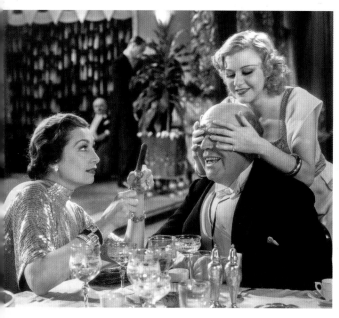

Aline MacMahon (left) and Ginger Rogers play with Guy Kibbee. Rogers would next receive her first leading role, in Professional Sweetheart (1933), *and a few months later she'd be dancing with Fred Astaire in* Flying Down to Rio (1933).

Aline MacMahon and Ruby Keeler in the foreground, Dick Powell standing in the middleground, and Ned Sparks (hands in pockets) standing in the background directing his chorus

patterns with giant snowballs for an overhead camera (Berkeley's trademark angle); and the girls walk out of the rain to disrobe in silhouette behind a screen—a bit of sexiness that would have been strictly forbidden a year later with the enforcement of the Hollywood Production Code. So would numerous bits of racy dialogue, as when Ginger Rogers says, "I look much better in clothes than any of you; if Barney could see me in clothes—," to which Aline MacMahon retorts, "He wouldn't recognize you."

For a long stretch, the film actually plays as a racy screwball comedy of mistaken identity, with Warren William and Guy Kibbee trying to thwart a romance between Dick Powell and Ruby Keeler. Meanwhile, Ned Sparks is a delight as the surly Broadway producer who's got the show, the music, the cast, and the theater all ready to go—but not the money. That was a plot point that audiences could relate to. *Gold Diggers of 1933* confronts the Depression head-on: characters joke about it, they sing about it, and, most poignantly, Berkeley builds his "Forgotten Man" number entirely around it. Joan Blondell laments the plight of World War I veterans now discarded by society while powerful images of soldiers fill the screen. They march to war triumphantly; stagger home, wounded; stand forlornly in bread-lines; and finally take the stage to plead with the audience to remember them. On this astonishing note of stark social reality, the movie fades out.

.............

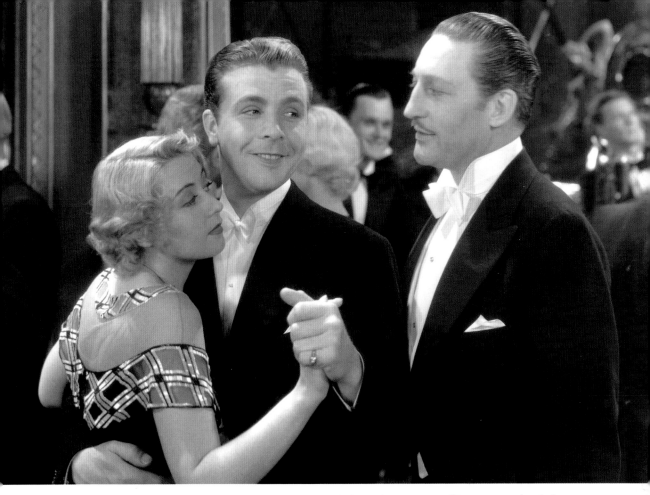

Joan Blondell and Dick Powell dance, but Warren William wants to break them up. William at this time was starring in a superb run of pre-Code comedies.

Gold Diggers of 1933 opened on May 27, 1933, and Warner Bros.' release strategy paid off: the film was an even bigger hit than *42nd Street*, with both titles among the studio's top three money-makers of the year. (*Footlight Parade* was the other.) Clearly the blend of escapist fantasy and real-world bluntness struck a chord with the public and validated Berkeley's approach. As he later said: "The way-out musicals never had been tried. A lot of people used to believe I was crazy, but I can truthfully say one thing: I gave 'em a show."

DREW BARRYMORE
—

"I thought it approached the Depression in a really innovative way. . . . And the women really reminded me of modern, working women. A lot of the film is about them just passionately wanting a job."

.............

In dreaming up the "Shadow Waltz" number, Berkeley remembered having once seen a young woman in New York perform a vaudeville act with a violin. He expanded it as only his fervent mind could—with sixty girls and sixty violins, an enormous winding staircase, and neon lighting on each fiddle. The girls move around to form mesmerizing patterns for the overhead camera, even taking the shape of a massive, neon violin. An earthquake struck during the shoot, seriously injuring one performer and throwing Berkeley off his chair on the camera crane; he dangled by one hand before pulling himself back up. The resulting number, however, is one of the high points of his career and of 1930s musicals.

—

At the ninety-eight-minute mark, Berkeley can be seen as a call boy who knocks on a dressing room door and shouts, "Hurry up, boys. Snap it up, will ya? Onstage, 'Forgotten Man' number!" He did the cameo because the studio didn't want to pay actors for such tiny speaking roles. Berkeley later recalled that when his "girls" saw the moment during the Chinese Theatre premiere, they "roared with laughter."

—

A powerful segment of "The Forgotten Man" is sung by Etta Moten, an acclaimed opera singer who would become a rare African American entertainer to perform at the White House when Franklin D. Roosevelt invited her to sing this song on his birthday.

The wondrous "Shadow Waltz" number, choreographed by Busby Berkeley

30

TWENTIETH CENTURY

Columbia, 1934
B&W, 91 minutes

DIRECTOR

Howard Hawks

PRODUCER

Howard Hawks (uncredited)

SCREENPLAY

*Ben Hecht and Charles MacArthur,
based on the play* Napoleon of Broadway
by Charles Bruce Millholland

STARRING

JOHN BARRYMORE OSCAR JAFFE

CAROLE LOMBARD LILY GARLAND

WALTER CONNOLLY OLIVER WEBB

ROSCOE KARNS OWEN O'MALLEY

RALPH FORBES GEORGE SMITH

CHARLES LEVISON (CHARLES LANE) MAX JACOBS

ETIENNE GIRARDOTMATTHEW J. CLARK

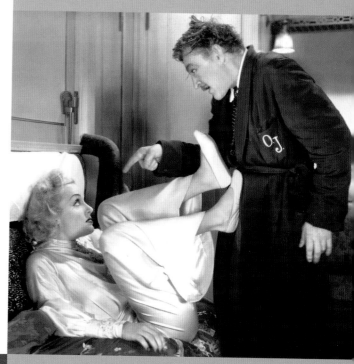

Director Howard Hawks encouraged
Carole Lombard to really kick John Barrymore.

**AN EGOTISTICAL
BROADWAY PRODUCER
TRIES TO LURE THE
STAR HE CREATED BACK
TO THE STAGE.**

WHY IT'S ESSENTIAL

Along with *It Happened One Night* (1934), which opened three months earlier, *Twentieth Century* kick-started the screwball comedy genre. It's actually the more purely "screwball" of the two, with romance taking a back seat to continuous, sharp, comic hijinks—from sophisticated wise-cracks to inspired slapstick. *Twentieth Century* is also essential for John Barrymore's last and arguably best major leading role, Carole Lombard's star-making performance, and director Howard Hawks's breakneck storytelling pace.

The film is a showbiz satire. Broadway impresario and egomaniac Oscar Jaffe makes

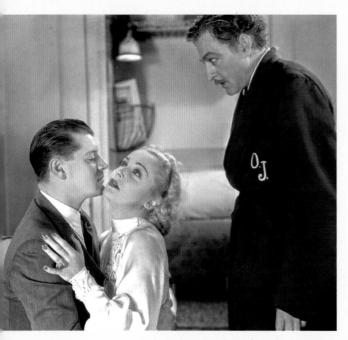

Carole Lombard with Ralph Forbes, who will prove no match for John Barrymore (right)

a stage star (and lover) out of novice Mildred Plotka, whom he renames Lily Garland, but after a run of hit plays, she decamps for Hollywood, having had enough of his overbearing methods and insufferable jealousy. She becomes a screen star and diva while his career heads downhill—until he runs into her on the Twentieth Century Limited train from Chicago to New York. Now they each try to outwit, outmaneuver, out-ridicule, and outplay each other as he aims to win her back and she defiantly refuses.

Twentieth Century was based on an unpro-duced play by Charles Millholland entitled *Napoleon of Broadway*. After being completely rewritten—and retitled—by the team of Ben Hecht and Charles MacArthur, whose earlier *The Front Page* bears similarity to this farce, the show was a success, prompting Columbia to buy the rights and retain Hecht and MacArthur for the screenplay. Working with Hawks, they created a new first act to help the story breathe more, move faster, and, most importantly, esta-blish a clear love-hate pattern to Oscar and Lily's relationship. They push and pull each other scene-to-scene, even moment-to-moment, toward ever greater comic heights.

John Barrymore, then fifty-two, was famed as a dramatic actor and silent matinee idol, not as a comedian. When he asked Hawks why he wanted him to play Oscar Jaffe, Hawks replied, "It's the story of the biggest ham on earth and you're

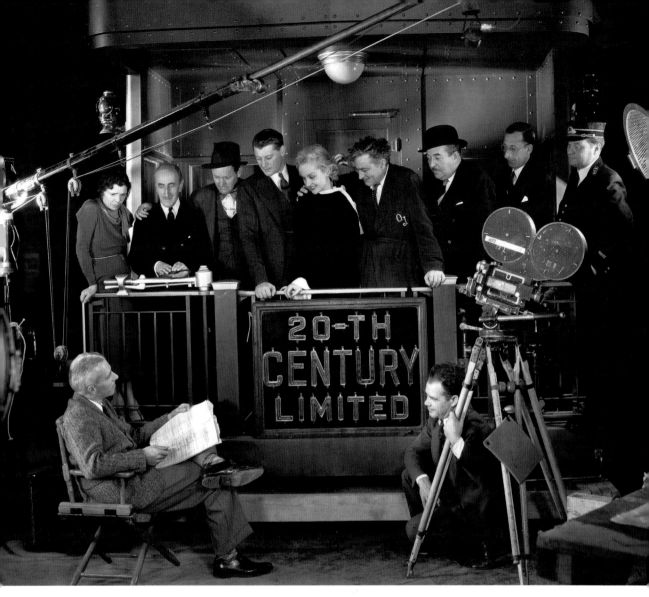

Director Howard Hawks (seated) with his cast and a crew member

the biggest ham I know." Barrymore went on to have a field day sending up his own image, at one point even imitating a camel as he pitches an idea for a passion play to Lombard. He later called this performance his favorite of his own work.

Carole Lombard had been in movies for a decade but her career still had not truly taken off.

Hawks correctly predicted that her uninhibited nature would be perfect for the role. In fact, she embodies one of the earliest "Hawks women" onscreen—strong-minded, liberated, and independent. Her electric chemistry with Barrymore was matched by mutual admiration: he gave her advice, rehearsed with her at length, and

.............

afterwards deemed her the finest actress he ever worked with. Lombard later said she learned more from Barrymore than she had in her entire time in Hollywood. "I'll never forget how swell I'd feel to hear that booming laugh of his," she said. "It was the most subtle flattery in the world."

One of Hawks's greatest contributions to the screwball genre, starting with this film, was his direction of lightning-fast, overlapping dialogue. "All you want to do is hear essential things," he said. "You have to tell the sound man what lines he *must* hear." Hawks additionally created plenty of visual comedy, from the convoluted chalk diagrams Oscar draws on the stage floor to the technique of treating the train-car sets like stages on which Oscar and Lily play-act for one another.

There's also an inspired bit of business with a "lunatic" who spreads REPENT stickers all over the train. Played by Etienne Girardot, the only Broadway cast member imported for the film, he is part of a superb supporting cast that includes ubiquitous Charles Lane ("The more you direct

her, the worse she gets!" he exclaims), wisecracking Roscoe Karns, and hilariously obsequious Walter Connolly, who at one point becomes so fed up during a crisis that his solution is to "get plastered." The audience might want to join him, but chances are they will be laughing too hard.

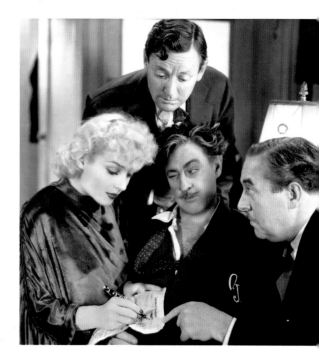

John Barrymore has another trick up his sleeve against Carole Lombard, as Roscoe Karns and Walter Connolly look on.

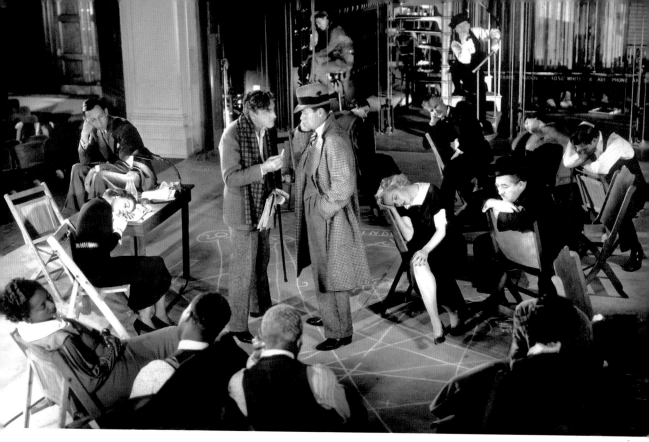

The theater company is wiped out, but as long as he has chalk, Oscar Jaffe (John Barrymore) can keep going. Standing with Barrymore: Roscoe Karns. Seated, center right: Carole Lombard.

Variety deemed *Twentieth Century* "probably too smart for general consumption." It didn't catch on, despite stellar reviews, but it impressed Hollywood with its approach to comedy and helped lead the way to such other screwball gems as *The Awful Truth* (1937) and *Bringing Up Baby* (1938). Barrymore began a descent into supporting roles, but Lombard was now redefined as a comedienne and leading lady, going on to star in more comedy classics including *My Man Godfrey* (1936) and *To Be or Not to Be* (1942), the latter released after her untimely death in a plane crash.

John Barrymore and Walter Connolly make nice with Etienne Girardot. They think he's a millionaire, not the "lunatic."

ROBERT OSBORNE
—

*"This is the movie in which
Carole Lombard emerged
as a really first-rate
comedienne. . . . I also find
it very poignant that this is
the last important film John
Barrymore ever starred in. . . .
I think this is his best performance
on film. He is so funny in it."*

According to Hawks, Lombard was nervous and holding back while rehearsing for a scene with Barrymore in a train compartment. Hawks took her aside and asked her what she would do in real life if someone insulted her the way Barrymore's character was doing. "I'd kick him," she said. Why not try it, asked Hawks. Lombard did just that, Barrymore loved it, and a classic scene was born. Lombard continued to let loose and improvise. Hawks said from then on, every time Lombard started work on a new film, she sent him a telegram that read, "I'm gonna start kicking him."

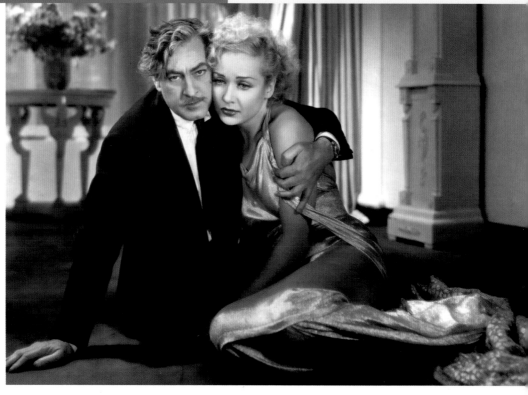

Constant fighting can make a couple tired, as John Barrymore and Carole Lombard learn. "[They] were dynamic on the set. Anything could happen," sound man Edward Bernds later recalled. "I have never worked on a picture in which the scenes commanded such rapt attention from the crew."

RKO, 1935
B&W, 101 minutes

DIRECTOR

Mark Sandrich

PRODUCER

Pandro S. Berman

SCREENPLAY

Dwight Taylor and Allan Scott;
story by Dwight Taylor

STARRING

FRED ASTAIRE JERRY TRAVERS

GINGER ROGERS. DALE TREMONT

EDWARD EVERETT HORTON.HORACE HARDWICK

ERIK RHODES. ALBERTO BEDDINI

ERIC BLORE. BATES

HELEN BRODERICK MADGE HARDWICK

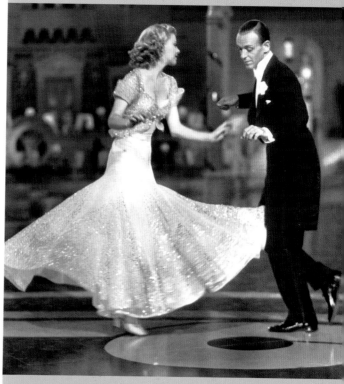

Fred and Ginger dance "The Piccolino." Astaire exercised great control over the way the numbers were filmed: full figure, in long takes, with minimal camera movement.

A WOMAN WRONGLY ASSUMES AN AMOROUS DANCER TO BE HER FRIEND'S HUSBAND.

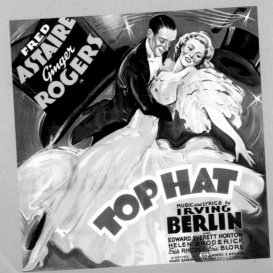

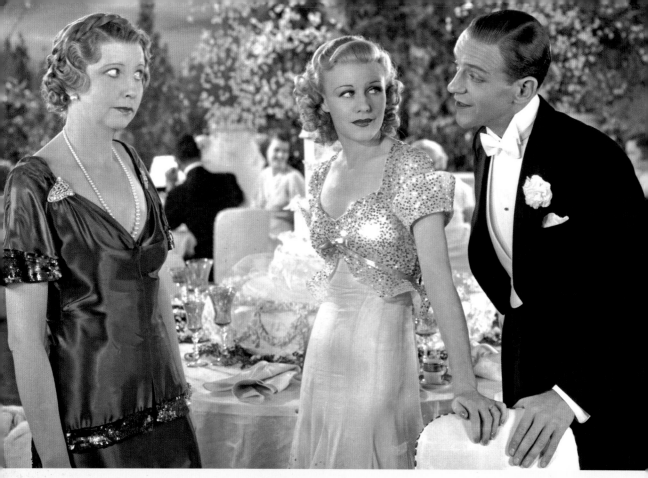

Indispensable comedienne Helen Broderick with Ginger Rogers and Fred Astaire

WHY IT'S ESSENTIAL

Of the ten musicals Fred Astaire and Ginger Rogers made together, *Top Hat* is usually the first that comes to mind. It exemplifies the series, and not just because it contains some of the most beloved musical numbers Fred and Ginger ever performed. Its very title summons the quintessential image of Astaire, *in* a top hat, as well as the elegant, carefree attitude that defines these musicals.

Top Hat is set in a world of wealthy characters, formal attire, and glitzy European hotels with colossal art deco bedrooms. It is extravagantly, ridiculously, wonderfully unreal-looking in every way, as far from the actual lives of most Depression-era audiences as possible. The emotion conjured by the musical numbers, however, is very real. Fred and Ginger may not dance enough in *Top Hat* (do they ever, in any movie?), but the romance, playfulness, and love that they do convey through dancing is utterly palpable and lifts the audience to a state of joy.

............

"Even the misunderstandings [in the plot] give rise to beautiful songs. . . . The music so buoyantly conveys the feeling, even when they're mad at each other. The music is connecting them."

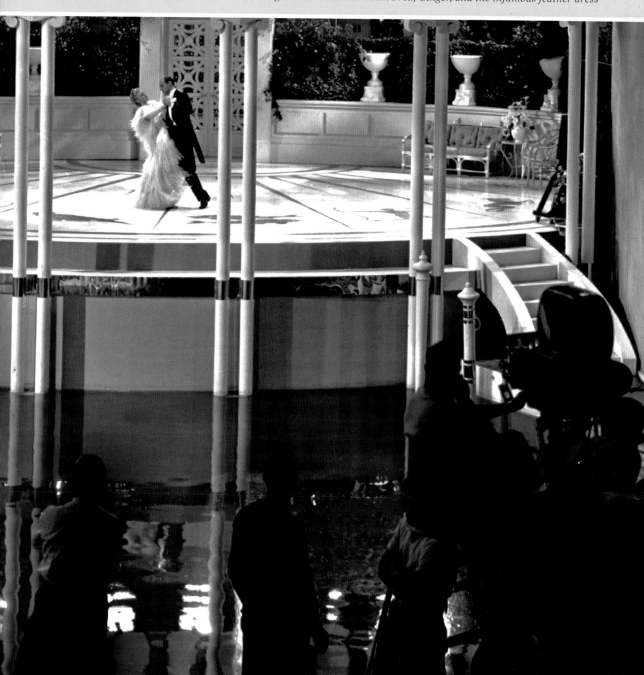

Filming "Cheek to Cheek" with Fred, Ginger, and the infamous feather dress

That magic starts with the first number. After inadvertently waking up Ginger by dancing "No Strings (I'm Fancy Free)" on the floor above her hotel room, Fred flirts with her via a soft-shoe reprise, helping her fall asleep and building surprisingly romantic heat given that they are in different rooms. They later fall in love by dancing the sublime "Isn't This a Lovely Day (To Be Caught in the Rain)?" and renew that love by performing "Cheek to Cheek." The connection they express, fused with the romantic music and lyrics, feels astonishingly intimate, and their occasional smiles seem to exist between Fred and Ginger themselves, not their characters, making the joy feel even more genuine.

Elsewhere, Astaire performs his signature solo number, "Top Hat, White Tie and Tails," with his timing and precision a marvel as he uses his cane to "shoot" down a line of tuxedo-clad gentlemen. (Irving Berlin thought this the best song he wrote for any Astaire-Rogers film.) In the finale, "The Piccolino," Rogers sings a solo and the pair reaffirm their love with a

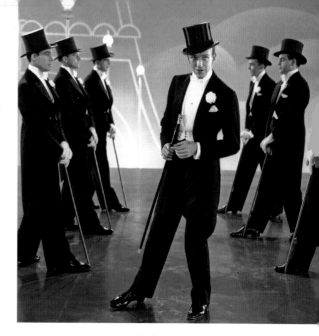

Fred Astaire in a signature image

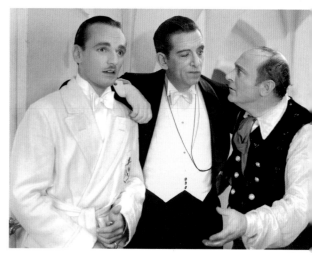

Three wonderful comedy players: Erik Rhodes, Edward Everett Horton, and Eric Blore

ROBERT OSBORNE

—

"I think one area that Fred Astaire and Ginger Rogers don't get credit for is the great acting they did in their songs. They're giving great performances. Just watch their faces. They're conveying exactly what we need to know, never overdoing it. They make it look so easy that we don't see all the work they did."

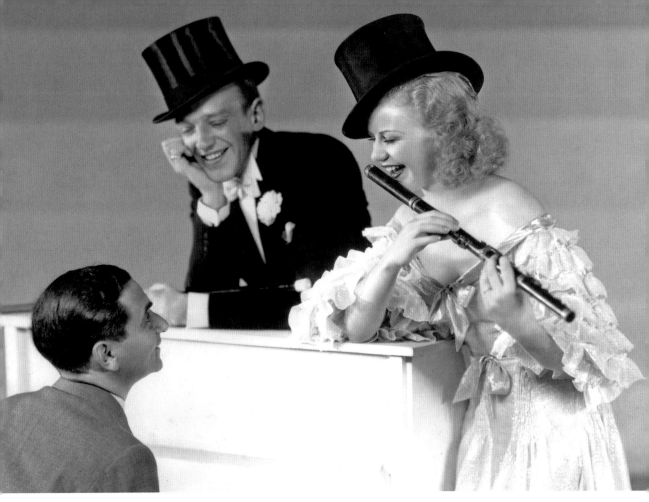

Fred Astaire, Ginger Rogers, and Top Hat *composer/lyricist Irving Berlin*

celebratory dance, overshadowing a part of the number that is performed by a large chorus. Irving Berlin said he worked harder on "The Piccolino" than on any other song in this film. By contrast, he wrote "Cheek to Cheek" in just one day.

At this point, the Astaire-Rogers productions were well-oiled machines, with a core group of artists creating their look and sound: Mark Sandrich (who directed five of the films), Allan Scott (who cowrote five), producer Pandro S.

Berman, choreographer Hermes Pan, art directors Van Nest Polglase and Carroll Clark, and musical director Max Steiner. RKO signed Irving Berlin to create the songs for two of the films, starting with *Top Hat*, but he was also welcomed into the overall filmmaking process. He participated in script conferences so that his songs would be well-integrated in the story, and he was present throughout production, approving the orchestrations and working closely with Astaire and Rogers to ensure that their recordings

.............

expressed his musical intentions. Berlin adored Astaire's singing, which is often underrated. "I'd rather have Fred Astaire introduce one of my songs than any other singer I know," he once said.

Top Hat has a wispy plot of mistaken identity that would otherwise place the film, without its musical numbers, into the realm of screwball comedy. There's good fun in seeing how the story devises ways for the misunderstandings to continue and prevent Fred and Ginger from getting together. It also gently satirizes the rich, starting with Edward Everett Horton's lament that his valet believes square bowties should be worn with evening attire. "A square tie, imagine! I prefer the butterfly," he declares. The valet is played by Eric Blore, who along with Horton, Helen Broderick, and Erik Rhodes ("Marry me. I am rich, I am pretty!") comprise the brilliant comedy players recurring through the Astaire-Rogers series. They are indispensable to *Top Hat*'s entertainment value.

The picture opened on September 6, 1935, and became the second-biggest moneymaker of the year, after *Mutiny on the Bounty*. It went on to be nominated for four Academy Awards, including Best Picture and Best Original Song ("Cheek to Cheek"). By the time of the Oscar ceremony in March 1936, the next Astaire-Rogers musical, *Follow the Fleet* (1936), had already opened, and preparations were underway for one of their finest, *Swing Time* (1936).

WHAT TO LOOK FOR

"Cheek to Cheek" feels effortlessly romantic, but Fred and Ginger were practically at war when they filmed it. The issue was Ginger's dress, adorned with countless ostrich feathers. During rehearsal they flew off to such an extent, Astaire later wrote, that it was "as if a chicken had been attacked by a coyote. . . . I had feathers in my eyes, my ears, my mouth, all over the front of my suit." After some sneezing fits, he refused to shoot the number unless she changed outfits, but Rogers held firm. Finally, the costume department sewed on each plume securely, which did the trick, although a few wayward feathers are still visible on the dance floor. Afterward, Astaire nicknamed Rogers "Feathers" and presented her with a feather-shaped gold brooch and a note that read, "You were right"—because even he had to admit the dress looked great on film. Astaire and Hermes Pan also sang this parody to her:

Feathers, I hate feathers
And I hate them so that I can hardly speak
And I never find the happiness I seek
With those chicken feathers dancing
Cheek to cheek

—

The water in the Venice lagoon sequence was dyed black in order to accentuate the whiteness of the sets on either side.

—

Lucille Ball appears in a bit part as a flower shop clerk.

MUTINY ON THE BOUNTY

MGM, 1935
B&W, 132 minutes

DIRECTOR

Frank Lloyd

PRODUCER

Albert Lewin (associate producer)

SCREENPLAY

Talbot Jennings, Jules Furthman, and Carey Wilson, from the book by Charles Nordhoff and James Norman Hall

STARRING

CHARLES LAUGHTON CAPTAIN BLIGH

CLARK GABLE FLETCHER CHRISTIAN

FRANCHOT TONE ROGER BYAM

HERBERT MUNDIN SMITH

EDDIE QUILLAN ELLISON

DUDLEY DIGGES BACCHUS

DONALD CRISP BURKITT

HENRY STEPHENSON SIR JOSEPH BANKS

FRANCIS LISTER CAPTAIN NELSON

SPRING BYINGTON MRS. BYAM

MOVITA . TEHANI

Charles Laughton

IN 1789, CREW MEMBERS OF THE HMS *BOUNTY* MUTINY AGAINST SADISTIC CAPTAIN WILLIAM BLIGH DURING A VOYAGE TO THE SOUTH SEAS.

Eighty-five years after its release, *Mutiny on the Bounty* remains one of the great screen adventures—the quintessential Hollywood version of the most notorious mutiny in seafaring history. As *Variety* noted in its review, the picture is lengthy "without being guilty of a single dull moment." Justly famous for Charles Laughton's intense performance as the tyrannical Captain Bligh, the film also illustrates MGM's ability at the time to mount an epic, romanticized entertainment with potent personal dramas and moral questions at its core.

Frank Lloyd, then one of the top directors in Hollywood and known for his way with action, had purchased the rights to a recently published,

three-part series of historical novels telling the story of the *Bounty*. He approached Twentieth Century-Fox, intending to play the part of Bligh himself, but the studio declined. MGM production chief Irving Thalberg then offered to make the picture with Lloyd directing but not acting. Lloyd agreed, and Thalberg quelled studio chief Louis B. Mayer's concerns that a lack of major female characters would limit the film's appeal.

The stars aligned for the casting of the three principal roles. Thalberg's choice of Wallace Beery for Captain Bligh fell through, paving the way for Laughton, because Beery was not keen on working with Clark Gable. Gable, in turn, needed serious convincing to play first officer Fletcher Christian because it required him to shave his mustache, wear period breeches, and

Charles Laughton as Captain Bligh is flanked by officers DeWitt Jennings, Ivan Simpson (holding book), Clark Gable, and Dudley Digges, who is endearing as the peg-leg alcoholic doctor, Bacchus.

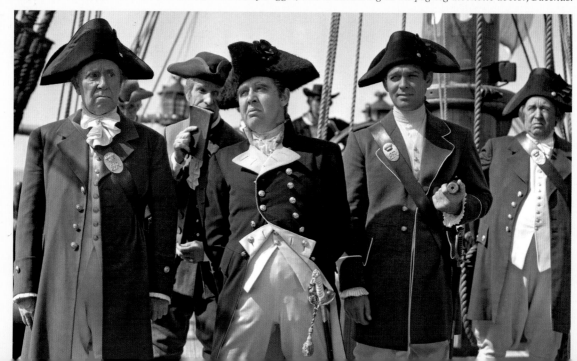

"It's done in a sweeping way by MGM with all the power they had behind them. And it holds up so well all these years later. . . . Those technicians and art directors and set decorators created [a] world that seems so real. They're geniuses who never get the credit they deserve."

grow a pigtail, all of which he thought would look silly and hurt his masculine image. Franchot Tone only got the part of midshipman Roger Byam after Robert Montgomery and Cary Grant proved unavailable.

The on-screen chemistry among all three actors is superb, but Laughton and Gable did not get along through much of the production. Gable complained that Laughton was ignoring him and not making eye contact during filming, thereby stealing the shots. After Thalberg intervened, Gable complained that Laughton was staring at him *too* intently. Privately, Thalberg was glad about the animosity, as he could tell from each day's rushes that it was translating into more robust conflict on-screen. The very contrast between the two actors—physically, vocally, and in their public images—could not have been more pronounced and effective.

Other troubles plagued the production. Frank Lloyd sailed full-size replicas of the *Bounty* and *Pandora* ships to Tahiti in order to shoot sequences without the principal cast, only to find when he returned that a technical error had underexposed

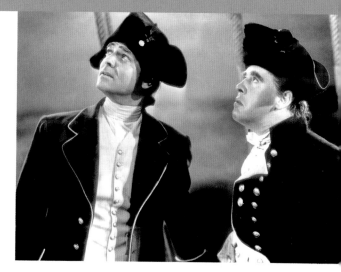

Clark Gable and Charles Laughton

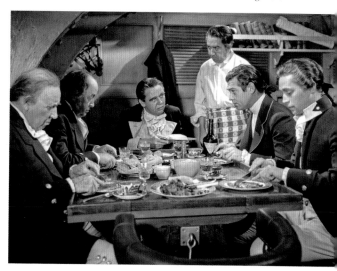

An awkward dinner with Captain Bligh. From left: DeWitt Jennings, Dudley Digges, Charles Laughton, Herbert Mundin, Clark Gable, Franchot Tone

............

If not for Fletcher Christian, his fellow mutineers would kill Bligh.
Center: Clark Gable, Charles Laughton, and Donald Crisp (with fist).

the film negative; Lloyd sailed back to shoot again. Later, while filming near the coast of Catalina Island off southern California, an assistant cameraman drowned when a barge capsized, and an eighteen-foot *Bounty* replica (used to achieve higher visual contrast with waves) was lost at sea for two days with two technicians aboard.

MGM spared little expense with all the replica ships, detailed sets, Tahitian voyages, and the filming of most ocean scenes on the ocean itself, a rarity at the time. Catalina served as the main production base, with art director Cedric Gibbons constructing Portsmouth harbor on one side of the island and a Tahitian village on the other. Laughton strived for realism, later recounting that he paid a visit to Gieves & Hawkes, the Savile Row tailor responsible for the real William Bligh's

uniform, and learned that they still had detailed records of the original's cut, fit, and material. Laughton had exact duplicates made to measure.

The finished film cost MGM nearly $2 million but became the highest-earning movie of the year, grossing well over $4 million. In addition to the profits and effusive reviews, *Mutiny on the Bounty* drew eight Academy Award nominations and has the unusual distinction of winning the Best Picture award but no other Oscars, something that had happened twice before but has not happened since. Laughton, Gable, and Tone were all nominated for Best Actor but possibly split the vote, leading to Victor McLaglen's win for *The Informer* (1935). The next year, the Academy introduced award categories of Supporting Actor and Supporting Actress.

.............

"What truly makes this an essential film to me is the story. There's nothing more dramatic than to be one among many inside a system where you know it's breaking down, and you know it's wrong, and you have to violate a code you've sworn to. . . . To [show] this kind of bravery against authority is a tremendous sacrifice, and it makes for a very dramatic film."

WHAT TO LOOK FOR

Mutiny on the Bounty establishes Bligh's abject cruelty right away when he insists that twenty lashes be applied to a sailor who is already dead, and he later orders even greater horrors upon the living, but Laughton's performance is not entirely villainous. The lifeboat sequence, shot in a studio tank, is one of the most brilliant in the film for the way Laughton draws a measure of sympathy for Bligh. Beautifully edited and scored to show the passage of forty-seven days, the five-minute montage reveals Bligh as an expert seaman and a wise—even gentle—leader, able to keep his men alive under the harshest of conditions. When Laughton declares, in a raspy voice, "We've beaten the sea itself," it's impossible, however briefly, not to admire the despicable Captain Bligh.

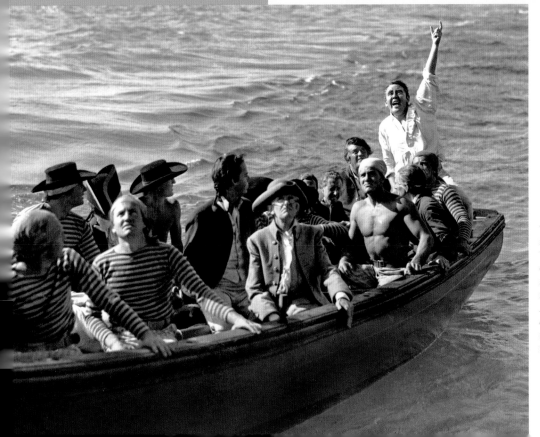

"You're sending me to my doom, eh? Well, you're wrong, Christian! I'll take this boat as she floats to England if I must. I'll live to see you, all of you, hanging from the highest yardarm in the British fleet!"

DODSWORTH

United Artists/Samuel Goldwyn Productions, 1936
B&W, 101 minutes

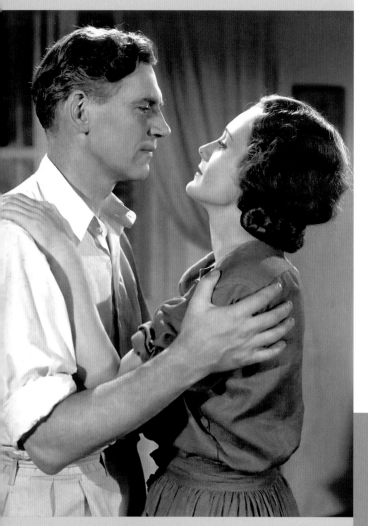

Walter Huston and Mary Astor generate
palpable chemistry in Dodsworth.

DIRECTOR

William Wyler

PRODUCER

Samuel Goldwyn

SCREENPLAY

*Sidney Howard, based upon the novel
written by Sinclair Lewis and
dramatized by Sidney Howard*

STARRING

WALTER HUSTON SAM DODSWORTH

RUTH CHATTERTON FRAN DODSWORTH

PAUL LUKAS ARNOLD ISELIN

MARY ASTOR. EDITH CORTRIGHT

DAVID NIVEN CAPTAIN LOCKERT

GREGORY GAYE KURT VON OBERSDORF

MARIA OUSPENSKAYA. . . BARONESS VON OBERSDORF

**A RETIRED AUTO
TYCOON'S MARRIAGE
STARTS TO UNRAVEL
DUE TO HIS WIFE'S
DIFFERING DESIRES IN
LIFE, SPAWNED BY HER
FEAR OF CONFRONTING
HER AGE.**

WHY IT'S ESSENTIAL

One of the most mature, deeply felt stories of marriage ever to come out of Hollywood, *Dodsworth* still feels remarkably modern and truthful as it charts the breakdown of a relationship. Sinclair Lewis's novel had been published in 1929, a year before the author won the Nobel Prize, and Sidney Howard's Broadway adaptation was a hit in 1934, running 315 performances and establishing Walter Huston in his most famous role as Samuel Dodsworth. Producer Samuel Goldwyn snapped up the rights and applied his usual fine taste to the film version. He retained Howard to write the screenplay, brought on Huston to re-create his iconic performance, and cast the other principal roles to perfection.

Howard's script uses a simple framework to explore a complex and delicate subject. Middle-aged Samuel Dodsworth sells his Midwestern automobile company and retires. "I'm out to learn how to enjoy my leisure," he says. But his wife, Fran, to whom he is devoted, sees this moment as a door to a very different type of freedom: a chance to start living in the glamorous way she desires after twenty years of raising their daughter, playing bridge, and attending tedious dinners with the other wives of Zenith, Ohio. "I want a new life all over from the very beginning," she tells Sam. "In Europe a woman of my age is

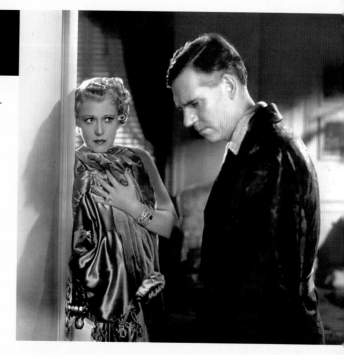

A tragic marital moment between Ruth Chatterton and Walter Huston

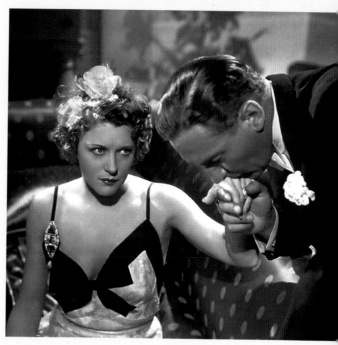

Ruth Chatterton likes the attention from Paul Lukas.

"A wonderful movie. Mary Astor is heaven. . . .
The story is set in many lavish places in Europe
and in the Midwest, [but] they didn't go on
location anywhere . . . [It's] a testament to
the set designers, art directors, and all those
people who turned a soundstage into Europe."

*Walter Huston, Mary Astor,
and a map of their potential future*

just getting to the point where men begin to take
a serious interest in her."

They embark on a long European vacation, but
Fran's paralyzing fear of growing old increasingly
warps her judgment as she attempts to join what
she sees as the sophisticated elite, cavorting
with wealthy, shallow playboys in Paris, Vienna,
and even on the ship crossing the Atlantic.
Meanwhile, her differences with Sam become
sharper in scenes of intensifying arguments that
are striking for their realism. All this pushes
Sam into a friendship—and possibly more—with
an American widow living in Italy.

Ruth Chatterton's embodiment of Fran is vital
to *Dodsworth*'s power. One can sympathize with
her point of view at the outset, which makes the
subsequent marital disintegration all the more
heartbreaking. A major star of the early 1930s
here in her final American feature, Chatterton
had wanted to play Fran as a villain from her first
scene. This caused considerable tension on the
set, as Wyler knew that some degree of empathy
for Fran was necessary if only to give an inkling

*William Wyler (seated, in white shirt) directs a
close-up of Kathryn Marlowe, who plays daughter
Emily Dodsworth. Walter Huston stands (center) and
cinematographer Rudolph Maté sits next to Wyler.*

of what had brought the couple together in the first place. Mary Astor, who delivers a luminous turn as the widow Edith Cortwright, later wrote that Chatterton "didn't like the role of Fran Dodsworth because the character was that of a woman who is trying to hang on to her youth—which was exactly what Ruth herself was doing. It touched a nerve. But she gave a beautiful performance in spite of herself." Indeed, Chatterton did soften her character in the early scenes just enough to allow for the story's increasingly tragic tone.

Dodsworth was pivotal to Astor's career. Since *Red Dust* in 1932, she had appeared in a steady run of mostly undistinguished movies, but the character of Edith was a huge break—a chance to express great tenderness and a powerful, if

subtle, sense of transformation. Edith and Sam grow closer just as believably and organically as Fran and Sam fade apart. Astor's silent reactions, especially in the final scenes, are unforgettable.

The picture is full of inspired storytelling touches from Howard and Wyler. A choice to show the Dodsworths undressing for bed as they argue brings them to their truest and most vulnerable states, visually and verbally. Many sequences that are set on moving vehicles—ships, cars, trains, fishing boats—feel like metaphors for a relationship that is in transit and could move in any direction. Even the film's last images of Huston and Chatterton are on vehicles, while the final image of Astor has her moving quickly through the frame.

Dodsworth marked the screen debuts of two future stars: David Niven, seen here with Ruth Chatterton, and John Payne, who plays the Dodsworths' son-in-law.

Dodsworth received seven Oscar nominations, including Best Picture, Director, Actor (Walter Huston), and Screenplay, winning for Richard Day's art direction that impeccably evokes European settings. This was Wyler's first of twelve nominations, still the most for any director, and Howard's second. His masterful screenplay would spur David O. Selznick to hire him for *Gone with the Wind* (1939), for which Howard would win the award posthumously (he died in a 1939 accident).

Ultimately, thanks to its superb characterizations, *Dodsworth* delivers to the audience believable tragedy as well as a convincing release of sheer joy, perfectly illustrating an adage of novelist and literary critic William Dean Howells—that what the American public wants is a tragedy with a happy ending.

WHAT TO LOOK FOR

Maria Ouspenskaya made her Hollywood debut in *Dodsworth* after a decade on Broadway and a handful of silent films in her native Russia. There she had trained under Konstantin Stanislavski, whose famous "system" later inspired Method acting. Ouspenskaya was a tiny woman, barely ninety pounds, and in *Dodsworth* she spends most of her time sitting in a chair—yet she commands the screen with astonishing power as she berates Ruth Chatterton in ways both subtle and piercing. "Have you thought how little happiness there can be," she admonishes, "for the old wife of a young husband?" Ouspenskaya's single scene was enough to garner an Oscar nomination for Best Supporting Actress in the first year that the category existed. At under five-and-a-half minutes, hers remains one of the shortest performances ever nominated.

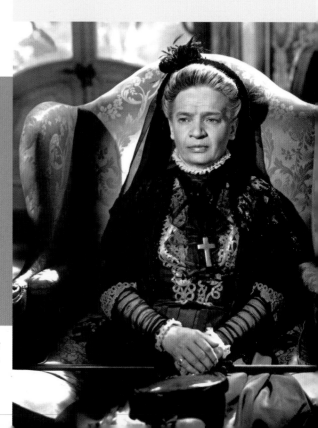

Maria Ouspenskaya is a commanding presence in her only scene.

THE AWFUL TRUTH

Columbia, 1937
B&W, 91 minutes

DIRECTOR

Leo McCarey

PRODUCER

Leo McCarey (uncredited)

SCREENPLAY

*Viña Delmar, based on a play
by Arthur Richman*

STARRING

IRENE DUNNE. LUCY WARRINER

CARY GRANT. JERRY WARRINER

RALPH BELLAMY DANIEL LEESON

ALEXANDER D'ARCY ARMAND DUVALLE

CECIL CUNNINGHAM. AUNT PATSY

MOLLY LAMONT BARBARA VANCE

ESTHER DALE. MRS. LEESON

JOYCE COMPTONDIXIE BELLE LEE

SKIPPY. MR. SMITH

DANGER! WILD WOMAN ON THE LOOSE!

Irene DUNNE · Cary GRANT

The Awful Truth

RALPH BELLAMY ·
ALEXANDER D'ARCY
CECIL CUNNINGHAM
A LEO McCAREY PRODUCTION
Screenplay by Vina Delmar
Associate Producer EVERETT RISKIN
Directed by LEO McCAREY
A COLUMBIA PICTURE

A MISTRUSTFUL MARRIED COUPLE DECIDE TO DIVORCE, THEN INTERFERE WITH EACH OTHER'S NEW PARAMOURS.

WHY IT'S ESSENTIAL

Three months after delighting audiences with the comic fantasy *Topper*, Cary Grant bowled them over with *The Awful Truth*, one of the finest of all screwballs. He had already appeared in some thirty films over five years, but it was *The Awful Truth* that essentially gave birth to the full-fledged Cary Grant comedy persona that audiences have loved ever since. Ironically, Grant initially resisted the artistic process responsible for unleashing that image.

Drawn from a 1922 stage play that had been turned into two prior features, the screenplay was a loose adaptation at best, with director Leo McCarey devising many gags and lines with his cast on the spot. The outline of the story was simple: Jerry and Lucy Warriner each suspect the other of having an affair and decide on a whim to get divorced. As they wait ninety days for the divorce to become final, they chide one another, undermine each other's new relationships, fight over custody of their dog, Mr. Smith (played by Skippy, best known as Asta in the *Thin Man* movies), and keep denying what the audience knows all the way through—that they still love each other. The lack of much plot actually enables *The Awful Truth* to reach a sort of screwball purity. It has just enough of a setup to allow for ever more elaborate comic situations and zany bits of business, with consummate slapstick and sophistication intermingling throughout.

McCarey was one of the foremost comedy directors in Hollywood, having honed his

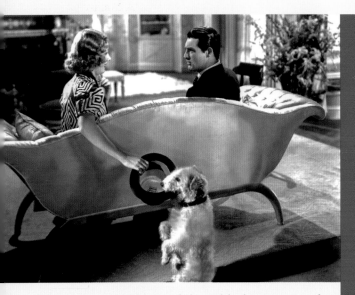

Irene Dunne, Cary Grant, and Skippy (also known as Asta, for his most famous role) in a classic moment of screwball comedy

ROBERT OSBORNE

"The first of three movies that Cary Grant and Irene Dunne made together. Few people have ever worked so well, and with such superior results, as Cary and Irene. It's witty, infectious, and hilarious—all about a subject that isn't. There's nothing funny about divorce, but this may be the one exception. . . . It may be the best screwball comedy of them all."

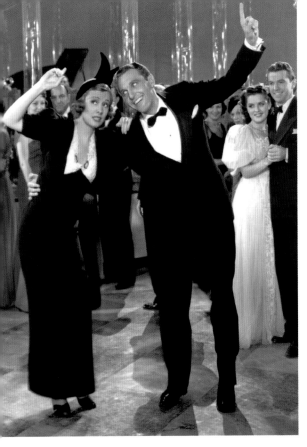

Irene Dunne trying to be a good sport with an exuberant Ralph Bellamy

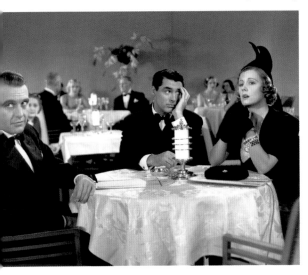

Ralph Bellamy, Cary Grant, and Irene Dunne are united in shock over the awful performance they are witnessing in a nightclub.

approach on countless Laurel and Hardy shorts that were also built around simple situations spiraling out of control. For McCarey, the best comedy came from actors playing off one another as genuinely and spontaneously as possible—with much improvised dialogue.

That approach was met with some surprise on *The Awful Truth*. Ralph Bellamy later reported that the script was never truly used, that McCarey would simply arrive on set with "a small piece of brown wrapping paper" on which he had scrawled ideas for the day's scene. "He'd give you the scene and see what happened," said Irene Dunne. "I don't remember many takes at all."

Bellamy said most of the cast quickly warmed to the system—but Cary Grant did not. He had no interest in working off-the-cuff and asked Columbia chief Harry Cohn to remove him from the film. He offered to do another movie for free and even suggested swapping parts with Bellamy, whose role was smaller. Cohn refused, and McCarey was not happy when he heard about the incident. Grant then relented and threw himself into the director's hands, with astounding results. His performance is joyfully loose and has a feel of spontaneity throughout, whether he's reacting to the surprise collapse of his chair, delighting in Dunne making a fool of herself on the dance floor, accompanying Mr. Smith on the piano, or hilariously straining to find excuses to keep visiting Dunne's bedroom at the film's climax.

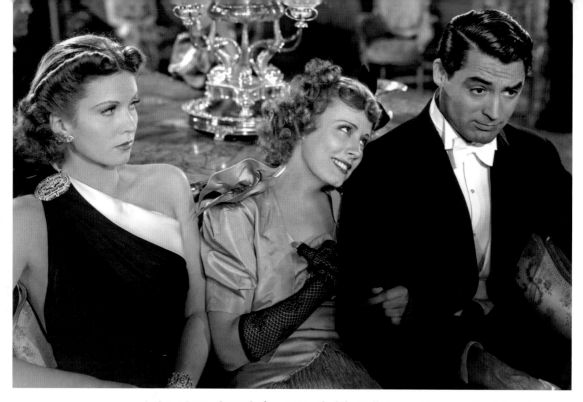

As Irene Dunne (center) play-acts to the hilt, Molly Lamont is annoyed and Cary Grant can barely contain his amusement—which only confirms that he and Dunne belong together.

Dunne, who is first-billed, was already a major star and two-time Oscar nominee whose own talent for comedy had just been proven in the hit film *Theodora Goes Wild* (1936). In *The Awful Truth*, she combines madcap humor with high glamour in the best screwball heroine tradition. One of the funniest moments of her career comes when she crashes a gathering of Grant and his new high-society girlfriend's family by pretending to be Grant's tacky sister—a character she models after his previous girlfriend, right down to an embarrassing dance routine. The scene, which Dunne said was written entirely on the set, helps bring the couple back together through their shared sense of humor. The duo's chemistry in this film makes them one of the definitive pairings in screwball comedy even though they only made one other, *My Favorite Wife* (1940). (They also starred in the 1941 romantic drama *Penny Serenade*.)

The Awful Truth was the top-grossing release of 1937 and was honored with six Oscar nominations, including Best Picture, Best Actress (Dunne), and Best Supporting Actor (Bellamy). Grant was not nominated—he never won a competitive Oscar—but he ultimately appreciated Leo McCarey so much that he worked with him on three more films, including *My Favorite Wife*. McCarey did win *The Awful Truth*'s sole Oscar, for Best Director, though he memorably quipped

.............

Dunne's costume designer was Robert Kalloch, an indispensable contributor to screwball comedy. He also clothed Claudette Colbert in It Happened One Night *(1934), Katharine Hepburn in* Holiday *(1938), and Rosalind Russell in* His Girl Friday *(1940).*

The Awful Truth is also significant for cementing the persona of Ralph Bellamy, who in this era had a field day playing the big, well-meaning, but incredibly boring oaf in movie after movie. It was a potentially thankless role from which he drew huge amounts of comedy, such as laughing heartily at a line of Grant's that isn't funny, or bringing an enthusiasm to his lousy dancing that makes it all the more amusing. Bellamy later wrote that when he showed up on set for the first day of filming, McCarey asked if he knew the song "Home on the Range." Bellamy said he did but he couldn't sing. "Great!" said McCarey, who took him to a piano where Irene Dunne was sitting, rolled the camera, and ordered Bellamy to "belt it out with loud Oklahoma pride." Bellamy recalled: "I threw back my head and slaughtered 'Home on the Range.' [Afterward], Leo was under the camera, so doubled up with laughter that he couldn't speak. Finally he said, 'Print it!'"

in his acceptance speech that the Academy had given him the award "for the wrong picture." He believed that his work on his other release that year, the heartbreaking drama *Make Way for Tomorrow*, was more deserving. Ultimately, both films have stood the test of time and are considered classics, with *The Awful Truth* seen by many as the absolute pinnacle of screwball comedy.

The aftermath of Cary Grant's expertly timed chair collapse

.............

Warner Bros., 1938
Color, 102 minutes

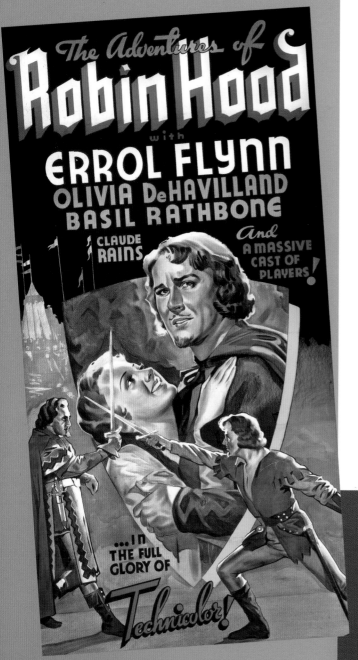

DIRECTORS

Michael Curtiz and William Keighley

PRODUCER

Henry Blanke (uncredited)

SCREENPLAY

Norman Reilly Raine and Seton I. Miller,
based upon ancient Robin Hood legends

STARRING

ERROL FLYNN	ROBIN HOOD
OLIVIA DE HAVILLAND	MAID MARIAN
BASIL RATHBONE	SIR GUY OF GISBOURNE
CLAUDE RAINS	PRINCE JOHN
PATRIC KNOWLES	WILL SCARLETT
EUGENE PALLETTE	FRIAR TUCK
ALAN HALE	LITTLE JOHN
MELVILLE COOPER	HIGH SHERIFF OF NOTTINGHAM
IAN HUNTER	KING RICHARD THE LION-HEART
UNA O'CONNOR	BESS
HERBERT MUNDIN	MUCH

DASHING BANDIT SIR ROBIN OF LOCKSLEY FIGHTS FOR SOCIAL JUSTICE AGAINST CORRUPT PRINCE JOHN, WHILE WOOING MAID MARIAN.

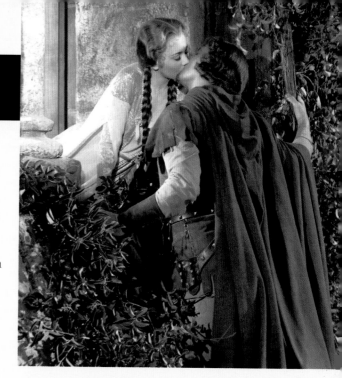

A classic movie kiss. This is the only sequence in the film in which Olivia de Havilland's hair is visible.

Few adventure movies are as consistently exhilarating as *The Adventures of Robin Hood*, the definitive swashbuckler. In every department—story, cast, color, music, costumes, sets—it creates a sense of exuberant joy from beginning to end. The script embraces the romantic legend of Robin Hood wholeheartedly: robbing the rich to give to the poor, building the band of Merry Men in sunny Sherwood Forest, romancing spirited Maid Marian, and nobly fighting the corrupt forces ruling England while King Richard the Lion-Heart is off fighting the Crusades. All the classic elements are presented with gusto, starting with the lovable rogue himself.

Certainly no actor was ever more perfect for a part than Errol Flynn for Robin Hood. Flynn's charisma leaps off the screen as surely as Robin Hood leaps from trees, off staircases, or, with his hands lashed behind his back, onto a horse to escape his own hanging. Flynn made the role his own, quite a feat since Douglas Fairbanks had already owned it since a 1922 silent production. Flynn effortlessly embodies the heroism that pervades the tale. He projects athleticism, fighting off hordes of swordsmen while bounding through a castle; he tosses off mischievous retorts, as when Olivia de Havilland admonishes him, "You speak treason!" and Flynn replies,

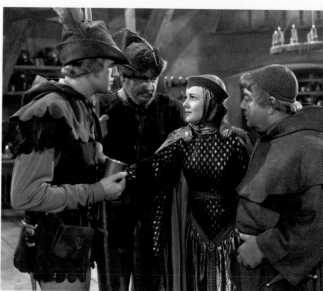

Olivia de Havilland surrounded by three of Robin Hood's band of Merry Men: Patric Knowles as Will Scarlett, Alan Hale as Little John, and Eugene Pallette as Friar Tuck. Hale had played Little John in the 1922 Robin Hood, *starring Douglas Fairbanks, and would play him for a third time in* Rogues of Sherwood Forest *(1950), released posthumously.*

Filming the banquet sequence, the first scene directed by Michael Curtiz after he replaced William Keighley. Curtiz is visible below the camera crane, in a hat, holding a microphone. Next to him, and looking up, is cinematographer Sol Polito.

"Fluently"; and he carries off love scenes with aplomb, scaling the ivy-covered wall to romance de Havilland and share an iconic movie kiss. De Havilland is flawless as the intelligent and crafty Marian and was here making her third of eight films with Flynn, their chemistry intensified by real-life (but unconsummated) infatuation.

The image of Flynn in green tights and feathered hat, arrow quiver strung to his back, is still the image of Robin Hood that persists in the popular imagination. Ironically, the role was first intended for James Cagney. When Warner Bros. started to plan *Robin Hood*, Flynn was not yet a viable candidate as he was only then shooting his first leading role, in *Captain Blood* (1935). By the time Cagney left the studio in a salary dispute, Flynn had been heralded as a new star and was an obvious choice.

He had just one request of Warner Bros.: not to assign director Michael Curtiz. Flynn had worked with him four times already and did not care for his autocratic methods. Jack Warner and studio executive Hal Wallis agreed to give the film instead to William Keighley, who had just directed the studio's first three-strip Technicolor feature, *God's Country and the Woman* (1937). But after two months on this much grander Technicolor production, Keighley was two weeks behind schedule and his action scenes were lacking in zest. Wallis made a drastic decision to replace him—with Curtiz.

Curtiz injected new energy as he directed all the interiors and reshot some exteriors, including parts of the archery tournament. For the famous splitting of the arrow, expert archer Howard Hill shot a custom-designed arrow along a hidden

.............

wire into a large bamboo arrow already in the target. Elsewhere through the film, Hill shot real arrows into stuntmen fitted with steel plates under balsam wood. They received $150 per shot—equivalent to about $2,700 today.

Beyond Flynn, de Havilland, Curtiz's dynamic visuals, and the magnificent supporting cast of Claude Rains, Basil Rathbone, Alan Hale, Eugene Pallette, and many more, *The Adventures of Robin Hood* boasts two not-so-secret weapons: its color and its score. Three-strip Technicolor—in which three film negatives in a single camera capture a shot in separate colors that are later combined—was still relatively new for feature films, but this may be the most spectacular example from the 1930s. The astoundingly vibrant color itself has emotional impact, making every frame exciting and joyful to watch.

Erich Wolfgang Korngold's score does the same. It further helps hold the film together through its action, romance, and comedy scenes, keeping the tone consistently enchanting. Thanks to the music, shots of pure pageantry never feel slow, love scenes never become mawkish, and action scenes remain light, even as characters are struck and killed by arrows and swords. Korngold initially turned down the movie because he did not enjoy scoring action films. But as the studio was trying to change his mind, Korngold learned that Germany had taken a major step toward annexing Austria, and that Korngold's family in

Errol Flynn was born to play Robin Hood.

"This has to be one of my favorite movies of all time. It never gets tiresome. It's the definitive romantic adventure with a swashbuckling hero and beautiful maiden, in cartoon Technicolor, with colors that just snap at you. . . . There's not a wasted moment. . . . I don't know who would not enjoy this film."

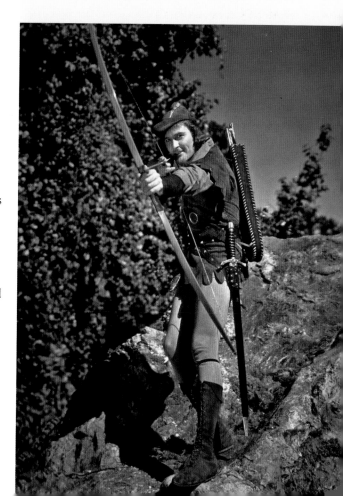

Claude Rains as Prince John, Basil Rathbone as Sir Guy of Gisbourne, and Melville Cooper as the High Sheriff of Nottingham. Thanks to their talents and to the control of director Michael Curtiz, their villains have satisfying depth and are vital parts of the movie's success.

Vienna would not be safe. He worked to get them out of Austria and decided to remain in Hollywood and score *Robin Hood* after all.

The process was still a great artistic struggle for him, but he won an Oscar (one of three for the film) and later said that *Robin Hood* saved his life. His symphonic score is still considered to be among the most dazzling and influential ever written. John Williams, for one, has credited Korngold as the key influence on his *Star Wars* film scores.

The Adventures of Robin Hood was Warner Bros.' most expensive picture to date, but its enormous success made it highly profitable. It set a standard for all future swashbucklers, and its appeal to all ages has never waned.

CARRIE FISHER | "'Welcome to Sherwood Forest!'—it's one of those fantastic, iconic moments in film. I love the scene where Robin Hood comes into the castle all alone. He has a bow and some arrows. He's asked to dinner; there are at least a hundred people there; they're going to trap him . . . and [he must] make it out."

WHAT TO LOOK FOR

Adding to the movie's high cost was its wondrous production design. The castle sets in particular, with high stone walls and winding staircases, greatly enhance the romantic, fairy-tale quality. For the unforgettable final swordfight between Errol Flynn and Basil Rathbone, who had previously dueled in Curtiz's *Captain Blood*, Curtiz used plenty of long shots to emphasize the evocative sets and inject grandeur. Most inspired was the choice to show part of the contest in dramatic shadow on a giant stone column. Art director Carl Jules Weyl won his only Oscar for this work.

Errol Flynn (right) squares off against Basil Rathbone, Hollywood's best fencer, in a vivid set designed by Carl Jules Weyl.

STAGECOACH

United Artists, 1939
B&W, 96 minutes

John Wayne as the Ringo Kid

DIRECTOR

John Ford

PRODUCER

Walter Wanger

SCREENPLAY

Dudley Nichols; original story by Ernest Haycox

STARRING

CLAIRE TREVOR	DALLAS
JOHN WAYNE	RINGO KID
ANDY DEVINE	BUCK
JOHN CARRADINE	HATFIELD
THOMAS MITCHELL	DOC BOONE
LOUISE PLATT	LUCY MALLORY
GEORGE BANCROFT	CURLEY
DONALD MEEK	PEACOCK
BERTON CHURCHILL	GATEWOOD
TIM HOLT	LIEUTENANT
TOM TYLER	LUKE PLUMMER

A DISPARATE GROUP OF STRANGERS TRAVEL TO LORDSBURG BY STAGECOACH THROUGH HOSTILE APACHE TERRITORY.

Director John Ford in Monument Valley with Tim Holt

WHY IT'S ESSENTIAL

Stagecoach is a landmark of American cinema. It brought depth, intelligence, and nuance to the western, changing the course of this previously maligned genre, while also rescuing John Wayne from B-movie purgatory and setting the respected John Ford on track to become the most renowned director of westerns. The picture was instantly recognized as a model of filmmaking craft, smoothly fusing action, characterization, mature themes, and a powerful visual approach that raised the story to a mythic level.

Stagecoach takes the structure of a journey, with nine people aboard a stagecoach speeding through dangerous country, all with different backstories, motivations, and concerns. They're presented as a microcosm of society, with supposedly respectable folks, such as a banker, thrust together with supposed pariahs, such as a prostitute and an outlaw. But assumptions can be wrong, the story suggests, as it delves into currents of class, hypocrisy, and morality—as well as poignant longing for love and fair-minded treatment by society.

This kind of meaning and dimension was practically unheard of in westerns, which for the

"*Stagecoach* turned the whole western genre on its ear—not only in the way Ford used the beautiful vistas of Monument Valley to tell the story, but also in how he for the first time presented multidimensional characters in a western. . . . The characters are allowed to be both good and bad, and many shades of gray. This is the film that also made John Wayne a star—finally."

past decade had been churned out primarily as routine, simplistic B films. John Wayne had acted in dozens of them at Republic Studios, and he had appeared in nearly eighty features overall, but his career was still going nowhere. Ford had known him since 1926 when Wayne was a prop boy at Fox, but he hadn't found a good leading vehicle for him until coming upon the 1937 story "Stage to Lordsburg" by Ernest Haycox, which was inspired by Guy de Maupassant's 1880 "Boule de Suif." Ford bought the rights and took it to David O. Selznick, but the producer insisted on casting Gary Cooper and perhaps Marlene Dietrich; otherwise, he was not interested in a cheap little western. Ford kept searching, and a year later he convinced indie producer Walter Wanger, who had a deal at United Artists, to take on the project.

It had been a long wait for Wayne, but Ford made it worth his while by giving him one of the most iconic "star" entrances in screen history: a rapid camera movement toward Wayne as he twirls a Winchester, ending on a huge close-up. From here on, Wayne commands the audience's attention even though he is part of a talented ensemble cast, with the likes of Claire Trevor,

Donald Meek, Louise Platt, and John Carradine

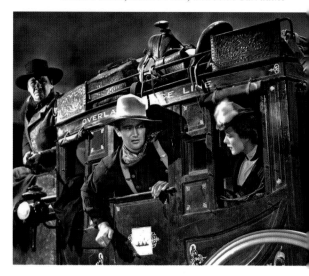
George Bancroft, John Wayne, and Louise Platt riding the stagecoach

.............

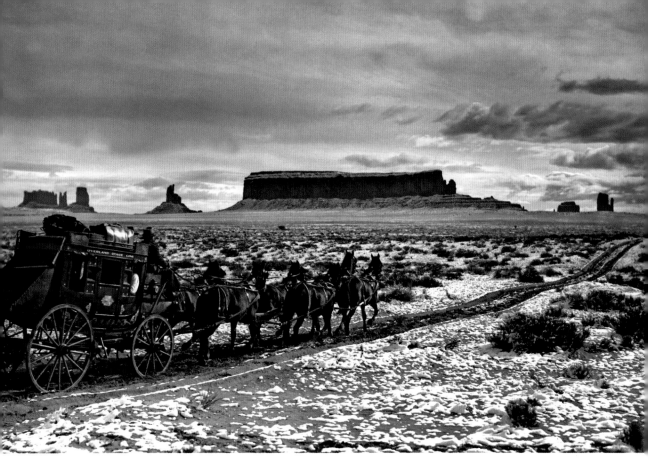

The stagecoach moves through Monument Valley, a location that had been briefly seen in The Vanishing American *(1925) but never used this prominently.*

Thomas Mitchell, John Carradine, and Andy Devine all giving top-notch performances. A trick Ford employed was to give Wayne plenty of reaction shots throughout, making him more prominent even in scenes where he doesn't speak. Ford later said, "I surrounded him with superb actors, and some of the glitter rubbed off on his shoulders. But he's still up there with the best of them. He's goddamn good."

Ford shot *Stagecoach* in the fall of 1938, filming much in the studio but also going on location to Victorville, California, for the exciting Indian chase sequence, as well as to Monument Valley on the Arizona-Utah border. It was Ford's first time there. He fell so in love with the valley, with its dramatic buttes and mythic feel, that he returned for many more films, making it truly his own.

Stagecoach drew seven Oscar nominations, including Best Picture—a rarity for a western—and won for Best Score and Best Supporting Actor (Thomas Mitchell). Mitchell had parts in four other all-time classics that year: *The Hunchback of Notre Dame, Mr. Smith Goes to Washington, Only Angels Have Wings,* and *Gone*

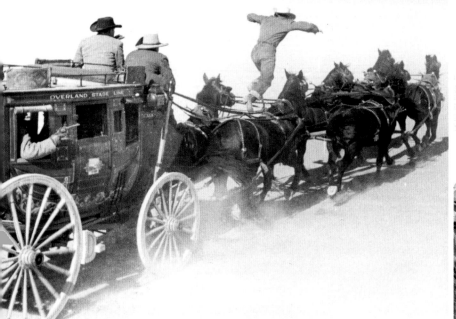

Yakima Canutt performs one of his most celebrated stunts.

WHAT TO LOOK FOR

Stagecoach features legendary maneuvers courtesy of stuntman Yakima Canutt. During the chase sequence, Canutt doubles John Wayne for a jump from the stagecoach to one of its six horses, followed by two more jumps until he is riding a horse in the front—all at full speed and in one continuous take. At another point, he doubles a Navajo rider by leaping from a galloping horse to one that is pulling the stagecoach. Ringo shoots him, he is dragged under the stagecoach for a few seconds, and finally he lets go and the stagecoach rushes over him.

Canutt had performed this stunt before, in a 1937 Monogram western, but it was no less dangerous. He later explained that he had the dry lakebed location churned and softened prior to filming. Of the stunt itself, he wrote: "It was kind of spooky, dragging along and looking back at those horses' hooves. But they were running straight, so I let go. I kept my legs together and my arms flat against my body, and nothing hit. As soon as the coach passed over me, I did a little roll and got up, then fell back again and lay still. That was an added touch of my own." John Ford's heart skipped a beat until he saw that Canutt was all right. The cameramen weren't positive they had gotten the shot, and Canutt offered to do it again. Ford immediately shook his head and replied, "I'll never shoot that again."

with the Wind. Nineteen thirty-nine was one of Hollywood's greatest years, and while *Stagecoach* did well at the box office, it was even more rapturously received by critics, who realized its historic significance.

So did Orson Welles, who watched it dozens of times to teach himself how to direct *Citizen Kane* (1941). "I wanted to learn how to make movies, and that's such a classically perfect one," he said. "What a textbook!" Welles was especially influenced by Bert Glennon's deep-focus cinematography, with compositions of action deep in the frame, as well as striking use of low angles and visible ceilings. He also noticed the performance of a young actor, Tim Holt, as a cavalry lieutenant, and later offered him the lead in *The Magnificent Ambersons* (1942), Welles's second film, which Holt would deem his favorite of his career.

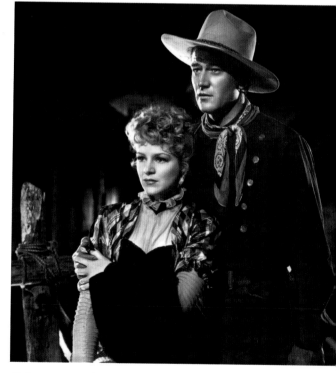

Claire Trevor and John Wayne in the dark, almost noir-like final section of the film. Ford thought Wayne "could personify great strength and determination without talking much."

............

MGM, 1939
B&W, 133 minutes

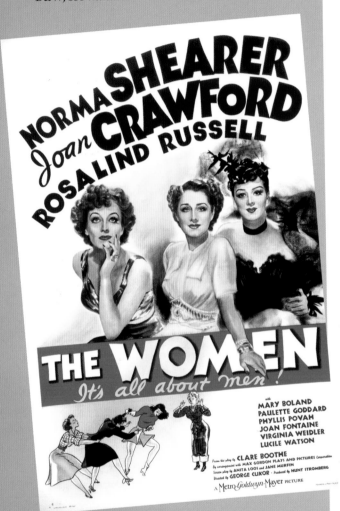

DIRECTOR

George Cukor

PRODUCER

Hunt Stromberg

SCREENPLAY

Anita Loos and Jane Murfin,
from the play by Clare Boothe

STARRING

NORMA SHEARER MRS. STEPHEN HAINES—MARY

JOAN CRAWFORDCRYSTAL ALLEN

ROSALIND RUSSELL . . . MRS. HOWARD FOWLER—SYLVIA

MARY BOLAND. THE COUNTESS DE LAVE—FLORA

PAULETTE GODDARDMIRIAM AARONS

PHYLLIS POVAHMRS. PHELPS POTTER—EDITH

JOAN FONTAINE MRS. JOHN DAY—PEGGY

VIRGINIA WEIDLER LITTLE MARY

LUCILE WATSONMRS. MOREHEAD

MARJORIE MAIN .LUCY

VIRGINIA GREY .PAT

RUTH HUSSEYMISS WATTS

**AMID CONSTANT GOSSIP AND BACKBITING,
A WEALTHY MANHATTAN WOMAN LEARNS
THAT HER HUSBAND HAS STRAYED WITH A SHOPGIRL.**

MGM's wickedly hilarious farce "about men" boasts 135 speaking roles and not a single man in sight. "Even the dog is a bitch," said director George Cukor, who had his hands full guiding *The Women*'s several major stars. Sparks fly as the ladies prey upon and manipulate each other through an endless stream of witty put-downs, vicious gossip, and even an all-out catfight—all over issues of men and marriage.

The Women began as a racy Broadway play by Clare Boothe, who later said she got the idea after overhearing two women in a powder room brutally gossiping about a good friend of hers. She went home and started writing. "I never conceived it as a commentary on my own sex," she said. "I wrote it about one particular group of women—the idle, stupid rich who marry for money. The kind of women who ought to be hit over the head with a meat ax."

MGM snapped up the rights and Jane Murfin turned out a screenplay, but it was so saucy that another writing pioneer, Anita Loos, was brought on board to tone down the dialogue and provide further tweaks during filming. "The most innocent jokes about sex were banned," Loos said. Nonetheless, the film still brims with verbal zingers, such as: "Thanks for the tip, but when anything I wear doesn't please Stephen, I take it off."

That's Crystal speaking to Mary—about Mary's husband—during one of *The Women*'s most famous confrontations, made extra juicy by

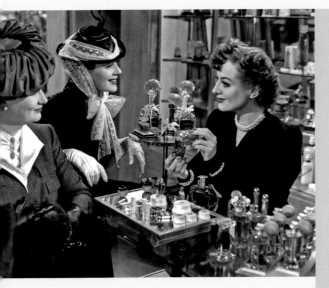

Phyllis Povah and Rosalind Russell trade cutting remarks with shopgirl Joan Crawford.

DREW BARRYMORE

—

"I like that this movie is women writing about women. . . . And it's not women just talking to women about their own lives. So much is about how their husbands are affecting [them]. The fact that you don't see these husbands is amazing—you don't get distracted from the women's journeys."

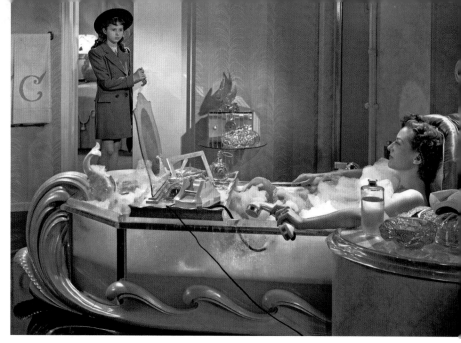

Even Waldo Lydecker, in Laura *(1944), didn't have a bathtub this good! Joan Crawford luxuriates as she hurls some nastiness toward little Virginia Weidler.*

the casting of real-life rivals Joan Crawford and Norma Shearer. Shearer had been queen of the MGM lot for years while married to studio production chief Irving Thalberg (who had recently died), and Crawford resented Shearer for getting what Crawford considered to be the most prestigious roles and leaving her with the cast-offs. By 1938, Crawford's career was on the skids, and she saw that while the role of Mary Haines was more sympathetic, the conniving, man-stealing Crystal Allen was the much better part. "I knew it was dangerous for me to play Crystal," she recalled, "but I couldn't resist. She was the epitome of the hardhearted gold digger on the big make, a really nasty woman who made the audience want to hiss." The two stars clashed on the set. While feeding lines to Shearer from off-screen, Crawford focused on her knitting, clacking the needles loudly. Shearer complained, Cukor tossed

Crawford off the set and forced her to apologize, and they resumed the next day, after which the stars never spoke again.

For all that drama, the biggest scene stealer in *The Women* is actually Rosalind Russell as the gossipmonger and hellcat Sylvia. She credited Cukor for encouraging her broad, exaggerated performance. "If you're a heavy, the audience will hate you. Just be ridiculous," he told her. "I did what he said," Russell later wrote, "and everything that came to me from *The Women*—namely, my reputation as a comedienne—I owe to George."

The film also set Marjorie Main, as the owner of a Reno ranch for divorcing wives, on the path to stardom, and features brilliant turns from Lucile Watson as Mary's practical mother and Mary Boland as the well-lubricated Flora, the Countess de Lave, who is on her way to Reno to divorce her fourth husband for attempting

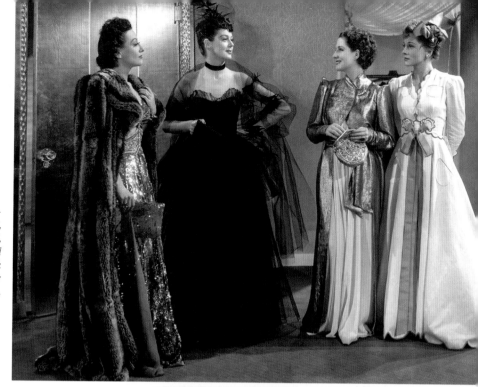

*Four of the women—
Joan Crawford,
Rosalind Russell,
Norma Shearer, and
Joan Fontaine—look
resplendent in their
gowns by Adrian.*

to poison her. "L'amour! L'amour! How it does let you down!" she laments, later uttering the immortal line, "Get me a bromide and put some gin in it."

As if all the sharp comedy and star power were not enough, *The Women* incorporates a five-minute fashion show—in bright Technicolor. Cukor didn't like it, as he thought it stopped the movie cold. He was right, but does it really matter? The fashion show works because it functions as both a breather for the women and an intermission for the audience. *Everyone* takes a break

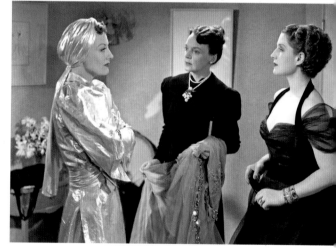

The big confrontation—in the movie and in reality: Joan Crawford and Norma Shearer, with Alice Keating in between

from the squabbling for a few minutes. Besides, the entire movie is a veritable fashion show, with dozens of chic outfits designed by Adrian on display from beginning to end, adorning some of the most glamorous women in Hollywood.

The Women was a crowd-pleasing hit, and the *New York Times* review summed up the prevailing sentiment well: "Marvelous . . . Every studio in Hollywood should make at least one thoroughly nasty picture a year."

At the Reno divorce ranch: Paulette Goddard, Rosalind Russell, Joan Fontaine, Norma Shearer, and Mary Boland

"L'amour! L'amour!" laments Mary Boland (center), on her way to Reno to divorce her fourth husband. She is flanked by Paulette Goddard and Norma Shearer.

WHAT TO LOOK FOR

Sometimes overlooked in *The Women* because of the higher-profile actresses surrounding her, Joan Fontaine delivers a performance that wound up being pivotal to her career. She plays Peggy, a shy young wife who is talked out of getting a divorce, and her big scene comes in Reno during a phone call to her husband. Nervous about telling him she's pregnant, she finally gets the words out and then collapses into a sofa as her anxiety melts away, replaced by a swooning, poignant love—all conveyed in a single, sixty-five-second shot. Cukor later told Peter Bogdanovich, "Joan did [the scene] with the most extraordinary power and feeling. . . . I think she suddenly felt, 'Yes, this is why I'm an actress.' [It] was a thrilling moment." Cukor recommended her to producer David O. Selznick, and a few months later she was playing the lead in *Rebecca* (1940), directed by Alfred Hitchcock. That film won the Oscar for Best Picture, garnered Fontaine her first Best Actress nomination, and made her a top star.

United Artists, 1940
B&W, 126 minutes

DIRECTOR
Charles Chaplin

PRODUCER
Charles Chaplin (uncredited)

SCREENPLAY
Charles Chaplin

STARRING

CHARLES CHAPLIN HYNKEL/A JEWISH BARBER

PAULETTE GODDARD HANNAH

JACK OAKIE . NAPALONI

REGINALD GARDINER SCHULTZ

HENRY DANIELL GARBITSCH

BILLY GILBERT . HERRING

MAURICE MOSCOVICH MR. JAECKEL

EMMA DUNN MRS. JAECKEL

A JEWISH BARBER RECOVERS FROM TWENTY YEARS OF AMNESIA TO FIND HIS COUNTRY RULED BY A FASCIST DICTATOR WAGING WORLD WAR II.

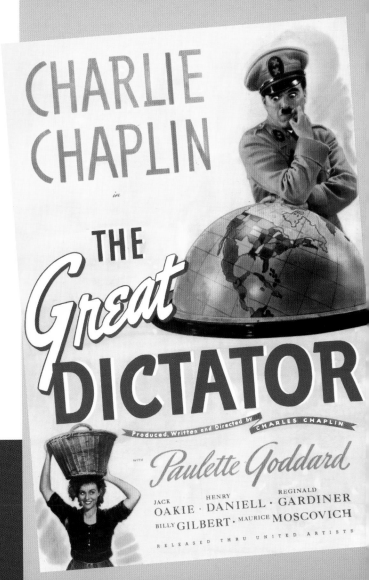

WHY IT'S ESSENTIAL

Charlie Chaplin's first talking picture is a brilliant satire of Adolf Hitler and Nazi Germany. It was a controversial success in its day and has only improved with age, offering a glimpse into the anxieties of a world just entering World War II while standing as a potent mockery of all megalomaniac leaders.

Since Hollywood's transition to sound in 1929, Chaplin had made two pictures: the silent *City Lights* (1931) and the mostly silent *Modern Times* (1936), which had sound effects and non-synced voices. *The Great Dictator* is a full-fledged talkie, with Chaplin fully embracing sound and dialogue to generate comedy without sacrificing his talent for pantomime. He plays a dual role, as Adenoid Hynkel, ruler of Tomainia, and a Jewish barber who happens to strongly resemble Hynkel (as well as Chaplin's own Little Tramp character). When the barber is released from a hospital two decades after the end of World War I, having suffered amnesia all the while, he returns to his shop in the ghetto with no idea of how the world has changed. He sees JEW painted on the window and simply starts to wash it off, leading to a fight with storm troopers that Chaplin makes funny as only he could, by means of deft maneuvering, a frying pan, and a dazed dance down the street.

As Hynkel, Chaplin delivers sputtering rants to the masses, hilariously emulating Hitler's

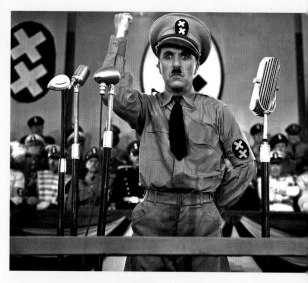

Charlie Chaplin as Adenoid Hynkel

"I want to be alone," declares the childlike Hynkel/Hitler.

oratory with gibberish that sounds German and blends in amusing references to "Wiener schnitzel," "lager beer," and "sauerkraut"—as well as chilling mentions of "Juden" (Jews). The movie's entire conceit of a fictional stand-in for Germany allows for laughter because the audience knows that nothing is real—characters, dialogue, actions, even props are wildly exaggerated—yet the story's overall world is obviously very *much* real, lending an uneasy edge to the comedy that was precisely Chaplin's intent. Nonetheless, Chaplin later wrote, "Had I known of the actual horrors of the German concentration camps, I could not have made *The Great Dictator*; I could not have made fun of the homicidal insanity of the Nazis."

The physical parallels between Chaplin's Little Tramp and Hitler had long been obvious, especially with their toothbrush moustaches. Chaplin also recognized the horrifying power of Hitler's ability to perform for an audience.

A comic impersonation seems in hindsight like a no-brainer, but at the time it was seen as daring. The United States had not yet entered the war, and Hollywood studios were still doing business with Germany. As a result, Chaplin faced significant pressure not to make this movie. President Franklin D. Roosevelt encouraged him, however, and Chaplin believed strongly that "if we can't sometimes laugh at Hitler, then we are further gone than we think. There is a healthy thing in . . . laughter at the grimmest things in life, laughter at death even."

He also had the means to finance the $2 million film entirely independently and to distribute it through United Artists, in which he was a partner. Chaplin pressed ahead with a script, and cameras finally rolled in September 1939, days after Germany invaded Poland. He surrounded himself with a fine supporting cast, starting with Paulette Goddard as the barber's fellow resister, Hannah. Goddard's career had

Paulette Goddard helps fight off the storm troopers in comic style.

Jack Oakie (in the chair at right) marveled at Chaplin's precision: "He was a master mathematician of comedy.... Working with Charlie Chaplin was the highlight of my career."

recently been boosted by *The Women* (1939), and she was also married to Chaplin, though their relationship was starting to strain. As Hynkel's henchmen Herring (i.e., Hermann Göring) and Garbitsch (i.e., Joseph Goebbels), Chaplin cast Billy Gilbert and the sneering audience-favorite Henry Daniell, respectively. His most inspired choice was Jack Oakie to play Napaloni, in a parody of Benito Mussolini. Chaplin and Oakie's scenes of absurd competition are a highlight of *The Great Dictator*, especially when they take turns soaring ever higher in their barber chairs.

But in the end this is Chaplin's show, with dazzling comic moments sprinkled throughout, from finding himself walking with enemy soldiers on a battlefield, to shaving a man to the tune of Brahms's "Hungarian Dance No. 5," and scampering up a curtain before telling Garbitsch to leave him alone. Chaplin's Hitler is a childish buffoon, by turns timid, impulsive,

impatient, and utterly full of himself, yet still capable of inflicting great harm with his orders.

Ultimately, Hynkel and the barber are mistaken for each other, and the barber ends the film with a speech that breaks the fourth wall to become a direct address from Chaplin to the movie audience, a plea for the world to unite in the name of democracy. The scene drew criticism for being abrupt and sentimental, but Chaplin shrugged it off. "They had their laughs," he said. "Now I wanted them to listen."

The Great Dictator opened with much fanfare in the fall of 1940, becoming one of the year's highest-grossing films and earning five Oscar nominations, including Best Picture and Best Actor. In England it was welcomed as a morale booster during the height of the Blitz, and according to projection logs discovered after his death, even Adolf Hitler screened a print of the film, alone, two nights in a row.

.............

"Chaplin was a true auteur because he didn't have anyone looking over his shoulder. He could take as long as he wanted to make a movie. . . . Not only were [audiences] seeing this story about making fun of Adolf Hitler, but they were also hearing Chaplin talk for the first time. It's hard to explain now how important that was for this star who was so popular everywhere as a silent comedian."

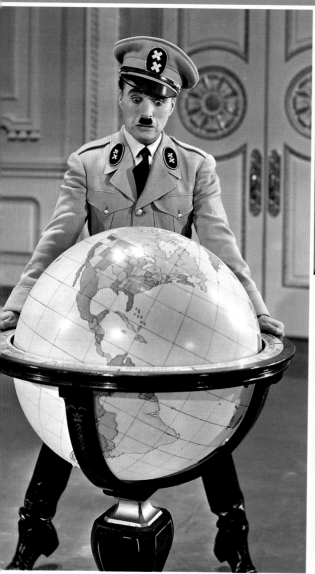

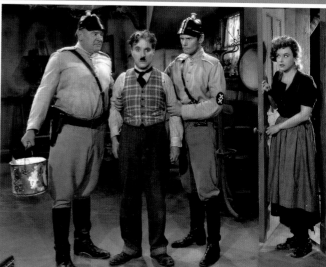

Charlie Chaplin's "Jewish barber" is menaced by storm troopers as Paulette Goddard looks on.

Chaplin starts his dance with the balloon globe, an image that is profound in its simplicity.

WHAT TO LOOK FOR

In one of the defining images of Chaplin's career, Hynkel performs a ballet with a balloon globe to the strains of Wagner's *Lohengrin,* Hitler's favorite opera. Chaplin had performed a similar routine with a balloon in a 1928 home movie; seeing photographs of a globe in Hitler's New Chancellery office inspired him to incorporate it here. The sequence is funny, beautiful, and haunting, an altogether profound distillation of Hitler as a child with the world in his hands.

THE PHILADELPHIA STORY

MGM, 1940
B&W, 112 minutes

DIRECTOR

George Cukor

PRODUCER

Joseph L. Mankiewicz

SCREENPLAY

*Donald Ogden Stewart,
based on the play by Philip Barry*

STARRING

CARY GRANT C. K. DEXTER HAVEN

KATHARINE HEPBURN TRACY LORD

JAMES STEWART MACAULAY CONNOR

RUTH HUSSEY ELIZABETH IMBRIE

JOHN HOWARD GEORGE KITTREDGE

ROLAND YOUNG UNCLE WILLIE

JOHN HALLIDAY SETH LORD

MARY NASH MARGARET LORD

VIRGINIA WEIDLER DINAH LORD

HENRY DANIELL SIDNEY KIDD

A VIBRANT BUT MISUNDERSTOOD PHILADELPHIA HEIRESS CONTENDS WITH HER DASHING EX-HUSBAND AND AN ENDEARING REPORTER ON THE EVE OF HER MARRIAGE TO A DULL BUSINESSMAN.

WHY IT'S ESSENTIAL

In May 1938, Katharine Hepburn was included on a national exhibitors' list of movie stars deemed to be "box-office poison." A month later, her new film *Holiday* only reinforced that notion when it flopped. Hepburn bought out her RKO contract and left Hollywood, determined to turn things around. She succeeded and then some: her return to the screen in December 1940 was with *The Philadelphia Story*, a huge hit that resurrected her stardom, earned her an Oscar nomination, and stands as one of the most sparkling romantic comedies ever made.

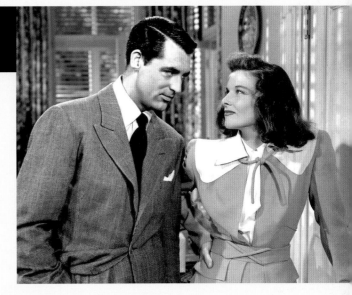

Cary Grant, Katharine Hepburn, and a shared look that sums up their dynamic

During those intervening two and a half years, Hepburn said, "I set myself a goal, and took charge of my life." She set about working with her playwright friend Philip Barry, the author of *Holiday*, on a new play that would revolve around the very issue that had caused moviegoers to retreat from her: their perception of Hepburn as haughty and icy. That is precisely the problem that flummoxes Tracy Lord in *The Philadelphia Story*.

A member of Philadelphia's social elite, Tracy lives on her family's Main Line estate. She's set to marry the pompous George in twenty-four hours but finds herself caught in a virtual love quadrangle with George, her ex-husband Dexter, and a tabloid reporter, Mike, who is staying with the Lords (along with a photographer, Liz) to do

a story on the wedding. Through all the comic complications, just about everyone makes unfair assumptions about others. The genius of the play, and Donald Ogden Stewart's screenplay, lies in the intricate variations of that theme which range from comedic to dramatic to intensely romantic. Hepburn's own genius was to embrace the idea of playing a character who develops humility after learning that she is seen as brittle and heartless even by her own (none-too-perfect) father. Other characters come to realize she has a heart after all—and so does the audience, who is with her, and the wonderfully appealing Hepburn, all the way. As she says at one point, "The time to make up your mind about people is never."

The Philadelphia Story ran 417 performances on Broadway and 254 on the road, a triumph

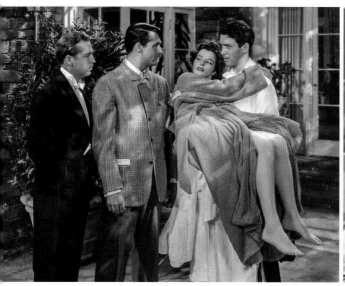

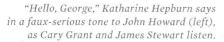
"Hello, George," Katharine Hepburn says in a faux-serious tone to John Howard (left), as Cary Grant and James Stewart listen.

In a movie filled with sophisticated verbal banter, James Stewart and Cary Grant are also a delight for their physical comedy.

that allowed Hepburn to sell the movie rights (which she had bought from Philip Barry) on her own terms: she would play Tracy, George Cukor would direct, and she would approve the casting of the two male leads. MGM eventually agreed to these conditions, and after Hepburn's choices of Clark Gable and Spencer Tracy proved unavailable, she and Louis B. Mayer settled on James Stewart and Cary Grant, making for a truly powerhouse cast.

Grant chose to play Dexter, a tricky role in that he spends much time in the background while essentially masterminding the plot. His history with Hepburn in three previous films also made him perfect for the classic, wordless opening scene, in which their marriage ends with comical drama and he pushes her flat on her backside—something that's a lot funnier on-screen

than it is on paper. It was devised at the last minute as a nod to Hepburn's perception by the public, many of whom might have wanted to knock her down to size themselves. "Just what Tracy—and I—needed," Hepburn later said.

Hepburn and Grant's chemistry is palpable, but so is that of all three stars in every combination. Stewart and Hepburn are a delight, whether they're antagonizing each other early on or finding love in the moonlight, and the two men share a marvelous scene that begins with Stewart drunkenly shouting at Grant's door in the middle of the night, "Oh, C. K. Dexter Haaaaaay-ven!" Once inside, Stewart lets out a hiccup that was not scripted and which he did not tell Grant or Cukor about in advance. Grant then ad-libs "Excuse me" and they each stifle a smile.

·············

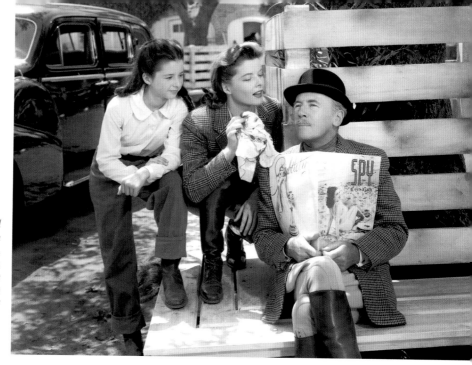

Virginia Weidler (left) and Katharine Hepburn chat with Uncle Willie (Roland Young). Hepburn said of Weidler, "She was so terrifyingly funny I truly had a difficult time doing scenes with her."

Not to be overlooked are child actress Virginia Weidler, whom Cukor had directed in *The Women* (1939) and who easily holds her own with three top stars, and Ruth Hussey, so fine in her supporting role as Liz—the photographer who loves Mike—that she garnered an Oscar nomination. The film received five additional nods, for Best Picture, Director, Actress (Hepburn), Actor (Stewart), and Screenplay, and it won two, for James Stewart and writer Donald Ogden Stewart.

Hepburn won something perhaps even more important. As she later put it: "I understood Tracy Lord, and what made her tick. I gave her life. She gave me back my career."

Director George Cukor watches as Katharine Hepburn, James Stewart, and Ruth Hussey rehearse a scene, scripts at their sides.

James Stewart's Oscar victory was generally assumed to be a consolation prize for not having won the previous year for *Mr. Smith Goes to Washington* (1939). Stewart revealed decades later that even he voted for his pal Henry Fonda in *The Grapes of Wrath* (1940). Stewart always downplayed his performance in *The Philadelphia Story*, but it is a superb one, so seemingly effortless that it's easy to overlook the range of emotions and tones he is called to depict. He flows smoothly from cynical to romantic, annoyed to enthusiastic, caustic to poetic, and he shares with Hepburn one of the most famous and lovely scenes in any romantic comedy. Late at night, after the party, they dance in the moonlight. They banter, argue, and goad one another, tipsy from champagne. They're drunk with love—and they almost fall *in* love. The feeling is enhanced by the full force of MGM's production values, from the luminous photography of Joseph Ruttenberg to the glistening gown designed by Adrian. When Stewart begins his speech with the words, "There's a magnificence in you, Tracy," we believe it because we don't just hear it—we see it.

"There's a magnificence in you, Tracy." Katharine Hepburn and James Stewart in one of the loveliest scenes in any romantic comedy

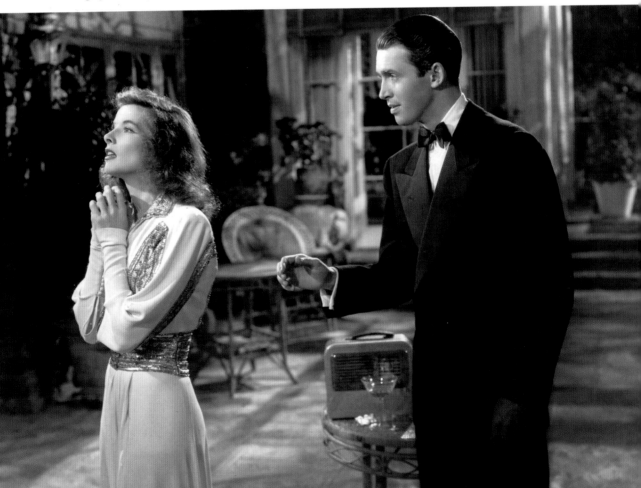

Warner Bros., 1941
B&W, 100 minutes

DIRECTOR

John Huston

PRODUCER

Henry Blanke (associate producer)

SCREENPLAY

John Huston, based upon the novel
by Dashiell Hammett

STARRING

HUMPHREY BOGART SAMUEL SPADE

MARY ASTORBRIGID O'SHAUGHNESSY

GLADYS GEORGE IVA ARCHER

PETER LORRE JOEL CAIRO

BARTON MacLANE . . . LIEUTENANT OF DETECTIVES DUNDY

LEE PATRICK .EFFIE PERINE

SYDNEY GREENSTREET KASPER GUTMAN

WARD BOND DETECTIVE TOM POLHAUS

JEROME COWAN MILES ARCHER

ELISHA COOK, JR. WILMER COOK

PRIVATE DETECTIVE SAM SPADE TAKES A CASE INVOLVING THE SEARCH FOR A PRICELESS, JEWEL-ENCRUSTED FALCON STATUETTE.

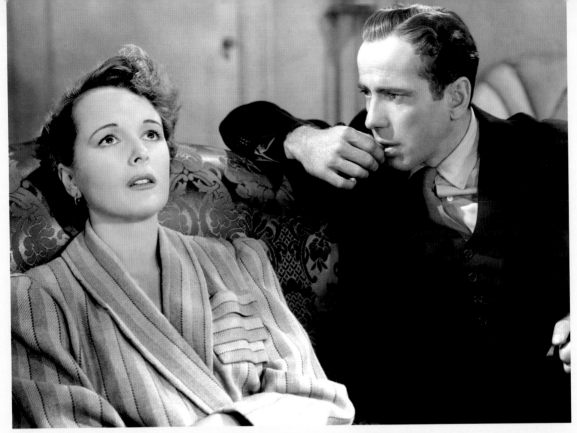

"You've got to trust me, Mr. Spade." Humphrey Bogart is mightily impressed with the ability of Mary Astor, as the treacherous Brigid, to lie her head off.

WHY IT'S ESSENTIAL

Produced on a modest budget to give a chance to a first-time director, *The Maltese Falcon* wound up as not just a surprise hit but a touchstone in Hollywood history. It set the mold as the quintessential private eye movie, was a vital early instance of film noir, launched John Huston's acclaimed directing career, and cemented Humphrey Bogart's stardom and screen persona. Its dialogue, ending, and "black bird" itself became ingrained in American popular culture.

But even with all those claims to fame, *The Maltese Falcon* is endlessly rewatchable, and perhaps most essential, simply for its spellbinding characters and cast: Sam Spade, private detective, played by Bogart as an ambiguous antihero after years of gangster roles; Brigid O'Shaughnessy, duplicitous, beautiful, liar of all liars, played by Mary Astor as one of the first noir *femmes fatales*; Gutman and Cairo, played by newcomer Sydney Greenstreet and veteran Peter Lorre, together for the first time and forever after known as a pair, thanks to their brilliant chemistry; Wilmer the gunsel (a word whose dual meaning may

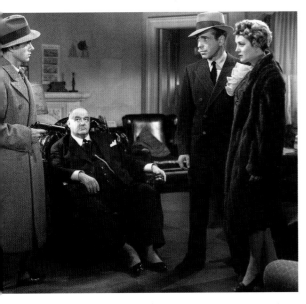

have gone over the censors' heads), played by Elisha Cook Jr. as a trigger-happy punk with a semi-automatic in each pocket—but who is still entertainingly out of his depth when confronting Sam. Even the smaller roles are wonderfully distinct and cast to perfection, such as Lee Patrick as Sam's trusty secretary, Effie, and Jerome Cowan as his partner, Miles Archer, who's "just dumb enough" to get himself killed.

The focus on characters over plot thrills was itself a change for detective films. *The Maltese Falcon*'s story line becomes so convoluted that one tends to get lost in it on every viewing. But it doesn't matter. It's clear enough that these

"Let's give 'em the gunsel." Elisha Cook Jr., as Wilmer "the gunsel," with Sydney Greenstreet, Humphrey Bogart, and Mary Astor

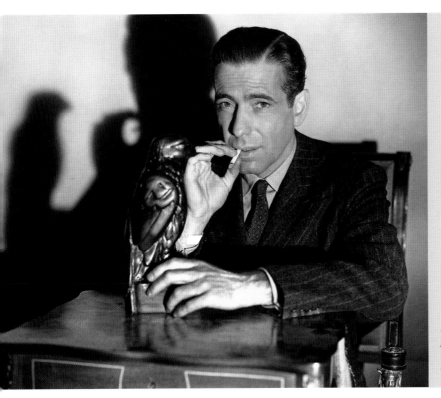

BRAD BIRD

"You would never imagine that this is John Huston's first film . . . because it's directed with such a sure hand. He has complete authority from first shot to last."

Humphrey Bogart, as Sam Spade, poses with the dingus, the falcon, the black bird—the "stuff that dreams are made of."

"When you're slapped, you'll take it and like it!"
Humphrey Bogart with Peter Lorre, as Joel Cairo

BEN MANKIEWICZ

"I love using The Maltese Falcon *as a counter to people who bemoan every Hollywood remake because this is the third version of* The Maltese Falcon. . . . *John Huston saw Sydney Greenstreet in a play in Los Angeles; he'd never been in a movie before [but] is such a sophisticated actor. . . . [He] and Lorre are connected, and they made fun of that themselves."*

John Huston directs his father, Walter Huston, in his cameo as Captain Jacoby. Lee Patrick and Humphrey Bogart watch from behind camera. Walter made the appearance as a good-luck gesture to his son. As a joke, John made Walter repeat the scene twenty times. The next day, he had Mary Astor pose as his secretary and call Walter to inform him that he had to shoot the scene again. "You tell my son to get another actor or go to hell!" Walter shouted as Astor held up the phone for all to hear. "He made me take twenty falls, and I'm sore all over."

characters are after the elusive, valuable falcon and will do whatever they need to acquire it. Enjoyment comes from watching them scheme, outwit, and double-cross one another—all while delivering sharp dialogue that comes almost entirely from the pen of novelist Dashiell Hammett.

When John Huston, after a decade as a screenwriter, finally got this chance to direct, he chose Hammett's novel even though it had already been made into two movies—one good but forgotten, the other poorly regarded. Since Warner Bros. already owned the property, there was little to lose by giving Huston a shot. He changed very little from the novel, considering it to be practically a ready-made screenplay.

Hammett, who had once worked as a Pinkerton detective (and whose first name was actually Samuel), said he created Sam Spade as an "idealized" detective. His creation, combined

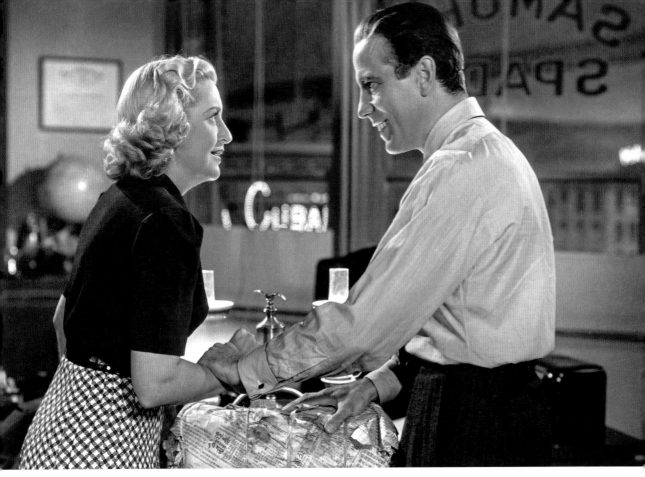

"We've got it, angel, we've got it!" Humphrey Bogart as Sam Spade, and Lee Patrick as his secretary, Effie, with "the bundle"

with Bogart's performance, did much to define movie detectives going forward: as a little unsavory, cynical, perhaps not fully on the side of the law. That quality, along with a high-contrast, expressive visual style and an overall attitude of corruption and fatalism, made *The Maltese Falcon* one of the most influential early examples of film noir.

Mary Astor—working here in another universe from that of Edith Cortwright in *Dodsworth* (1936)—also set the template for the noir femme fatale with her seductive turn as Brigid, whose treachery knows no bounds. Brigid lies so much in this movie that Astor said she hyperventilated before most of her scenes in order to give her voice a breathless, ambiguous quality. As Sam Spade would say, she's "good, very good."

The Maltese Falcon turned out better than anyone had imagined going in, drawing excellent reviews, robust box office, and three Academy Award nominations, including Best Picture and Screenplay. For all involved, as well as generations of audiences, it was truly "the stuff that dreams are made of."

.............

"By Gad, sir, you're a chap worth knowing, an amazing character!" Sydney Greenstreet's girth is emphasized through the film and made to look menacing.

WHAT TO LOOK FOR

The film's third Oscar nomination went to stage veteran Sydney Greenstreet as Best Supporting Actor—quite a Hollywood welcome for a debut performance. At age sixty-one, weighing 285 pounds, his impact on audiences seeing him for the first time cannot be overstated. He was utterly unique in his combination of size, voice, distinctive laugh, and the blend of menace and gentlemanliness which would define his screen persona. "I am a man who likes talking to a man who likes to talk," he says memorably. Greenstreet was an absolute natural on the screen, although according to Mary Astor, he was so nervous before shooting his first scene (in which he waits for a poisoned drink to knock Bogart out) that he asked Astor to hold his hand for reassurance. Huston and cinematographer Arthur Edeson enhanced Greenstreet's performance by shooting him from low angles with moody lighting to emphasize his intimidating hulk.

—

As Bogart speaks with Ward Bond at the scene of Archer's murder, a poster for *Swing Your Lady* (1938) can be glimpsed in the background, peeling off a wall. This was an inside joke: Bogart considered *Swing Your Lady* to be the worst picture he ever made.

.............

Samuel Goldwyn Productions/RKO, 1941
B&W, 112 minutes

DIRECTOR

Howard Hawks

PRODUCER

Samuel Goldwyn

SCREENPLAY

Charles Brackett and Billy Wilder,
from an original story by
Billy Wilder and Thomas Monroe

STARRING

GARY COOPER	PROFESSOR BERTRAM POTTS
BARBARA STANWYCK	SUGARPUSS O'SHEA
OSCAR HOMOLKA	PROFESSOR GURKAKOFF
DANA ANDREWS	JOE LILAC
DAN DURYEA	DUKE PASTRAMI
HENRY TRAVERS	PROFESSOR JEROME
S. Z. SAKALL	PROFESSOR MAGENBRUCH
TULLY MARSHALL	PROFESSOR ROBINSON
LEONID KINSKEY	PROFESSOR QUINTANA
RICHARD HAYDN	PROFESSOR ODDLY
AUBREY MATHER	PROFESSOR PEAGRAM
ALLEN JENKINS	GARBAGE MAN
CHARLES LANE	LARSEN
ELISHA COOK	WAITER
GENE KRUPA AND HIS ORCHESTRA	THEMSELVES

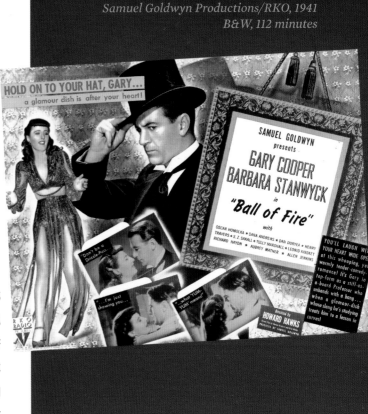

**EIGHT STRAITLACED
PROFESSORS WRITING
AN ENCYCLOPEDIA
FIND THEMSELVES
IN HOT WATER
WHEN THEY ASK A
BURLESQUE DANCER
TO HELP
THEM WITH THEIR
ENTRY FOR "SLANG."**

WHY IT'S ESSENTIAL

There is a wonderful sequence in *Ball of Fire* in which Gary Cooper attends a nightclub performance by Gene Krupa and His Orchestra, with Barbara Stanwyck as a showgirl singing and dancing to "Drum Boogie." Cooper taps his fingers but is sheepishly unable to keep the beat. A few minutes later, Krupa reprises the song by drumming matchsticks on a tabletop as Stanwyck and others crowd around to sing. Cooper peers awkwardly over everyone's shoulders, blurting out "Boogie!" at just the wrong moment. His character has zero sense of rhythm, but Cooper's own, intentionally bad, comic timing is just perfect.

That scene shows worlds colliding in a lively, classic comedy that must have been a particular delight for wartime audiences in January 1942,

when the film went into wide release. Just a few months earlier, they would have seen Cooper in *Sergeant York* (1941), a rousing war drama for which he would win the Oscar. It's hard to think of two more different back-to-back characters for one actor than Alvin York and Professor Bertram Potts, whom Stanwyck affectionately calls "Pottsie."

He is one of eight prim, innocent professors who have been holed up in a Manhattan apartment for nine years writing an encyclopedia. They're now at "S," and Pottsie realizes his entry on slang needs updating. A research trip brings him to dancer Sugarpuss O'Shea (Stanwyck), who winds up moving into the professors' townhouse to hide from the cops, who are after her gangster boyfriend played by Dana Andrews. Ostensibly she's there to teach the gentlemen about slang,

"The mouse is a dish; that's what I need the moolah for." Allen Jenkins (right) teaches Gary Cooper some modern slang.

Barbara Stanwyck teaches the professors how to conga: (from left) S. Z. "Cuddles" Sakall, Oskar Homolka, Aubrey Mather, Leonid Kinskey, Stanwyck, and Henry Travers.

| "The chemistry between Stanwyck and Cooper is magical. . . . She's wonderful in this as a comedienne. The same year, 1941, they also made a Capra movie called *Meet John Doe* that was so serious. . . . It shows their range."

"Go on—feel that foot." Barbara Stanwyck toys with Gary Cooper and his fellow professors.

but what they *really* know nothing about is sex; she helps on that front, too, with comic—and romantic—results, all with a charming tone befitting what is essentially a variation on *Snow White and the Seven Dwarfs*.

Ball of Fire feels tailor-made for Cooper and Stanwyck, whose chemistry here is a highlight of both their careers, but the film was conceived expressly for Cooper. Producer Samuel Goldwyn borrowed the writing team of Billy Wilder and Charles Brackett from Paramount to create a comedy vehicle for the star, and Wilder thought to expand a story treatment he had written years earlier in Germany before even learning to speak English—ironic for a film that relies so much on clever dialogue and slang. Wilder also negotiated a clause in his contract that allowed him access to the set to observe Howard Hawks direct. Tired

of seeing his scripts altered by other directors, Wilder was determined to become a director himself, which he did in short order with *The Major and the Minor* (1942).

Goldwyn's first choice for Sugarpuss was Ginger Rogers, but she was riding high after winning the Best Actress Oscar for *Kitty Foyle* (1940) and

Gary Cooper's interest in Barbara Stanwyck is purely professional; gangster Dan Duryea watches.

Gangster Dana Andrews (left) wants Barbara Stanwyck back from the professors.

WHAT TO LOOK FOR

Since launching the screwball comedy genre with *Twentieth Century* (1934), Howard Hawks had brought his flair for directing lightning-fast comic dialogue to new heights in *Bringing Up Baby* (1938) and *His Girl Friday* (1940). With *Ball of Fire*, he used rapid dialogue a bit differently. Some characters outside the professor group do talk at breakneck pace, but the professors themselves speak more deliberately. That contrast generates comedy in many scenes, as when Allen Jenkins or Barbara Stanwyck rattle off slang faster than the gents can understand it, or when Stanwyck schemes with henchmen Dan Duryea and Ralph Peters. Hawks reasoned that *Ball of Fire* took place in a different kind of "reality" than the other comedies. "When you've got professors speaking lines," he said, "they can't speak 'em like crime reporters."

—

Dan Duryea makes an amusing reference to *Sergeant York* when he says, "I saw me a picture last week," and then wets the sight of his gun with his thumb—just as Cooper repeatedly does in that film, which was also directed by Hawks.

felt the role was too frivolous. With Jean Arthur unavailable and Carole Lombard uninterested, Goldwyn was on the verge of casting Lucille Ball when Cooper suggested Stanwyck, with whom he had just made *Meet John Doe* (1941). Stanwyck was not just among the finest actresses in Hollywood but one of the most versatile. Over her career, she excelled in a great many genres by fully committing herself to every character—even the so-called "frivolous" ones. She is completely believable as Sugarpuss, from her toughness and cynicism to her vulnerability as she falls in love with Pottsie, all laced with comedy. The industry recognized her talent by nominating her for an Academy Award, the second of four nods in her career—and one of four nominations for this film, along with Best Story, Score, and Sound.

The supporting cast is filled with lovable character actors, with those playing the professors—such as Henry Travers, Oscar Homolka, and Tully Marshall—creating an endearing sense of warmth in the group. Dana Andrews modeled his performance as dapper gangster Joe Lilac on the mobster Bugsy Siegel, and supposedly Siegel's real-life girlfriend, Virginia Hill, appears fleetingly as a showgirl.

Ball of Fire was such a success that Goldwyn and Hawks remade it in 1948 as a Danny Kaye musical, *A Song is Born*, in which the professors are researching jazz, but that film was unable to recapture the magic and cleverness of the original.

"One of my favorite scenes is when Barbara Stanwyck builds the little book mound so she can kiss him. And [then] he has to go put a washcloth on his neck! She's just so beautiful in this. And Dana Andrews is beautiful. But no one is as handsome as Gary Cooper."

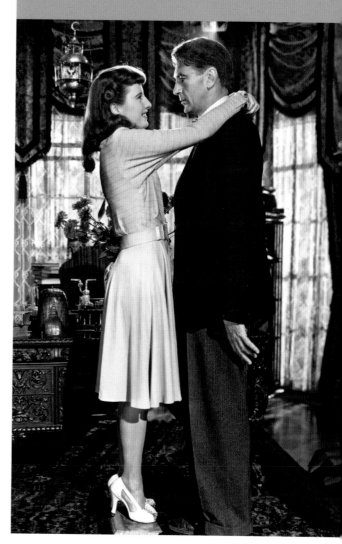

Barbara Stanwyck stands on some books in order to show Gary Cooper what "yum-yum" is.

SULLIVAN'S TRAVELS

Paramount, 1942
B&W, 90 minutes

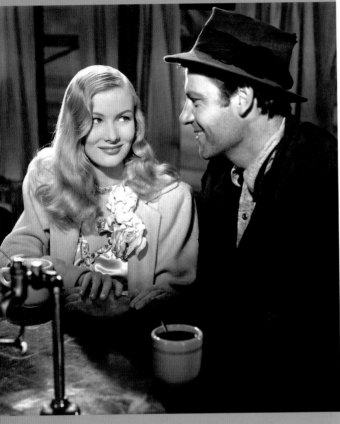

Veronica Lake and Joel McCrea

DIRECTOR

Preston Sturges

PRODUCER

Paul Jones (associate producer)

SCREENPLAY

Preston Sturges

STARRING

JOEL McCREA JOHN L. SULLIVAN

VERONICA LAKE THE GIRL

ROBERT WARWICK MR. LeBRAND

WILLIAM DEMAREST MR. JONES

MARGARET HAYES SECRETARY

PORTER HALL MR. HADRIAN

ROBERT GREIG SULLIVAN'S BUTLER

FRANKLIN PANGBORN MR. CASALSIS

ERIC BLORE SULLIVAN'S VALET

DETERMINED TO MAKE A SOCIALLY CONSCIOUS DRAMA ABOUT HUMAN SUFFERING, A COMEDY DIRECTOR SETS OUT FROM HOLLYWOOD AS A TRAMP TO EXPERIENCE THE REAL THING.

After Preston Sturges became the first prominent writer of the sound era to start directing his own scripts, he embarked on one of the most astonishing creative bursts in Hollywood history: seven brilliant comedies in four years (along with the uneven comedy-drama *The Great Moment* [1944], reedited without his involvement). His fourth film, *Sullivan's Travels*, has become especially beloved because it is also one of the great movies about movies—an affectionate satire of Hollywood that is likely as cherished by classic-film lovers as it was by Sturges himself.

He wrote the script as a response to the preachiness he saw in other recent comedies, which in his view had "abandoned the fun in favor of the message." He dreamed up the character of a hotshot light-comedy director, John L. Sullivan, who yearns to make a hard-hitting drama but feels he must first experience what hardship and suffering are really like. "I'm not coming back till I know what trouble is," he tells the studio chief as he heads to wardrobe for a hobo outfit. By the end of his adventures, he realizes "there's a lot to be said for making people laugh," and the audience is in complete agreement.

In a story that esteems the value of comedy, Sturges incorporates just about every *kind* of comedy: visual, verbal, and aural. There's physical slapstick, witty dialogue, sophisticated irony, and cartoonish sight gags and sound effects. There are references to real filmmakers, such as

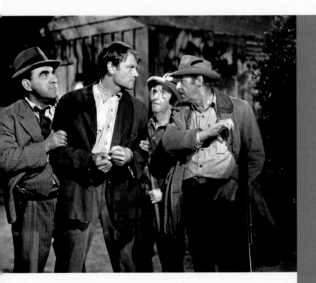

John L. Sullivan is finally discovering what hardship really is. From left: Dewey Robinson, Joel McCrea, Jimmy Conlin, and Alan Bridge.

ROBERT OSBORNE
—

"It wasn't a raging hit when it came out, but over the years this film thankfully has been rediscovered. . . . I love those great faces of the guys laughing as they're watching the cartoon. Casting directors know what they're doing to round up those kind of faces. . . . It's a great comedy but also with a great deal of substance to it."

Eric Blore, as Sullivan's valet, helps adjust Joel McCrea's hobo costume . . .

. . . and director Preston Sturges adjusts Veronica Lake's.

Frank Capra and Ernst Lubitsch, and numerous satirical jabs at Hollywood, from its heavy-handed dramas (Sullivan has to sit through a triple feature of them at one point) to studio brass wanting to inject "a little sex" into every picture.

Sturges also integrates poignant—even grim—dramatic scenes. One character dies a shocking death in a train yard. Later, Sullivan is sent to a prison, forced to work on a chain gang, and confined to a torturous "sweatbox" for a day. Most striking is a six-and-a-half-minute wordless montage of Sullivan and The Girl living in a slum, scavenging for food—a powerful piece of silent filmmaking. That these scenes fit into a picture known mostly for its humor is a testament to Sturges and even reminiscent of Charlie Chaplin, the ultimate master of blending comedy and pathos. Like Chaplin, Sturges clearly understood how and when to make an audience feel safe to laugh.

Sturges wrote the part of Sullivan specifically for Joel McCrea, a first for the star after over a decade in Hollywood. That personal attention was a big factor in McCrea's decision to turn down Cecil B. De Mille's concurrent offer of a lead in *Reap the Wild Wind* (1942). De Mille told him he was making a mistake, that Sturges's film would soon be forgotten, but history would prove that De Mille had it backwards. McCrea was a perfect fit for the part of Sullivan, and he enjoyed working with Sturges so much that he did so twice again. "I have to say the money I got for [*Sullivan's*

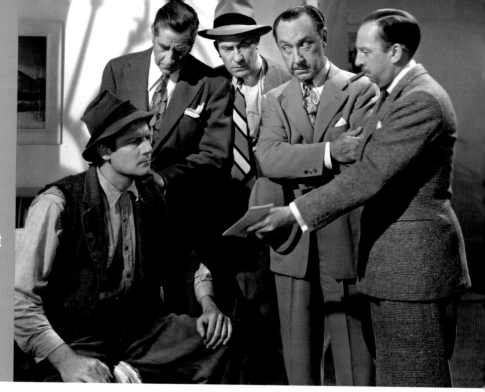

Preston Sturges employed his usual ace stock company of beloved character actors. Here with Joel McCrea (seated) are Robert Warwick, William Demarest, Franklin Pangborn, and Porter Hall.

Travels] was unnecessary; I don't know any other director where I had so much fun," McCrea recalled, adding, "He wasted less time and less film than anyone, except maybe Hitchcock."

For the role of The Girl (unnamed as a reference to one of the movie's jokes, that "there's always a girl in the picture"), Paramount wanted Barbara Stanwyck or Ida Lupino, but Sturges pressed for Veronica Lake, a rising actress he'd seen and liked in *I Wanted Wings* (1941). She took the role without telling Sturges that she was six months' pregnant, and when she did inform him, after production began, he was not pleased. Costume designer Edith Head had to make new, looser costumes to disguise the pregnancy,

especially for later in the shoot, and Sturges and cinematographer John Seitz had to readjust camera angles. A double was used for several of Lake's physical scenes, such as jumping on and off trains and getting pulled into a pool.

The most famous and even revered sequence of *Sullivan's Travels* comes near the end, in a church that converts into a makeshift movie theater. A downtrodden prison chain gang, including Sullivan, marches inside as a black congregation sings "Way Down Moses," led unforgettably by Jess Lee Brooks as the preacher. (He and the congregants are portrayed with so much warmth and respect that the NAACP sent a letter of appreciation to Sturges.) A white

Veronica Lake and Joel McCrea. When this film opened, Lake was already shooting her next one, This Gun for Hire *(1942), which would catapult her to stardom.*

sheet is unfurled, the lights are dimmed, and a 16mm projector starts unspooling the Disney cartoon *Playful Pluto* (1934), leading to laughter of pure joy from the demoralized men. Sturges had originally wanted to use a Chaplin short, but Chaplin didn't grant permission. It didn't matter.

The scene works beautifully with the cartoon, prompting a tremendous emotional release as Sullivan, the audience, and perhaps Sturges himself all discover that there can never be enough laughter in the world, and that the ability to create it through art is one of the greatest gifts one can offer.

.............

Early in *Sullivan's Travels,* in a movie studio office, Joel McCrea pleads his case for making a drama to Robert Warwick and Porter Hall, two fine character actors who play the executives with affection and humor. The scene was scheduled to be filmed over two days, but Sturges and John Seitz instead devised a single, four-minute take that was achieved in one morning. It's easy not to notice because of some clever staging of the three actors, with their movements and repositioning within the frame giving the illusion of editing.

—

Sturges can be glimpsed in a cameo toward the end of the film, standing and turning behind Veronica Lake as she reacts to a newspaper photo.

Joel McCrea and Veronica Lake amid a sea of vivid faces

YANKEE DOODLE DANDY

Warner Bros., 1942
B&W, 126 minutes

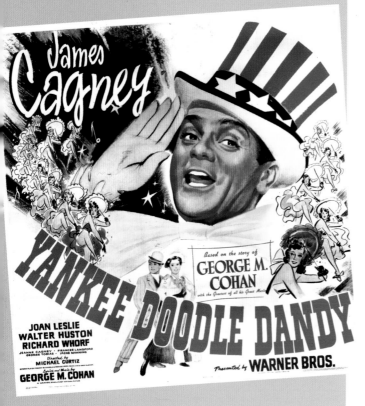

DIRECTOR

Michael Curtiz

PRODUCER

Hal B. Wallis (executive producer)

SCREENPLAY

*Robert Buckner and Edmund Joseph;
original story by Robert Buckner*

STARRING

JAMES CAGNEY	GEORGE M. COHAN
JOAN LESLIE	MARY
WALTER HUSTON	JERRY COHAN
RICHARD WHORF	SAM HARRIS
IRENE MANNING	FAY TEMPLETON
GEORGE TOBIAS	DIETZ
ROSEMARY DeCAMP	NELLIE COHAN
JEANNE CAGNEY	JOSIE COHAN
FRANCES LANGFORD	SINGER
GEORGE BARBIER	ERLANGER
S. Z. SAKALL	SCHWAB

GEORGE M. COHAN RISES FROM THE VAUDEVILLE CIRCUIT TO THE HIGHEST PEAKS OF BROADWAY AS A COMPOSER, PRODUCER, ACTOR, DANCER, AND SINGER.

WHY IT'S ESSENTIAL

Yankee Doodle Dandy started production on December 3, 1941. On the morning of Monday, December 8, the day after the bombing of Pearl Harbor, a dazed cast and crew gathered around a radio as President Franklin D. Roosevelt made his historic "infamy" speech and asked Congress to declare war on Japan. The company took a moment of prayer at James Cagney's suggestion, and then director Michael Curtiz said, in his Hungarian-accented English, "Now, boys and girls, we haff work to do. We haff bad news, but we haff a wonderful story to tell the world. So,

let us put away sad things and begin!" They proceeded to do just that, and as actress Rosemary DeCamp later wrote, "Throughout that picture all of us worked in a kind of patriotic frenzy."

The outbreak of war only underscored why it made such perfect sense to produce a biopic of George M. Cohan. Known as the father of American musical comedy, "the man who made Broadway," Cohan practically ruled the Great White Way over the first quarter of the twentieth century. He wrote, produced, and performed in over fifty shows and composed such standards as "Give My Regards to Broadway," "Mary's a Grand Old Name," "Over There," and "You're a Grand Old Flag." He was also an American

James Cagney, Jeanne Cagney, Walter Huston, and Rosemary DeCamp performing "You're a Grand Old Flag," a lavish, rousingly patriotic number staged with 100 dancers

SALLY FIELD

"When he dances, there's something that comes out of him that's just joyful, and infectious. . . . He tap-dances down that staircase without ever looking down: that you cannot look at and not grin."

"My mother thanks you, my father thanks you, my sister thanks you, and I thank you." From left: Rosemary DeCamp, Walter Huston, Jeanne Cagney, and James Cagney.

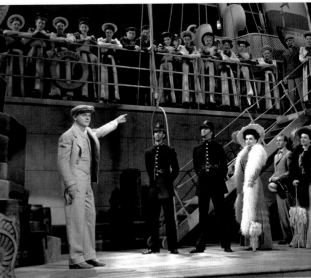

James Cagney—as George M. Cohan, in character as Little Johnny Jones— performing "Give My Regards to Broadway"

success story, rising from vaudeville with his parents and sister (who performed as the Four Cohans), and incorporating flag-waving patriotism into much of his work. With Hollywood now starting to churn out morale-boosting films, Cohan's life story was ideal.

Yankee Doodle Dandy turned out to be far more than just a World War II morale booster. It was so well crafted that it remains rousing, moving, completely engaging entertainment today, one of the finest musical films ever made. It set the standard for the musical biography, a genre that would become increasingly popular as the decade wore on, and, just as essentially, it showcased the amazing versatility of James Cagney.

Known then and now primarily for his gangster and tough-guy roles, Cagney had started in vaudeville and always considered himself foremost a hoofer. "I didn't have to pretend to be a song-and-dance man," he wrote of taking this role. "I was one." He took a great interest in doing justice to the still-living Cohan, whose production

ROBERT OSBORNE
—

"George M. Cohan was not keen to have a movie made about his life because there was so much he really didn't want exposed. But they catered to him to get this because it was the spirit of him that they were really trying to capture, which they did. . . . James Cagney was truly one of the legends among actors of that era, and I think this is his best performance."

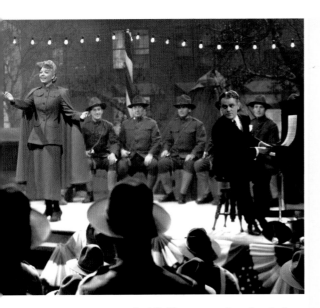

Frances Langford (left) was cast four days before shooting this number, "Over There," her only scene in the film. James Cagney sits at the piano.

deal gave him approval of the finished film. When Cagney read Robert Buckner's screenplay, he was surprised to find "not a single laugh" and insisted that Warner Bros. hire the ace writing team of Julius and Philip Epstein to inject humor, which they did, uncredited. To perfect Cohan's unique, strutting style of dance, Cagney rehearsed with choreographer Johnny Boyle, who had worked with Cohan extensively in the 1920s. Cagney also channeled Cohan's singing voice, which was more like rhythmic speaking, and brought his own charisma to the romantic, comedic, and dramatic scenes. During the deathbed sequence with Walter Huston (excellent as Cohan's father), Cagney's performance had the entire crew in tears—including Curtiz, who ruined a take with his sobbing and said afterward, "Jimmy, you break my heart."

Joan Leslie, who delivers a lovely performance as George's wife, Mary, recalled Cagney's total ease as he improvised on the spot. Their charming "Harrigan" number was not originally meant to be sung by the two taking turns, as it is on-screen. "He put it all together in about fifteen minutes before we shot it," Leslie said. Another burst of inspiration resulted in a treasured moment of Hollywood musicals, in which Cagney tap-dances down the White House staircase. He thought of it just before cameras rolled and did not tell Curtiz what he planned to do.

Yankee Doodle Dandy is a blend of truth and conjuring in the service of a well-told story. Cohan was actually married twice, for instance, and neither wife was named Mary; the film's Mary incorporates qualities of both wives and

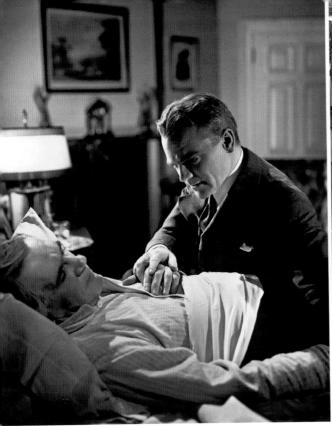

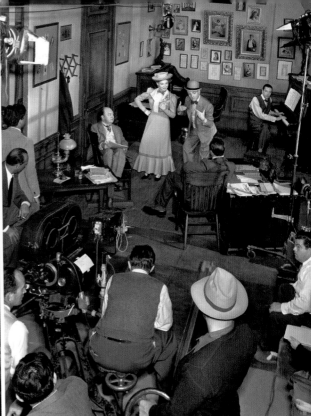

*The deathbed scene that brought the crew to tears:
Walter Huston (left) and James Cagney*

*Filming the "Harrigan" number. Seated at far left, in suit
and tie: director Michael Curtiz. Standing center:
Joan Leslie and James Cagney. Seated by Leslie: Chester
Clute. Seated in front of Cagney: George Tobias.*

allows for a plot link to "Mary's a Grand Old Name," which is sung by Joan Leslie and later by Irene Manning. In general, the arc of Cohan's life is portrayed correctly, including the detail of a brief blackface number performed by the Four Cohans, historically accurate for its 1890s setting. Perhaps the cleverest bit of storytelling magic comes at the end, when Cohan's World War I song, "Over There," is used as a rousing bridge to present-day 1942, showing Cohan's talent still inspiring American fighting forces—and audiences.

The film was the second-biggest moneymaker of the year and scored eight Oscar nominations, including Best Picture, Director, and Supporting Actor (Huston). It won for Score, Sound, and Actor—the sole Academy Award of James Cagney's career. George M. Cohan saw the picture before he died in November 1942 and reportedly said afterward, "My God, what an act to follow." The next morning, he sent a congratulatory telegram to Cagney, who later described his performance as "one song-and-dance man saluting another, the greatest of our calling."

RKO, 1942
B&W, 73 minutes

DIRECTOR

Jacques Tourneur

PRODUCER

Val Lewton

SCREENPLAY

DeWitt Bodeen

STARRING

SIMONE SIMON IRENA DUBROVNA REED

KENT SMITH .OLIVER REED

TOM CONWAY DR. LOUIS JUDD

JANE RANDOLPH ALICE MOORE

JACK HOLT THE COMMODORE

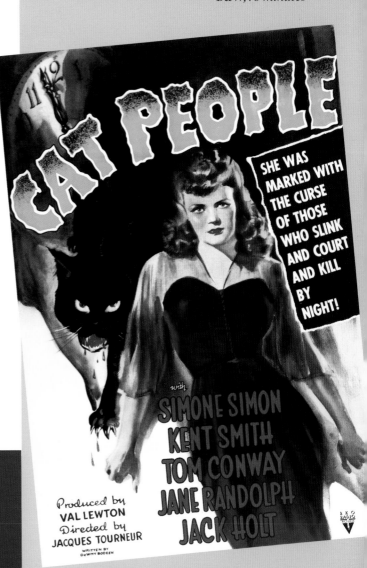

A YOUNG BRIDE FEARS THAT EXPERIENCING INTIMACY OR JEALOUSY WILL TRIGGER A CURSE AND TURN HER INTO A LETHAL PANTHER.

WHY IT'S ESSENTIAL

While Preston Sturges was directing his string of comedy masterpieces at Paramount, Val Lewton was around the corner at RKO, producing his own brilliant series of horror movies. Lewton, however, had only a fraction of Sturges's budgets and star power. As head of RKO's new "B" horror unit, he was tasked with helping return the studio to profitability following heavy losses on Orson Welles's *Citizen Kane* (1941) and *The Magnificent Ambersons* (1942).

Lewton's boss, RKO production chief Charles Koerner, saw an opportunity to compete with Universal, whose longtime success in the horror genre had recently produced *The Wolf Man* (1941), an instant classic. Koerner's idea was to dream up vivid titles, test them for commercial viability, and assign them to Lewton, who had complete freedom to develop story lines and assemble collaborators as long as his budgets stayed below $150,000 and running times did not exceed 75 minutes. The first title: "Cat People." Screenwriter DeWitt Bodeen later said that

Kent Smith is newly married to Simone Simon (center), but has eyes for Jane Randolph.

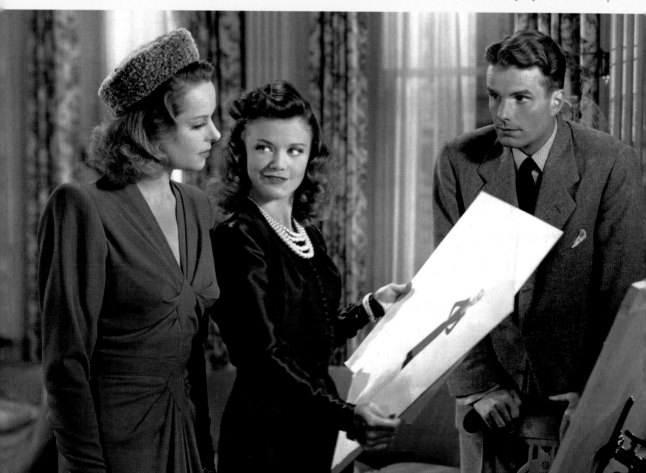

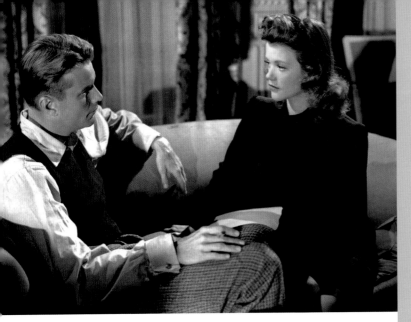

Kent Smith with Simone Simon, who, as Irena, admits,
"The darkness is lovely. It's where I feel most at home."

Koerner believed "vampires, werewolves, and manmade monsters had been overexploited [but] 'nobody has done much with cats.'"

Koerner expected a lurid movie in return but received something much subtler. Lewton was a man of taste and sensitivity who happened to have phobias of cats and of being touched; he applied it all to the character of Irena, a Serbian woman in New York who believes she is descended from a tribe that transformed into cat people when their passions were aroused. She marries a ship designer, Oliver, but is afraid to consummate the marriage for fear she will kill him. When her jealousy of Oliver's coworker, Alice, is provoked, Irena stalks her in feline form—or so we're led to believe.

Lewton, Bodeen, and director Jacques Tourneur never show Irena's transformation. They imply it with editing, lighting, sound, and reaction shots, allowing the audience's imagination to fill in the rest. "The less you see, the more you believe," said Tourneur. In fact, Nicholas Musuraca's cinematography is so stunningly dark and atmospheric that *Cat People* is essentially a horror film noir. The film creates unease in other ways, too. Characters speak in quiet, polite tones, belying the constant undercurrent of danger, and the settings are modern and ordinary, such as a zoo, an office, a pet shop, a swimming pool—seemingly safe places that take on menace.

Cat People's most famous scene finds Alice walking home at night along a Central Park transverse, followed by Irena. The frame is almost pitch-black except for occasional pools of light from the streetlamps. Alice hears footsteps

.............

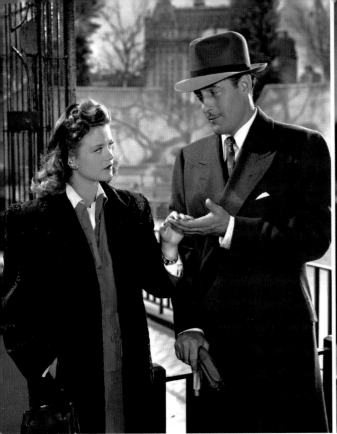

Simone Simon with Tom Conway as the psychiatrist, Dr. Judd. Conway was the brother of actor George Sanders. As Alec Baldwin said, "He's a leaner version of his brother but sounds exactly like him. Same voice, same oiliness."

Jane Randolph as Alice, entering the swimming pool area and about to have the fright of her life

behind her . . . then they stop. She turns . . . and sees no one. But she senses a presence and starts to run from one lamp to the next. Finally, a bus lurches into the frame with a suddenness guaranteed to jolt audiences, no matter how many times it's experienced. Editor Mark Robson said the intensity of that shock came almost by accident. "I put a big, solid sound of air brakes on it," he said, "cutting it in at the decisive moment so that it knocked viewers out of their seats." The moment was so influential that a sudden visual shock is still sometimes referred to by editors

as a "Lewton bus." Each Lewton picture used a variant of the device, and so have countless films ever since—although in less talented hands, it can feel like a cheap gimmick.

Because it was so low-budget, *Cat People* was cast mostly with unknowns. Kent Smith and Jane Randolph had just started their careers, though Simone Simon, as Irena, was more familiar. A star in 1930s France, she had made a few films in Hollywood, notably *The Devil and Daniel Webster* (1941). Her offbeat beauty and hesitant technique were perfect for the uncomfortable, achingly

vulnerable Irena, and *Cat People* would wind up as her best-known American work. It's to her great credit that the images one remembers from this film are not just the scary set pieces but the moments of loneliness and yearning: Irena huddled against a closed door, her husband on the other side, or Irena hunched in a bathtub, her wet shoulders quivering as she cries in shame after having killed as the panther.

Studio bosses were not happy with all this visual poetry at the expense of explicit horror, and they slipped the movie into lesser theaters in December 1942. Reviews were tepid, but audience word of mouth was sensational. Theaters extended their runs again and again, drawing the attention of critics who now reassessed the film more highly. *Cat People* was a true sleeper hit and became one of the most profitable titles of 1943. Produced for $141,659, it grossed (according to *Variety*) $1.2 million, though some sources claim an even higher figure. RKO was ecstatic and let Lewton keep producing these films the way he wanted, resulting in eight more horror classics over the next four years.

Modern filmmakers, including Joe Dante, Guillermo del Toro, and Martin Scorsese, still cite this film's influence. Scorsese has said that "in its own way, *Cat People* was as important as *Citizen Kane* in the development of a more mature American cinema."

ROBERT OSBORNE

"It was made for peanuts and yet it has great power. Practically the whole movie is in shadow. . . . That adds to the mood of the film, but it also is very economical because then you don't have to decorate the whole set."

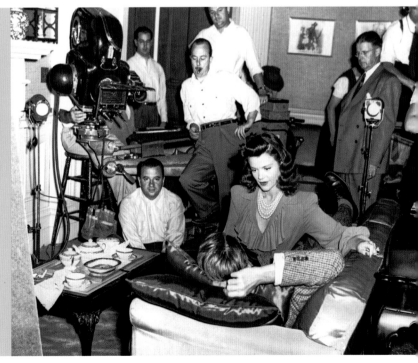

Jacques Tourneur (seated beneath the camera) directing Simone Simon and Kent Smith

WHAT TO LOOK FOR

Jane Randolph ventures to a New York building's basement pool. Sensing a presence, she dives into the water to escape, but grows terrified as the sound of growling emanates from every direction. All she sees are shadows—or does she?

Director Jacques Tourneur and producer Val Lewton filled the movie with macabre feline imagery, as in this scene with Simone Simon.

This heart-racing scene is legendary for conjuring dread—not to mention a large cat—entirely through the power of suggestion. Tourneur used a pool with a low ceiling and white walls to generate claustrophobia and produce unnerving water reflections. He shot the walls and shadows from Randolph's perspective and heightened the sounds of dripping water, in effect bringing the audience into the pool.

Growls were produced by real lions and a voice actress. For the fleeting shadows of a moving creature, Tourneur said, "I used my fist to make shadows against the wall." The result, like the bus scene, is frightening every time one sees and hears it. Tourneur was inspired by personal experience: he had been swimming alone in a friend's pool one day when the friend's pet cheetah (!) escaped its cage and walked to the pool, growling.

—

Feline imagery appears throughout the film. There are paintings and figurines of cats; cats' claws in the design of a bathtub; tiger lilies in a flower shop; and even a statue of the Egyptian cat goddess, Bastet.

—

Simone Simon dubbed the voice of the "cat woman" played by Elizabeth Russell in the Serbian restaurant scene, giving the words "my sister" an even creepier effect.

LAURA

Twentieth Century-Fox, 1944
B&W, 88 minutes

DIRECTOR

Otto Preminger

PRODUCER

Otto Preminger

SCREENPLAY

Jay Dratler, Samuel Hoffenstein,
and Betty Reinhardt,
from the novel by Vera Caspary

STARRING

GENE TIERNEY LAURA HUNT

DANA ANDREWS.DETECTIVE MARK McPHERSON

CLIFTON WEBB. WALDO LYDECKER

VINCENT PRICESHELBY CARPENTER

JUDITH ANDERSON. ANN TREADWELL

DOROTHY ADAMS.BESSIE

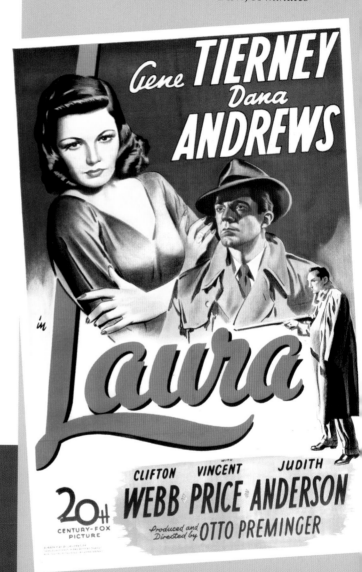

**A DETECTIVE FALLS
IN LOVE WITH
THE WOMAN WHOSE
MURDER HE IS
INVESTIGATING.**

ROBERT OSBORNE
—

"It's one of those great movie accidents. . . . You can have so many things go wrong, and so many other visions for it, [but] then it's put together and becomes this perfect movie. . . . [It's] in my top ten favorite movies of all time. I fell madly in love with Gene Tierney when I saw it."

"I shall never forget the day Laura died."

With that opening narration, *Laura* transports its audience into the dreamlike world of one of the finest mysteries ever made. *Laura* is cherished for its clever storytelling, witty dialogue, haunting score, and the alluring beauty of Gene Tierney, but it's also a famous happy accident—a film that, like *Casablanca* (1942), was not seen as particularly special while it was being made, yet somehow found all the right ingredients to become an enduring classic.

The film's characters are highly distinct and most seem like viable suspects as the story plays out, both of which are essential qualities of a good whodunit. They also dwell among the upper crust of New York society, making the potential evil lurking beneath their genteel facades all the more entertaining. (Vincent Price described them as "upper-class scum.") Yet *Laura* is not simply a whodunit. As the detective, Mark McPherson, tries to solve the mystery of advertising executive Laura Hunt's murder, he falls in love with Laura herself—by conjuring a romanticized image of her from other characters' accounts and, most indelibly, from the beguiling portrait hanging in her empty apartment. *Laura* delves into themes of voyeurism, hopeless yearning, and the mixed emotions that arise when fantasy blends into reality, all the while

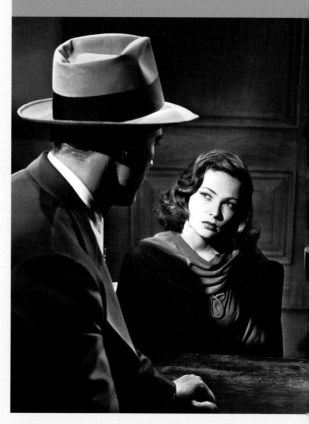

Dana Andrews questions Gene Tierney in the police station: "[I] reached a point where I needed official surroundings."

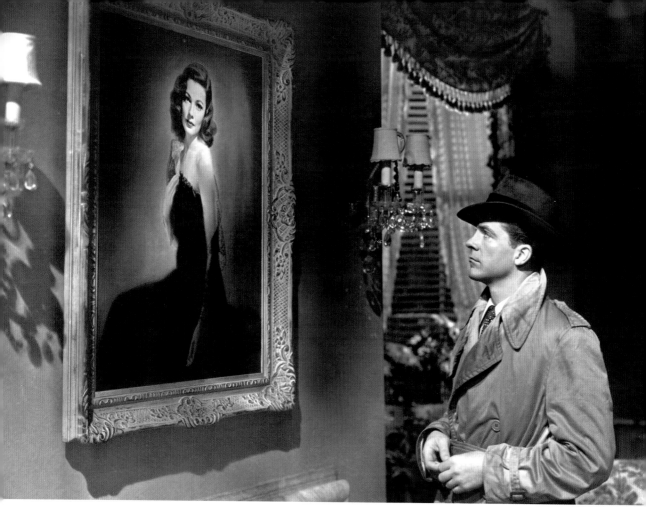

An indelible image of 1940s Hollywood: Dana Andrews gazes longingly at the portrait of Gene Tierney. Original director Rouben Mamoulian used a portrait painted by his own wife, but when Otto Preminger came on board, he decided it didn't resemble Gene Tierney enough and scrapped it in favor of a photograph touched up with paint. In a cast of "second choices," even the painting was one.

incorporating such memorable dialogue as "I don't use a pen; I write with a goose quill dipped in venom."

Those words are delivered by Clifton Webb as the acerbic Waldo Lydecker, a character inspired by literary critic Alexander Woollcott. Webb's casting was one of the film's many so-called accidents. Studio chief Darryl Zanuck had envisioned Monty Woolley or Laird Cregar before producer Otto Preminger convinced him to take a chance on fifty-five-year-old Webb, a musical stage actor who had never appeared in a talking picture. John Hodiak was planned for the detective until Dana Andrews, not yet a leading man, got wind of the project and craftily charmed Zanuck's wife. Gene Tierney, a Fox star but not yet a major one, got the title role after Jennifer Jones and Hedy Lamarr each turned it down.

.............

As Tierney later wrote, "We were a mixture of second choices."

Even Otto Preminger only secured the director's chair when original director Rouben Mamoulian was fired. Preminger's very existence at the studio was a fluke. He'd had a stint there a decade earlier that resulted in a falling-out with Zanuck; in 1942, with Zanuck on leave producing war documentaries, an interim chief rehired Preminger, who urged the studio to purchase Vera Caspary's novel *Laura*. When Zanuck returned soon after, he told Preminger, "You can go ahead and produce it, but as long as I'm here you will never direct." In a further swipe, Zanuck designated the film as a minor, lower-budget feature, though to his credit, when he read the screenplay, he elevated it to "A" status. Preminger later said that Zanuck fired Mamoulian three

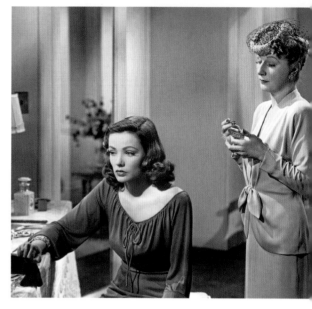

Gene Tierney and Judith Anderson in the powder room, whe[re] they exchange some of the most sophisticated dialogue in the fil[m]

weeks into production out of unhappiness over the director's work; other accounts have Preminger purposefully undermining Mamoulian so that he'd be fired. Either way, Zanuck realized that Preminger was the obvious choice to step in.

Dana Andrews asks Clifton Webb a few questions. Webb's working bathtub is swell—but it can't top Joan Crawford's in The Women.

*Vincent Price as Shelby Carpenter, "a vague sort of a fellow," asking Laura
(Gene Tierney) for a job. Tierney's chic attire was designed by Bonnie Cashin.*

As director, Preminger started shooting from scratch with a new cameraman, Joseph LaShelle, framing scenes in a style that prompted the audience to watch as objective observers and the characters to be seen as equally suspect.

The result, finalized after an alternate ending was written, shot, and then discarded, was far better than anyone had imagined for this troubled production, except perhaps Preminger. Reviews were excellent and the film scored five Oscar nominations, including nods for Director, Screenplay, and Supporting Actor (Clifton Webb). LaShelle won for his black-and-white, film noir–style cinematography, but most importantly, *Laura* struck an emotional chord with audiences,

who flocked to cinemas. Webb became an unlikely, instant star, Andrews finally broke through as a leading man, and Tierney was now on her way to becoming one of the top stars at Fox.

She is still best remembered for this role, though she downplayed her talent. "I never felt that my own performance was much more than adequate," she wrote. "I am pleased that audiences still identify me with Laura, as opposed to not being identified at all. Their tributes, I believe, are for the *character*—the dreamlike Laura—rather than any gifts I brought to the role. . . . I doubt that any of us connected with the movie thought it had a chance of becoming a kind of mystery classic, or enduring beyond its generation."

.............

Filming on the set of Waldo's apartment. Standing at right: Clifton Webb and Gene Tierney. Standing behind camera, with balding head: producer-director Otto Preminger.

WHAT TO LOOK FOR

Laura is impossible to imagine without its poignant score, so perfectly deployed and affecting that it is still used as a model to teach the art of film music. Yet this was another happy accident. After Alfred Newman and Bernard Herrmann each declined the picture, the job was assigned to staff composer David Raksin. "I saw immediately it was not a detective story but a love story in a detective story milieu," he recalled. He was especially taken by a scene in which Dana Andrews wanders around Laura's bedroom one rainy night, looking through her lingerie and perfume before returning to the portrait in the living room. Zanuck thought it dragged and wanted to cut it way down, but Raksin protested. It was crucial to showing that the detective was in love with Laura, he said,

and it simply needed music. Zanuck and Preminger gave Raksin the weekend to come up with a main theme; otherwise, they would use Duke Ellington's "Sophisticated Lady." The next day, Raksin received a letter from his wife ending their marriage. Heartbroken, he placed the letter atop his piano, and out of his sorrow came the romantic, wistful tune that has touched audiences ever since.

Audience demand for the music was so strong that Johnny Mercer was commissioned to write lyrics, resulting in a hit song, "Laura," that is still among the most recorded. Years later, Hedy Lamarr quipped that she had turned down *Laura* because "they sent me the script, not the score."

.............

MILDRED PIERCE

Warner Bros., 1945
B&W, 111 minutes

DIRECTOR

Michael Curtiz

DIRECTOR

Michael Curtiz

PRODUCER

Jerry Wald

SCREENPLAY

Ranald MacDougall,
based on the novel by James M. Cain

STARRING

JOAN CRAWFORD	MILDRED PIERCE
JACK CARSON	WALLY FAY
ZACHARY SCOTT	MONTE BERAGON
EVE ARDEN	IDA CORWIN
ANN BLYTH	VEDA PIERCE
BRUCE BENNETT	BERT PIERCE
LEE PATRICK	MAGGIE BIEDERHOF
MORONI OLSEN	INSPECTOR PETERSON
VEDA ANN BORG	MIRIAM ELLIS
JO ANN MARLOWE	KAY PIERCE
BUTTERFLY McQUEEN	LOTTIE

Joan Crawford as Mildred Pierce, with James Flavin (left)
and Jack O'Connor as detectives

A DIVORCED HOUSEWIFE WORKS TO BUILD A SUCCESSFUL BUSINESS FROM THE GROUND UP—ALL TO PROVIDE A BETTER LIFE FOR HER SPOILED, UNGRATEFUL DAUGHTER.

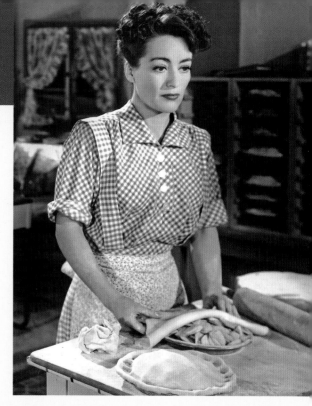

Mildred (Joan Crawford) ascends from baking pies at home . . .

Mildred Pierce grabs the audience immediately. Late at night, at a Malibu beach house, shots ring out. A man falls dead, saying "Mildred" with his final breath. A door slams, a car drives off—and in one of the great movie star comebacks of Hollywood history, Joan Crawford anchors the electric drama that follows. The anger, determination, and fight that she displays on-screen is enthralling, and it drives what is essentially the ultimate meshing of film noir and women's melodrama.

Mildred may or may not have committed that murder, but soon enough she is sitting at police headquarters relating a winding tale that unfolds in flashback. The heart of the story is her relationship with her daughter, Veda. Obsessed with gaining her love by giving her a materially better life, Mildred splits from her unemployed husband, takes a waitressing job, and works hard to learn the restaurant business, eventually opening a successful chain. But Veda is such a horrid, spoiled brat, interested only in social status, that she doesn't think twice about telling her mother, "You'll never be anything but a common frump whose father lived over a grocery store and whose mother took in washing." Veda is a pure noir femme fatale, luring her mother along and bringing her down. Mildred is a pure noir protagonist, as doomed as any male noir antihero,

as she makes futile sacrifices for the love she craves from Veda.

James M. Cain's hardboiled novel, published in 1941, had been thought unfilmable due to its many sordid, racy elements—such as Mildred finding Veda in bed with Mildred's new husband, Monte. Producer Jerry Wald enlisted several writers—though only Ranald MacDougall received credit—to eliminate the seamiest story points and concoct the murder and flashback structure, which are key to imparting the fatalistic and cynical atmosphere. But even in somewhat sanitized form, several actresses did not want to play Mildred because they found the script too offensive or were apprehensive about

. . . to running a restaurant empire. Business partner Ida (Eve Arden) delivers wisecracks with aplomb, such as: "Personally, Veda's convinced me that alligators have the right idea. They eat their young."

portraying mothers. Barbara Stanwyck, however, lobbied hard for the role. "I knew what a role for a woman it was, and I knew I could handle every facet of Mildred," she later said.

Director Michael Curtiz favored Stanwyck, but Wald insisted he consider Joan Crawford, who wanted the part so badly that she even agreed to shoot a screen test. Crawford had been labeled box-office poison on the same 1938 exhibitor list that included Katharine Hepburn. Still, she rode out her contract with her home studio of MGM until 1943, by which time her box-office numbers had begun to dwindle and the prominent roles had started going to the likes of Lana Turner and Greer Garson. Warner Bros. signed her almost immediately but didn't offer her any decent parts for two years. Jack Warner even scoffed at the idea of her playing Mildred,

ROBERT OSBORNE

—

"I love Mildred Pierce. Besides it being a big comeback for Joan Crawford, I think it's about as definitive a Warner Bros. film as you could have. It's got a gritty side—the kind of movie that only Warners made this well. . . . Joan Crawford has no mannerisms in this movie. She's very real, very honest . . . I think this is Joan at a perfect period."

calling her a "has-been." Her test changed everyone's mind, even that of the hard-nosed Curtiz.

Curtiz—here directing his first film noir as assuredly as his definitive swashbuckler (*The Adventures of Robin Hood* [1938]), musical biography (*Yankee Doodle Dandy* [1942]), and wartime romance (*Casablanca* [1942])—clashed with Crawford at first; she favored a more glamorous look for Mildred's early scenes than Curtiz thought appropriate. (They especially fought over her affection for shoulder pads.) Eventually, they found mutual respect and later even made another picture together, *Flamingo Road* (1949).

After many young actresses tested for the juicy role of Veda, sixteen-year-old Ann Blyth got the part on loan-out from Universal. She had only appeared in three movies but found a ferocity that made the character one of the most venomous and memorable in film noir. Blyth famously slaps Crawford at one point (after Crawford slaps her earlier on), and Blyth later reported that the slap was "very real. There was nothing fake about it. We were both reeling afterwards with emotion."

The cast was rounded out with Zachary Scott in a typically oily role as rich playboy Monte, Bruce Bennett as Mildred's stolid first husband Bert, and Jack Carson as an annoying, lecherous business associate. That those are the three men in Mildred's life speaks volumes about the sorry world she's forced to inhabit, but luckily the outstanding Eve Arden is also on hand as Ida,

An awkward moment as Joan Crawford walks in on Ann Blyth and Zachary Scott

Shooting a scene with Joan Crawford and Zachary Scott

Butterfly McQueen is amused as Joan Crawford ties an apron around Jack Carson.

Mildred's acid-tongued friend and restaurant partner, who is always ready to lend support, crack wise, or sit for a shot of bourbon and lament the male sex.

Mildred Pierce was a smash hit and drew six Oscar nominations, including Best Picture, Screenplay, and Supporting Actress for both Arden and Blyth. The sole winner was Joan Crawford as Best Actress—the only Oscar of her career. The award capped a magnificent career reinvention and propelled her once again to the top ranks of stardom. She later said, "I loved being called a star, and even more *being* a star. But it was nice with *Mildred Pierce* to finally be certified as an actress."

ALEC BALDWIN

"This is probably the most compelling I've ever seen Joan Crawford in a film. . . . Ann Blyth was a very interesting actress to me because she was so doll-like. She had a very ethereal, almost otherworldly kind of facial mask. You don't know what is going to happen to her or come out of her. And she's just this monster— your worst nightmare as a kid."

A dysfunctional mother-daughter relationship: Joan Crawford and Ann Blyth

BRIEF ENCOUNTER

Rank/Cineguild (UK), 1945
B&W, 86 minutes

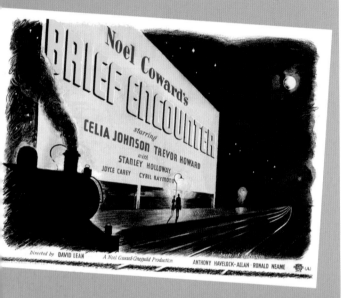

DIRECTOR

David Lean

PRODUCER

Noël Coward

SCREENPLAY

Anthony Havelock-Allan, David Lean,
and Ronald Neame, from the play
Still Life by Noël Coward (all uncredited)

STARRING

CELIA JOHNSON LAURA JESSON

TREVOR HOWARD DR. ALEC HARVEY

STANLEY HOLLOWAY ALBERT GODBY

JOYCE CAREY MYRTLE BAGOT

CYRIL RAYMOND FRED JESSON

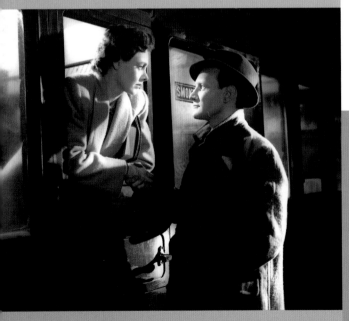

A lushly romantic moment between
Celia Johnson and Trevor Howard

IN PRE-WORLD WAR II ENGLAND, A MARRIED WOMAN FALLS IN LOVE WITH A MARRIED MAN WHOM SHE MEETS AT A TRAIN STATION.

An all-time classic romance, *Brief Encounter* packs an emotional wallop that has made it a continual favorite on both sides of the Atlantic. At heart, it's a modest tale of unconsummated yet illicit love, distinctly British in its undercurrents of stoicism, repression, and self-sacrifice. But it is also universal, with a touching portrayal of love growing between two people who were not looking for it and find themselves overwhelmed by it. "I'm an ordinary woman," says Celia Johnson in her voice-over narration. "I didn't think such violent things could happen to ordinary people."

Married with two kids to a kindly but dull husband, Johnson innocently meets a married doctor (Trevor Howard) at a train station one day when he gallantly removes a speck of grit from her eye. In the weeks ahead, they meet by chance again, fall into conversation, and find an attraction developing. Neither has sought an affair, yet their strong feelings are undeniable

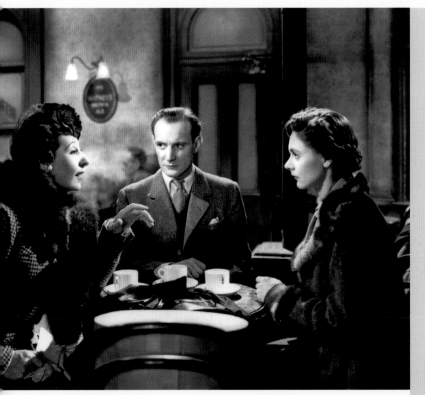

Everley Gregg (left) as the bothersome Dolly Messiter, who interrupts a heartfelt moment between Trevor Howard and Celia Johnson

MOLLY HASKELL

"This is the woman's film for people who don't like women's films, a genre . . . about middle-class women who had very few options. They had narrow lives, little dreams, little hope for anything different . . . and the [genre] gave expression to that suffering that had gone unrecognized, and which in its way was the prelude to the women's movement."

"This was one of the first British films that really made an impact in the American market. People in ordinary movie theaters in small towns went to see Brief Encounter. *It's kind of a bedtime story for the older tots—an adult love story which is very romantic and really beautiful. . . . A small, very tender, very touching movie."*

and threaten to uproot their steady, middle-class lives. Johnson narrates the story as a poignant inner monologue, an unspoken confession to her husband; this makes *Brief Encounter* specifically a woman's story, with Johnson's concerns, anxieties, and desires framing the audience's experience.

Since transitioning from film editor to director in 1942, David Lean had made three pictures—all

Stanley Holloway and Joyce Carey engage in a comic, romantic subplot of their own in the station refreshment room.

with producer Noël Coward, and two with scripts by Lean, Anthony Havelock-Allan, and Ronald Neame, based on Coward's plays. *Brief Encounter* continued the pattern. It was drawn from Coward's 1936 one-act *Still Life*, part of a broader Coward series titled *Tonight at 8:30* that had been sold to MGM. In a complicated chain of dealings, Britain's Rank Organisation bought the rights and sold them back to Coward and Lean.

Still Life had been set entirely in the train station refreshment room where the two characters meet, but the film opens up the play considerably—so well that one would never otherwise know the story had *been* a play. But *Brief Encounter* does retain the original's late-1930s time period. Lean told biographer Kevin Brownlow that this was intended to be clear from the lack of any reference to World War II as well as from an unstylish, dated hat worn by Celia Johnson, which was also meant to make her look provincial. (Coward had insisted that "they are absolutely ordinary people.")

The prewar setting adds extra poignancy, calling into question the lovers' assumptions

.

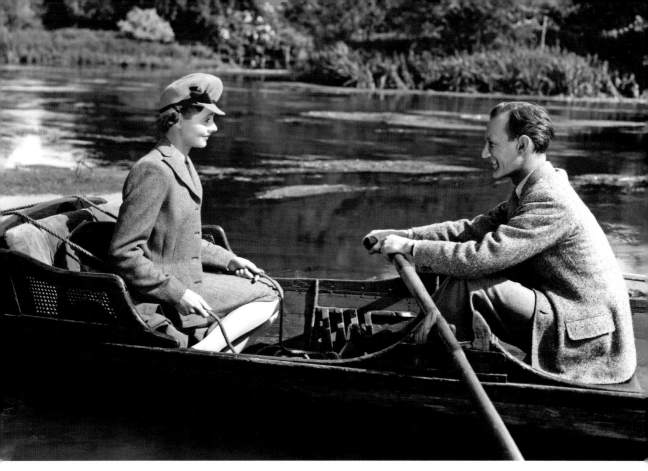

Celia Johnson and Trevor Howard enjoy a romantic outing. Johnson's hat, purposefully out of date to indicate the time period as well as her ordinary character, drew some derision at the time. Film critic Dilys Powell reported, "The French . . . thought it so charming that a woman could be loved wearing a hat like that."

about the future since they don't know the whole world is about to change. When the film was made, however, the war was a very real part of daily life, and the production had to travel to the relatively safe Lake District area for a four-week location shoot at Carnforth station in Lancashire. Celia Johnson wrote that she and Lean loved standing on the edge of the platform late at night as the express trains whooshed by, and that early one morning she was filming a scene as "the fish train from Aberdeen" rattled through.

"I was playing a sad little scene with the scent of herrings in the air."

Johnson will forever be best remembered for *Brief Encounter*, though she was far more a mainstay of the theater and made only twelve feature films. Her pained face, holding back the anguish of love and her discontent over being trapped into her place in the world—as she sits silently in the living room with her oblivious husband—is unforgettable. So is the chemistry she forms with Trevor Howard, who was basically still learning

*Celia Johnson trapped in domestic monotony
with husband Cyril Raymond*

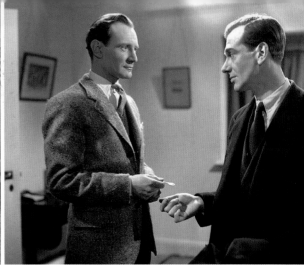

*Trevor Howard hands Valentine Dyall his key
in the scene that inspired Billy Wilder's
The Apartment (1960). Anthony Havelock-Allan
said that Dyall was cast for his disapproving face.*

to act for the camera in only his third movie. He credited Johnson for his effectiveness, saying after her death in 1982, "She was simply the best actress I have ever worked with."

Brief Encounter was a surprise hit upon its British release in November 1945, and it played in U.S. theaters for eight months starting the next year, drawing Oscar nominations for David Lean, Celia Johnson, and its screenplay. At the time it raised some eyebrows for its frank and sympathetic treatment of potential adulterers, but that quality has only helped the film's sense of tragic beauty endure. So has its atmospheric black-and-white cinematography by Robert Krasker, which by turns captures the drabness of ordinary life and the doom and passion of the romance, with vivid black shadows, steam, and relentless trains rushing through the night.

WHAT TO LOOK FOR

The scene in the flat is extraordinary for its powerful shifting of emotion. Johnson and Howard meet one night in a flat belonging to Howard's friend, who has lent him a key. Their nervousness and moral qualms seem to be preventing anything from happening before the friend, played by Valentine Dyall, shows up unexpectedly. Johnson escapes, but Dyall proceeds to humiliate and belittle Howard in a tense exchange. The lighting, set design, and choice of angles all contribute to the scene's uneasy effect. As Lean later put it, "That flat's a really hostile place, uncozy, unwelcoming. . . . Guilt is all over the place."

This is also the scene that inspired Billy Wilder to dream up the idea for *The Apartment* (1960), about a man who lends his apartment key to coworkers for their extramarital trysts.

RKO, 1946
B&W, 101 minutes

DIRECTOR

Alfred Hitchcock

PRODUCER

Alfred Hitchcock (uncredited)

SCREENPLAY

Ben Hecht

STARRING

CARY GRANT .DEVLIN

INGRID BERGMAN ALICIA HUBERMAN

CLAUDE RAINS. ALEXANDER SEBASTIAN

LOUIS CALHERN PAUL PRESCOTT

LEOPOLDINE KONSTANTIN MADAME SEBASTIAN

REINHOLD SCHUNZEL "DR. ANDERSON"

MORONI OLSENWALTER BEARDSLEY

IVAN TRIESAULT. ERIC MATHIS

ALEX MINOTIS . JOSEPH

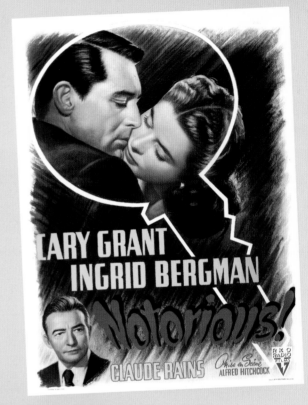

Expertly blended romance and suspense, as Claude Rains walks in on Ingrid Bergman and Cary Grant

A U.S. INTELLIGENCE AGENT RECRUITS THE DAUGHTER OF A GERMAN WAR CRIMINAL TO SPY ON HER FATHER'S NAZI ASSOCIATES, FALLING IN LOVE WITH HER IN THE PROCESS.

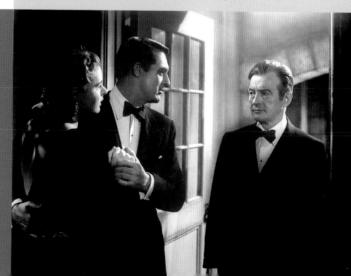

WHY IT'S ESSENTIAL

Alfred Hitchcock's masterful blend of romance and spy thriller started as another collaboration with producer David O. Selznick, with whom he had just made *Spellbound* (1945). Their plan was to work again with *Spellbound* writer Ben Hecht and star Ingrid Bergman on this loose adaptation of the 1921 short story "The Song of the Dragon." During the writing process, however, Selznick found himself in need of more funding for his mega-production *Duel in the Sun* (1946), so he sold *Notorious* as a lucrative package to RKO, complete with Hitchcock, Hecht, and Bergman attached.

To play the intelligence agent Devlin, Hitchcock cast Cary Grant, whom he had directed to great effect in *Suspicion* (1940) by delving into the dark side of the star's persona. With *Notorious*,

Grant had a chance to explore that side even more, balancing resentment and even disgust at Bergman's "notorious" character against his growing love for her. He must stand by as she literally sleeps with the enemy—which, ironically, she does out of her love for Grant and belief that it is what he wants. For Bergman as well, the character of Alicia was darker than the norm.

With Bergman and Grant at their most alluring, it's sometimes easy to underrate the superb performance by Claude Rains as the tragically unsuspecting Alex Sebastian, who unwittingly brings a spy into his house and bed. (He was Oscar-nominated for the role, as was Hecht's screenplay.) Like many a Hitchcock character, Alex has a domineering mother, played by the Austrian actress Leopoldine Konstantin in her sole Hollywood film. She makes the most of her limited screen time, especially in the

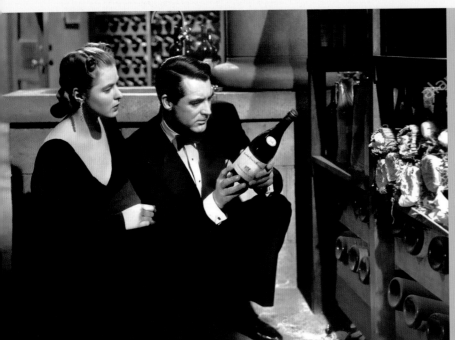

The suspenseful wine cellar scene. Edith Head, who designed Ingrid Bergman's costumes for Notorious, *later wrote, "The simpler Ingrid's lines, the less ornamentation, the better. Simplification is the best medicine for making a beautiful woman more beautiful." As for Ingrid's costar, Head declared, "I consider Cary Grant the most beautifully dressed man in the world."*

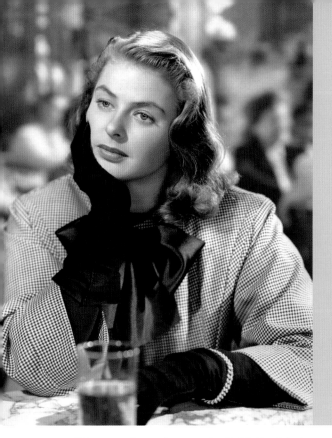

"This, to me, is the apex of great film acting. . . . There are transitions [by] Rains that are just incredible, [and] I've never believed a woman loved a man in a movie more than I believed Ingrid Bergman loved Cary Grant. . . . Hitchcock was great at sexual double entendre. I mean, when she says to him 'I have a chicken in the refrigerator' and she's kissing him, you're just reading Cary Grant's mind: 'We're not having chicken for dinner, honey!'"

Ingrid Bergman in another stunning Edith Head design

entertaining moment after her son informs her that he is married to a spy: she slowly sits up in bed, then methodically reaches for and lights a cigarette with one hand, letting the audience— and Rains—know who's boss.

Several remarkable set pieces reveal Hitchcock's mastery at directing the audience's attention and imbuing simple objects with emotional meaning. When Bergman steals a key off Rains's keychain, point-of-view shots heighten the suspense and make the audience care about that key to an astonishing degree. Later, as she and Grant sneak away from a party to search the wine cellar for an important clue, Hitchcock generates suspense with shots of otherwise nonthreatening wine bottles. The most striking example is the traveling camera shot that introduces the party sequence. Hitchcock's (and cinematographer Ted Tetzlaff's) camera starts from high above the front hall in a wide long shot. As Bergman and Rains greet their guests, the camera lowers to the ground while zooming in on Bergman, ending on an extreme close-up of the key she is hiding in her hand.

Notorious marked the first collaboration between Hitchcock and renowned costume designer Edith Head, who created Bergman's wardrobe. Head would go on to work with Hitchcock ten

Claude Rains has just admitted to his formidable mother that he's been duped. This was Austrian actress Leopoldine Konstantin's only American movie. "I was lucky to get [her]," said Alfred Hitchcock. Konstantin was just three years older than Rains.

Alfred Hitchcock (whispering) directs the elaborate camera move (combined with a zoom) toward the key in Ingrid Bergman's hand. The scaffold was constructed solely for this shot.

more times and later named him the director who influenced her the most. "Every costume is indicated when he sends me the script," she wrote. "There is always a story reason behind his thinking, an effort to characterize."

Smoothly entertaining, *Notorious* feels like the easiest film in the world to have made, which only underscores the great artistry of Hitchcock, Hecht, Tetzlaff, Head, and the rest of the crew and cast. The love story and the spy story are so expertly intertwined that one could not exist without the other, something perhaps best illustrated by the movie's final sequence, during which audiences hang on Grant and Bergman's romantic passion as much as they sit in breathless suspense.

Cary Grant and Ingrid Bergman stand on a balcony in Rio. They embrace, and kiss, as the camera moves in, and they keep kissing as they walk to a phone, make a call, move to the front door, and part. Hitchcock's camera keeps them tightly framed for the duration of this two-minute-and-forty-second shot, and the result is one of the most famous, sensuous kisses in movie history—or series of kisses, to be precise. The Motion Picture Production Code outlawed "excessive and lustful kissing," and at the time this meant an unofficial rule of about three seconds per screen kiss. Hitchcock got around it by having *many* kisses in a row, none lasting longer than three seconds—and when Grant and Bergman aren't actually smooching, they're nuzzling, cuddling, nibbling, and gazing at each other in tight close-up.

The effect is of one lengthy, highly charged kiss. Hitchcock later said the actors felt awkward doing the scene, especially having to stay so close together during their walk, but he knew the effect would be strongest that way. "The whole idea was based on not breaking the romantic moment," he told Peter Bogdanovich. "I didn't want to cut it up." The sequence also carries an important storytelling purpose: to make the audience feel the characters' love for one another, which will pay off later during two more tightly framed love scenes.

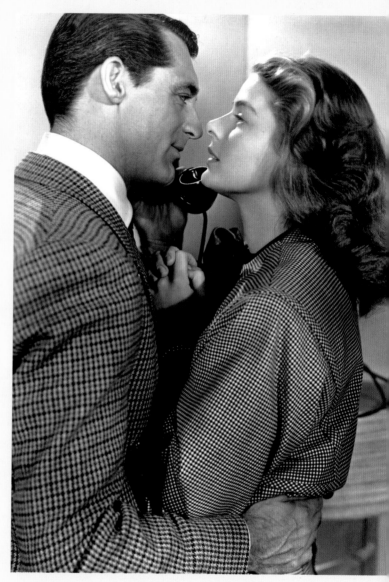

Cary Grant and Ingrid Bergman in between kisses

·············

133

THE GHOST AND MRS. MUIR

Twentieth Century-Fox, 1947
B&W, 104 minutes

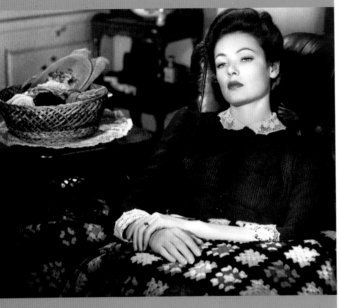

Gene Tierney as Lucy Muir

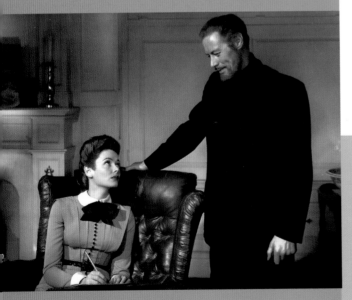

Rex Harrison dictates his life story to Gene Tierney for a salacious novel that may pay off the house.

DIRECTOR

Joseph L. Mankiewicz

PRODUCER

Fred Kohlmar

SCREENPLAY

Philip Dunne, from the novel by R. A. Dick (pseudonym for Josephine Leslie)

STARRING

GENE TIERNEY .LUCY MUIR

REX HARRISONCAPTAIN DANIEL GREGG

GEORGE SANDERS MILES FAIRLEY

EDNA BESTMARTHA HUGGINS

VANESSA BROWNANNA MUIR—ADULT

ANNA LEE MRS. FAIRLEY

ROBERT COOTE MR. COOMBE

NATALIE WOODANNA MUIR—CHILD

ISOBEL ELSOM. ANGELICA MUIR

VICTORIA HORNEEVA MUIR

A YOUNG WIDOW IN TURN-OF-THE-CENTURY ENGLAND MOVES INTO A SEASIDE COTTAGE THAT IS HAUNTED BY THE GHOST OF A SEA CAPTAIN, WITH WHOM SHE FALLS IN LOVE.

After *Laura* boosted her stardom to new heights, Gene Tierney starred in four successive commercial hits for Twentieth Century-Fox, including the smash *Leave Her to Heaven* (1945), for which she was Oscar-nominated, and the prestige drama *The Razor's Edge* (1946). Her next picture, *The Ghost and Mrs. Muir*, was a quieter change of pace, and while it drew only mild reviews and earnings, it nonetheless stands as one of the most beautiful and touching romances ever made.

Tierney plays Lucy Muir, a widow with a young daughter in the year 1900. Her first words in the film are "And now my mind is made up"—perfectly establishing her character as no-nonsense, liberated, and independent. She is telling her former mother- and sister-in-law that a year after her husband's death, the time has come for Lucy and daughter Anna to move out on their own. The overbearing in-laws protest, but Lucy stands firm; in fact, she's taking the housekeeper, Martha, too.

Martha (Edna Best) and Anna (Natalie Wood) eavesdropping—and learning that they and Mrs. Muir will all be moving out

Gene Tierney's gaze calls into question whether Rex Harrison's ghost is really there . . . or in her imagination.

SALLY FIELD | "Rex Harrison's performance is just wonderful. They don't ever touch, but you feel how much he loves her. It's one of the most romantic movies ever."

Other characters, all men, will continue to tell Lucy what she should and shouldn't do, and Lucy will keep doing what she wishes regardless, providing the movie with a strong current of female empowerment that spoke to women in 1947 and helps keep it feeling modern today. When Lucy discovers firsthand that her new seaside home is inhabited by a ghost, she reacts with delight: "Haunted. How perfectly fascinating!" When she finally sees the ghost, a salty sea captain named Daniel Gregg who lived and died in the cottage—and who is played by gruffly handsome Rex Harrison in his second American film—an unlikely romance is born. Daniel is so taken with Lucy, whom he calls Lucia ("a name fit for a queen!"), that he even helps her pay for the house by dictating his life story for her to type into a salacious, best-selling book.

The story could easily lend itself to comedy, but *The Ghost and Mrs. Muir* instead creates an atmosphere of deeply felt love blended with yearning, loneliness, and laces of comic whimsy, without ever becoming cloying. That distinctive tone was not so easy to come by. Screenwriter Philip Dunne saw the first few days' worth of rushes and was dismayed to see Lucy tiptoeing around the house and reacting to the ghost's pranks with almost screwball comedy. "I had thought of Muir," he later wrote, "as a practical, courageous young woman whose main reaction [to the ghost] was one of extreme irritation. Her practicality was exactly what would make the scene playable and funny." He took his concerns to director Joseph L. Mankiewicz, and the scenes were reshot. This was Mankiewicz's fourth directing effort after years as a producer and

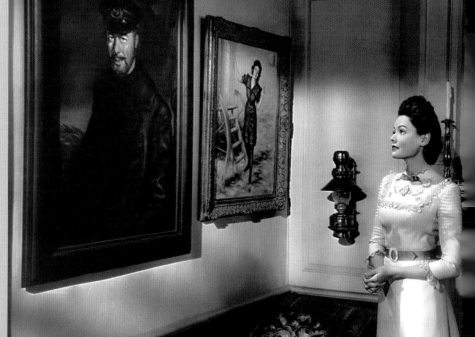

Three years after Laura, *Gene Tierney was now the one to gaze at a painting on the wall. In both films, the painting represents a seemingly impossible love.*

"I'm a great, great Gene Tierney fan; she can do no wrong. She had played a successful businesswoman in Laura *and [was] strong in* Leave Her to Heaven, *and here she was, the number one dramatic star at Twentieth Century-Fox, cast against type as a very gentle, very kind [and] compassionate woman. . . .* The Ghost and Mrs. Muir *I think is really underrated."*

writer; he would soon achieve the unique feat of winning writing and directing Oscars in two consecutive years, for *A Letter to Three Wives* (1949) and *All About Eve* (1950).

Also vital to this picture's emotional pull is the gorgeous music by Bernard Herrmann. Best remembered for his scores for Alfred Hitchcock, including *Vertigo* (1958) and *Psycho* (1960), Herrmann considered *The Ghost and Mrs. Muir* to be his finest work. It actually anticipates *Vertigo* in a way, evoking a yearning for someone who is unattainable and the possibility that love can transcend death. The music conjures what Herrmann biographer Steven C. Smith has called "the beautiful loneliness of solitude," and in the movie's later stages, it also poignantly signals the passage of much time.

In addition to Gene Tierney and British star Rex Harrison, who was just becoming known to American audiences, *The Ghost and Mrs. Muir* features a prominent future star: eight-year-old Natalie Wood. This was a busy time for Wood, who made the film concurrently with *Miracle on 34th Street* (1947) while going to school practically

George Sanders as his usual unmitigated cad, attempting to charm Gene Tierney. Tierney's impeccable costumes were designed by Oleg Cassini, whom she married in 1941. They had recently separated, but reconciled during the making of this film.

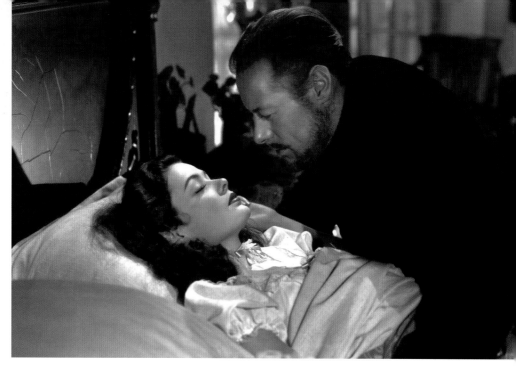

Rex Harrison almost kisses Gene Tierney in a memorable, heartfelt scene.

"in between takes," as she later recalled. "It was confusing and I loved it. I wore long dresses and period hairdos one day; the next I dressed in pigtails and pinafores." At one point she even started filming a third movie, *Scudda Hoo, Scudda Hay* (1948).

Miracle on 34th Street, which brought little Natalie to everyone's attention, would open in June 1947 and was still playing when *The Ghost and Mrs. Muir* opened a few weeks later. But *Ghost* performed only modestly at the box office. It would receive a single Oscar nomination, for Charles Lang's lush black-and-white cinematography, before becoming more or less forgotten. In recent decades, however, it has found new audiences, and its mesmerizing romantic quality, created by superb craftsmanship, has ensured its status as a classic.

WHAT TO LOOK FOR

In one of the most moving scenes, Daniel bids farewell to Luc as she sleeps, mourning what might have been but accepting that she needs to forge her own life. Rex Harrison's vocal performance and Bernard Herrmann's music work in tandem to make the scene ebb and swell like an ocean wave—from a hushed near-kiss to Harrison's loud, stirring lament, "What we've missed, Lucia!" Beautifully lit, performed, and edited, it's enough to tear at anyone's heartstrings. Screenwriter Philip Dunne later called this his favorite moment of his entire writing career, and director Joseph L. Mankiewicz recalled the scene as his "most striking memory" from the film. "There is the wind," he said, "there is the sea, there is the search for something else . . . and the disappointments that one meets. These are the feelings that I wanted to convey."

THE TREASURE OF THE SIERRA MADRE

Warner Bros., 1948
B&W, 126 minutes

DIRECTOR

John Huston

PRODUCER

Henry Blanke

SCREENPLAY

*John Huston, based on the
novel by B. Traven*

STARRING

HUMPHREY BOGARTDOBBS

WALTER HUSTON . HOWARD

TIM HOLT . CURTIN

BRUCE BENNETT .CODY

BARTON MacLANEMcCORMICK

ALFONSO BEDOYA GOLD HAT

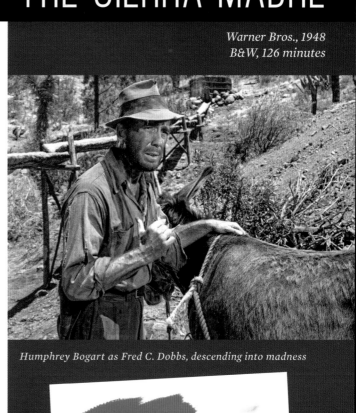

Humphrey Bogart as Fred C. Dobbs, descending into madness

**IN MEXICO, TWO DOWN-
AND-OUT AMERICANS
TEAM WITH AN OLD
PROSPECTOR IN
SEARCH OF GOLD, BUT
ONE MAN'S GROWING
PARANOIA AND GREED
THREATEN THE
ENTIRE UNDERTAKING.**

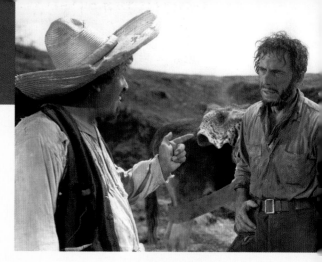

Alfonso Bedoya (left) as Gold Hat, tormenting Humphrey Bogart

With its riveting take on greed and human nature, *The Treasure of the Sierra Madre* has long since entered the popular culture. Writer-director John Huston's classic is at once a grand adventure of the hunt for gold in a hostile landscape and a portrait of one man's breakdown into paranoia and delusion. Humphrey Bogart delivers one of his greatest performances, but stealing the show is Walter Huston—John's father—as Howard, a grizzled prospector and philosophizer.

"I know what gold does to men's souls," Howard says. "When the piles of gold begin to grow, that's when the trouble begins." Those words fall on the mostly deaf ears of Fred C. Dobbs (Bogart) and Bob Curtin (Tim Holt), two bums in Tampico, Mexico, looking to get rich. Dobbs is naturally cynical and suspicious; Curtin is softer, with a greater sense of morality; Howard is practical and shrewd. Together, they venture to a remote corner of Mexico where, sure enough, the discovery of gold sets Dobbs on the road to destroying the group and himself.

Bogart had dipped into unhinged characters before with *Black Legion* (1937) and *High Sierra* (1941), and he would do so again with *In a Lonely Place* (1950) and *The Caine Mutiny* (1954). His portrayal of Fred C. Dobbs, however, is something else entirely. It embodies, as admirer Martin Scorsese has said, "one of the great disintegrations of character" in American movies. Dobbs takes to muttering about himself in the third person ("If you know what's good for you, you won't monkey around with Fred C. Dobbs!") and comes to see any conversation between the other two men as evidence of a conspiracy. As his thoughts grow more insane, he increasingly becomes a physical wreck. Dobbs is probably the most despicable character Bogart ever played, which is ironic, since he had finally escaped years of villainous roles with *The Maltese Falcon* (1941) and *Casablanca* (1942) to become a romantic, if still caustic, leading man. By 1948, Dobbs was an against-type character.

John Huston had wanted to direct *Sierra Madre* soon after *The Maltese Falcon*. At the time, he was even considering his father, Walter, for the role of Dobbs. But with the onset of World War II, the director left Hollywood to make documentaries for the Army Signal Corps. He checked back with producer Henry Blanke

"This is the movie that gave us the line about 'stinking badges,' delivered by the Mexican bandit played by Alfonso Bedoya. . . . While the dialogue itself [is] wonderful, great screenplays provide much, much more than words. And in this movie, you have shifting circumstances, scenes that constantly test the strength of human virtues. Virtues that can so easily give way to our cruelest impulses. . . . It's an indisputable essential that should be, and will be, a treasure for as long as we watch movies."

several times during the war to confirm that *Sierra Madre* was being held for his return. Huston had been enamored of the novel by B. Traven, a reclusive German writer living in Mexico, since its U.S. publication in 1935 and did not want it to slip away.

After the war, Huston wrote the screenplay—with input from a man "representing" Traven who probably was Traven himself—and convinced Warner Bros. to let him make the picture in Mexico, at a time when it was unheard of for an American film to shoot outside the country. The high cost was worth it for the resulting authenticity. The performances all have a remarkably lived-in feel, especially that of Walter Huston, who supplies welcome humor and warmth with his twitchy movements, cackles of laughter, and rapid dialogue. (His son persuaded him to do the role without his dentures, which added to the effect.)

Rivaling Walter Huston for scene-stealing is Mexican actor Alfonso Bedoya as the toothy

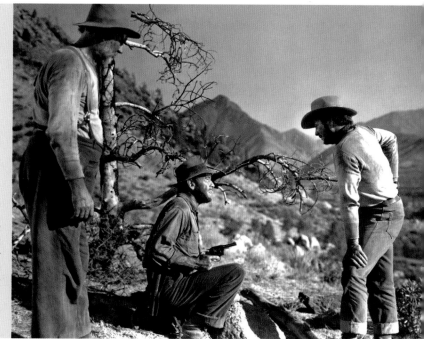

"Okay, I'm a liar—there isn't a gila monster under there. Let's see you stick your hand in and get your goods out." From left: Walter Huston, Humphrey Bogart, Tim Holt

bandit Gold Hat, who delivers one of the most quoted—and misquoted—lines of dialogue in Hollywood history: "Badges? We ain't got no badges. We don't need no badges! I don't have to show you any stinkin' badges!" Bedoya had already enjoyed a long career in Mexican cinema, but this performance brought him to Hollywood's attention and he acted in American films over the next decade.

With Bogart, Walter Huston, and Bedoya in such showy parts, Tim Holt's excellent turn as Curtin is often overlooked. He projects decency and stillness, an important contrast to Dobbs and Howard. Holt occasionally took parts in major productions like this one, but he much preferred to work steadily in B westerns. He was even ranked for many years, including 1948, among Hollywood's top ten moneymaking western stars. After *Sierra Madre*, offers poured in for more prestige productions, but he turned them down.

The Treasure of the Sierra Madre was not a significant box-office success, perhaps in part because Bogart's character was not the hero that audiences expected. Nonetheless, the film drew four Academy Award nominations, including Best Picture, and it made father-and-son Oscar history: John Huston won Best Director and Best Screenplay, and Walter Huston won Best Supporting Actor. Bogart was not nominated but would eventually win the award for another John Huston essential, *The African Queen* (1951).

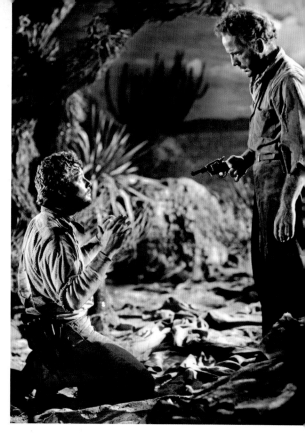

Humphrey Bogart has the better of Tim Holt—for now.

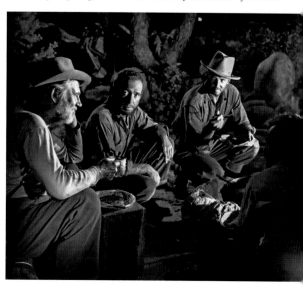

Bruce Bennett (third from left) has imposed himself upon the others, who will decide what to do with him. As with his turn in Mildred Pierce (1945), *Bennett's performance is effective and underrated.*

.............

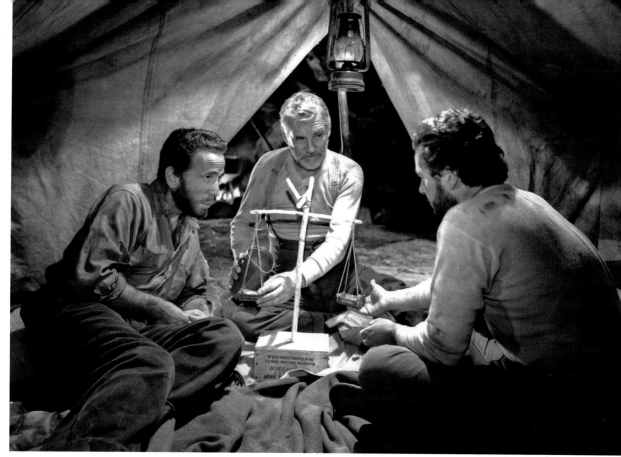

Humphrey Bogart, Walter Huston, and Tim Holt split up their gold each night.

WHAT TO LOOK FOR

When Walter Huston finally discovers gold, he lets his companions know with an astonishing jig and bales of raucous laughter—yet another of *Sierra Madre*'s indelible moments. He had danced that jig before, in the 1924 Broadway production of *Desire Under the Elms*, with guidance from playwright Eugene O'Neill himself. Huston thought to resurrect it here but didn't tell his son beforehand; he simply advised him to keep the camera rolling. John Huston later said the image of his "old man" dancing was his most cherished of all the shots he ever directed.

—

Tim Holt's father, Jack Holt, a prominent star of silent westerns, makes a cameo as a bum conversing with Walter Huston in the flophouse. John Huston plays a small role as the American in the white suit who gives handouts to Humphrey Bogart in the opening scenes.

THE ASPHALT JUNGLE

MGM, 1950
B&W, 112 minutes

Sterling Hayden as Dix Handley, one of his best roles

DIRECTOR

John Huston

PRODUCER

Arthur Hornblow, Jr.

SCREENPLAY

Ben Maddow and John Huston,
from a novel by W. R. Burnett

STARRING

STERLING HAYDEN DIX HANDLEY

LOUIS CALHERN ALONZO D. EMMERICH

JEAN HAGEN DOLL CONOVAN

JAMES WHITMOREGUS MINISSI

SAM JAFFE DOC ERWIN RIEDENSCHNEIDER

JOHN McINTIRE POLICE COMMISSIONER HARDY

MARC LAWRENCE.COBBY

BARRY KELLEY.LIEUTENANT DITRICH

ANTHONY CARUSO LOUIS CIAVELLI

TERESA CELLI MARIA CIAVELLI

MARILYN MONROEANGELA PHINLAY

A GROUP OF THIEVES CARRY OUT AN INTRICATE JEWEL HEIST BEFORE MISTRUST, BETRAYALS, AND THEIR OWN WEAKNESSES THREATEN THEIR UNDOING.

WHY IT'S ESSENTIAL

After taking home Oscars for writing and directing *The Treasure of the Sierra Madre* (1948), John Huston made the fine film noir *Key Largo* (1948), the political drama *We Were Strangers* (1949), and then *The Asphalt Jungle*, a noir masterpiece that reinvented the heist genre. Earlier movies had included elaborate robberies, but here the planning, execution, and aftermath of a single jewel heist comprises the entire arc of the story. It also sets the framework for the real focus of the film: the rich, vividly drawn characters. They are complex and at times paradoxical antiheroes, with needs, hopes, and dreams beyond just scoring the loot—in a word, they are human. As Huston said, "You may not admire these people, but I think they'll fascinate you."

For the criminals in *The Asphalt Jungle*, the robbery is simply a job in their line of work. The mastermind, Doc, has dreamed up the scheme and now visits a bookie for references to assemble a crew. He finds a financial backer in the form of a crooked lawyer, Emmerich, as well as three specialists: a "boxman" (or safecracker), a "hooligan" (or gunman), and a driver. They are all professionals who just happen to operate on

ALEC BALDWIN

—

"We've seen caper films before, but sometimes more care goes into the set design and the casting and so forth. . . . Sam Jaffe had kind of a twinkle to him from his earliest years doing Gunga Din (1939), and he dials into the very strange tone in this film. . . . One of [his] greatest performances."

Hatching a plan. From left: Sam Jaffe, Sterling Hayden, James Whitmore (standing), and Anthony Caruso

.............

Sterling Hayden takes care of a guard as Anthony Caruso and Sam Jaffe look on.

the wrong side of the law—an arbitrary boundary in this film, since cops and members of "respectable" society are shown to be as corrupt and ruthless as the thieves, and sometimes more so. Emmerich puts it best: "Crime is only a left-handed form of human endeavor."

Such an attitude is partly the reason this film drew the ire of studio chief Louis B. Mayer, who described it as "full of nasty, ugly people doing nasty, ugly things. I won't walk across the room to see a thing like that." *The Asphalt Jungle* was hardly typical for MGM, known for glamorous musicals and romantic fare. The studio's parent company, however, had recently installed Dore Schary as head of production, and he was interested in grittier, socially conscious dramas. (Mayer was soon forced out of the studio.) Schary acquired the rights to W. R. Burnett's novel and assigned the project to producer Arthur Hornblow Jr. John Huston, who had written *High Sierra* (1941) with Burnett, came on board to write the taut script with Ben Maddow.

Most of *The Asphalt Jungle* was shot by cameraman Harold Rosson in beautiful, high-contrast photography typical of film noir, but some scenes were filmed on real locations in

Jean Hagen and Sterling Hayden on a desperate drive

Marilyn Monroe, here with Louis Calhern, made a huge impression in The Asphalt Jungle.

..............

a gritty, naturalistic style using available light. Like other American filmmakers of the period, Huston was very taken with Italian neorealist films, such as *Bicycle Thieves* (1948), and he incorporated the style to create a sense of authenticity. The effect sets the mood of the film right away, as a police cruiser prowls the streets of a run-down city neighborhood and Sterling Hayden hides behind a decaying concrete pillar.

Hayden plays Dix, the hooligan, who is tough enough to say "Why don't you quit crying and get me some bourbon!" and sensitive enough to pine for the horse farm of his Kentucky youth; all he wants, if this scheme goes through, is to get back there. Huston had to fight the studio to cast Hayden as one of an ensemble of character actors, another change of pace for star-driven MGM. The characters are all extremely distinct. Doc is played by Sam Jaffe with a mischievous glint as he dreams of Mexico City and posits that "one way or another, we all work for our vice." (His vice, girls, will memorably do him in.) Louis the boxman, who has a family to feed, is played poignantly by Anthony Caruso, and Gus the driver, a tough guy with a soft spot for cats, is portrayed by the naturalistic James Whitmore. Louis Calhern had been a romantic leading man in the silent era but is best remembered for his supporting roles in MGM films of this period, such as his shady yet refined lawyer here, Emmerich.

"Experience has taught me never to trust a policeman. Just when you think one's all right, he turns legit." A cop has the goods on Sam Jaffe.

John Huston directing a shot of Louis Calhern writing a note...

...and working with Marilyn Monroe.

Calhern was never better, and he also enjoyed the distinction of acting in the first significant scenes in the career of Marilyn Monroe, who plays his mistress, Angela. Monroe is dressed and lit beautifully, but for the first time she does not come off simply as set decoration. Huston uses her sexuality in an intelligent manner that contributes to the story, and the result is an effective performance that made Hollywood take notice. Monroe revered Huston, who would direct her again in her final completed film, *The Misfits* (1961).

The Asphalt Jungle made only a slight profit, but it drew four Academy Award nominations, for Best Screenplay, Director, Supporting Actor (Sam Jaffe), and Black-and-White Cinematography. The picture's strong, bleak fatalism ensured its place in Hollywood history as a key film noir, and its approach to the heist plot ensured its lasting influence on such films as *Rififi* (1955), *The Killing* (1956, also starring Hayden), *Reservoir Dogs* (1992), the *Ocean's 11* movies, and many others.

RASHOMON

Daiei (Japan), 1950
B&W, 88 minutes

Toshiro Mifune (The Bandit) and
Daisuke Kato (The Policeman) at the tribunal

DIRECTOR

Akira Kurosawa

PRODUCER

Jingo Minoura

SCREENPLAY

*Akira Kurosawa and Shinobu Hashimoto,
based on "In a Grove"
by Ryunosuke Akutagawa*

STARRING

TOSHIRO MIFUNE THE BANDIT

MACHIKO KYO THE WOMAN

TAKASHI SHIMURA THE WOODCUTTER

MASAYUKI MORI THE MAN

MINORU CHIAKI THE PRIEST

KICHIJIRO UEDA THE COMMONER

NORIKO HONMA THE MEDIUM

DAISUKE KATO THE POLICEMAN

**IN TWELFTH-CENTURY
JAPAN, FOUR PEOPLE
RELAY CONTRADICTORY
VERSIONS OF EVENTS
IN A FOREST THAT LED
TO A MAN'S DEATH.**

Akira Kurosawa's groundbreaking *Rashomon* became an international sensation for its approach to storytelling as well as its subject matter—essentially storytelling itself. As the great British filmmaker Michael Powell recalled decades later, "All we directors and actors, who thought we knew something about acting and directing, suddenly discovered that we knew nothing. . . . There was no story, only a situation. But Kurosawa had us in the hollow of his hand."

Rashomon is about conflicting eyewitness testimony of the same event, a phenomenon that has been known ever since—in the worlds of movies, television, literature, law, and sociology—as the "Rashomon effect." The film shows four different accounts of a crime by means of flashbacks that call into question the concepts of truth, reality, and human nature, as well as the relationship inherent in cinema between seeing and believing.

The picture opens on a rainy day at the ruins of the Rashomon Gate. Taking shelter from the downpour, a woodcutter and a priest tell a

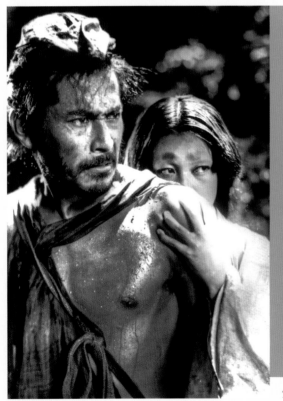

AVA DuVERNAY

"The fractured narrative—where you're seeing a story line from different points of view, perhaps [from] an unreliable narrator, jumping back in time—could have been applied to any topic, something silly, [but it's applied] to a question of justice and truth. . . . What is truth? What's true for you may not be true for me. *Rashomon* takes that experience [and] addresses it cinematically in a way that hadn't been done. . . . The technique is in every film and TV show now. It's just a part of the way we consume story."

Toshiro Mifune and Machiko Kyo in the forest

"A classic of world cinema—so successful, so important, that now it's part of the vernacular. [It's] the movie that made the world take notice not just of Kurosawa but that Japanese films were worthy of being seen, considered, and discussed."

commoner about a tribunal they just attended. The tribunal was investigating an attack of a samurai and his wife by a bandit; the samurai was found dead. All three participants testified at the tribunal (with the samurai doing so through a medium), but each account was completely different. The woodcutter then reveals to the priest and the commoner that he actually witnessed the whole attack, and he gives yet another conflicting account.

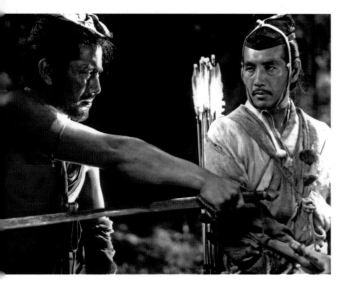

Toshiro Mifune with the samurai, played by Masayuki Mori

The genius of the movie, critic Roger Ebert said, "is that all of the flashbacks are both true and false." The characters seem to believe their recollections as fact, but their own natures shade their memories. As Kurosawa later wrote in his memoir, "Human beings are unable to be honest with themselves about themselves. They cannot talk about themselves without embellishing." Creating even greater intrigue is the fact that three of the accounts in *Rashomon* are told to the commoner secondhand, with the woodcutter and priest relaying what they have heard, and thereby making those flashbacks potentially more unreliable.

Rashomon could have turned out as a wholly analytical and calculated experience if not for the incredible atmosphere that Kurosawa brings to the tale. Working with the cinematographer Kazuo Miyagawa, he presents the forest as a visually sensual place, with imagery of trees, leaves, and dappled sunlight creating lushness and dominating the humans—as if nature is helping to bring out their primal emotions. Early on,

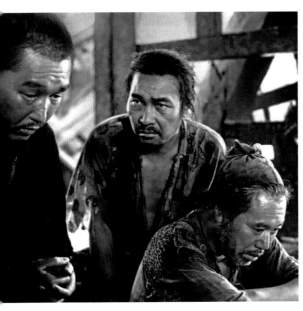

Minoru Chiaki (The Priest), Kichijiro Ueda (The Commoner), and Takashi Shimura (The Woodcutter) grapple with the tale at the Rashomon Gate.

in a renowned two-minute sequence, the wood-cutter walks deep into the forest until he finds a body. Nothing is happening in terms of plot during this walk, but Kurosawa turns it into a tour de force with a constant moving camera that captures the walk from above, below, front, back, in wide angle, telephoto, close-up, and long shot. It's as though every part of the forest itself is alive to the woodcutter's presence. Kurosawa also cuts in direct shots of the sun shining through the trees, something exceedingly rare in movies to that point and which drew much attention at the time.

The production was a happy one for Kurosawa, who at forty was making his twelfth film; he later wrote that despite the sultry heat of the locations, his crew was enthusiastic and would dance in the moonlight after long days. The best-known cast member at the time was Masayuki Mori, wonderful as the samurai, but best-known today is Toshiro Mifune, who plays the bandit in his fourth teaming with Kurosawa. He would eventually become the greatest leading man in Japanese cinema as well as a major international star, working with Kurosawa many more times in one of the essential director-actor pairings in film history. This was one of Machiko Kyo's earliest films, and her performance as the wife is remarkable for its breadth as she conveys completely different sets of emotions in each flashback, much more so than the other characters.

Rashomon was a success in Japan when it opened in August 1950. A full year later, it played the Venice Film Festival and won the top prize, bringing worldwide prominence not just to the film but to Japanese cinema, which was not well known in the Western world. RKO released the picture in the United States in late December 1951, and a few months later it received an honorary Oscar as the best foreign film of the year. (The official foreign film category did not yet exist.) The following year it was eligible in other categories and drew a nomination for Best Black-and-White Art Direction. It has remained a touchstone for writers and directors—and lawyers and philosophers—ever since.

.............

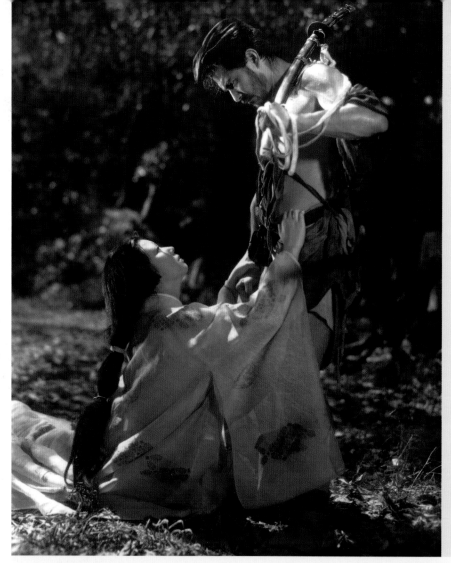

*One of several versions
of the relationship between
The Woman (Machiko Kyo)
and The Bandit (Toshiro Mifune)*

WHAT TO LOOK FOR

Kurosawa was inspired by silent films and their "peculiar beauty" in his approach to *Rashomon*. The woodcutter's walk is one stunning example; another is the scene in which the bandit, lazing under a tree, first sees the samurai walk by with his wife on a horse. In the course of two minutes of pure cinema, emotion and tension are conveyed through lighting, angles, and editing, with no dialogue. To create the unique high-contrast effect in all the forest scenes, cinematographer Kazuo Miyagawa used a mirror, rather than traditional reflector boards, to reflect sunlight onto the actors. For many shots, leaves were then placed in front of the mirror to reduce the harshness of the effect and create shadow patterns on the actors' faces.

·············

A PLACE IN THE SUN

Paramount, 1951
B&W, 122 minutes

DIRECTOR

George Stevens

PRODUCER

George Stevens

SCREENPLAY

Michael Wilson and Harry Brown, based on the novel An American Tragedy *by Theodore Dreiser and the Patrick Kearney play adapted from the novel*

STARRING

MONTGOMERY CLIFT GEORGE EASTMAN

ELIZABETH TAYLOR ANGELA VICKERS

SHELLEY WINTERS ALICE TRIPP

ANNE REVERE HANNAH EASTMAN

KEEFE BRASSELLE EARL EASTMAN

FRED CLARK . BELLOWS

RAYMOND BURR DISTRICT ATTORNEY MARLOWE

HERBERT HEYES CHARLES EASTMAN

SHEPPERD STRUDWICK ANTHONY VICKERS

FRIEDA INESCORT ANN VICKERS

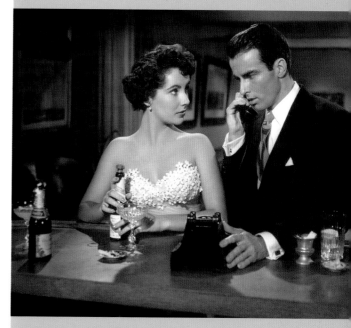

Elizabeth Taylor is charmed as Montgomery Clift calls his mama.

A YOUNG, WORKING-CLASS MAN BECOMES INVOLVED WITH A COWORKER, THEN FALLS INTO A PASSIONATE ROMANCE WITH A GLAMOROUS, WEALTHY SOCIALITE.

WHY IT'S ESSENTIAL

One of the great romantic films of its era, *A Place in the Sun* is not to be missed for its gripping, deeply felt emotion. In this update of Theodore Dreiser's 1925 novel *An American Tragedy*, director George Stevens conjures intense longing, loneliness, and passion from his principal cast of Montgomery Clift, Elizabeth Taylor, and Shelley Winters, resulting in unforgettable love scenes as well as a haunting portrait of dejection.

The story also resonates for the way it taps into the American Dream, the idea that upward social mobility is possible for anyone. Impoverished George Eastman lands an entry-level position at his wealthy uncle's plant and starts a romance with a plain factory girl, Alice. After he meets and falls in love with beautiful, glamorous Angela Vickers, he is on the verge of upgrading his life on every level—girl, job, social status—but Alice becomes pregnant, and abortion is impossible. George's thoughts turn ever darker as he contemplates killing Alice so he can attain his dream life, even as the film ironically shows that life to be largely shallow and ultimately *not* attainable for anyone. The tale climaxes in a courtroom. "I always had a feeling," director Stevens said, "that it wasn't so much [George Eastman] on trial as us—the society."

Stevens had long wanted to adapt Dreiser's novel because he felt the first film version, directed by Josef von Sternberg in 1931, hadn't done it justice. But even more than the novel's themes, what attracted Stevens was its emotional pull. "I was interested in the mood and emotional effect of the story," he recalled. "I wanted to relate the audience to a character whose behavior it might not subscribe to."

Intense, unforgettable close-ups of Elizabeth Taylor and Montgomery Clift. Taylor later revealed that she had experienced her first, real-life kiss just two weeks earlier. "My kiss with Monty was much more exciting," she said.

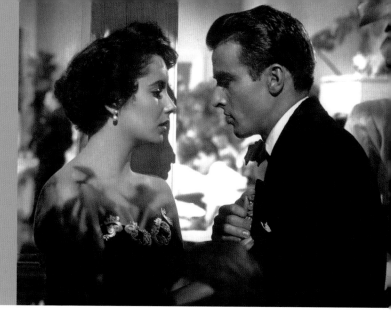

"Their scenes together, their dance scenes, the close-ups—sometimes you almost want to look away, they're so powerful. You feel like a real voyeur, like you've gone over the line."

Elizabeth Taylor and Montgomery Clift as Angela Vickers and George Eastman, falling in love

Casting Montgomery Clift certainly helped. A Method-trained actor, the twenty-nine-year-old preceded Marlon Brando and James Dean with his performance of an alienated young loner—an antihero with sensitive masculinity. Clift's intense concentration is apparent right from the opening shot, in which he is hitch-hiking: he steps slowly backwards toward the camera until finally he turns around, revealing his face in a tight close-up. Elizabeth Taylor, who was on loan from MGM and turned eighteen during production, was astonished by Clift's talent. "For the first time in my life I started to take acting seriously," she said. "I realized it was something that could make this man shake from head to toe with emotion. . . . Monty is the most emotional actor I have ever worked with." The two became extremely close lifelong friends and worked together twice again.

Their dazzling looks and chemistry, coupled with Stevens's technique, generated the film's most remembered scene. George and Angela slip out of a party onto a balcony and declare their love. They speak in heated fragments and then kiss passionately, as Stevens fills the screen with enormous, intimate close-ups. "I wanted to get the feeling of them both being totally lost in each other," he recalled.

A Place in the Sun significantly boosted the career of Shelley Winters, a surprising choice to play Alice because she had been developing more of a glamour girl image. She got the part by dressing in old clothes with no makeup and arriving early to a lunch meeting with Stevens; he never noticed her as he arrived and waited, and only when he was about to leave in frustration did she approach him. He offered her the part as long as she would agree to keep

Shelley Winters as Alice, with Montgomery Clift. Both were Oscar-nominated.

Shepperd Strudwick, as Anthony Vickers, gives his blessing to his daughter Angela (Elizabeth Taylor) and George (Montgomery Clift).

that plain appearance for the character. Winters is exceptional in the doctor's office sequence as she tries several ways of asking for an abortion (the word is never uttered) before it's clear the doctor won't be performing one. She later wrote of Stevens, "He was the greatest director I've ever worked for. He made me understand that acting, especially film acting, is not *emotion*, but *thinking*."

Stevens filmed *A Place in the Sun* for over four months starting in the fall of 1949 and then spent nearly a year editing and honing a mountain of footage. The picture was released in September 1951 to excellent reviews. After the premiere, Charlie Chaplin was heard calling it "the greatest movie ever made about America." It was

*Elizabeth Taylor,
Montgomery Clift,
and Shelley Winters
chat on location.*

nominated for nine Academy Awards, including acting nods for Clift and Winters, and it won six, including Best Director, Screenplay, Score (Franz Waxman), Costumes (Edith Head), and Black-and-White Cinematography (William C. Mellor). It was nominated for Best Picture but lost that award to *An American in Paris*.

Six years before taking on his best-known role as defense attorney Perry Mason, Raymond Burr (left) played the prosecuting district attorney in this film. Flanking Montgomery Clift at the table are character actors Walter Sande and Fred Clark.

WHAT TO LOOK FOR

Beyond his close-ups and languorous dissolves, Stevens makes fascinating use of long shots at unlikely moments. When George and Angela dance, for instance, the camera moves through the room in a stunning, slow tracking shot that keeps them at a distance yet makes their connection feel even more poignant. In the most striking example, Stevens keeps his camera locked down far behind Montgomery Clift as George has two phone conversations across the room—the first with Alice, the second with Angela. The composition reveals the actual words to be unimportant; what matters are George's feelings for each girl, conveyed through Clift's body language and posture, as well as the audience's awareness that George is working himself into a precarious situation. It's a remarkably engaging visual choice. Stevens later said he gave "careful consideration of where the audience should and . . . should not be. This moves the audience into participation. . . . An audience must be a responsive thing. It has a creative function."

AN AMERICAN IN PARIS

MGM, 1951
Color, 113 minutes

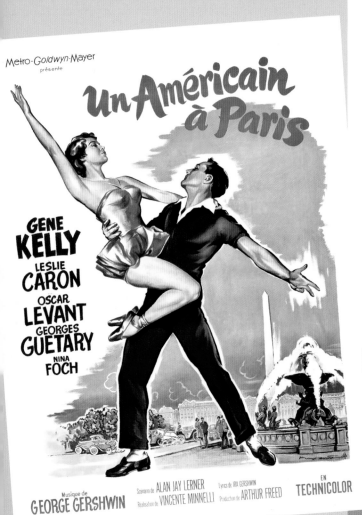

French poster art

DIRECTOR

Vincente Minnelli

PRODUCER

Arthur Freed

SCREENPLAY

Alan Jay Lerner

STARRING

GENE KELLY JERRY MULLIGAN

LESLIE CARON LISE BOUVIER

OSCAR LEVANT ADAM COOK

GEORGES GUETARY HENRI BAUREL

NINA FOCH MILO ROBERTS

**A STRUGGLING
AMERICAN ARTIST
FALLS IN LOVE
WITH A YOUNG
PARISIENNE WHO
IS ENGAGED
TO HIS FRIEND.**

Only Oscar Levant (center) knows that Georges Guetary and Gene Kelly are swooning over the same girl.

WHY IT'S ESSENTIAL

In 1949, MGM producer Arthur Freed decided to do for the music of George and Ira Gershwin what he had just done for the music of Irving Berlin in *Easter Parade* (1948): use it as the basis for an entire picture. George's 1928 tone poem "An American in Paris" could make for an outstanding set piece, Freed thought, as well as provide the movie's title and inspire the story. George had died in 1937, but his brother Ira liked the idea; with George's estate on board, Freed hired Vincente Minnelli to direct and Gene Kelly to play the title character and choreograph all the musical numbers. The result was a melding of high art and popular entertainment that would bring the movie musical to new levels of sophistication. *An American in Paris* positively brims with startling color, imaginative visuals at every turn,

Gene Kelly and Nina Foch at the masquerade ball. Director Vincente Minnelli said he designed this to be a black-and-white-themed ball so as to contrast with the eye-popping colors in the ballet sequence to follow. "No color but the flesh tones," he said.

ALEC BALDWIN
—

"Gene Kelly's athleticism made these movies so great. . . . For my money, Vincente Minnelli is one of the top twenty-five directors of all time."

Leslie Caron relaxes with a good book.

and superlative singing, dancing, and choreography that express emotion and propel the narrative.

To create that narrative, Freed turned to Alan Jay Lerner, who was flummoxed until he thought of "a kept man [falling] in love with a kept woman." An expatriate painter, Jerry Mulligan, agrees to be sponsored by a rich American woman, Milo, who pines for him. Meanwhile, Jerry falls in love with a gaminelike French girl, Lise, who is already engaged to a singer, Henri. Jerry's friend Adam, an aspiring concert pianist, is also on hand to supply sardonic wit. This was enough to support ten songs from the Gershwin catalogue in addition to "An American in Paris," which became a spectacular ballet finale.

To play Lise, Kelly remembered a teenaged French ballerina named Leslie Caron whom he had seen perform two years earlier. He flew to Paris to test her and she won the role, rocketing to stardom practically overnight. The character of Henri, originally planned as a comeback for Maurice Chevalier, went to Georges Guetary, a veteran of the French musical stage. Oscar Levant was tailor-made to play Adam, "the world's oldest child prodigy," and B-movie veteran Nina Foch got one of her best roles as Milo.

Gene Kelly's choreography represents a peak accomplishment of his career. His re-teaming here (following 1948's *The Pirate*) with Vincente Minnelli, one of the finest directors of movie

.............

musicals, was symbiotic. Consider "Embraceable You," which introduces Lise in various poses: Kelly directed this number himself but was stymied until Minnelli suggested designing each of the six vignettes in a monochromatic color, allowing Caron's costume to create sharp contrast. "It sounds terribly simple," Kelly recalled, "but it was a brilliant idea, the kind that choreographers can really use." Kelly devised his later pas de deux with Caron, "Love Is Here to Stay," so that he would sing the entire song *to* her—since Caron was no singer.

After shooting everything but the ballet, production shut down for nearly three months while sets were constructed and Kelly planned the ballet's choreography. Minnelli directed an entire movie during that time, *Father's Little Dividend* (1951), collaborating on the ballet design all the while. Caron later wrote that Minnelli and Kelly "treated each other with love and respect. They both allowed for each other's sensibilities." She added that Kelly "was the one who always placed the camera during the numbers."

Ending the film with a seventeen-minute wordless ballet was a genuine risk. ("I hope you know what you're doing, kid," Irving Berlin told Kelly on the MGM lot one day.) The result demonstrates Minnelli and Kelly's (and Gershwin's) combined artistry, with sensuous emotion emanating from color, composition, movement,

Gene Kelly brings to life Toulouse-Lautrec's 1896 "Chocolat dansant dans un bar" in the ballet sequence.

Gene Kelly and Leslie Caron in the ballet sequence.

and music. With Caron and a small army of dancers, Kelly fuses jazz, tap, and ballet into a coherent whole. The sequence also functions as a study of French art, with Dufy, Renoir, Toulouse-Lautrec, and other painters represented by large-scale backdrops coming to life through dance—and through Minnelli's impeccable eye for color and décor. Costume designer Irene Sharaff recalled creating some 500 costumes for the sequence and using twenty-five shades of yellow for the Van Gogh segment alone. To capture the ballet's shifting visual moods, Minnelli brought on master cinematographer John Alton, best known for his expressionistic film noir lighting, here working for the first

time in Technicolor. All told, it cost nearly half a million dollars, a staggering amount for seventeen minutes of screen time.

An American in Paris won six Oscars, including Best Picture, beating out the favored *A Place in the Sun* and *A Streetcar Named Desire*. Minnelli became the first director nominated for a musical since Michael Curtiz for *Yankee Doodle Dandy*. Arthur Freed won the Irving Thalberg Memorial Award, and Gene Kelly won an honorary Oscar, the only one of his career, "in appreciation of his versatility as an actor, singer, director, and dancer, and specifically for his brilliant achievements in the art of choreography on film."

The closing sequence on an outdoor staircase was achieved through ingenious technical wizardry hatched by art director Preston Ames. Caron and Kelly run toward each other on what is shown as three flights of steps separated by small landings. In reality, only one flight, some prop lampposts, and a little shrubbery was in the frame with the actors. Everything else—the top two flights, the trees, the Paris cityscape—was painted and matted in, then captured with a special motion control camera for the final, dazzling upward tilt.

—

Another clever trick comes at the beginning of "I'll Build a Stairway to Paradise." Musical director Saul Chaplin was stumped trying to figure out how to allow Henri to perform his song in English, since the character is a French singer in a Paris music hall. After Henri sings the first few bars in French, he notices an American friend in the audience and speaks to him—and to the crowd—in English. Then he simply continues singing in English. It is all done so smoothly that the audience never questions the shift.

—

During the Rousseau segment of the ballet, Kelly channels the dancing style of George M. Cohan. "I wanted to do something immediately identifiable as American," he said, "because this is an American looking at Paris."

For the spectacular "I'll Build a Stairway to Paradise," Gene Kelly helped Georges Guetary (at center) perfect his movements up and down the staircase. Kelly also thought to have the steps light up.

ROBERT OSBORNE

"Gene Kelly had down-to-earth appeal, but he could dance like gangbusters. . . . I also love the fact—and want people to particularly notice when they see this movie—that very rarely when he dances does [the film] cut away. He loved to have a camera on him full-body, [for] long stretches of time within a number, so you really saw he was doing the work."

THE QUIET MAN

Republic, 1952
Color, 129 minutes

DIRECTOR

John Ford

PRODUCERS

John Ford and Merian C. Cooper (uncredited)

SCREENPLAY

*Frank S. Nugent, from the story
by Maurice Walsh*

STARRING

JOHN WAYNE	SEAN THORNTON
MAUREEN O'HARA	MARY KATE DANAHER
BARRY FITZGERALD	MICHAELEEN "OGE" FLYNN
WARD BOND	FATHER PETER LONERGAN
VICTOR McLAGLEN	"RED" WILL DANAHER
MILDRED NATWICK	MRS. SARAH TILLANE
FRANCIS FORD	DAN TOBIN
EILEEN CROWE	MRS. ELIZABETH PLAYFAIR
ARTHUR SHIELDS	REVEREND CYRIL PLAYFAIR

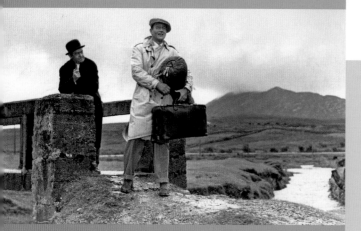

*Barry Fitzgerald watches John Wayne
light up at seeing Innisfree.*

**A RETIRED AMERICAN
BOXER MOVES TO
HIS CHILDHOOD
VILLAGE IN IRELAND
AND FALLS FOR A
FEISTY LOCAL LASS.**

WHY IT'S ESSENTIAL

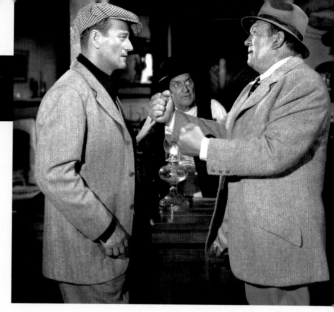

John Wayne and Victor McLaglen, with Harry Tyler tending bar

After Sean Thornton first locks eyes with Mary Kate Danaher, he asks his companion, Michaeleen, "Hey, is that real? She couldn't be!"

It's a sentiment, and moment, that defines *The Quiet Man*, John Ford's loving tribute to the Ireland of his ancestors. The imagery of the scene is almost impossibly idyllic, yet it was filmed on a very real Irish location. Mary Kate herds sheep in a picture-perfect field, her red skirt and red hair standing out against the vivid greens in the frame. The ravishing color, her earthy beauty, the romantic notion that love is already forming between this couple, even the sunny weather, all conjure Ireland as a magically atmospheric place. *The Quiet Man* transports the audience there as it does Sean Thornton, and moviegoers have been cherishing the experience for generations.

Even for John Ford, with his decades of hits, masterpieces, and awards, it was practically a miracle that he obtained the green light to go to Ireland and make this comic charmer.

The original story by Maurice Walsh had first been published in 1933; Ford read it in 1936 and bought the rights for $10, promising more if the movie got made. In 1944, he secured handshake promises from John Wayne, Maureen O'Hara, Barry Fitzgerald, and Victor McLaglen to act in the film, but for years he could not convince any studio to finance it. They thought it was an art-house movie that wouldn't make money, especially since Ford wanted to shoot in Ireland in expensive Technicolor. Finally, Herbert Yates, the head of lower-rung Republic Studios, agreed to finance

WILLIAM FRIEDKIN

"One of the most beautiful love stories I've ever seen. . . . This film was the passion project of John Ford's life, and you can feel it in every frame. . . . The authenticity just leaps off the screen."

Ford's "silly little Irish story" if Ford would first give him a western—a surefire moneymaker.

Ford made the western, *Rio Grande* (1950), with roles for Wayne, O'Hara, and McLaglen, and it was indeed a hit. Finally, in June 1950, cameras rolled in County Mayo, Ireland, on Ford's dream project. Set in the 1920s, the story follows Sean, a retired Irish-American boxer, as he arrives in Innisfree to buy and settle down in the cottage of his childhood. But a neighbor, "Red" Will, is a bully of a man who wants the cottage, too—and refuses at first to let Sean marry his sister, Mary Kate. That his permission is even necessary is

one of the many old-world customs—by turns funny, aggravating, and heartwarming—that rule this world.

Eventually, Will's withholding of Mary Kate's dowry becomes a source of conflict to the point that Mary withholds herself from Sean unless he fights Will for what is, by extension, her identity and independent spirit. But she doesn't know that Sean has sworn off fighting because he accidentally killed an opponent in the ring. That push-pull dynamic, there between Sean and Mary Kate from their first encounter, is the main delight of *The Quiet Man*. Wayne and

A fight before a kiss—typical of the tempestuous relationship between Sean (John Wayne) and Mary Kate (Maureen O'Hara). O'Hara said, "I loved Mary Kate Danaher. I loved the hell and fire in her."

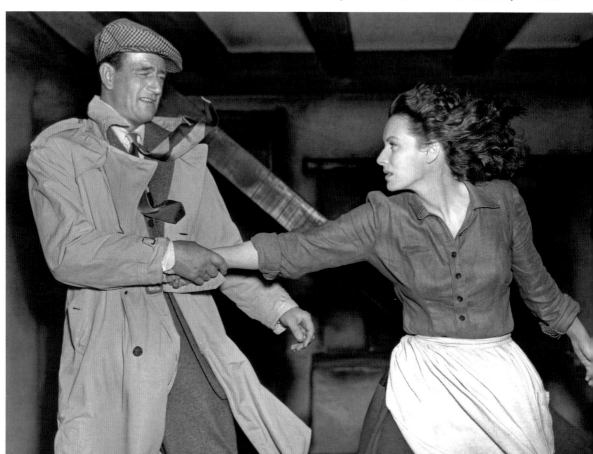

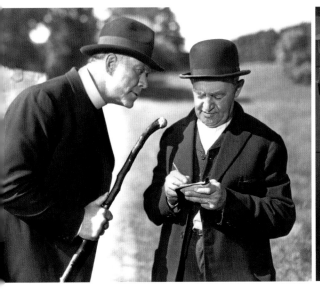

Ward Bond and Barry Fitzgerald in a deleted sequence

*Barry Fitzgerald holding the crib, with
Charles FitzSimons (Maureen O'Hara's brother),
Sean McClory, John Wayne, and Maureen O'Hara*

O'Hara's chemistry creates passionate moments—brief, intense kisses and embraces—that are all the more heated for coming in the middle of feisty confrontations.

Sometimes the feistiness spilled into real life. In their first encounter in the cottage, O'Hara was meant to slap Wayne after their tempestuous kiss, but because she really was angry at Wayne over some real-life incident, she tried to truly wallop him. He blocked her hand with his, and she fractured her wrist, hiding her pain for the rest of the shot. Later on, they share one of the most romantic of all movie kisses, in a cemetery in the rain, as Wayne's white silk shirt becomes translucent in the downpour. Ford later said, "I think I made the sexiest picture ever," and many audiences would tend to agree.

The Quiet Man is especially beloved for its large and wonderful supporting cast of eccentric townspeople, such as Ward Bond's priest, Barry Fitzgerald's matchmaker, Arthur Shields's Anglican reverend, Mildred Natwick's no-nonsense widow, and Jack McGowran as one Ignatius Feeney, who says of Sean's new bed, "Is that a bed, or a parade ground? A man would have to be a sprinter to catch his wife in a bed like that!"

ALEC BALDWIN

—

"John Wayne isn't what I always think of when I think of an actor, but he's everything I think of when I think of star. . . . Maureen O'Hara owns this role; it could only have been played by her."

John Wayne and Maureen O'Hara, as Sean and Mary Kate, outside their home

Victor McLaglen supplies boisterous energy as Red Will, who ultimately engages Sean in an entertainingly drawn-out brawl that even pauses for them to share a pint in the local pub. Actors Fitzgerald and Shields were real-life brothers, and the production was a family affair: O'Hara's brothers had small roles, Wayne's children appear with O'Hara in the horse race scene, and Ford's relatives had jobs on the crew.

Ford's persistence was vindicated when *The Quiet Man* became Republic's biggest success, grossing $5.8 million after a final cost of $1.6 million. It garnered six Oscar nominations, including the only Best Picture nod for any Republic film. Winton Hoch and Archie Stout won for their sublime color cinematography, and John Ford won Best Director, the fourth and final Oscar of his career.

WHAT TO LOOK FOR

The Quiet Man ends with Mary Kate whispering something in Sean's ear that causes him to look at her with surprise, then drop what he's doing to run with her toward their cottage (and presumably their "parade ground" of a bed). Maureen O'Hara said that Ford instructed her what to whisper, and she was so appalled that at first she refused. But Ford insisted—he wanted Wayne to react with as much shock as possible. O'Hara agreed to do it if Ford would never reveal the words to anyone else, and after the scene, Wayne agreed to this as well. O'Hara later wrote, "I'll never tell." And she never did.

United Artists/Stanley Kramer Productions, 1952
B&W, 85 minutes

DIRECTOR

Fred Zinneman

PRODUCER

Stanley Kramer

SCREENPLAY

*Carl Foreman, based on the magazine story
"The Tin Star" by John W. Cunningham*

STARRING

GARY COOPER MARSHAL WILL KANE

THOMAS MITCHELL MAYOR JONAS HENDERSON

LLOYD BRIDGES DEPUTY MARSHAL HARVEY PELL

KATY JURADO HELEN RAMIREZ

GRACE KELLY AMY FOWLER KANE

OTTO KRUGER JUDGE PERCY METTRICK

LON CHANEY MARTIN HOWE

HENRY MORGAN. SAM FULLER

IAN MacDONALD FRANK MILLER

LEE VAN CLEEF JACK COLBY

ROBERT WILKE. JIM PIERCE

SHEB WOOLEY BEN MILLER

STANLEY KRAMER
PRODUCTIONS
presents

GARY
COOPER

a man who was too
proud to run at...

"HIGH NOON"

STANLEY KRAMER PRODUCTIONS presents GARY COOPER in 'HIGH NOON'
with THOMAS MITCHELL · LLOYD BRIDGES · KATY JURADO · GRACE KELLY
OTTO KRUGER · Lon Chaney · Henry Morgan · DIRECTED BY FRED ZINNEMANN
Screen Play by Carl Foreman · Music Composed and Directed by
Dimitri Tiomkin · Director of Photography Floyd Crosby, A.S.C. UNITED ARTISTS

**UNABLE TO FIND ANY TOWNSPEOPLE WILLING TO HELP HIM,
A MARSHAL MUST FACE A BAND OF KILLERS ALONE.**

An inexpensive, unadorned black-and-white western, *High Noon* surprised everybody, including its makers, when it became a sleeper hit in the summer of 1952 and won four Academy Awards. In the decades since, it has continually ranked among the most popular westerns ever made. An early "message movie" from acclaimed producer Stanley Kramer, *High Noon* is considered by many to be the quintessential film about standing up for what is right no matter what—even if you are standing all alone and your life is on the line.

Told in ostensibly real time, with clocks frequently visible to build suspense, the story has a simple setup. Frank Miller is arriving on the noon train to come gunning with three henchmen for Marshal Will Kane (Gary Cooper). Kane has just gotten married and is about to leave town for a new life. But the new marshal won't arrive till tomorrow, and noon is only eighty minutes away: Kane decides he's got to stay and fight. The problem, as he discovers, is that not a single townsperson appears courageous enough to help him in what they see as a suicide mission. Instead, they come up with all sorts of excuses not to get involved and advise him to save himself and run while he can.

The story is as much about cowardice and apathy as it is about courage and duty, with the spare situation lending itself to much symbolic meaning. While he was writing the screenplay, Carl Foreman was subpoenaed by the House Un-American Activities Committee as part of its

Gary Cooper in an iconic image as Marshal Will Kane, walking the town alone

The Kane wedding. From left: Lon Chaney, Thomas Mitchell, Henry Morgan, Eve McVeagh, Otto Kruger, Grace Kelly, and Gary Cooper

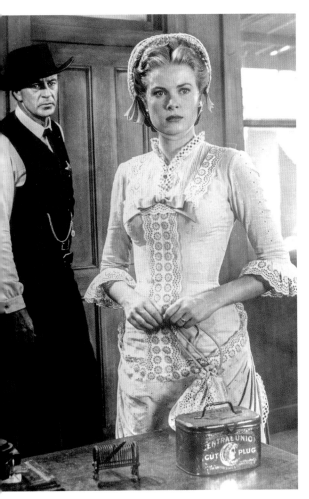

Minutes after the wedding, the Kane marriage is in trouble. Grace Kelly, in her second feature, registered with audiences: [h]e attention led to a role in Mogambo *(1953) and then* Dial 'M' for Murder *(1954), her first of three Alfred Hitchcock films.*

anti-Communist witch hunt, and he realized that the pressure he faced to do something that he felt was not right (name names before the committee) paralleled the situation of Will Kane, who is pressured to leave town. Foreman finished the script with the analogy in mind and said certain scenes and lines of dialogue were taken from that real-life context.

He kept his interpretation to himself, however. To director Fred Zinneman, the story was simply "about conscience. It's not a western, as far as I'm concerned; it just happens to be set in the Old West." *High Noon* is indeed unusual for a western of the time, with more talk than action, a hero who expresses fear and disappointment, and a flat, harsh visual look. This was intentional on the part of Zinneman and his cameraman Floyd Crosby, who were inspired by the graininess and white skies of Civil War photographs. Zinneman said he wanted *High Noon* to look like a newsreel of that time—had cameras and newsreels existed. With front lighting, a lack of soft filters, and of course black-and-white

ROBERT OSBORNE

"*High Noon* competed for the Best Picture prize but lost to Cecil B. De Mille's circus epic *The Greatest Show on Earth*, which surprised many people—although at the time, there were some marks against *High Noon*. [Screenwriter] Carl Foreman was implicated in the Communist witch hunts going on in Hollywood. [Producer] Stanley Kramer was a maverick, and the film industry didn't cotton to mavericks back then as it does now. Further, westerns had never been taken very seriously by Oscar. But time has proven the worth of this great film."

filmstock, he and Crosby achieved a stark look for a stark tale.

They also created one of the most iconic images in Hollywood history: Gary Cooper standing alone, fearful yet determined, driven by duty and morality, as the camera dramatically cranes up and back to reveal the empty town around him. The shot sums up the story, the character, and, for many observers, the essence of the western hero and even the ideals of America. Cooper had been going through a dry spell in his career when the *High Noon* script came along. The role of Will Kane, he said, "took everything I had, and I gave it everything I had." That included performing in physical discomfort from what was diagnosed afterward as a stomach ulcer. Cooper's genuinely pained facial expressions and movements enhanced his performance.

Among the supporting cast are twenty-one-year-old Grace Kelly, holding her own opposite Cooper as his Quaker bride in just her second feature; Mexican actress Katy Jurado in a complex role as the former lover of both Kane and Miller; Lon Chaney Jr., a fan favorite from *The Wolf Man* (1941), as a cynical former marshal; and future star villain Lee Van Cleef making his screen debut as one of the killers.

Van Cleef is the first character to appear on-screen, in a wordless opening accompanied by the beautiful title ballad "Do Not Forsake Me, Oh My Darlin.'" Sung by Tex Ritter, and written by

Dimitri Tiomkin with lyrics by Ned Washington, the song is as famous as the movie itself, plaintively expressing the loneliness of Will Kane's situation. It recurs several times through the film as Kane walks around town looking for help. This was a very rare device at the time. Possibly only the combat film *A Walk in the Sun* (1945) and the western *Man in the Saddle* (1951) had previously used songs, instead of instrumental scoring, in that manner. A commercial recording by Frankie Lane became a hit in 1952 and helped promote the film, which counted among its fans President Dwight D. Eisenhower. He proclaimed it his favorite picture and held three White House screenings. It was also a favorite of Ronald Reagan and Bill Clinton, with Clinton screening it a reported seventeen times.

Katy Jurado smacks Lloyd Bridges. The Mexican actress wo the role following her excellent performance in Budd Boetticher Bullfighter and the Lady (1951), her first American film

The bad guys heading to town for the shootout. From left: Robert Wilke, Lee Van Cleef in his film debut, Ian MacDonald, and Sheb Wooley

High Noon drew seven Oscar nominations, including Best Picture and Director, and it won for Score, Song, Film Editing, and Best Actor—Gary Cooper's second career win. Carl Foreman was also nominated for his screenplay. After testifying as an uncooperative witness during production, he had been stripped of his associate producer credit and blacklisted. He moved to London and resumed his career there, writing or producing such acclaimed films as *The Bridge on the River Kwai* (1957) and *The Guns of Navarone* (1961).

WHAT TO LOOK FOR

Fred Zinneman said, "My whole idea in shaping the drama of the film was to play the threat as statically as possible." He achieved this by having Cooper constantly walk around the town while the killers wait at the train station practically motionless. The static shots of train tracks—and the clocks that appear throughout—also take on an ominous quality.

—

Gary Cooper was costumed in black pants, vest, and hat to make him stand out against the town and look more isolated.

KISS ME DEADLY

United Artists, 1955
B&W, 106 minutes

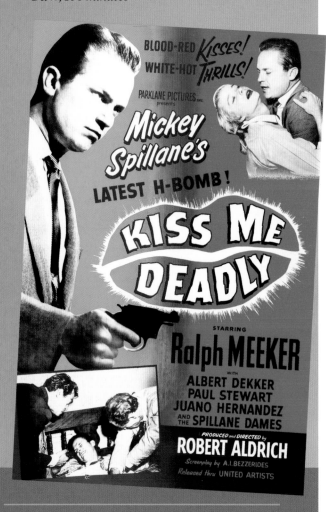

Robert Aldrich

PRODUCER

Robert Aldrich

SCREENPLAY

A. I. Bezzerides, based on the novel
by Mickey Spillane

STARRING

RALPH MEEKER MIKE HAMMER

ALBERT DEKKERDOCTOR G. E. SOBERIN

PAUL STEWART CARL EVELLO

MAXINE COOPER . VELDA

CLORIS LEACHMAN.CHRISTINA

GABY RODGERSLILY CARVER

JUANO HERNANDEZEDDIE YEAGER

WESLEY ADDYLIEUTENANT PAT MURPHY

MARION CARR. FRIDAY

FORTUNIO BONANOVA.CARMEN TRIVAGO

STROTHER MARTIN HARVEY WALLACE

JACK ELAM.CHARLIE MAX

PERCY HELTON.DOC KENNEDY

JACK LAMBERT SUGAR SMALLHOUSE

PRIVATE DETECTIVE MIKE HAMMER PICKS UP A FEMALE HITCHHIKER AND SOON FINDS HIMSELF ENTANGLED WITH RUTHLESS GANGSTERS SEARCHING LOS ANGELES FOR A MYSTERIOUS PACKAGE.

WHY IT'S ESSENTIAL

Character actor Percy Helton is priceless as the morgue doctor trying to fleece Mike Hammer (Ralph Meeker), as Lily Carver (Gaby Rodgers) watches.

As a film noir dripping with atomic-age paranoia, *Kiss Me Deadly* was very much of its time. With its audacious, jittery style and still-shocking violence, it was also far *ahead* of its time, and it stands now as an important and influential title of the era, despite being ignored upon release as a distasteful cheapie.

Energy and danger course through the picture. Every scene is ominous, with the sense that a threat is possible around any corner. The audience is kept on edge from the first frame of bare feet running down a highway at night. They belong to a panicked woman wearing only a trench coat. She flags down a passing sports car, which swerves off the road. The driver doesn't care about her distress; he just sneers, "You almost wrecked my car!" But he nonetheless gives her a lift. With the camera set up behind them, the woman panting and moaning in her seat, and Nat King Cole's "Rather Have the Blues" playing from the radio, the opening credits roll down from the top of the screen. The image is bizarre, outrageous, and exhilarating, feelings that define *Kiss Me Deadly* to the very end.

Screenwriter A. I. Bezzerides and producer-director Robert Aldrich didn't think much of their source material, a pulp novel by Mickey Spillane featuring private investigator Mike

A gas station attendant (Bob Sherman) greets Mike (Ralph Meeker) and Christina (Cloris Leachman) during the sensational opening sequence.

Hammer. "So I went to work on it," recalled Bezzerides. "I wrote it fast, because I had contempt for it. It was automatic writing." The result was a nightmarish satire that took tropes of film noir—such as a private eye of dubious morality,

...........

177

a femme fatale, underworld violence, off-kilter visuals, and a tone of impending doom—and heightened them to extremes that reflected the anxiety of the atomic age and the cynicism fostered by the McCarthy witch hunts. As Bezzerides said, "Things were in the air at the time, and I put them in." The plot finds Mike Hammer working his way up a chain of gangsters to find the thing that all are searching for, a mysterious boxed item that Mike's secretary, Velda, has nicknamed "the great whatsit"— because she and Mike have absolutely no idea what it is. They will learn the answer in the film's explosive ending, legendary in film noir.

Ralph Meeker is fascinating as Mike Hammer, who is no respectable detective but a "divorce dick" who uses his secretary to set up the husbands of his female clients. He is a sleazier, more antiheroic version of Humphrey Bogart's Sam Spade but also a bit of an early James Bond: he looks sharp in a suit, is often surrounded by attractive women, drives a sleek sports car, and has state-of-the-art gadgets, such as the reel-to-reel answering machine built into his wall. He can also handle himself physically against the toughest of bad guys, as in the amazing sequence in which he is attacked by a man with a switchblade while walking on a sidewalk one night. They have a brutal fight, after which Mike resumes his walk without a word of dialogue having been exchanged.

"What's in the box?" Albert Dekker and Gaby Rodgers with "the great whatsit"

Jack Elam and Jack Lambert as a pair of goons

.............

Kiss Me Deadly's dynamic cast includes three actresses in their first, or nearly first, film: Gaby Rodgers as the strange, birdlike Lily Carver; Maxine Cooper as Mike's secretary and sometimes lover, Velda; and Cloris Leachman as Christina, the woman in the trench coat who, after the opening credits, starts to psychoanalyze Mike in the car.

The picture also functions as a time capsule of midcentury Los Angeles, as Mike drives his Corvette Roadster to Bunker Hill downtown (he drives under the iconic Angels Flight funicular in one shot), Beverly Hills, the Hollywood Athletic Club, and a decaying Malibu beach house. The city is portrayed as ethnically diverse—strikingly so for a film of this vintage. Mike's best friend

ROBERT OSBORNE
—

"This movie was so violent at the time. I think that's why it didn't catch on more. I don't think people were quite ready for that in 1955. . . . And [it] has the wildest credits I ever saw—they're all backwards. Right off the bat it [prepares you for] an unsettled, turn-the-world-upside-down story."

Ralph Meeker and Gaby Rodgers in the Corvette Roadster

"Ralph Meeker is very subtle. The character's brutal, but he himself is subtle, so there's an interesting tension there. [The film] has freshness and humor and, of course, it's very prophetic, and the freshness comes, I think, because all these actors were unfamiliar then and are still unfamiliar. Cloris Leachman is the only one who went on to fame. It's such a memorable role—it just hangs over the whole film. She says, 'If anything happens to me, remember me.' And we do."

is Greek auto mechanic Nick, a lovable bundle of energy played by Nick Dennis, whose catchphrase is "Va-va-voom! Pretty pow!" Mike also hangs out at an African American jazz club, visits an Italian American wannabe opera singer (never mind that he torments the poor fellow), and seeks help from a black boxing trainer played by the excellent actor Juano Hernandez. Bezzerides was of Greek heritage and often worked multicultural elements into his screenplays.

After being ignored or denigrated by American critics, *Kiss Me Deadly* was hailed as brilliant art in France, where its abrupt editing style and expressive angles directly influenced directors of the French New Wave. Those French films, in turn, later influenced American movies of the 1960s, such as *Bonnie and Clyde* (1967). Modern filmmakers, from Martin Scorsese and Alex Cox to Steven Spielberg and Quentin Tarantino, have continued to sing the movie's praises and reference it in their work.

WHAT TO LOOK FOR

The most shocking violence in *Kiss Me Deadly* is all the more effective for occurring off-screen. Sometimes it is just barely out of frame, as when an image of dangling legs is accompanied by screams. At other times, it's entirely implied, as when the film shows only the aftermath of violent acts—or even just a character's reaction to having witnessed the mayhem. The audience is left to imagine the worst.

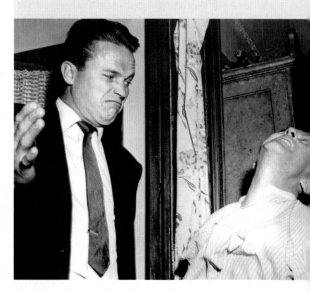

Ralph Meeker slaps around a reluctant witness.

THE NIGHT OF THE HUNTER

United Artists, 1955
B&W, 93 minutes

DIRECTOR

Charles Laughton

PRODUCER

Paul Gregory

SCREENPLAY

James Agee, from the novel by Davis Grubb

STARRING

ROBERT MITCHUM HARRY POWELL

SHELLEY WINTERS WILLA HARPER

LILLIAN GISH RACHEL COOPER

JAMES GLEASON UNCLE BIRDIE STEPTOE

EVELYN VARDEN ICEY SPOON

PETER GRAVES BEN HARPER

DON BEDDOE WALT SPOON

BILLY CHAPIN JOHN HARPER

SALLY JANE BRUCE PEARL HARPER

GLORIA CASTILO . RUBY

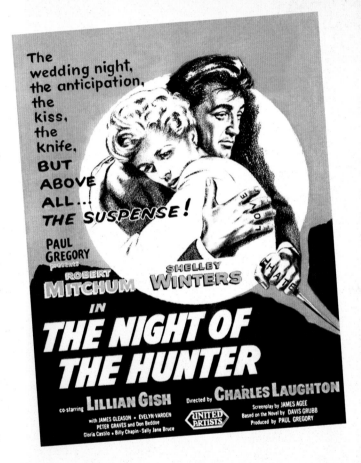

A MURDEROUS, DELUSIONAL PREACHER IN 1930s APPALACHIA STALKS TWO CHILDREN IN ORDER TO FIND OUT WHERE THEIR FATHER HID $10,000 IN STOLEN MONEY.

WHY IT'S ESSENTIAL

Three months after distributing *Kiss Me Deadly*, a film noir with the feel of a grown-up's nightmare, United Artists released *The Night of the Hunter*, a film noir that is akin to a child's nightmare. Both were box-office disappointments. Both are masterpieces.

The Night of the Hunter is less sensationally violent than *Kiss Me Deadly* but more profoundly terrifying. From the outset, with its image of Lillian Gish appearing over a night sky and teaching children a lesson from the Bible, it presents itself as a parable of good and evil.

"Beware of false prophets which come to you in sheep's clothing," Gish intones, and soon enough the audience is introduced to Robert Mitchum as a psychotic "preacher," Harry Powell, roaming West Virginia. He is deluded enough to believe that a higher power wants him to marry widows and kill them for their money; there have been about a dozen victims so far.

When Harry learns that an executed prisoner stashed away $10,000 before he was captured, he sets his sights on the man's widow, played by Shelley Winters, and her two children—one of whom, John, sees right through him. Harry will eventually hunt down the kids in a nightmarish

Robert Mitchum channels frightening anger as Reverend Harry Powell.

ROBERT OSBORNE

—

"I love it because of Robert Mitchum. This, to me, is his definitive performance. He never got much attention from it because the film itself was not successful, but he is brilliant in it. . . . He makes it look so easy that you think he's not doing a lot of acting, [but] people don't realize the work that goes into something like that."

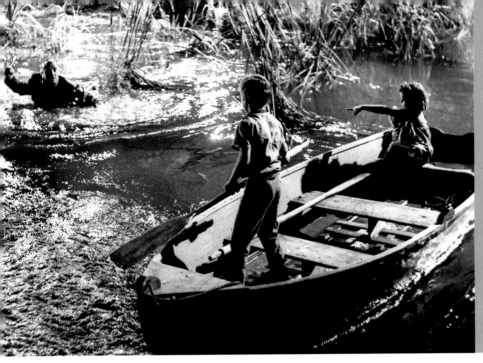

The otherworldly howl that Robert Mitchum lets out as the kids escape onto the river was created by blending his real howl into an electronic sound effect. Novelist Davis Grubb said he considered the river to be "the real hero of the story."

pursuit through the countryside until meeting his match in Rachel Cooper, played by Lillian Gish as a sort of Mother Goose with a house full of orphans. The film's brilliance lies in the way it tells this tale with a child's attitude. Good and evil are clearly defined, with no gray areas; adult characters are larger than life; settings are vivid and exaggerated; even the soundtrack alternates ominous underscoring with simple children's songs. The visual look is stunningly beautiful, with dramatic interplays of light and shadow creating moods that range from sinister to magical.

This was the only movie ever directed by Charles Laughton. He had recently directed several Broadway plays produced by Paul Gregory, and when Gregory read the galleys of *The Night of the Hunter*, a Southern Gothic novel by Davis Grubb, he suggested it to

Laughton as the basis for a film. Acclaimed writer and former film critic James Agee came on board to write the screenplay, to which Laughton contributed so much that Agee offered to share the writing credit. (Laughton declined.)

The cast and crew knew they were making something special, and the production was a happy one, with Laughton encouraging others to bring him their creative ideas. "Every day of shooting was a joy," recalled Shelley Winters, who was ecstatic to be working on the film because Laughton had been her mentor and acting teacher. Gish said, "I have to go back to D. W. Griffith to find a set so infused with purpose and harmony." Robert Mitchum, realizing that Harry Powell was a perfect role for him, gave a masterful performance. He comes off as pure—yet charismatic—evil moving through the frame,

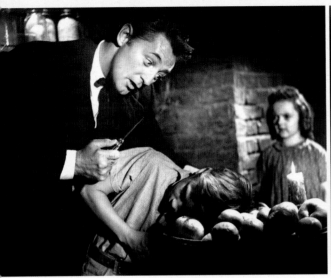

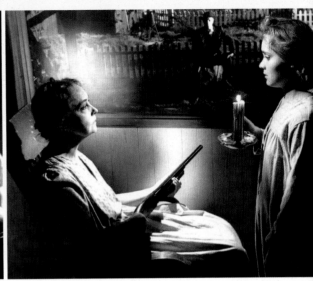

A terrifying moment as Robert Mitchum threatens Billy Chapin, with Sally Jane Bruce watching. Laughton, who sometimes grew frustrated with the kids, occasionally had Mitchum direct them.

Intrepid Lillian Gish guards the children (including Gloria Castilo, right) from a lurking Robert Mitchum.

able to turn on the charm when needed but with no compunction about threatening to kill a child. In an unforgettable scene, Gish sits on her porch late at night in silhouette, shotgun in her lap. Mitchum lurks in the front yard, singing a hymn, "Leaning on the Everlasting Arms," in chilling baritone. After a verse, Gish joins in with a set of uplifting lyrics, creating a perfect harmony of good and evil. The exquisite lighting and camera-work are by cinematographer Stanley Cortez, who deemed this film, "after *The Magnificent Ambersons* [1942], the most exciting experience I have had in the cinema."

Cortez and Laughton drew inspiration from the silent classics of D. W. Griffith and German expressionism. The river sequence, shot entirely on a soundstage, feels dreamlike with its exaggerated close-ups of wildlife guarding the kids as they drift in the moonlight. An unnerving scene in which John sits in a hayloft watching Harry ride his horse on the horizon was constructed in forced perspective (a device used in *Sunrise*). It is actually a dwarf riding a pony less than five hundred feet away on the soundstage. "The lighting gave the illusion I needed," said Cortez of this shot, "the feeling of mystery, of strange shadows." Mitchum's voice, made to sound distant as he ominously sings, also lends to the effect. Harry is a relentless monster in the night, and a wide-eyed John says in disbelief, "Don't he never sleep?"

This poetic artistry did not help the picture at the box office. It bombed and was soon forgotten. Even many critics were barely lukewarm, deeming the film simplistic or silly; only in later decades did admiring filmmakers and critics

"It's a great thriller. It just kind of seeps into your bones. . . . It's terrifying and heartbreaking and you're on the edge of your seat the whole time. . . . Lillian Gish has this herd of children that she takes care of in the movie and each one is allowed a great personality."

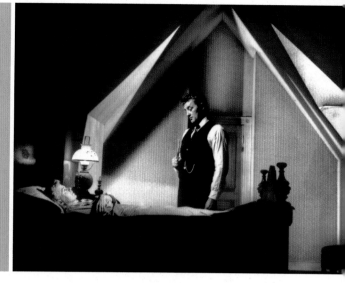

Cinematographer Stanley Cortez and production designer Hilyard Brown worked to make this bedroom look eerily churchlike.

rescue it from oblivion. But Laughton, who died in 1962, wasn't around to enjoy the accolades. He was so devastated by the original reaction that he withdrew from directing another movie, *The Naked and the Dead* (1958), and never directed again—a tragic loss for audiences after one of the greatest first films in Hollywood history.

WHAT TO LOOK FOR

In a movie filled with haunting visuals, the most incredible may be the image of one of Mitchum's victims underwater and lifeless, her hair undulating weightlessly around her. Stanley Cortez said he filmed the scene in a studio tank, with one camera underwater and a second shooting through glass. He lit the macabre spectacle with ten massive lamps from above the water and devised an artificial current to create "that strange flow of the hair." A realistic wax dummy was fashioned by Maurice Siederman, a makeup artist who had worked on *Citizen Kane* (1941) and *The Magnificent Ambersons* (1942).

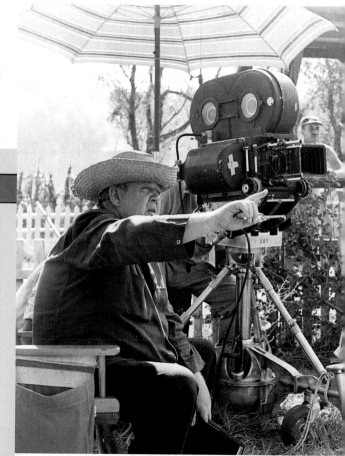

Director Charles Laughton

PATHER PANCHALI

Aurora/Government of West Bengal (India), 1955
B&W, 125 minutes

Karuna Banerjee, Uma Das Gupta, and
Subir Banerjee share a family moment.

DIRECTOR

Satyajit Ray

SCREENPLAY

*Satyajit Ray, based on the novel
by Bibhutibhusan Banerjee*

STARRING

KANU BANERJEE HARIHAR, APU'S FATHER

KARUNA BANERJEE. SARBAJAYA, APU'S MOTHER

CHUNIBALA DEVI"AUNTIE" INDIR THAKRUN

UMA DAS GUPTA DURGA

SUBIR BANERJEE . APU

RUNKI BANERJEE YOUNG DURGA

REBA DEVISEJO THAKRUN, BITTER NEIGHBOR

APARNA DEVI NILMONI'S WIFE, KIND NEIGHBOR

Subir Banerjee on the move. Pather Panchali's
title translates as "little song of the road."

**AN IMPOVERISHED
FAMILY STRUGGLES
TO MAKE ENDS
MEET IN A RURAL
BENGALI VILLAGE.**

Subir Banerjee as Apu

WHY IT'S ESSENTIAL

In 1949, Satyajit Ray was working as a graphic artist at a Calcutta advertising agency and longing to be a filmmaker. When he was assigned to illustrate a new edition of a classic Bengali novel, *Pather Panchali*, he grew inspired by "its humanism, its lyricism, and its ring of truth." Here, he thought, was the material for his first film. Six years later, the finished movie would draw global acclaim as a lyrical masterpiece. Ray would go on to build a legacy as a master of cinema and cultural icon whose influence still resonates today with filmmakers around the world.

Ray translated the novel's qualities into cinematic terms with astonishing command. It's a film with no real "plot" but a deeply poignant story of a poor family in rural India. The mother runs a destitute household with two children, Durga and Apu, as well as an ancient aunt, while her husband is absent for long stretches, not trying hard enough to make money and harboring dreams of being a playwright. ("I had lots of dreams, too," the mother intones softly at one point.) The film immerses the audience so

fully into the concerns of these characters, into the vivid details of their daily lives, that minor incidents become major, such as an accusation that Durga stole a neighboring girl's necklace, or a dispute between neighbors over taking fallen fruit from an orchard.

The main focus, however, is on the kids, Apu and Durga, brother and sister—their love, their typical sibling battles, and their sense of discovery of the world. *Pather Panchali* is unforgettable for its conveyance of childhood wonder, rendered in images of simple poetry with a minimum of dialogue. The kids run playfully through a distant field of towering *kaash* flowers and see massive, otherworldly power lines for the first time; they place their ears against the strangely humming poles; Apu sees his first train and feels the thrill of its power; they experience the death of a loved one, and are exposed to heartbreak and grief. As Ray said, "I have tried to discover universal traits in human behavior, emotions, and relationships within the orbit of my own culture. . . . I believe human beings are basically the same all over the world, and I try to prove it through my films."

Ray's tenacity in getting the film made was as impressive as the movie itself. After his treatment was rejected by every producer in Calcutta, he drew fresh encouragement from one of his idols, French director Jean Renoir, who was in India scouting locations for *The River* (1951), as well as from a viewing of Vittorio De Sica's *Bicycle*

Portrait of grief: Kanu Banerjee and Karuna Banerjee

Thieves (1948). That Italian neorealist classic gave Ray the confidence to make his film on a shoestring budget, using real locations and amateur actors. He pooled resources with friends and shot on weekends and holidays over two-and-a-half years, with a crew that had virtually no filmmaking experience. (His cinematographer, Subrata Mitra, had never even handled a movie camera.) After a one-year break when the money ran out, during which time Ray almost gave up completely, the West Bengal government stepped in to finance the film's completion.

Only two cast members had any experience: Kanu Banerjee as the father, and eighty-year-old Chunibala Devi as lovable Auntie Indir. The many scenes involving Auntie, the mother, and the other female characters in different combinations are captivating. Women basically rule this story's world, illustrating something that Ray later observed about his approach to female characters:

"One of the great films of world cinema. . . . Creates a sense of time and place where you think—even though you've never been there—that is exactly what it was like. . . . No way in 1955 would we get from an American movie the willingness to show full-bodied grief. [It's] evidence of what an entire other culture of films can bring us."

"The women I like to put in my films are better able to cope with situations than men."

As for the children, Ray said that thirteen-year-old Uma Das Gupta had natural talent as Durga, but he had to mold six-year-old Subir Banerjee's performance as Apu down to the smallest movements. For a scene in which Apu walks through a field looking for Durga, Ray placed obstacles in his path so he would have to maneuver over or around things and move more naturally. For the dramatic scene in which the mother drags Durga outside by her hair for having shamed the family, Apu watches, wide-eyed, and flinches in shock. To get that reaction, Ray had Subir stand on a stool, and an assistant then whacked the stool with a hammer. Ray admitted it was "mechanically contrived, but you could not tell the difference on the screen."

Pather Panchali also benefits from a dynamic, playful score by famed sitar player Ravi Shankar

Uma Das Gupta plays the beaming Durga.

"I genuflect before the effort to undertake something so massive and so controversial at the time with no safety net, no idea whether or not it would work, or . . . even be seen. There's a bravery, . . . a brashness to it, and yet it's so gentle, so respectful, so humble in the things that it shows us. . . . It has such a strong sense of place. I feel like I'm there. There are scenes where I can smell the food, I can feel the air, the heat, all of it. It's a beautiful achievement."

Uma Das Gupta and Subir Banerjee as sister and brother amid kaash *flowers in a lyrical sequence*

(later a creative partner of George Harrison and the father of Norah Jones). Shankar composed the musical cues in one day after seeing a rough cut of half the film. The picture was a word-of-mouth hit in India in 1955 and won an award at Cannes in 1956. Two years later, it opened in New York and ran for eight months in a single theater. Ray next made two sequels focusing on Apu as he continues to grow up, *Aparajito* (1956) and *The World of Apu* (1959), with the three films collectively known as the "Apu Trilogy" and forming a jewel in the history of Indian—and humanist—filmmaking.

WHAT TO LOOK FOR

Another way in which Satyajit Ray built Subir Banerjee's performance as Apu was through editing. There are reaction shots of the boy throughout, even in scenes where he doesn't speak, effectively bringing the audience into his perspective—into his discovery and experience of the world around him. They also cleverly help to create a captivating "performance" from a child who, Ray said, had only the vaguest understanding of the story being told.

............

REBEL WITHOUT A CAUSE

Warner Bros., 1955
Color, 111 minutes

DIRECTOR

Nicholas Ray

PRODUCER

David Weisbart

SCREENPLAY

Stewart Stern, adaptation
by Irving Shulman,
from a story by Nicholas Ray

STARRING

JAMES DEAN	JIM STARK
NATALIE WOOD	JUDY
SAL MINEO	JOHN "PLATO" CRAWFORD
JIM BACKUS	FRANK STARK
ANN DORAN	CAROL STARK
COREY ALLEN	BUZZ GUNDERSON
WILLIAM HOPPER	JUDY'S FATHER
ROCHELLE HUDSON	JUDY'S MOTHER
DENNIS HOPPER	GOON
EDWARD PLATT	RAY FREMICK

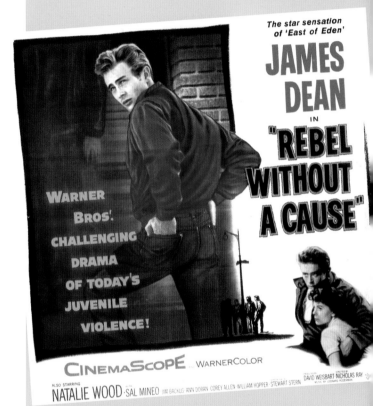

AN ALIENATED TEENAGER, TRYING TO CONNECT TO HIS PARENTS AND NEW FRIENDS, FINDS KINSHIP WITH TWO OTHER DISAFFECTED TEENS.

WHY IT'S ESSENTIAL

Even those who haven't seen *Rebel Without a Cause* probably have an idea of what its iconic title represents: disaffected youth, teen gangs, the 1950s, an entire cycle of teen-oriented movies, and, most of all, James Dean. It also conjures specific images: the knife fight, the "chickie-run" sequence of cars headed toward a cliff, the Griffith Observatory in Los Angeles. *Rebel Without a Cause*

carried a mystique even before it opened, due to James Dean's tragic death in a car crash four weeks prior to release. That had the effect of tying Dean's image directly to the era—and to this movie—forever after. He starred in three features, but it is the image of angst-ridden James Dean from *Rebel*, in blue jeans, white T-shirt, and red jacket, that is by far the most remembered and evoked.

Dean put all of his Method-actor training into playing Jim Stark, a teen from an affluent family

In the opening police station scene, Jim (James Dean, right) offers his jacket to Plato (Sal Mineo) as Judy (Natalie Wood) watches. Louise Lane plays the policewoman and Marietta Canty plays Plato's guardian.

............

*James Dean
as Jim Stark*

who has just moved to Los Angeles. He struggles to fit in and connect, to handle his emotions, to figure out for himself how toughness and gentleness blend into masculinity. His alienation speaks to just about every teenager—then and now—in some way. The screenplay has him wail to his parents, "You're tearing me apart!" but even more affecting are moments where Jim struggles to find any words at all to express what he's feeling, as in his touching romantic scene with Judy in an abandoned mansion.

Judy is played by Natalie Wood, who was sixteen when filming began and showed that she could make a successful transition out of child roles, a rarity throughout Hollywood history. She fought hard to get this part and later said,

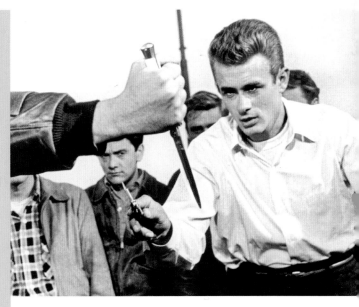

James Dean in the knife-fight sequence, which was performed with real switchblades and without body doubles

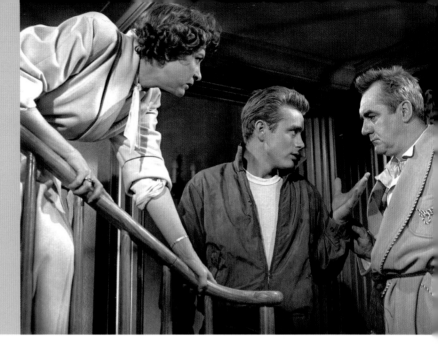

Jim in a tense exchange with his parents, played by Jim Backus and Ann Doran. The pair had already played husband and wife in Universal's Here Come the Nelsons *(1952) and Monogram's* The Rose Bowl Story *(1952), in which Natalie Wood portrayed their daughter.*

"It kind of opened the door for me to be thought of as a serious actress." She and Dean are captivating as adolescents who both feel alienated from their clueless parents and fall in love for the first time. Wood died tragically early as well, at age forty-three, as did the third *Rebel* star, Sal Mineo, who was murdered at thirty-seven.

Mineo plays Plato, a sensitive teen whose parents are absent and who latches onto the others to form a kind of make-believe family in a crumbling mansion hideaway. Mineo plays the role with an undercurrent of romantic desire for James Dean's character, which is all the more poignant for never being explicitly stated (it couldn't be, due to Production Code limitations).

Director Nicholas Ray had been interested in making a film from the perspective of troubled, middle-class kids and wrote a treatment called *The Blind Run*. With "youth films" then in vogue, Warner Bros. liked the idea but insisted on using the title of a nonfiction book the studio had optioned, *Rebel Without a Cause*. Ray began shooting in black and white, and after three days Jack Warner was so happy with the rushes—and aware of the tremendous buzz surrounding Dean's newly released *East of Eden* (1955)—that he elevated *Rebel*'s importance and ordered Ray to start over in color and CinemaScope. Ray and cameraman Ernest Haller used color as part of their storytelling, with red in particular connecting the three teens and representing their bursting emotions.

Mineo later remembered Ray as a bohemian, directing in bare feet and jeans. Ray established

a kinship with his stars, even letting Dean direct some scenes. (Dean had ambitions to become a director.) Most notable was the sequence in which Dean argues with his estranged parents, played by Jim Backus and Ann Doran, and ends up grabbing Backus and flinging him across the room. It's a violent moment, and Backus later said the only way to avoid injury, take after take, was to place himself completely in Dean's hands and not try to resist. "He had the greatest power of concentration I have ever encountered," Backus said.

The Griffith Observatory plays such a prominent role in the story that it is still connected to the film in the popular imagination; a bust of James Dean stands on the grounds even today. The abandoned mansion, which was owned by J. Paul Getty and torn down soon after filming, holds a legendary place in movie history for having also been used as Norma Desmond's mansion in *Sunset Boulevard* (1950). Even the swimming pool, which is empty and the site of a confrontation in *Rebel*, is the same pool in which William Holden once floated. Paramount

Natalie Wood and James Dean in their touching love scene

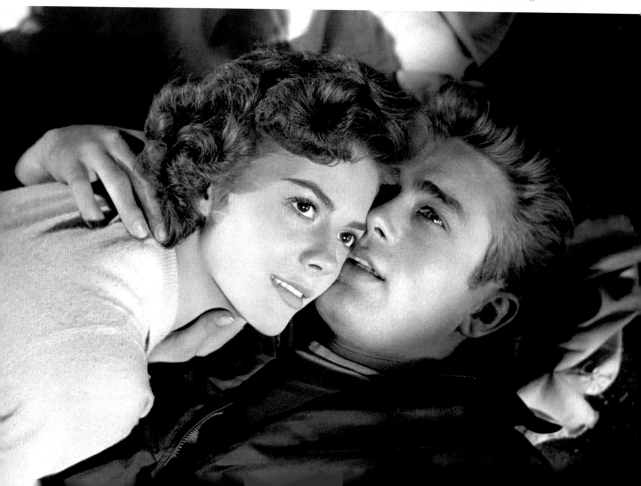

had built it for the earlier film and left it on the property. As it was not designed to be functional, eagle-eyed viewers will notice that it has no drain.

Rebel Without a Cause became a major hit in the fall of 1955 and garnered Oscar nominations for Natalie Wood and Sal Mineo, as well as for Nicholas Ray's story. James Dean received a posthumous Best Actor Oscar nomination—but for *East of Eden*. A year later, he would be posthumously nominated again, for *Giant* (1956). While some aspects of *Rebel* have become dated, the film tapped into something timeless about the teen years. Jeans, T-shirts, and fast cars have never gone away. Neither have bullying, family dysfunction, and lonely adolescents trying to make sense of life and themselves.

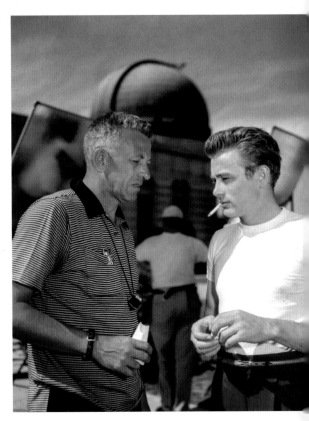

Director Nicholas Ray and James Dean on location at the Griffith Observatory in Los Angeles

WHAT TO LOOK FOR

Rebel Without a Cause marked an important early use of CinemaScope, an anamorphic camera process that created a much wider image than had been seen in films up to that time. It was developed during the rise of television as a way to lure moviegoers to theaters with the promise of a bigger screen. Nicholas Ray and Ernest Haller used 'Scope expressively, with spatial relationships between characters conjuring loneliness, alienation, connection, and disconnection. The opening police station sequence and the staircase scene with Jim and his parents are great examples of how a smart use of widescreen can enhance a film's emotional impact.

—

Nicholas Ray makes a cameo in the final shot as the man walking toward the Griffith Observatory.

DIRECTOR

Elia Kazan

PRODUCER

Elia Kazan (uncredited)

SCREENPLAY

Budd Schulberg

STARRING

ANDY GRIFFITH LARRY "LONESOME" RHODES

PATRICIA NEAL MARCIA JEFFRIES

ANTHONY FRANCIOSA.JOEY DE PALMA

WALTER MATTHAU MEL MILLER

LEE REMICK BETTY LOU FLECKUM

PERCY WARAM GENERAL HAYNESWORTH

PAUL McGRATH MACEY

ROD BRASFIELD. BEANIE

MARSHALL NEILAN. . . .SENATOR WORTHINGTON FULLER

AN ARKANSAS JAILBIRD RISES TO THE HEIGHTS OF RADIO AND TELEVISION CELEBRITY AS A POPULIST SINGER AND COMMENTATOR.

Warner Bros., 1957
B&W, 126 minutes

Lonesome (Andy Griffith) captivates Marcia Jeffries (Patricia Neal), the radio reporter who has discovered him in an Arkansas drunk tank.

"I'm not just an entertainer," says Lonesome. "I'm an influence, a wielder of opinion, a force!"

Nearly twenty years before *Network* (1976), *A Face in the Crowd* satirized the power of television and warned about the growing intersection of media, celebrity, and politics. The movie was astoundingly prophetic and still plays today as insightfully as its 1970s successor. Further, it contains one of the great performances of the era in Andy Griffith's portrayal of Larry "Lonesome" Rhodes, the hillbilly singer who becomes a powerful, corrupt TV personality.

Writer Budd Schulberg drew inspiration for the character from the likes of TV host Arthur Godfrey and humorist Will Rogers, both of whom professed to have a common touch. Rhodes begins his journey in the sheriff's drunk tank of a small Arkansas town, where reporter Marcia Jeffries interviews him for her local radio program, "A Face in the Crowd." His charisma, folksy humor, and bluesy singing captivate her—and her audience. She nicknames him "Lonesome", and he gets his own radio show, on which he mixes songs, jokes, and homespun aphorisms to charm housewives and ordinary country folk. Quickly he becomes a populist hero and even influences a local mayoral race.

He moves up—to Memphis, to television, and to New York, where national advertisers come calling, followed by national politicians, whom he advises on how to use TV to manipulate voters.

In her film debut, Lee Remick gives a multidimensional performance as a sexy baton twirler who becomes involved with Lonesome.

Patricia Neal with Walter Matthau, excellent as the reporter who sees through Lonesome early on

Lonesome at his height,
using the power of television

All the while, it is clear that his sole interest is himself, that he is playing one long con on the media and the public for his own power and profit. As he says to Marcia in the drunk tank, "What do I get out of this? I mean Mr. Me, Myself, and I?"

Director Elia Kazan, who had worked with Schulberg on the Oscar-winning *On the Waterfront* (1954), shared in the fascination with the dangers of television and media personalities.

Together they researched their story by talking to senators in Washington and visiting advertising agencies in New York. From that trip came the idea for one of their most jaw-droppingly prescient scenes: a commercial (featuring Lonesome) for a pill called Vitajex. The pill is benign, but the public believes it will make their libidos soar because of the manipulative advertising, which now looks like a part-replica and part-satire of Viagra ads forty years later.

ROBERT OSBORNE
—

"It's so powerful, [and] a great example of how deceiving television can be. . . . This is about a man who literally seduces the country through television. He's not what he seems to be at all, and it is chilling because you realize how many times we've probably been, and are being, seduced by people who are not worth our time."

ROSE McGOWAN

"Andy Griffith's singing voice is raw, and it's got a dangerous sexuality that works with his character. . . . There's something about Lee Remick in this movie—kind of like a sexpot that shot out of the cannon. She's very seductive, like Lolita, but knowing her power and using it to get out of her situation. . . . This film is just a sock to the gut."

An intense moment between Andy Griffith and Patricia Neal

Andy Griffith's powerful, energetic acting still amazes audiences who only remember him from his later, kindlier TV roles. Griffith had never acted in a movie before, but Kazan caught his performance in the Broadway comedy *No Time for Sergeants* and saw a charisma and capacity for darkness that proved perfect for Lonesome. The director molded Griffith's performance to such a degree that the actor "became" Lonesome to all around him while making the film. "I was not a very nice man," Griffith recalled.

Patricia Neal had not appeared in an American movie for five years when Kazan offered her the part of Marcia. She is the one who "creates" Lonesome, and her increasing attraction and horror guide the audience through the story. Neal's performance is underrated, ranging from strongly self-assured to emotionally shattered. Walter Matthau also excels in the small but important role of Mel Miller, a writer who is in love with Marcia and intelligent enough to realize that he can simply wait for Lonesome's inevitable downfall.

............

Critics and audiences did not pay much attention to *A Face in the Crowd* in 1957; the film vanished quickly and received no awards attention beyond a Directors Guild nomination for Kazan. Time has been much kinder to this film. Its predictions of television helping to create and blur the roles of entertainer, populist, influencer, pitchman, and politician have long since come true, as have its entertaining yet stark warnings about the dangers of charlatans who use media to shape their images and sway the public for corrupt purposes.

Director Elia Kazan (right) confers with Lee Remick on location in Piggott, Arkansas.

WHAT TO LOOK FOR

Kazan came up with all sorts of ways to generate the performances he wanted. Schulberg recalled that the county sheriff who holds Lonesome in the drunk tank and later runs for mayor was played by a man "we plucked from a border country roadhouse and who had never faced a camera before." His name was Big Jeff Bess, which Schulberg used as his character's name. For the scene in which he opens his front door to find countless dogs in his front yard (brought there by residents at the behest of Lonesome), Big Jeff wasn't able to summon the necessary anger. Finally, Kazan slapped him hard, immediately rolled the camera, and "Big Jeff came forward with angry tears in his eyes, ready to murder Kazan."

In another scene, Patricia Neal secretly turns on Lonesome's microphone from a control room so that the world can hear what he's really like, then covers the switchboard with her body until two men pull her away. Neal recalled that the first two takes didn't achieve the intensity that Kazan desired. Before the third take, he directed her to hold onto the switchboard as hard as she could. Then he directed the men to pry her loose as quickly as *they* could. "We did the scene again," Neal wrote, "my hands bled, and I sobbed as the men pulled me away. [Kazan] had his scene—and the way he wanted it."

—

Several real-life television personalities appear as themselves, including Mike Wallace and Walter Winchell, the latter of whom would serve as the basis for the character of J. J. Hunsecker in *Sweet Smell of Success* (1957).

SWEET SMELL OF SUCCESS

United Artists, 1957
B&W, 96 minutes

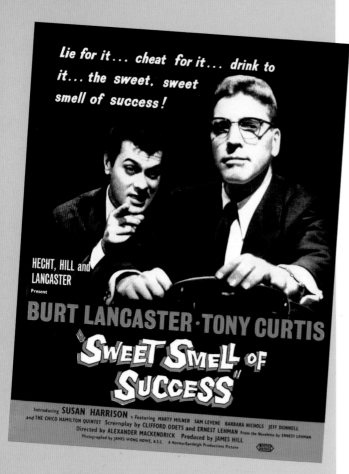

Lie for it . . . cheat for it . . . drink to it . . . the sweet, sweet smell of success!

HECHT, HILL and LANCASTER
Present

BURT LANCASTER · TONY CURTIS

Sweet Smell of Success

Introducing SUSAN HARRISON · Featuring MARTY MILNER · SAM LEVENE · BARBARA NICHOLS · JEFF DONNELL and THE CHICO HAMILTON QUINTET · Screenplay by CLIFFORD ODETS and ERNEST LEHMAN from the Novelette by ERNEST LEHMAN
Directed by ALEXANDER MACKENDRICK · Produced by JAMES HILL
Photographed by JAMES WONG HOWE, A.S.C. · A Norma-Curtleigh Productions Picture

DIRECTOR

Alexander Mackendrick

PRODUCER

James Hill

SCREENPLAY

Clifford Odets and Ernest Lehman, from the novelette by Ernest Lehman

STARRING

BURT LANCASTER J. J. HUNSECKER

TONY CURTIS SIDNEY FALCO

SUSAN HARRISON SUSIE HUNSECKER

MARTY MILNER STEVE DALLAS

JEFF DONNELL . SALLY

SAM LEVENE FRANK D'ANGELO

JOE FRISCO.HERBIE TEMPLE

BARBARA NICHOLS RITA

EMILE MEYER LIEUTENANT HARRY KELLO

AN UNSAVORY MANHATTAN PRESS AGENT TRIES TO INGRATIATE HIMSELF WITH A POWERFUL GOSSIP COLUMNIST BY DOING HIS DIRTY WORK.

WHY IT'S ESSENTIAL

Just one month after the release of *A Face in the Crowd* came another, more cynical take on power and the media. It fared even worse at the box office, but *Sweet Smell of Success* is now esteemed as one of the great American films of the 1950s. Its electric dialogue and smarmy, amoral characters are bathed in the brilliant nighttime photography of cameraman James Wong Howe, making this also a quintessential New York movie and one of the last hurrahs of classic film noir.

At the heart of the story is the cat-and-mouse interplay between Burt Lancaster and Tony Curtis, who delve into the fascinating sleaze and cruelty of their characters to deliver two of their finest performances. Lancaster plays J. J. Hunsecker, a *New York Globe* gossip columnist and radio commentator modeled on Walter Winchell. He wields his powerful column like a sword, able to make or break celebrities and politicians according to his whim; he also appears to harbor incestuous feelings for his sister, Susie. Curtis plays Sidney Falco, an obsequious press agent who provides items for J. J.'s columns as a way

ROBERT OSBORNE

"At [this] point, people really only knew Lancaster as a hero, so to have him play this despicable, dangerous man was very unusual. . . . Tony Curtis had always been just a pretty boy. Nobody really took him seriously as an actor, [but] he's just superb in this film. . . . I do love getting to see New York in 1957—what it was like then, the different face of the city compared to now."

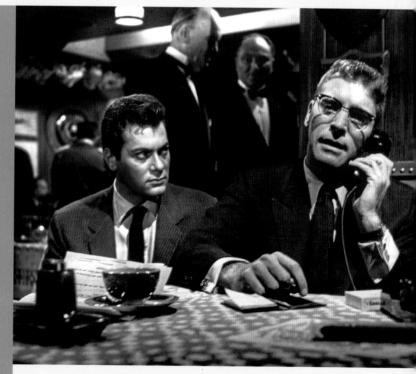

J. J. Hunsecker (Burt Lancaster, right) projects absolute power in his usual booth at 21 with Sidney Falco (Tony Curtis).

of getting his clients publicized in print—and who is so desperate for success that he will do anything, no matter how unethical, to curry J. J.'s favor. At the moment, J. J. wants Sidney to break up the romance between Susie and a local jazz guitarist. It doesn't matter how; J. J. just wants him gone. "What's this boy got that Susie likes?" J. J. wonders. "Integrity," replies Sidney. "Acute, like indigestion."

That is just one of many acidic lines of dialogue in a movie that presents the New York nightscape as an arena for verbal blood sport. "You're dead, son. Get yourself buried," J. J. says early on. "I'd hate to take a bite out of you. You're a cookie full of arsenic," he tells Sidney later. Sidney gets his own share of caustic dialogue, such as, "The cat's in the bag and the bag's in the river."

That line was written at two in the morning by Clifford Odets in the back of a props truck, shortly before it was filmed—a perfect illustration of this production's chaos and genius. The script was based on a 1950 novella by Ernest Lehman, one of Hollywood's finest writers, who had worked as a press agent in the 1930s. Burt Lancaster's independent production company, Hecht-Hill-Lancaster, riding high after a Best Picture Oscar for *Marty* (1955), bought the rights. The plan was for Lehman to adapt the screenplay and make his directorial debut, but distributor United Artists preferred someone experienced,

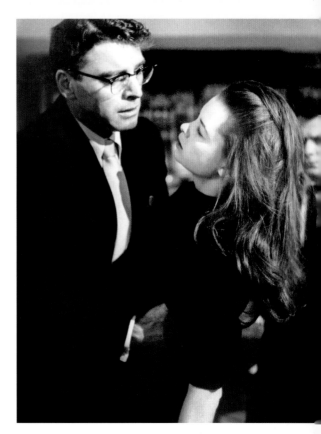

Susie (Susan Harrison, in her first feature) is desperate to escape the grip of her brother, J. J.

"Match me, Sidney." J. J. denigrates Sidney before chastising Senator Walker (William Forest, right) for running around in the open with an obvious mistress (Autumn Russell, sitting next to Jay Adler). "Are we kids or what?"

and Alexander Mackendrick got the job instead. The American-born, Scottish-raised director had worked exclusively in Britain, making now-classic comedies for Ealing Studios such as *The Ladykillers* (1955).

When Lehman withdrew before completing the screenplay, due to exhaustion and stress, Mackendrick suggested bringing on celebrated playwright Clifford Odets, who reworked the script to increase each scene's "tension and dramatic energy," as Mackendrick put it. But he took so long in doing so that the production started filming without a finished screenplay—and that is why Tony Curtis found Odets late one night typing in a van. Meanwhile, Mackendrick and Lancaster clashed constantly on the set over blocking and characterization, and the picture wound up going far over schedule.

Sweet Smell of Success bristles with aggressive New York energy. In addition to the full-fledged exterior scenes, Mackendrick made an inspired decision to start many interior sequences with

Sidney Falco (Tony Curtis) projects desperation.

Alexander Mackendrick (center) directs Tony Curtis and Susan Harrison.

brief bits on the bustling sidewalks. The camera then follows the characters inside—or, conversely, follows them outside at the end of the scene. Mackendrick did this to prevent the film from feeling too talky, but it also resulted in an amazingly seamless trick: making viewers believe that the nightclub interiors were real. They are actually sets on a Hollywood soundstage. Cinematographer James Wong Howe recalled varnishing the walls of the sets to get the sleek appearance he wanted. "I used very small bulbs," he said, "because we had so much polish on the walls it made everything shine. The whole film shimmered; few films have that look."

The final result, complete with a soundtrack that blends Elmer Bernstein's jazzy score with music from the Chico Hamilton Quintet (who appear as themselves on-screen), was recognized by some critics but fell flat with the few audiences who even bothered to see it. Ernest Lehman recalled that one preview card said, "Don't touch a foot of this film. Burn the whole thing." *Sweet Smell of Success* was too cynical for general consumption, and moviegoers especially did not take to Lancaster and Curtis playing such despicable characters. But the picture has long since become a touchstone in the history of New York filmmaking, capturing the city's life and vibrancy like few others. As J. J. Hunsecker says one night, after watching a drunk get tossed out of a nightclub, "I love this dirty town."

............

"Son, I don't relish shooting mosquitoes with elephant guns. Suppose you just shuffle along and call it a day?"
After a broadcast of his show, J. J. lays into Steve (Marty Milner) as Sidney and Susie listen.

WHAT TO LOOK FOR

The character and power dynamics between Tony Curtis and Burt Lancaster come across in their body movements.
Throughout the film, Curtis darts around the frame in constant motion—twitchy, desperate, and wound up. Lancaster
is like a rock, barely moving, all power at the center of his universe. In one scene as they walk together outside, Curtis
constantly repositions himself in the frame around Lancaster, who walks ahead steadily.

—

Alexander Mackendrick convinced Lancaster to wear heavy glasses to help give J. J. an eerie, somehow more threatening
appearance. James Wong Howe lit them from above so that Lancaster's eye sockets would look deeper and his face skull-like.
"Throughout the entire film," wrote Mackendrick, "a light moved with Burt, just in front of him, often with Jimmy holding
it himself, to produce this strange mask of a face."

THE BRIDGE ON THE RIVER KWAI

Columbia, 1957
Color, 161 minutes

Alec Guinness as the proud Colonel Nicholson

DIRECTOR

David Lean

PRODUCER

Sam Spiegel

SCREENPLAY

Carl Foreman and Michael Wilson,
based on the novel by Pierre Boulle

STARRING

WILLIAM HOLDEN SHEARS

JACK HAWKINS MAJOR WARDEN

ALEC GUINNESS COLONEL NICHOLSON

SESSUE HAYAKAWA COLONEL SAITO

JAMES DONALD MAJOR CLIPTON

GEOFFREY HORNE LIEUTENANT JOYCE

ANDRÉ MORELL COLONEL GREEN

PETER WILLIAMS CAPTAIN REEVES

IN 1943, BRITISH POWs CONSTRUCT A BRIDGE FOR THEIR JAPANESE CAPTORS WITH THE ARDENT COOPERATION OF THEIR OWN COMMANDER, UNAWARE THAT AN ALLIED COMMANDO MISSION IS ON THE WAY TO DESTROY IT.

WHY IT'S ESSENTIAL

In the decade following *Brief Encounter* (1945), David Lean directed seven more, relatively small-scale, pictures. On the set of the seventh, *Summertime* (1955), he received a cable from producer Sam Spiegel with an offer to direct *The Bridge on the River Kwai*, a World War II tale based on the building of the infamous Siam-Burma Railway with forced Allied labor. Lean asked his star, Katharine Hepburn—who had worked for Spiegel on *The African Queen* (1951)—for her advice. "Take it," she said. "You'll learn a lot from him. And he'll learn a lot from you."

Major Warden (Jack Hawkins) and Shears (William Holden) get off to a rocky start.

The Bridge on the River Kwai would be pivotal to Lean's career: his first epic, his first international production, his first time working in anamorphic widescreen, his first time commanding a veritable army of actors and crew. Its massive success would give Lean a reputation

David Lean with camera

ROBERT OSBORNE

—

"Even though it's a long film, and you have to stick with it, it's never boring. It grabs you right in the beginning . . . it's very rugged . . . and the ending is dynamite."

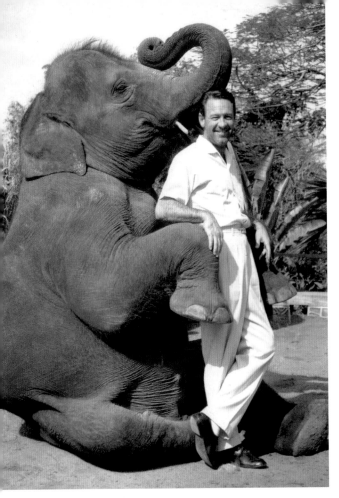

William Holden poses with a friend at the Ceylon location. Elephants helped build the bridge by dragging massive logs. Property master Eddie Fowlie said they took breaks every four hours, lying in the water to rest, and no one could make them budge again until they were ready.

hundreds of British prisoners of war while an Allied commando unit traverses enemy territory to blow it up. The intimate story is the war of wills between the British and Japanese commanders, Nicholson and Saito, as well as the growing madness inside Nicholson himself, who is obsessed with building a solid bridge but blind to how this helps the enemy. All these threads of outward action and inner drama are held in satisfying balance.

Finding the right tone for this antiwar story was a challenge, especially for the Nicholson character, who collaborates with the enemy but only inadvertently, his judgment clouded by obstinate pride. Writer Carl Foreman, blacklisted following *High Noon* (1952) and now working in London, had optioned Pierre Boulle's novel and written the screenplay. Lean disliked it, and after much clashing of wills, Foreman left the project; Michael Wilson, who had been blacklisted following his Oscar win for *A Place in the Sun* (1951), wrote a new draft with significant, uncredited input from Lean.

But *Kwai*'s troubles continued. Alec Guinness arrived on location in Ceylon (now Sri Lanka) knowing full well that he had been far from the first choice to play Nicholson; Lean had wanted Charles Laughton or Ralph Richardson, and Spiegel had favored Cary Grant, Noël Coward, or Ronald Colman. Lean and Guinness clashed mightily, with Guinness wanting to inject bits of

as one of the top directors in the world, and he would make only large-scale productions for the rest of his career—although there would be just four more of them, starting with *Lawrence of Arabia* (1962). With *Kwai*, he showed a mastery of blending the big and the small, the grand and the intimate—a balance that is essential to any epic film. In this case, the grand story is the building of the railway bridge in Burma by

.............

humor into a role that Lean saw as deadly serious. Sessue Hayakawa—one of the great Hollywood silent screen stars, known in the 1910s for both romantic and villainous leads—was an inspired choice for Colonel Saito, whose most memorable moments are the silent ones in which he expresses his wounded sense of honor; he would be Oscar-nominated. For Shears, the captive who escapes only to be pressed into joining the commando mission, Spiegel and Lean changed the character to an American so as to better engage American viewers, then cast the top box-office star in Hollywood at the time: William Holden.

The unit constructed a real bridge over five months in the Ceylon jungle, with elephants hauling the timber. During the eight-month shoot, the company had to deal with illness, dysentery, leeches, humidity, and a union strike. Two crew members died, one in a car crash and one performing a stunt. When it came to blowing up the bridge, the first attempt was aborted as the train hurtled across and smashed into a generator car on the other side, becoming derailed; luckily, the crew was able to reset the train for a successful attempt the next day.

The defining image—and sound—of the film is of the British regiment marching into camp, whistling the "Colonel Bogey March." That tune had been composed during World War I and been given various sets of cheeky lyrics by soldiers over the years. During World War II, this was

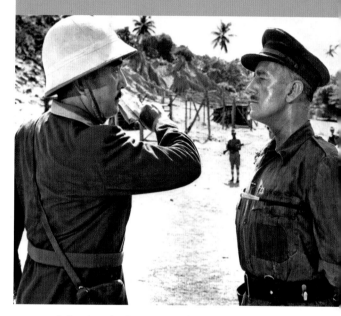

Colonels Saito (Sessue Hayakawa) and Nicholson (Alec Guinness) square off. Hayakawa had been a rare Asian superstar in American silent movies.

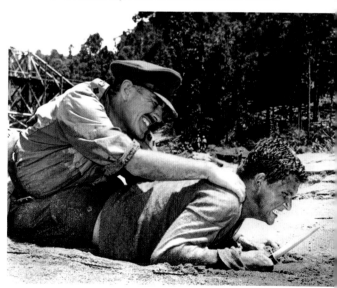

Alec Guinness and Geoffrey Horne in a tense moment

a common version: "Hitler, has only one right ball / Goering, has two but they are small / Himmler, has something sim'lar / But Goebbels, has no balls, at all." As this was too racy to be heard on-screen, Lean thought to have the men whistle instead, a way of conjuring up resolve and morale in the face of adversity. Composer Malcolm Arnold wrote a countermarch and blended both into the overall soundtrack, which became a major hit.

So did the film itself, which won seven Academy Awards, including Best Picture, Director, Actor (Alec Guinness), Score, and Cinematography (Jack Hildyard). The Best Screenplay award was given, absurdly, to Pierre Boulle, who didn't even speak English, because Foreman and Wilson were blacklisted and uncredited. In 1984, the Writers Guild of America decided to credit the two men going forward. Foreman received the news of the credit change—and that he would be awarded a belated Oscar—the night before his death.

William Holden and Ann Sears. Her part as a nurse was expanded in order to give Holden some love scenes to satisfy his fan base.

WHAT TO LOOK FOR

After weeks of being confined to "the oven," a tiny metal shed in the blistering sun, Colonel Nicholson is released, and he walks across the compound to Colonel Saito's hut. Guinness makes the walk a wondrous physical performance, convincingly portraying a man who can barely move his body yet is pushing himself to walk with dignity in front of his men. Guinness and Lean fought over this, with Guinness insisting that the walk was too long to be credible. But when Guinness saw a rough assembly of the sequence a few weeks later, he admitted to Lean that it was "the best thing I've ever done." Years later, Guinness revealed that he based his lurching movements on the "stiff, strange" walk of his son at age twelve, when he was recovering from polio.

DIRECTOR

Alfred Hitchcock

PRODUCER

Alfred Hitchcock (uncredited)

SCREENPLAY

*Alec Coppel and Samuel Taylor,
based on the novel* D'Entre les Morts
by Pierre Boileau and Thomas Narcejac

STARRING

JAMES STEWARTJOHN "SCOTTIE" FERGUSON

KIM NOVAK. MADELEINE ELSTER/JUDY BARTON

BARBARA BEL GEDDES MIDGE WOOD

TOM HELMORE.GAVIN ELSTER

HENRY JONES .CORONER

RAYMOND BAILEY SCOTTIE'S DOCTOR

**A RETIRED
DETECTIVE BECOMES
ROMANTICALLY
OBSESSED WITH A
WOMAN HE IS HIRED TO
INVESTIGATE, BUT ALL
IS NOT AS IT SEEMS.**

*Paramount, 1958
Color, 128 minutes*

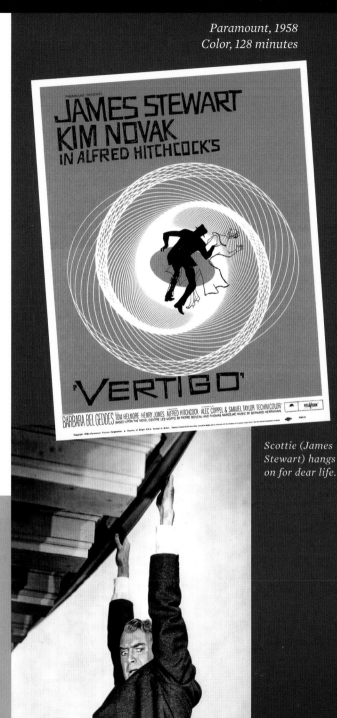

*Scottie (James
Stewart) hangs
on for dear life.*

Alfred Hitchcock's masterpiece is a romantic, tragic thriller, a hypnotic tale of obsession. Every aspect of *Vertigo*'s meticulous production is geared toward bringing the audience into an unsettling frame of mind where reality, fantasy, and illusion intertwine—as they do for the characters played so hauntingly by James Stewart and Kim Novak. A highly personal achievement for Hitchcock, *Vertigo* was largely misunderstood or ignored in 1958 but is now widely considered to be his most profound work and one of the most spellbinding films ever made.

The screenplay was adapted from a French novel translated as *From Among the Dead*, whose setting Hitchcock moved to San Francisco. It centers on a police detective, Scottie Ferguson, with a fear of heights that gives him debilitating vertigo. He retires from the force only to be cajoled by an old friend into investigating the man's wife, Madeleine, who the man worries is possessed by a long-dead ancestor and may be suicidal. As Scottie follows her around

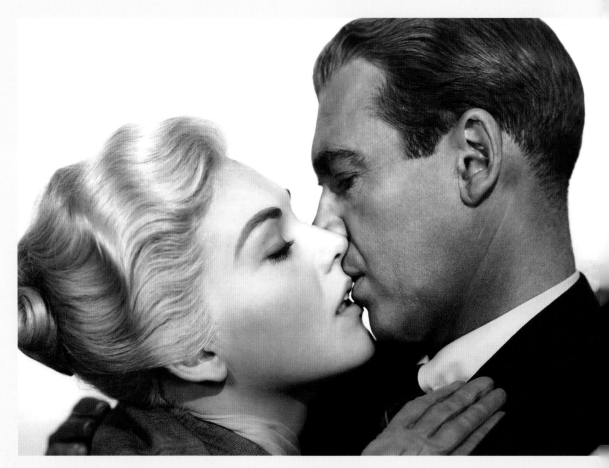

Kim Novak and James Stewart

ROBERT OSBORNE

"Some movie thrillers hinge on the notion that seeing isn't necessarily believing, and there was one director who told that kind of story best: Alfred Hitchcock. He never told such a tale with more panache and suspense than in *Vertigo*. . . . San Francisco, that beautiful city by the bay, really deserves costar billing. The location shooting adds so much to the mood and visual impact."

Alfred Hitchcock directs Kim Novak for a scene involving her, James Stewart, and a coffee cup.

San Francisco, he becomes infatuated. After he saves her life, infatuation turns to love. But after he sees her fall to her death, having not been able to save her for a second time due to his vertigo, he becomes obsessed with her memory and enters a downward psychological spiral.

Barbara Bel Geddes is often underrated for her touching and poignant turn as Midge.

Then he meets another woman, Judy, who bears a striking resemblance to Madeleine . . .

There is still much more plot to come, but the solution to *Vertigo*'s central mystery is actually revealed well before the film's end. Even more gripping are the emotions that drive the plotline forward: Scottie's longing, obsession, and growing instability. He tries to bring his love back from the dead by transforming Judy into Madeleine, obsessively changing her clothes, makeup, and hairstyle to match. In Hitchcock's hands, this speaks profoundly to the movie-making process: Scottie is both like a director, shaping the specific look of an actress to play a part, and like an audience, in love with an image of someone who is not exactly "real."

Stewart and Novak give courageous, soul-baring performances. Stewart's plunge to the edge of insanity is all more unnerving coming from an actor known for his nice-guy image, but it is also the culmination of a career-long exploration of the darker side of his persona. He had shown glimmers of obsessive anger as far back as *Mr. Smith Goes to Washington* (1939), even more so in *It's a Wonderful Life* (1946), and in several westerns, such as *The Naked Spur* (1953).

Novak, a glamorous Columbia Pictures star, was a late replacement for Vera Miles, whom Hitchcock had planned to boost to stardom with *Vertigo*. After the film was delayed, Miles became pregnant and had to back out. Novak's performance drew some criticism at the time for iciness, but it is actually heartbreakingly vulnerable and affecting—her greatest.

Scottie (James Stewart) rescues Madeleine (Kim Novak) from San Francisco Bay.

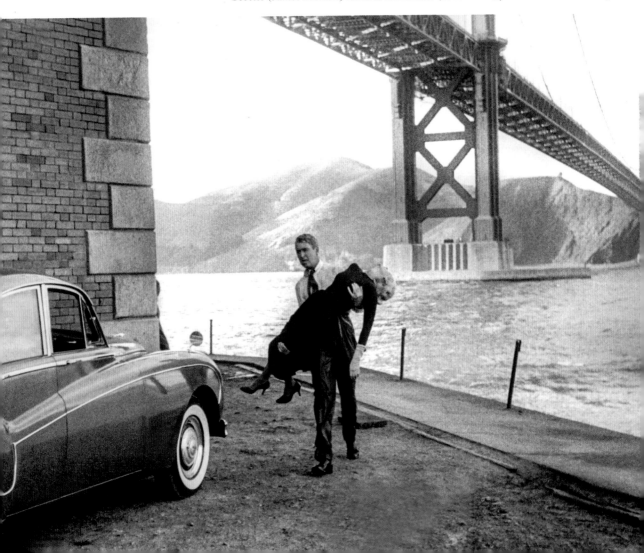

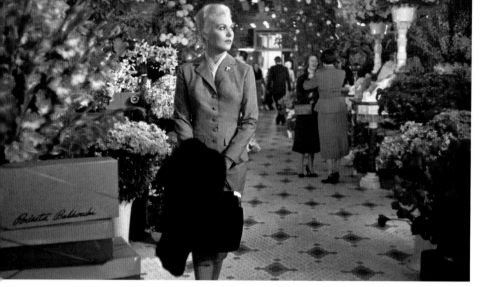

One of Vertigo's most haunting and beautiful images. Kim Novak's gray suit, designed by Edith Head, makes Madeleine look ghostly amid the colors of the flower shop. The impact of this moment is heightened by coming immediately after a scene in a dark alley and drab storeroom. The cinematography is by frequent Hitchcock collaborator Robert Burks.

Bernard Herrmann's score is one of the finest ever composed, conveying the romance, darkness, and mystery of the story with melodies that are beautiful in their own right. *Vertigo's* long, dialogue-free stretches, especially when Scottie follows Madeleine by car, are kept riveting and eerie largely by Herrmann's music.

Vertigo is such an all-encompassing emotional, intellectual, and sensory experience that it tends to make audiences themselves a bit obsessed. The film contains lingering mysteries (How does Scottie get down after hanging from that gutter? How does Madeleine vanish from the McKittrick Hotel?), but it also simply grows richer on repeat viewings, with new details and insights to discover. This quality was reflected in 2012 by the once-a-decade *Sight & Sound* poll of critics worldwide to determine the greatest movie ever made. After slowly climbing through the ranks over previous decades, *Vertigo* finally took the top spot, supplanting *Citizen Kane* (1941).

Kim Novak as Judy, in another Edith Head costume that creates a vivid contrast to Madeleine

An image from Scottie's dream sequence

WHAT TO LOOK FOR

Vertigo's emotional impact is heightened by fascinating use of color. Scottie, for instance, is constantly associated with red and Madeleine with green. At their first encounter, in Ernie's restaurant, Hitchcock makes the contrast especially pronounced. Scottie sits at the bar, eyeing Madeleine and her husband across the room; Madeleine's emerald-green dress stands out dramatically. As she walks through the restaurant and stops near Scottie in a profile, her green dress is framed against the velvety red walls. Hitchcock plays with the color scheme throughout the film, at one point having the characters wear each other's colors. And when Judy is transformed "into" Madeleine, she emerges through a foggy green light that enhances the romanticism and ghostliness of the moment.

—

To achieve the disorienting "vertigo" effect seen in the stairwell of the bell tower, Hitchcock worked with a model of the set placed on its side, with the camera at one end to simulate an overhead shot; the camera then zoomed in while tracking backward, a technique that has since been used by many other filmmakers.

—

The new owner of Madeleine's green Jaguar, with whom Scottie shares a brief scene, is played by Lee Patrick, who portrayed Humphrey Bogart's secretary, Effie, in *The Maltese Falcon* (1941).

.............

PILLOW TALK

Universal, 1959
Color, 102 minutes

DIRECTOR

Michael Gordon

PRODUCERS

Ross Hunter and Martin Melcher

SCREENPLAY

Stanley Shapiro and Maurice Richlin, based on a story by Russell Rouse and Clarence Greene

STARRING

ROCK HUDSON	BRAD ALLEN
DORIS DAY	JAN MORROW
TONY RANDALL	JONATHAN FORBES
THELMA RITTER	ALMA
NICK ADAMS	TONY WALTERS
JULIA MEADE	MARIE
ALLEN JENKINS	HARRY
MARCEL DALIO	PIEROT
LEE PATRICK	MRS. WALTERS
MARY McCARTY	NURSE RESNICK

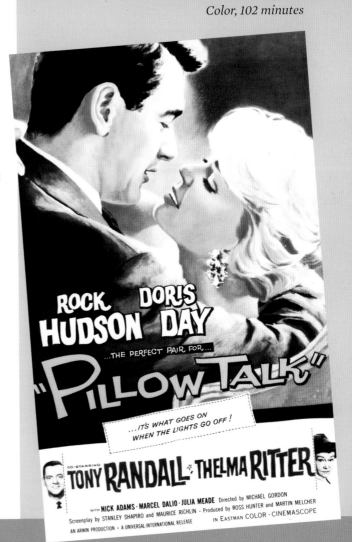

A MANHATTAN CAREER WOMAN FALLS FOR A CHARMING TEXAN, NOT REALIZING THAT HE IS ACTUALLY THE EXASPERATING PLAYBOY WHO SHARES HER PARTY LINE AND HAS ASSUMED AN ALTER EGO TO SEDUCE HER.

The script for *Pillow Talk* had been floating around Hollywood for more than fifteen years before producers Martin Melcher and Ross Hunter bought it in 1958. They were looking for a film to rejuvenate the career of Melcher's wife, Doris Day, who had been the number-one-ranked female star in 1952 but had lately been going through a bit of a slump. Here, they thought, was a sex comedy that could reinvent her image from girl next door to sophisticated career woman. The plan worked and then some: *Pillow Talk* became one of the biggest hits of 1959 and propelled both Day and Rock Hudson to the top of the star rankings, which they effectively ruled for the next five years. Their on-screen chemistry was so appealing that they became

an essential screen couple of the era, reuniting for two more comedies—*Lover, Come Back* (1961) and *Send Me No Flowers* (1964).

Pillow Talk is a battle-of-the-sexes farce whose plot owes something to *The Shop Around the Corner* (1940). Day plays a Manhattan interior decorator named Jan who shares a party line (a single telephone circuit serving multiple homes) with Brad, a womanizing songwriter played by Hudson. Annoyed by his phone-hogging and repulsed by his philandering manner, she detests him even though they have never physically met. Intrigued, Brad decides to seduce Jan in person by assuming the guise of a charming, respectful Texan.

Even though the film now plays quite innocently, despite its amusing sexual innuendo, it was seen differently at the time. Rock Hudson

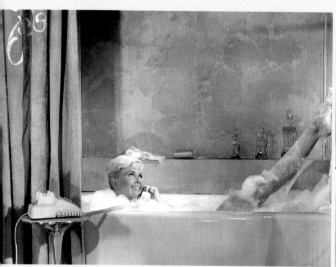

Pillow Talk's best-known image is the split-screen bathtub scene with Doris Day and Rock Hudson.

.............

recalled worrying that "we'd ruin our careers because the script was pretty daring stuff for 1960. The story involved nothing more than me trying to seduce Doris for eight reels." Hudson had built his stardom with dramas, westerns, and war movies, and his lack of comedy experience made him nervous to play opposite such an accomplished comedienne. But he found Day to be "an Actors Studio all by herself," teaching him comic timing and reactions by example. In the finished film, Hudson comes across as a natural—perfectly relaxed and confident.

Songwriting playboy Brad Allen (Rock Hudson) romances Marie (Julia Meade).

Day loved modernizing her image in *Pillow Talk*, down to her new hairdo and Jean Louis wardrobe. "For the first time I was wearing clothes in a picture that I felt accentuated my body and enhanced the part I was playing," she wrote. "The contemporary in me finally caught up with a contemporary film, and I really had a ball." She and Hudson developed a close friendship that lasted to his death in 1985. Certainly the rapport helped make their screen chemistry sizzle. The only trouble, said Hudson, "was trying not to laugh."

Lending the pair indispensable support are comedy players Thelma Ritter and Tony Randall. Ritter, a delight as Day's constantly hungover housekeeper, scored her fifth Oscar nomination with the role (she would be nominated a sixth time but never won the award). Randall's performance

Doris Day with Thelma Ritter, who was described as "one continuous laugh" in the Hollywood Reporter's *review*

as the friend of Hudson's who also pursues Day—in something of an update of Ralph Bellamy from *The Awful Truth* (1937)—sparked such winning chemistry that he returned for the two follow-up Hudson/Day comedies.

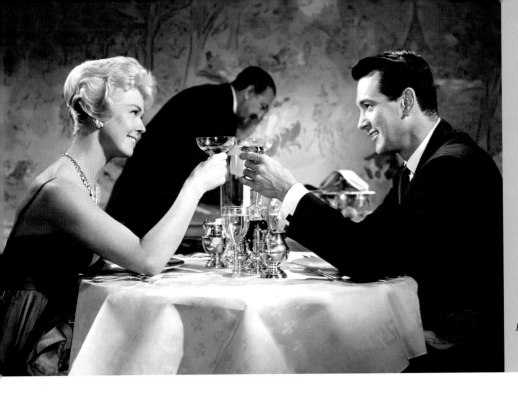

Picture-perfect
Doris Day and Rock
Hudson, who became
lifelong friends

Tony Randall wants Doris Day,
but she's got Rock Hudson on her mind.

Pillow Talk's most iconic image is the bathtub sequence, in which Day and Hudson have a phone conversation while luxuriating in their own tubs. The mischievous, split-screen composition makes it appear as if their toes are touching. The Production Code Administration complained about the scene, stating with remarkable perceptiveness in a letter to Universal: "The basic ingredient which we feel makes this sequence excessively sex suggestive is the fact that the two people seem to be facing each other in their separate tubs." Obviously, that was the entire, comedic point, and producer Ross Hunter was able to keep the scene intact.

The film was a comeback for director Michael Gordon, whose promising career had been cut short in 1951 after he refused to name names in

"The laughs come fast and often. The reaction to Doris and Rock as a romantic new team was so strong, plans were immediately put into motion to find another script for them. . . . For Rock, *Pillow Talk* was the start of a whole new career. Up to this point he'd always played the handsome, dramatic, leading man, but from here on, comedy became his forte. And although this is a romantic comedy and in no way a musical, Doris Day does sing three songs—certainly a nice added bonus."

Doris Day and Rock Hudson in a publicity photo

the McCarthy anti-Communist hearings. Blacklisted and desperate for work by 1958, he agonized before deciding to cooperate in secret, and was able to resume his career.

Pillow Talk opened in October 1959 and was number one at the box office for two months, grossing some $18 million (after a cost of $2 million). Reviews were effusive: the *Hollywood Reporter* compared Rock Hudson to Cary Grant, and *Time* magazine hailed the stars as "a couple of 1960 Cadillacs that just happen to be parked in a suggestive position." Doris Day received her sole Academy Award nomination, one of five nominations for the movie in all. It won for Best Original Screenplay.

WHAT TO LOOK FOR

The first scene to be shot was a comic set piece in which Rock Hudson carries Doris Day out of her apartment, across the street, and up to his own apartment. Because he had a back problem, the crew created a special shelf for Day to sit on so that the only weight Hudson had to hold with his arms were her legs and shoulders. In the same sequence, director Michael Gordon devised an amusing and believable way to introduce a cat, leading to a comic payoff when the cat enters Hudson's apartment.

THE APARTMENT

United Artists, 1960
B&W, 125 minutes

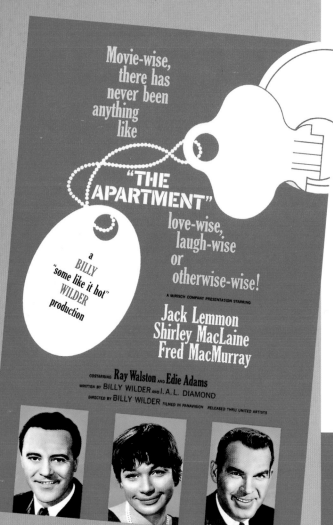

DIRECTOR
Billy Wilder

PRODUCER
Billy Wilder

SCREENPLAY
Billy Wilder and I. A. L. Diamond

STARRING

JACK LEMMON	C. C. BAXTER
SHIRLEY MacLAINE	FRAN KUBELIK
FRED MacMURRAY	JEFF D. SHELDRAKE
RAY WALSTON	JOE DOBISCH
JACK KRUSCHEN	DR. DREYFUSS
DAVID LEWIS	AL KIRKEBY
HOPE HOLLIDAY	MRS. MARGIE MacDOUGALL

A NEW YORK OFFICE WORKER TRIES TO CLIMB THE CORPORATE LADDER BY LENDING HIS APARTMENT TO HIS BOSSES FOR THEIR EXTRAMARITAL TRYSTS.

WHY IT'S ESSENTIAL

The plot of *The Apartment* could easily have made for pure farce. C. C. "Bud" Baxter, an accountant at a large Manhattan insurance firm, lends the key to his Upper West Side apartment to his higher-ups, who use it for their extramarital trysts; in exchange, they promise to promote Bud within the company. It's worth it to Bud, even if he must spend hours coordinating his bosses' schedules and standing outside in the cold, waiting to get into his own apartment. He also is the butt of neighbors' jokes about all the womanizing they assume *he* is doing. Yet *The Apartment* is only partially a farce. In the hands of producer-director Billy Wilder and his cowriter, I. A. L. "Izzy" Diamond, the plot's inherent comedy is laced with drama and heartbreak; the result is an achingly honest tale of two souls looking for tenderness in a harsh, cynical world. Sixty years on, *The Apartment* feels as fresh and incisive as ever, striking a perfect balance of comedy and drama, delight and despair, romance and cynicism, from beginning to end.

The film creates a great deal of compassion for Bud, who doesn't like the game he has gotten himself into. He yearns for a romantic connection with a spirited elevator girl, Fran Kubelik, only to discover, to his heartbreak, that she takes part in the philandering herself. But Fran only does

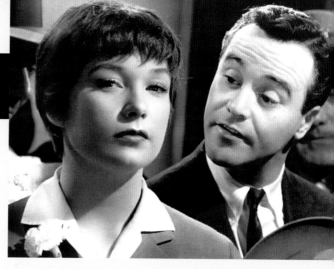

A comic moment as C. C. "Bud" Baxter (Jack Lemmon) tries to charm elevator operator Fran Kubelik (Shirley MacLaine)

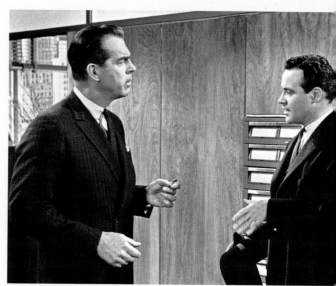

Fred MacMurray, Jack Lemmon, and the all-important key

so because she is fragile, so desperately in need of love that she will take what little she can get. Wilder lets the audience see the humanity in these characters, with the question becoming whether they will be able to see it in each other in the midst of their dehumanizing world. And still—the movie is also laugh-out-loud hilarious.

............

225

Wilder once said, "When I'm making a picture, I never classify it. . . . We get to the preview and if they laugh a lot, I say, 'This is a comedy.'" When he first had the idea for *The Apartment*, fourteen years earlier, Wilder didn't know what tone the story would ultimately take. He saw *Brief Encounter* (1945) and grew intrigued by the scene in which Trevor Howard and Celia Johnson rendezvous at the apartment of Valentine Dyall, who has lent Howard a key. Perhaps, Wilder thought, an entire movie could be made about the Dyall character. He filed the idea away for future use because the censorship restrictions at the time were too onerous. By 1959, however, they had loosened, and Wilder realized

that Jack Lemmon, whom he had just directed in *Some Like It Hot* (1959), would be perfect for the character.

To play Fran, Wilder cast twenty-five-year-old Shirley MacLaine, who had just played opposite Frank Sinatra and Dean Martin in two dramas and a musical comedy. *The Apartment* would be a major career breakthrough. She even inadvertently contributed a story element when she mentioned that her Rat Pack friends had taught her how to play gin; Wilder and Diamond immediately wrote a running gin game into the script, which prompts the movie's classic last line.

For the third major character, sleazy insurance executive Jeff D. Sheldrake, Wilder cast Paul

Bud (Jack Lemmon) is a cog in the machine.

Billy Wilder directs Shirley MacLaine.

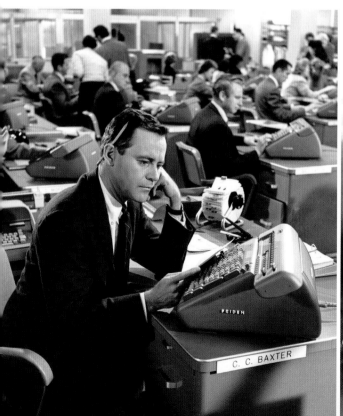

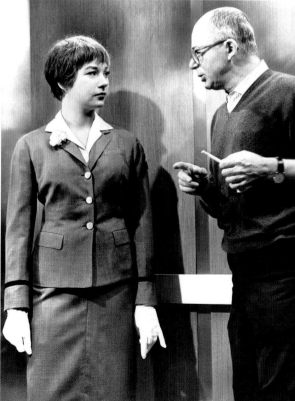

Jack Lemmon and Shirley MacLaine in a serious moment

Douglas. When the actor died of a heart attack two weeks before production, Wilder called his old friend Fred MacMurray, whom he had cast against type in 1944 as another sleazy insurance man, in *Double Indemnity*. By now, MacMurray was even more associated with light family comedies, and the notion of playing Sheldrake gave him considerable pause. Luckily, he took the part, a perfect bit of casting because Sheldrake is a character with a wholesome surface that hides a shady interior. *Double Indemnity* and *The Apartment* would wind up as arguably the two best films of MacMurray's long career.

Wilder shot *The Apartment* in fifty days and said the editing took less than a week. It was "a very lucky and happy picture," he later told Cameron Crowe, "the picture that has the fewest faults." He greatly valued the work of his art director, Alexander Trauner. For the early scenes of Jack Lemmon at his desk, with seemingly hundreds of other desks and workers behind him, Trauner designed a set in forced perspective to create the illusion of a massive room. The desks and workers all become smaller in size until they are very small desks with dwarf extras; beyond them, far in the background, the desks are tiny, with cutouts of people.

The Apartment was nominated for ten Academy Awards, including nods for Lemmon, MacLaine, and supporting actor Jack Kruschen. After winning for Best Art Direction and Best Editing early in the ceremony, the film won Best Original Screenplay, shared by Wilder and Diamond. A little later, playwright Moss Hart presented Wilder with his second Oscar, for Best Director, and jokingly whispered, "Billy, it's time to stop." Shortly afterward, *The Apartment* won Best Picture and Wilder returned to the podium yet again to become the first person in history to win three Oscars for a single movie.

.............

ROBERT OSBORNE

"Of all the films that won the Academy Award for Best Picture, I think it's one of the hardest to classify. It's not really a comedy. It's not really a drama. It's so many different kinds of movies. . . . I think Billy Wilder's one of the few who can walk that tightrope between cynicism and charm."

WHAT TO LOOK FOR

During the office Christmas bacchanal, Bud and Fran share a scene in which he recognizes her broken compact mirror and instantly realizes she has been having a secret affair. Bud is suddenly deflated, Fran seems lonelier than ever, and the audience sees their dynamic in a new light—all from one quick shot of Jack Lemmon's reflection in that mirror. It is an efficient moment that keeps the audience actively involved in the storytelling. As Wilder once said, "Let the audience add things up; let them do it for you. Don't say, '1 and 1 and 1 and 1 is 4—you get it?' Just say '2 and 2.' It's enough."

Jack Lemmon and Shirley MacLaine, who is delivering one of The Apartment's *most famous lines*

.............

Paramount, 1960
B&W, 109 minutes

DIRECTOR

Alfred Hitchcock

PRODUCER

Alfred Hitchcock (uncredited)

SCREENPLAY

*Joseph Stefano, based on the
novel by Robert Bloch*

STARRING

ANTHONY PERKINS NORMAN BATES

JANET LEIGH MARION CRANE

VERA MILES LILA CRANE

JOHN GAVIN SAM LOOMIS

MARTIN BALSAM DETECTIVE MILTON ARBOGAST

JOHN McINTIRE SHERIFF AL CHAMBERS

SIMON OAKLAND DR. FRED RICHMAN

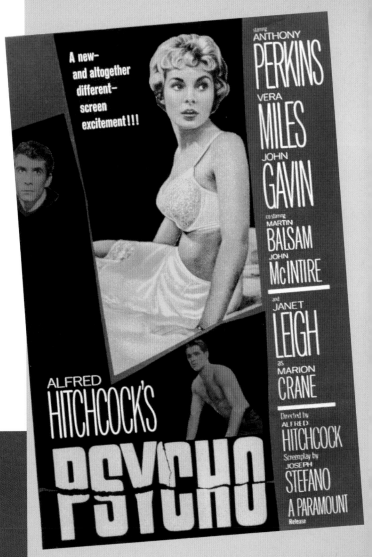

**ON THE RUN WITH
$40,000 SHE
EMBEZZLED, A
SECRETARY DRIVES
FROM PHOENIX
TOWARD LOS ANGELES,
STOPPING ONE
RAINY NIGHT AT
THE BATES MOTEL.**

WHY IT'S ESSENTIAL

Perhaps the highest compliment that can be paid to *Psycho*, sixty years after its release, is that it is still scary, still unsettling, still riveting. That is no small feat for one of the most analyzed classics in movie history, a film that changed the course of the horror genre and has influenced countless pictures to this day—not to mention spawning three sequels, a five-season television prequel, numerous parodies, and a near shot-for-shot remake. *Psycho*'s raw emotional power has endured thanks to Alfred Hitchcock's mastery of film form. As he told François Truffaut, "It's tremendously satisfying to be able to use the cinematic art to achieve something of a mass emotion. . . . They were aroused by pure film."

Every aspect of the movie is designed to create tension in the audience. It's in the credits designed by Saul Bass, with words breaking apart on the screen to the accompaniment of Bernard Herrmann's frantic score. It's in the opening scene of Marion (Janet Leigh) and Sam (John Gavin) sharing an awkward tryst in a hotel room. It's in Marion's office, as a man crudely hits on her, and it runs through Marion's long drive out of Phoenix, as she is tormented by guilt and paranoia. Tension also certainly abounds at the creepy Bates Motel. Even when Marion's anxiety begins to subside, the audience has grown uneasy over something new: the strangeness of Norman Bates. There is ominous tension literally *within* Norman, and when Marion exits the picture, the audience is left only with him—forced by

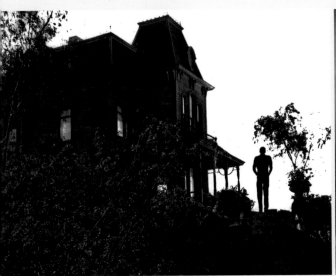

Norman (Anthony Perkins) outside the Bates house, which still stands on the Universal Studios back lot

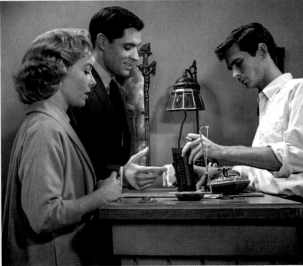

Vera Miles and John Gavin share a tense moment with Anthony Perkins.

Janet Leigh and John Gavin shooting the opening scene, which was considered risqué at the time

Hitchcock's camera to share his perspective and even feel relief when he cleans up the aftermath of a brutal crime.

That shift remains highly unnerving and is part of the reason *Psycho* is so esteemed—because the movie masterfully, and repeatedly, changes the audience's point of view. "I was playing them, like an organ," Hitchcock said. Over and over, Hitchcock makes the audience feel safe, and then unsafe. The car is safe—until a cop starts asking questions. The motel room is safe—until Norman spies through a peephole. There is safety in one of the most private places anyone could be—the shower—until a moment so shocking that no viewer ever forgets it.

Perhaps no movie scene has been pored over more than *Psycho*'s shower sequence. Killing off the main character—and the film's only star—less than halfway through the story was a shock in its own right in 1960. The scene itself holds up as terrifying and technically groundbreaking. Rapid editing, disorienting jump cuts, extreme close-ups, and stabbing sounds (created by slashing a casaba melon and a sirloin steak) all combine to give the impression of being brutally murdered. Bernard Herrmann's music—shrieking, piercing violins—intensifies the terror so dramatically that it is still one of the world's best-known pieces of film music. Ironically, Hitchcock didn't want this sequence scored. Herrmann composed the

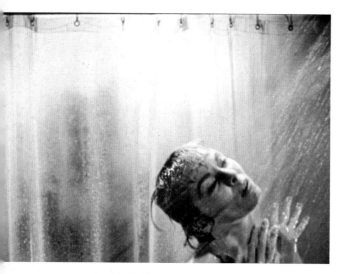

A shadow behind Janet Leigh ratchets up the tension.

cue anyway and ran it for Hitchcock with the finished scene, and Hitchcock immediately conceded that Herrmann was correct. The sequence was shot over seven days in mid-December 1959. Janet Leigh recalled, "During the day, I was in the throes of being stabbed to death, and at night I was wrapping presents from Santa Claus for the children."

Thanks to Hitchcock's (and Herrmann's) brilliant use of cinema, the shower scene is a shock to the senses that lingers for the rest of the picture. Hitchcock knew this would happen, which is why his later "shocks" are less violent. "As the film went on," he said, "the manifestation of horror on the screen could diminish. But it increased in the mind of the audience."

Based on a novel by Robert Bloch that was inspired by the gruesome tale of real-life killer Ed Gein, *Psycho* was considered by Paramount to be a distasteful property. Hitchcock could only procure a budget of $800,000 and even deferred his salary in exchange for a financial stake in the film. To cut costs, he used crew members from his *Alfred Hitchcock Presents* television show, with a few exceptions—most notably Herrmann, whose all-stringed score is vital to *Psycho*'s effectiveness. For long stretches with no dialogue, it is the music that generates unease in the audience. Hitchcock actually felt the film was a failure and was going to drastically recut it until Herrmann convinced him to hold off for a score.

The rest was history. *Psycho* was a sensation despite middling initial reviews and became the most profitable film of 1960. It drew four Oscar nominations, including nods for Hitchcock and Leigh—and it set the foundation for the modern horror movie.

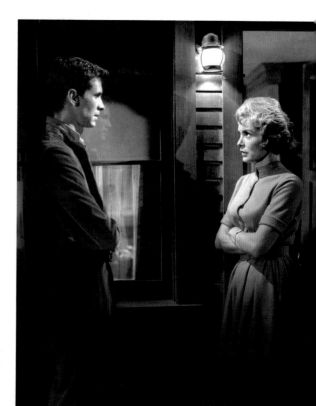

Norman Bates (Anthony Perkins) and Marion Crane (Janet Leigh)

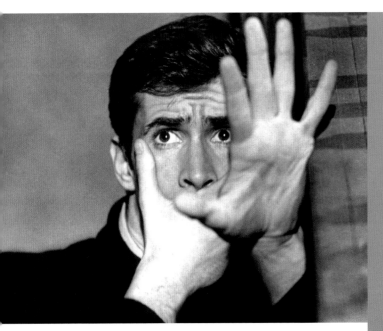

"This so changed the direction of [Perkins's] career. He was identified with horror films and he kept doing sequels. I always felt badly about that because he was too good an actor to just be categorized as a horror film actor. . . . This is also a movie that had to be in black and white because that kind of graininess and look helped add to the coldness and fright of the film."

Anthony Perkins in his career-defining performance as Norman Bates. Perkins returned to the role in three sequels, one of which he directed.

WHAT TO LOOK FOR

For much of Marion's drive to the Bates Motel, Hitchcock keeps the audience with her in the car, cutting between a shot of Janet Leigh looking straight ahead into the camera and a shot of the road from her point of view through the windshield. This builds viewers' identification with her but also sets up a clever, subtle payoff. Just before Marion arrives at the motel, it starts to rain. The neon *Bates Motel* sign emerges in the distance as water beats down and the windshield wipers slice sharply across the frame. This "entry" to the motel will be visually paralleled by Marion's "exit" from it—and from the world—with the imagery of a knife slashing through the shower.

—

Psycho is also a film about voyeurism, a theme Hitchcock explored throughout his career. In the opening seconds, the airborne camera moves through a window to reveal Marion and Sam partially undressed on a bed, immediately turning the audience into voyeurs of an intimate moment. Later, Norman spies on Marion through a peephole, an uncomfortable moment of voyeurism because it shifts the audience to Norman's point of view.

—

While facing Production Code challenges for violence and nudity, Hitchcock got away with showing—and flushing—a toilet on-screen for supposedly the first time in a Hollywood movie.

.............

RIDE THE HIGH COUNTRY

MGM, 1962
Color, 94 minutes

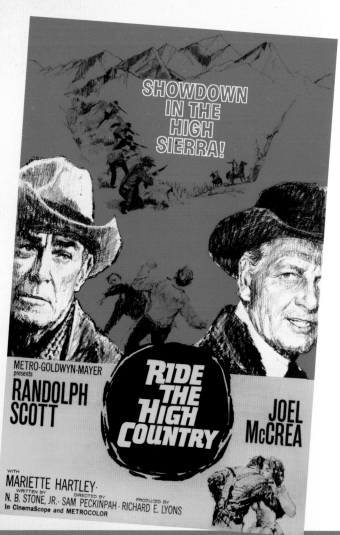

DIRECTOR

Sam Peckinpah

PRODUCER

Richard E. Lyons

SCREENPLAY

N. B. Stone, Jr.

STARRING

RANDOLPH SCOTT GIL WESTRUM

JOEL McCREA STEVE JUDD

MARIETTE HARTLEY ELSA KNUDSEN

RON STARR HECK LONGTREE

EDGAR BUCHANAN JUDGE TOLLIVER

R. G. ARMSTRONG JOSHUA KNUDSON

JENIE JACKSON . KATE

JAMES DRURY BILLY HAMMOND

L. Q. JONES SYLVUS HAMMOND

JOHN ANDERSON ELDER HAMMOND

JOHN DAVIS CHANDLER JIMMY HAMMOND

WARREN OATES HENRY HAMMOND

**TWO AGING EX-LAWMEN TAKE A JOB TRANSPORTING
A SHIPMENT OF GOLD FROM A MINING CAMP TO A BANK,
BUT ONE PLANS TO DOUBLE-CROSS THE OTHER.**

Director Sam Peckinpah's second feature was this lyrical, ultimately poignant look at an Old West—and a movie genre—in transition. Peckinpah represented the future of the western, with his revisionist and more violent *The Wild Bunch* (1968) still to come, and Randolph Scott and Joel McCrea embodied the traditional western past. Durable, talented, enormously popular movie stars, they had been known almost exclusively for westerns over the preceding decade, though they had never worked together until now. While McCrea would appear again years later in three minor films, Scott retired for good after *Ride the High Country*, and the film effectively serves as a swan song for both—a chance to saddle up one more time and ride off in poetic glory.

McCrea, who turned fifty-six during production, plays Steve Judd, an ex-lawman who signs on to deliver gold from a mining camp to a small-town bank. Helping him are his old friend Gil Westrum, played by sixty-three-year-old Scott, and a young gun named Heck. The time is the early 1900s: the town employs a uniformed policeman, there's a horseless carriage parked on the road, and Steve and Gil are clearly out of place and past their prime. Despite light comedy about their age, fading eyesight, and aching bodies, it's just as clear that the world doesn't

Joel McCrea, Mariette Hartley, and Ron Starr amidst scattered autumnal leaves

Mariette Hartley, Ron Starr, Joel McCrea, and Randolph Scott ride into the mining camp. Cameraman Lucien Ballard used soap suds to represent snow in the searing heat of this location.

know they are still western heroes. They can easily defend themselves when need be and they live by a strong moral code—or at least Steve does. Gil plans to steal the gold if he can't talk his friend into stealing it with him. Steve will have none of it. "All I want is to enter my house justified,"

............

"I think it's the most moving, the most lyrical, of all Peckinpah westerns. Somehow he's able to face women and death [here]. He's pushing it away in some way in his later films, but he's grasping it here. . . . It's unusual in focusing on two old guys. And it's very funny. Joel McCrea had a very strong sense of who he was and what he could play, and that kind of integrity comes through in his characterizations."

he says in the film's most famous line, getting to the heart of this satisfying morality tale.

Peckinpah had spent years in television and made one film before MGM producer Richard E. Lyons offered him this project, originally known as *Guns in the Afternoon*. Peckinpah jumped at the chance to turn the screenplay into something truly personal. Rewriting the vast majority of the dialogue, he deepened the characters' friendship and heightened themes that would dominate Peckinpah's entire career—the death of the West, self-respect, maintaining a moral code. The "enter my house justified" dialogue (a near-quote from the Bible) was something that Peckinpah's father had said before his death, and Peckinpah went so far as to see Steve as representing his father and Gil as a stand-in for the director himself.

Scott and McCrea were already considering retirement, but the quality of the script and the chance to work together lured them on board. Luckily, they each wanted to play different parts. McCrea was initially offered the role of morally compromised Gil Westrum, but he replied that "if I was going to make one more picture, I wasn't going to destroy my image with it. My image was

Mariette Hartley and James Drury in a brief moment of calm amid a tense wedding sequence. Hartley's hair was cut short because she had just played St. Joan onstage.

Steve Judd (Joel McCrea, far left) at the mining camp with the Hammond father and sons (from left: John Anderson, John Davis Chandler, James Drury, and Warren Oates). Chandler and Oates would reappear in future Peckinpah films.

Not your usual western town: Ron Starr sits astride the camel. Sam Peckinpah remembered seeing a camel-horse race as a child in North Fork, California.

Steve Judd." Scott, meanwhile, wanted to play Gil because he thought it would be an interesting change of pace.

In her film debut, Mariette Hartley plays Elsa, who joins the group to escape her overly religious father and to reunite with her fiancé at the mining camp. One of Hartley's finest hours is the grotesque wedding sequence held at a brothel—a marvel of complex staging and editing by Peckinpah. Through the marriage ceremony, a terrifying dance, a chilling bedroom scene, and a tense showdown, Peckinpah keeps the audience continually grounded in Elsa's growing unease, confusion, and fear.

Ride the High Country had a low budget of about $800,000 but looks highly polished thanks to its widescreen, color cinematography by the great Lucien Ballard. The picture shot for four days in the High Sierras near Mammoth Lakes (an area Peckinpah knew from his childhood),

until snowy weather prompted MGM to move the production to the Santa Monica mountains. After Peckinpah produced a cut of the film with editor Frank Castillo, MGM's studio management changed. The new chief, Joseph Vogel, fell asleep during a screening of the film, then woke up and declared it the worst picture he had ever seen. He barred Peckinpah from the lot, prompting Castillo to finish the sound editing while Peckinpah gave his input over the phone. Luckily, Vogel considered the film too cheap and minor to be worth recutting; instead, he released it with zero fanfare on the lower half of a double bill. Critics, however, discovered it for the instant classic it was. Their rave reviews baffled MGM, but the studio nonetheless finally gave it a proper release, and it found commercial success.

Ride the High Country is a pleasure for the chemistry and droll banter between McCrea and Scott, two old pros and western heroes who essentially debate through the film what it means to *be* a hero. Their final scene is iconic in American cinema. According to Peckinpah's sister, the poignant final image, which includes McCrea turning to look at the western landscape, was inspired by a photograph that Peckinpah had taken of his father not long before his death. Mariette Hartley recalled that after filming this shot, the set remained quiet, and she "looked up at the tears streaming down Randy Scott's face. I was awestruck. I had never seen that kind of acting."

Two western heroes sharing the frame: Randolph Scott and Joel McCrea

ROBERT OSBORNE

—

"*Joel McCrea and Randolph Scott both made a definite decision to only do westerns after a certain point. I think it was 1947 when Randolph Scott decided he would never do a non-western again, and never did. . . . It was a great way to go out for both of them.*"

WHAT TO LOOK FOR

Peckinpah's distinct stamp is visible in the climactic shootout on a farm between the two heroes, Gil and Steve, and three of the Hammond brothers, as chickens wander on the ground between them all. Peckinpah shot it over six days from some 150 camera positions, capturing extreme long shots, tight close-ups, subjective shots, tracking shots, and reactions of Elsa and Heck watching from the sideline. The result was a brilliant, rapid montage, showing an approach to violence that was a portent of even more stylized things to come in *The Wild Bunch*. The chickens make for a great payoff when the Warren Oates character shoots at them in frustration during the gunfight—a touch that only Sam Peckinpah could have dreamed up.

THE BATTLE OF ALGIERS

Casbah Films/Igor Films (Algeria-Italy), 1966
B&W, 121 minutes

DIRECTOR

Gillo Pontecorvo

PRODUCERS

Antonio Musu and Saadi Yacef

SCREENPLAY

Franco Solinas

STARRING

BRAHIM HAGGIAG	ALI LA POINTE
JEAN MARTIN	COLONEL MATHIEU
SAADI YACEF	EL-HADI JAFFAR
SAMIA KERBASH	FATIHA
UGO PALETTI	CAPTAIN
FUSIA EL KADER	HASSIBA
MOHAMED BEN KASSEN	LE PETIT OMAR

Tension in a Casbah alley with Saadi Yacef and Brahim Haggiag as FLN fighters in disguise

ALGERIAN REVOLUTIONARIES BATTLE FOR INDEPENDENCE AGAINST COLONIAL FRENCH MILITARY FORCES IN 1950s ALGIERS.

"A MOST EXTRAORDINARY FILM!"
—NEW YORK TIMES

WHY IT'S ESSENTIAL

Groundbreaking and still influential, *The Battle of Algiers* is a war movie with the pacing and suspense of a Hollywood thriller but the look and feel of a documentary. Its realism is at times so intense that its first American distributor added a disclaimer before the credits: "This dramatic re-enactment of The Battle of Algiers contains NOT ONE FOOT of newsreel or documentary film." In other words, every shot was meticulously staged, including scenes of riots, demonstrations, and bombings that punctuate the movie and are carefully designed to *look* like newsreel footage. The brilliant technique by Italian director Gillo Pontecorvo creates immediacy and relentless energy as the film examines the morality of political violence.

Set in Algiers primarily between 1954 and 1957, the movie depicts the battle between the Algerian FLN (National Liberation Front) and French paratroopers sent to put down the rebellion after the police are unable to do so. The FLN operatives are simply fighting for their independence; the French are simply trying to defeat what they consider to be terrorists. As the French Colonel Mathieu says, "It's a faceless enemy, unrecognizable, blending in with hundreds of others. It is everywhere. In cafés, in the alleys of the Casbah, or in the very streets of the European quarter." One of Pontecorvo's achievements is to present both sides in shades of gray, even if the film does lean a bit more sympathetically toward the freedom fighters. Both sides commit inhuman acts of violence and brutality, and both are led by smart, charismatic

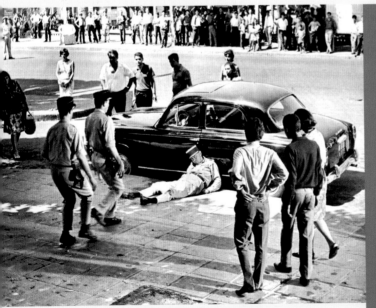

One of many images that look like documentary footage

BEN MANKIEWICZ

"I can't have a conversation about the ten or fifteen best movies withou including The Battle of Algiers. . . . *I know they didn't use documentary or newsreel footage, and yet every tim I see certain scenes, I think, 'That's obviously newsreel footage,' and you cannot convince me otherwise—eve though I know they're not lying."*

Director Gillo Pontecorvo at work

Le Petit Omar (Mohamed Ben Kassen) reads a letter to Ali La Pointe (Brahim Haggiag).

commanders—Mathieu on one side and El-Hadi Jaffar on the other.

Jaffar is portrayed by Saadi Yacef, a real-life FLN leader, essentially as himself. Yacef had been captured during the war, released after Algeria won its independence in 1962, and was now running the Casbah Film Company in Algiers (he said he "substituted the camera for the machine gun"). His memoir of the battle served as a primer for the eventual screenplay by Franco Solinas, who interviewed many eyewitnesses to the real-life rebellion. The script and direction cleverly avoid almost any hint of traditional melodrama, keeping the tone intentionally detached and observational.

Pontecorvo was inspired by his own country's tradition of neorealist cinema, especially Roberto Rossellini's *Rome, Open City* (1945) and *Paisan* (1946), and he used a variety of techniques to achieve the documentary effect. He shot on 16-millimeter filmstock, then blew it up to 35-millimeter, with the final prints struck from a duplicate of a duplicate of the camera negative— all of which created a desired graininess and "decrease" in quality. He and cinematographer Marcello Gatti shot in diffuse light, blocking out the sun when necessary so that the film would look mostly gray. They used a long lens for many scenes to create a deliberately flat look. For crowd sequences, Pontecorvo directed each extra near the camera to move with a distinct purpose in

"[Pontecorvo] is able to conjure a sense of time and place, but also energy, the revolutionary spirit. The filmmaking is so visceral. . . . Grand themes [are] rendered with real intimacy and brashness, and also a humility in the filmmaking in the choice of the faces shown in the midst of war."

mind, and he chose camera angles to give the audience a sense of glimpsing the edges of real events as they unfold, with occasional zooms and a shaky camera.

Most crucially, he had the cooperation of the Algerian government to shoot on location in the labyrinthine alleys of the Casbah, as well as the enthusiastic support of the city's residents, from whom he cast almost every role in the film. The only professional actor on-screen is Jean Martin as Colonel Mathieu; all others are amateurs whom Pontecorvo found on the streets or in cafés.

Second from left: Saadi Yacef as Jaffar, the FLN leader. Far right: Brahim Haggiag as Ali La Pointe

This includes Brahim Haggiag as the third primary character, Ali La Pointe, a young recruit who rises toward the top of the FLN. Haggiag was an illiterate farmer who had never even seen a film, but he looked almost exactly like the real Ali La Pointe. Pontecorvo fed him his lines before each shot, and his screen presence is unforgettable.

Pontecorvo's final stroke of inspiration was in asking Ennio Morricone to score the film. It became one of the composer's finest, from the opening cue that generates instant energy and tension to the mournful "Ali's Theme," based on a four-note sequence that Pontecorvo had whistled.

The Battle of Algiers premiered at the 1966 Venice Film Festival, where it won the Golden Lion. It was Oscar-nominated for Best Foreign Language Film, and then two years later (due to its release schedule and Academy rules at the time) it was nominated again, for Best Screenplay and Best Director. In the years that followed, it came to be seen as a primer both in guerrilla warfare and in tactics used to defeat such warfare, and it has been screened by insurgent groups and government agencies for those purposes. Most important of all, it remains thrilling cinema for any audiences.

.............

The only professional actor in the film: Jean Martin as Colonel Mathieu

WHAT TO LOOK FOR

The picture's most suspenseful scene, drawn from real life, depicts the planning and execution of three bombings by three Algerian women. They begin by cutting their hair and dressing in western clothes to impersonate French women—a segment that was originally four minutes long and contained much dialogue. When Pontecorvo realized its tone was too lighthearted, he cut the dialogue and reshot the scene while playing Ennio Morricone's propulsive score on the set. This put the actors in a more serious frame of mind and launched the sequence's tremendous tension. The lack of dialogue has the effect of maintaining a dispassionate tone, so that the audience roots neither for nor against the women but simply observes their tragic actions.

—

The man who plays the informer in the opening scene was a petty thief in the middle of a fifteen-day jail sentence. According to Pontecorvo, he cried when his work was done because he had to go back to jail.

.............

243

THE PRODUCERS

Embassy Pictures, 1968
Color, 89 minutes

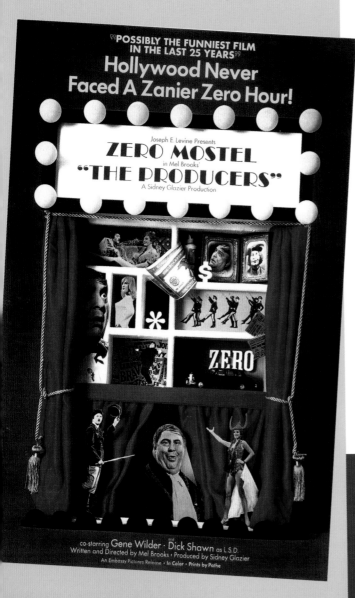

DIRECTOR

Mel Brooks

PRODUCER

Sidney Glazier

SCREENPLAY

Mel Brooks

STARRING

ZERO MOSTEL MAX BIALYSTOCK

GENE WILDER. LEO BLOOM

ESTELLE WINWOOD "HOLD ME TOUCH ME"

CHRISTOPHER HEWETT ROGER DE BRIS

KENNETH MARS FRANZ LIEBKIND

LEE MEREDITH . ULLA

DICK SHAWN . L.S.D.

RENEE TAYLOR EVA BRAUN

ANDREAS VOUTSINAS CARMEN GHIA

BILL HICKEY THE DRUNK

TWO BROADWAY PRODUCERS DEVISE A SCHEME TO MAKE MONEY BY INTENTIONALLY PRODUCING A FLOP, BUT THE PLAN BACKFIRES.

WHY IT'S ESSENTIAL

From *The Great Dictator* (1940) and *To Be or Not to Be* (1942) to *Jojo Rabbit* (2019), filmmakers have long found ways to make audiences laugh at Adolf Hitler. In 1968, Mel Brooks launched his directing career by accomplishing the feat with his unique blend of witty and outrageous humor, resulting in a comedy milestone that eventually worked its way into American popular culture.

In fact, the central joke of *The Producers* is rooted in the very nature of comedy itself. Max Bialystock and Leo Bloom, two Broadway "producers" (only Max has any experience), plan

Leo Bloom (Gene Wilder) and Max Bialystock (Zero Mostel). Mel Brooks said that as a first-time director, he didn't fully understand the importance of shooting coverage (a variety of angles), "so there were a lot of tight shots and close-ups which, in my naiveté, saved me."

to make a fortune by raising more money than they need to mount an intentionally awful show; when it flops on the first night, they will pocket the leftover money. They find a terrible script: a musical comedy called *Springtime for Hitler: A Gay Romp with Adolf and Eva in Berchtesgarten*, written by a crazed Nazi named Franz Liebkind. They convince Franz that they will show the world the Hitler he loved, "the Hitler with a song in his heart." The problem is that what they believe will be seriously bad crosses the boundary into hilariously bad; the opening-night audience sees it as pure satirical farce, and the show becomes a Broadway sensation. Max laments, "I picked the wrong play, the wrong director, the wrong cast. Where did I go right?"

Mel Brooks had dreamed up this idea more than a decade earlier, after working for a producer

Comedian Dick Shawn as a hippie nicknamed "L.S.D." playing Hitler, with Renee Taylor as an actress playing Eva Braun

.............

who seduced little old ladies for their money and after hearing about two other producers who made flop after flop. "God forbid they should ever get a hit," a press agent told Brooks, "because they'd never be able to pay off the backers." Instantly, the story came to Brooks's mind. He tried writing it as a novel and then as a play before realizing it would work best as a movie. No studio would touch it, however; the story and title (which was then *Springtime for Hitler*) were seen as too risky. Eventually, a private investor put up half the budget, with the rest coming from Embassy Pictures' Joseph Levine, who also agreed to take a chance on Brooks directing—if he would change the title so as not to cause trouble with theater owners.

Brooks later said that Peter Sellers accepted the role of Leo but never replied to further communications; Brooks then offered it to his friend Gene Wilder, a theater actor with just one movie credit, a small role in *Bonnie and Clyde* (1967). *The Producers* would introduce Wilder to the world as a major comic talent, with his nervous hysteria and growing panic a perfect

Eighty-five-year-old stage actress Estelle Winwood is a hoot as a rich lady romanced by Zero Mostel for her money, but she was not proud of the film. "I must have needed the money," she said ironically. She lived to age 101.

Andreas Voutsinas (right) fixes up Christopher Hewett, who plays Roger De Bris, the director of Springtime for Hitler. *Brooks directed Voutsinas to "play it like Rasputin, but move like Marilyn Monroe."*

ROB REINER
—

"The Producers is a comedy landmark. It has a take on humanity that could only come from Mel Brooks. Of all his movies, I think it is the single most pure expression of Mel's humor. He is never afraid to go where no comic genius has gone before."

Franz the Nazi (Kenneth Mars) terrorizes Leo (Gene Wilder), Max (Zero Mostel), and Ulla (Lee Meredith), their Swedish bombshell of a secretary. Meredith's real name is Judi Lee Sauls; this was her first feature appearance.

complement to the brashness and confidence of Zero Mostel, who plays Max. Wilder and Mostel are not just hilarious but also poignant and lovable, in the tradition of Laurel and Hardy.

Brooks surrounded them with a brilliant supporting cast led by Kenneth Mars as Franz Liebkind, who is so happy that his play will be produced that he shares the news with his rooftop birds and breaks into a rendition of "Yankee Doodle Dandy." Mars stayed in character by supposedly wearing the same clothes for the entire two-month shoot, even sleeping in them. He also insisted on having bird droppings placed on his German helmet. "I didn't know whether the character was

crazy or Kenny Mars was crazy," said Wilder.

The comic centerpiece of *The Producers* is the show *Springtime for Hitler* and its unforgettably great/awful title number. Brooks wrote the lyrics and told composer John Morris to make the music "big, wonderful, flashy, but terrible." Choreographer Alan Johnson said "there were no limits" as Brooks encouraged him to go bigger and broader, resulting in a riotous throwback to Busby Berkeley—an overhead shot of dancers forming a swastika.

The Producers opened in limited release to poor attendance and mostly negative reviews until Peter Sellers saw it by chance at a private screening. He was so impressed that he took

.............

out full-page ads in *Variety* and the *New York Times* proclaiming the film a masterpiece, "the essence of all great comedy combined in a single motion picture." Thanks in no small part to that endorsement, *The Producers* performed well in several cities, although overall it did not make money. Hollywood, however, recognized the achievement by awarding Brooks the Oscar for Best Original Screenplay and nominating Wilder for Best Supporting Actor. In the years following, *The Producers* became a cult favorite, and in 2001, Brooks refashioned it into one of the most successful Broadway musicals of all time. In 2005, he turned that show into a movie musical. "It's been one of my lifelong jobs," he said, "to make the world laugh at Adolf Hitler."

"Springtime for Hitler"

| WHAT TO LOOK FOR | |

Late at night, sitting on the edge of the fountain at Lincoln Center, Max finally convinces Leo to go along with the scheme. Leo stands and shouts, "I'll do it!" The fountain lights up, water shoots skyward, and Leo runs a triumphant lap. This stirring scene was the last to be shot. Filming started after dusk. The water was set to shoot eight feet high until an engineer told Brooks that he could rig it to soar sixteen feet. Gene Wilder recalled, "It was [a] great thrill. . . . When the water shot up from the fountain, and I was running around, I said I'd like to do this for the rest of my life." The production wrapped as dawn broke, and everyone went to a restaurant to celebrate over breakfast.

—

The Producers introduced two phrases to the world: "creative accounting" and "when you've got it, flaunt it."

2001: A SPACE ODYSSEY

MGM, 1968
Color, 149 minutes (including overture, entr'acte, and exit music)

DIRECTOR

Stanley Kubrick

PRODUCER

Stanley Kubrick

SCREENPLAY

Stanley Kubrick and Arthur C. Clarke

STARRING

KEIR DULLEA DAVE BOWMAN

GARY LOCKWOOD. FRANK POOLE

WILLIAM SYLVESTER HEYWOOD FLOYD

DANIEL RICHTER MOONWATCHER

LEONARD ROSSITER ANDREI SMYSLOV

MARGARET TYZACK ELENA

DOUGLAS RAIN VOICE OF HAL 9000

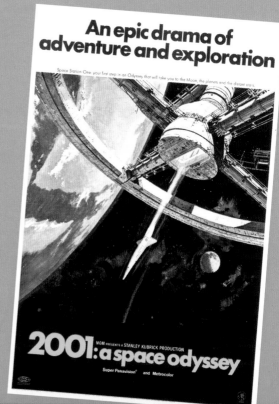

AFTER A MYSTERIOUS MONOLITH IS FOUND BURIED BENEATH THE LUNAR SURFACE, ASTRONAUTS VENTURE DEEP INTO THE SOLAR SYSTEM TO INVESTIGATE FURTHER.

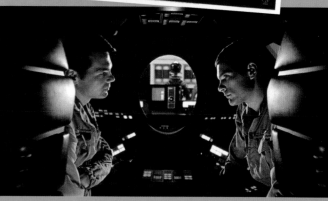

Gary Lockwood (left) and Keir Dullea as astronauts Frank Poole and Dave Bowman, discussing what to do about the malfunctioning HAL, who can see them with his "eye," the red light at frame center

WHY IT'S ESSENTIAL

In the spring of 1964, Stanley Kubrick wrote a letter to novelist and futurist Arthur C. Clarke, proposing they collaborate on "the proverbial 'really good' science-fiction movie." Four years later, the resulting *2001: A Space Odyssey* opened in theaters, surviving a mixed initial reception to become one of the great touchstones of cinema. It would influence every science-fiction filmmaker to come with its unparalleled realism, grand scale, wondrous technical achievements, and bold departure from traditional movie storytelling.

Structured in four sections that span the millennia from the time of pre-human apes to an unspecified point in the future, *2001*'s "story" is essentially the nature and evolution of human consciousness, mankind's place in the universe, and the possibility of future evolution into a state beyond current understanding. The film poses questions rather than answers, but Kubrick creates a spellbinding sense of wonder and awe through which those questions become engaging, fulfilling, and even suspenseful.

In each of the four acts, a black monolith of unknown origin somehow nudges human

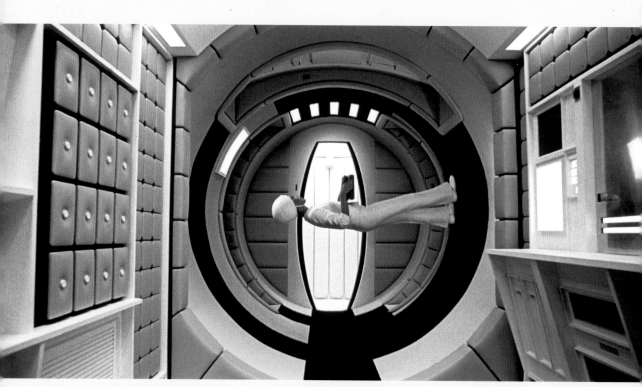

Penny Brahms as a flight attendant. Since 2001 was made before the era of computer-generated imagery, this was a practical effect created by rotating the entire set, and camera, around the actress with perfect precision.

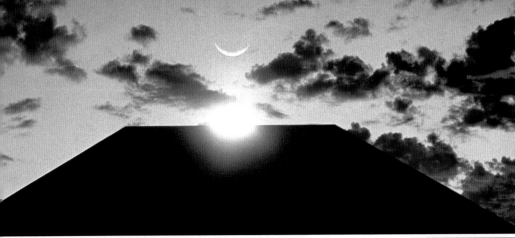

The monolith

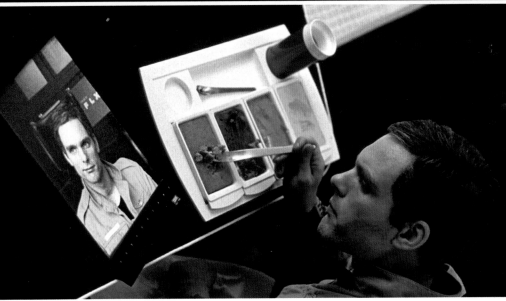

Dave Bowman (Keir Dullea) dines while watching an interview of himself on a tablet called a "News Pad," one of several predictions that 2001 got right. The film also foresaw seatback video screens, video phone calls, jogging astronauts, and a Siri-like interface in HAL. One thing the film got wrong: the survival of the airline Pan Am.

development along. The one on the moon sends a signal toward Jupiter, prompting a manned mission to that vicinity; the mission becomes the heart of the picture, a riveting tale of man versus machine, as the spacecraft's HAL 9000 supercomputer malfunctions and tries to take over the ship and murder the crew.

An interactive computer both dominating human life and breaking down are just some of the ways in which *2001* proved to be prescient—

the result of intense research by Kubrick and Clarke. But HAL also fascinates by coming across as more "human" than the human characters. Voiced by Douglas Rain, he has the most entertaining lines of dialogue and reveals more emotion than the banal astronauts played by Keir Dullea and Gary Lockwood, who speak and move almost robotically. Dullea said that Kubrick directed them to underplay their scenes to generate this very contrast. On the other hand,

Kubrick didn't want to overdo it, as evidenced by his decision to replace HAL's original voice actor, Martin Balsam, because Balsam was speaking *too* emotionally. Yet the dialogue is ultimately incidental to the movie. Kubrick tells his story with mesmerizing images, sound, and classical music that keep the film's meaning on the grandest of scales. The soundtrack, best known for Johann Strauss's *Blue Danube* waltz and Richard Strauss's commanding *Also Sprach Zarathustra*, also makes use of the work of Gyorgy Ligeti and Aram Khachaturian.

Most of the production time and budget were devoted to creating the pioneering special effects, from detailed spaceship miniatures to a life-sized, rotating set that depicts the revolving space station interior. For the mind-blowing stargate sequence in which Keir Dullea travels through a light show of time and space, one of the film's photographic effects supervisors, Douglas Trumbull, custom-built a special "slit-scan" photography machine: each frame, or 1/24th of a second, took four minutes to produce. Trumbull, just twenty-four years old, went on to become one of the most renowned artists in his field.

Filmed in Super Panavision 70 for release in 70mm Cinerama, *2001* is a film that ought to be experienced in a theater. It has an almost subliminal effect that is heightened by a bigger screen. Upon its initial release, however, the movie was greeted with derision and bafflement, especially by older audiences and critics who were turned off by its pacing and mysterious ending. Kubrick trimmed it by nineteen minutes, but the release was really saved by young hippies

HAL's blood-red memory bank, where Dave attempts to shut HAL down in a haunting, poignant sequence

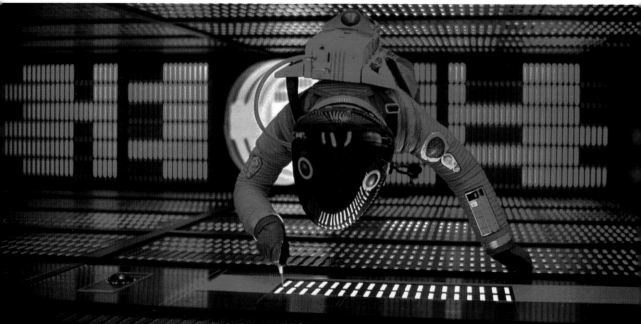

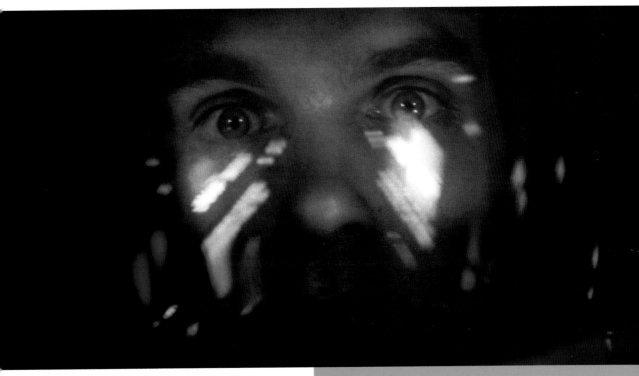

Dave Bowman experiencing the psychedelic "stargate" sequence

who started going to the theater while stoned or on acid. MGM soon embraced this phenomenon as a selling point, creating a new poster with the tagline: "The Ultimate Trip."

Eventually, critics revised their judgments, but the next generation of directors saw *2001* as an inspiring masterpiece right off the bat, with James Cameron perhaps speaking for many when he said this was the movie that made him want to become a filmmaker. George Lucas deemed it "the best of the best of special effects movies, and it will always be," while Kubrick himself once said, "If *2001* has stirred your emotions, your subconscious, your mythological yearnings, then it has succeeded."

SYDNEY POLLACK

"Kubrick gets to our feelings in a way that's not highbrow or brainy even though he's dealing with really big stuff. It's science fiction, but it's really about our place in the universe and our future as a race. Stanley found a way to handle the material with a direct, emotional style. . . . His control, the way he grabs your attention and makes you think, is something not many filmmakers can do. Somehow he could see things nobody else could see. *2001* became almost a dividing line between the way movies were and the way they would be."

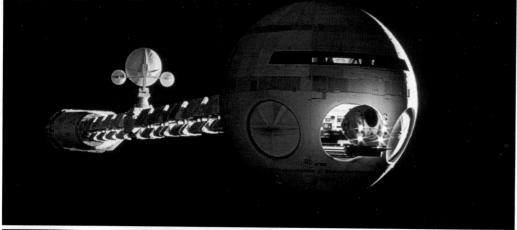

*The spacecraft
Discovery*

*The Star Child
and planet Earth*

WHAT TO LOOK FOR

Each of the film's four episodes shows the evolution—or devolution—of certain facets of human behavior, including speaking and eating. The grunts of the apes are perhaps more interesting than the constant pleasantries on board the space station, but even those trivial pleasantries contain more feeling than the words of the astronauts on the spaceship *Discovery*. The lack of any speech in *2001*'s final section might even be argued as an evolutionary leap!

Kubrick also devotes much screen time to the act of eating, such as the apes consuming plants and meat, scientist Heywood Floyd and his colleagues picking through ordinary sandwiches on their flight to the moon, the astronauts eating unappetizing mush on the *Discovery*, and astronaut Dave Bowman eating an elegant dinner that may or may not even be real. The meaning of all this is yet something else for the audience to ponder.

—

In one of the most famous direct cuts in film history, a bone tossed into the air by an ape jumps three million years ahead to become a spacecraft.

THE STING

Universal, 1973
Color, 129 minutes

DIRECTOR

George Roy Hill

PRODUCERS

Tony Bill, Michael Phillips, and Julia Phillips

SCREENPLAY

David S. Ward

STARRING

PAUL NEWMAN HENRY GONDORFF

ROBERT REDFORD JOHNNY HOOKER

ROBERT SHAW. DOYLE LONNEGAN

CHARLES DURNING. . . . LIEUTENANT WILLIAM SNYDER

RAY WALSTON J. J. SINGLETON

EILEEN BRENNAN . BILLIE

HAROLD GOULD KID TWIST

JOHN HEFFERNAN. EDDIE NILES

DANA ELCAR FBI AGENT POLK

JACK KEHOE . ERIE KID

DIMITRA ARLISS LORETTA

ROBERT EARL JONES. LUTHER COLEMAN

SALLY KIRKLAND CRYSTAL

Paul Newman gives the signal.

IN 1936 CHICAGO, TWO SMALL-TIME GRIFTERS PLAN THE GREATEST CON OF THEIR LIVES AGAINST A POWERFUL RACKETEER.

WHY IT'S ESSENTIAL

Four years after costarring in *Butch Cassidy and the Sundance Kid* (1969), Robert Redford and Paul Newman teamed up again for *The Sting*, an even bigger hit that stands as one of the most satisfying and joyful caper films ever made. This time around, Newman dons the mustache and Redford stays clean-shaven, but the pair's chemistry remains as potent as ever.

Given that chemistry, it's amazing the picture wasn't actually conceived as another vehicle for them. Redford and director George Roy Hill (also of *Butch Cassidy* fame) were attached to the script, but the character of Henry Gondorff had been written as a colder, rougher type; screenwriter David S. Ward had imagined Lee Van Cleef in the role. Hill lightened up the story in several ways, including reaching out to Newman for this part, and Ward was happy to adjust the character to suit the star's persona.

Redford plays a small-time grifter, Johnny Hooker, who teams with the more experienced Gondorff to launch an elaborate con against a dangerous Irish mobster, Doyle Lonnegan, played by Robert Shaw. They recruit a small army of fellow scammers to join them, all of whom are eager to exact revenge on Lonnegan for murdering Luther Coleman, a beloved figure in their community.

The Sting doesn't stop there, however. Its witty, ingenious plotting incorporates many

Hooker (Robert Redford) waits in the wings for his girlfriend to finish her striptease act.

more cons, big and small, along the way—not just on various characters but on the audience. Screenwriter Ward said he spent a year writing the script because of the challenge of ensuring that all the complicated plot threads didn't contradict or interfere with each other. The result: a seamless and lightning-fast pure entertainment that fools the audience fairly, without cheap tricks or outright lies in the storytelling.

Adding to the magic of *The Sting* is its vivid Depression-era atmosphere, with pitch-perfect

art direction, costumes, color schemes, and cinematography tailored to a 1930s look. Art director Henry Bumstead, who claimed *Vertigo* (1958) and *To Kill a Mockingbird* (1962) among his credits, suggested a brown color motif to run through his gorgeous design of the picture. He also pressed Hill to shoot on the Universal lot, as Bumstead believed he could create a more convincing period look from scratch. "Bummy" mostly got his wish; only a very few scenes were filmed on Chicago or Los Angeles area locations. Those included the opening street scene, inspired by Walker Evans photographs, shot on a Pasadena street that Bumstead found by sheer chance.

The Sting features more stylish visual nods to the past: the 1930s-style Universal logo that opens the film; optical irises and wipes to transition

between scenes throughout; and title cards that evoke Norman Rockwell's *Saturday Evening Post* illustrations. Hill avoided using extras in most of his street scenes because he noticed that many '30s gangster films lacked them.

The extraordinary use of Scott Joplin's ragtime piano music, adapted and arranged by Marvin Hamlisch, is vital to *The Sting*'s charm. It doesn't matter that ragtime had actually been popular thirty years before the story's setting; it recalls a bygone era and helps create the light, playful tone that Hill was after. Joplin had been more or less forgotten in the decades since his death, but the popularity of this soundtrack, which hit number one on the *Billboard* charts for five weeks, helped lead to Joplin's posthumous 1976 Pulitzer Prize for his contributions to American music.

Hooker with his mentor, Luther, played by Robert Earl Jones, the father of James Earl Jones

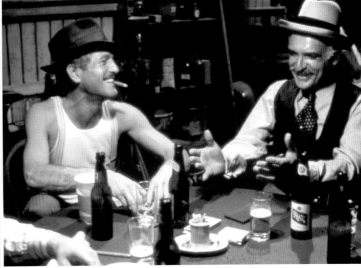

Paul Newman as Henry Gondorff with Harold Gould as the natty Kid Twist

"A wonderful movie. It very much looks like the 1930s re-created on film. The costumes by Edith Head are great.... What's amazing is that Newman and Redford made only two films together, but that pair of movies has forever linked the actors as if they were a prolific team, such as Bob Hope and Bing Crosby or Walter Matthau and Jack Lemmon."

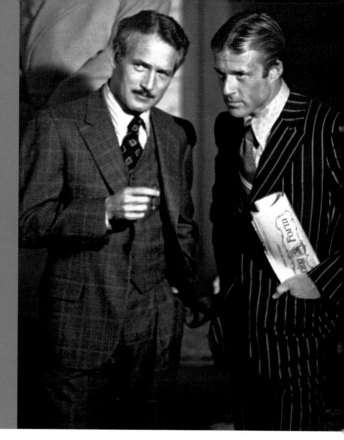

Paul Newman and Robert Redford make for a dapper duo.

The Sting was an enormous critical and commercial success and made Robert Redford the number-one male star in the country, a ranking he held for three years. (Newman, top-ranked years earlier, climbed back up to number three.) Nominated for ten Academy Awards, including Redford's only career acting nomination, the film took home seven: Best Editing, Musical Score, Costume Design, Art Direction, Original Screenplay, Director, and Picture—which was awarded just after a streaker ran across the Oscar stage.

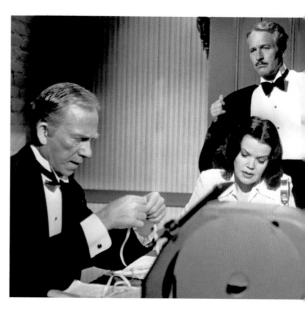

Ray Walston and Eileen Brennan set up a con as Paul Newman looks on.

WHAT TO LOOK FOR

The music is all the more effective for being used mostly during montages and other conversation-free sequences rather than as underscoring to dialogue. Hill designed the purely visual sections specifically for the music, and Hamlisch later wrote that he was "in heaven" scoring them. He believed that these "little oases without dialogue" helped the Joplin tunes catch on with the public.

—

Robert Shaw's limp in the film is real. Two days before production, he injured his knee playing handball at the Beverly Hills Hotel. He offered to give up his salary if a replacement actor was needed, but George Roy Hill decided the limp would lend more flavor to the character of Lonnegan.

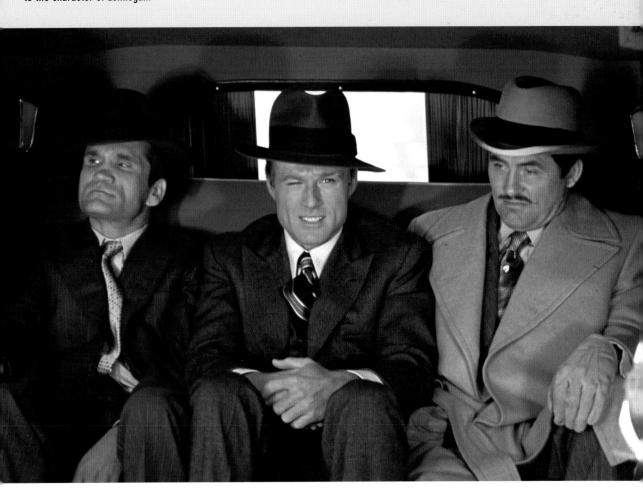

Hooker (Robert Redford) sits between Doyle Lonnegan (Robert Shaw, right) and Lonnegan's bodyguard, Floyd (Charles Dierkop, left). Dierkop also appeared with Redford and Newman in Butch Cassidy and the Sundance Kid *(1969).*

.............

259

ONE FLEW OVER THE CUCKOO'S NEST

United Artists, 1975
Color, 133 minutes

DIRECTOR

Miloš Forman

PRODUCERS

Saul Zaentz and Michael Douglas

SCREENPLAY

*Lawrence Hauben and Bo Goldman,
based on the novel by Ken Kesey*

STARRING

JACK NICHOLSON	R. P. McMURPHY
LOUISE FLETCHER	NURSE RATCHED
WILLIAM REDFIELD	HARDING
WILL SAMPSON	CHIEF BROMDEN
MICHAEL BERRYMAN	ELLIS
PETER BROCCO	COLONEL MATTERSON
DEAN R. BROOKS	DOCTOR SPIVEY
ALONZO BROWN	MILLER
SCATMAN CROTHERS	TURKLE
MWAKO CAMBUKO	WARREN
DANNY DeVITO	MARTINI
CHRISTOPHER LLOYD	TABER
BRAD DOURIF	BILLY BIBBIT

A PRISON INMATE IS TRANSFERRED TO A SOUL-CRUSHING MENTAL INSTITUTION WHERE HE DEFIES AUTHORITY AND INSPIRES OTHER PATIENTS TO MAINTAIN THEIR INDEPENDENT SPIRITS.

WHY IT'S ESSENTIAL

One of the most lauded films of the 1970s has stood the test of time for its extraordinary characters, authenticity, and rousing depiction of one man standing against the system. The "system" that novelist Ken Kesey had in mind in 1962, when he wrote *One Flew Over the Cuckoo's Nest*, was American society and its stifling pressure to conform. For Miloš Forman, who directed the film in 1975, the "system" represented the totalitarian regime that he had left behind in his native Czechoslovakia. The movie works as an allegory on both fronts but above all as a psychological comedy-drama, at once life-affirming and devastating.

Jack Nicholson delivers one of his finest performances as R. P. McMurphy, who is transferred from prison to an Oregon state mental hospital. He may or may not be "faking it," but the audience does not question his sanity for very long; his zest for life is too irresistible. He is a nonconformist, a sometimes out-of-control free spirit who cares little for rules and regulations and finds himself pitted against the complete opposite, Nurse Ratched. She presides over the ward of male patients with icy-calm detachment, caring only about her own power and control. Medications, suffocating daily

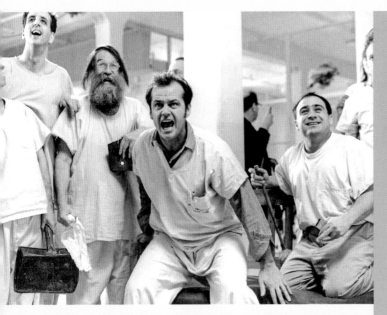

From left: William Duell, Vincent Schiavelli, Delos V. Smith Jr., Jack Nicholson, Danny DeVito. Producer Michael Douglas likened director Miloš Forman to a conductor: "He played the group like a symphony and had a clear picture in his mind of exactly what he wanted."

ROBERT OSBORNE

—

"This is one of those few movies that, I think, works on every level. . . . Jack Nicholson allows the other actors to have their moments and trusts his own talent [not to] get lost or overshadowed. The richness of those supporting performances not only add to the movie, they add to his performance."

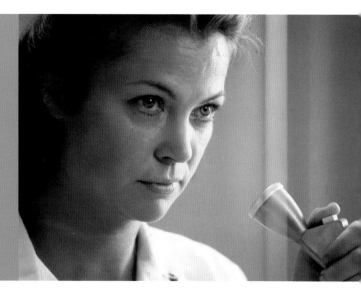

SALLY FIELD

"What's interesting about Louise's work is how she keeps her own rhythm, which is very hard to do when the rest of the room—and Jack especially—is so kinetic. She never allows herself to step outside of her rhythm and join his rhythm. It makes it very, very eerie."

Louise Fletcher, as Nurse Ratched, wore no makeup other than some Vaseline on her lips.

routines, and group therapy sessions seem designed to humiliate and mentally torment the men—to keep them in their place. One of the great movie villains, Nurse Ratched is a passive-aggressive monster in sheep's clothing, and Louise Fletcher is unforgettable in the role.

When the novel was published, Kirk Douglas bought the rights and played McMurphy in a 1963 Broadway adaptation. He wanted to star in a movie version but no studio would take a chance on what they saw as an uncommercial project. In 1971, realizing he was too old for the role, Douglas gave the rights to his son, Michael Douglas, an actor who was not yet a star. Michael teamed with Saul Zaentz, who was forming an independent film company, and they secured what eventually became a $4 million budget and a distribution deal with United Artists.

After Gene Hackman and Marlon Brando declined offers, Douglas and Zaentz cast Jack

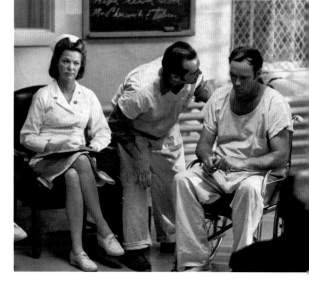

McMurphy tries to win a battle with Nurse Ratched, and she enjoys letting him try. From left: Louise Fletcher, Jack Nicholson, Ted Markland.

Nicholson in what became a defining part, even waiting six months for his schedule to clear. During that time, they and director Miloš Forman assembled an extraordinary ensemble of actors ranging from barely known to amateur to

completely unknown. The idea was for the audience to identify with a recognizable star as McMurphy, then to share his experience of entering the new world of the hospital and its unfamiliar faces. Several in the cast, however, went on to become major character actors or stars—including Danny DeVito, Vincent Schiavelli, and newcomers Christopher Lloyd and Brad Dourif—making *Cuckoo's Nest* a now-fascinating glimpse into their burgeoning talents.

The production filmed on location in Salem, Oregon, at a functioning mental hospital whose superintendent, Dean R. Brooks, was so support-ive of the film that he agreed to play the role of Dr. Spivey, basically a version of himself. He also served as technical adviser and paired the actors with real patients whose conditions mirrored those of the characters. The actors shadowed them for weeks, attended group therapy sessions, and even stayed in an unused ward. At Brooks's suggestion, his patients played extras. The result of all this was a lived-in, almost documentary-like texture, a quality further enhanced by improvised scenes.

Nicholson's improvisation throughout *Cuckoo's Nest* is remarkable, beginning with the smooch he plants on a guard after his handcuffs are removed. (The actor playing the guard had no idea what was coming.) A moment in which he addresses Nurse Ratched by her first name surprised Louise Fletcher so much that she

Jack Nicholson recommended Scatman Crothers (right) for the part of Turkle, the orderly. They had worked together on The King of Marvin Gardens (1972) *and* The Fortune (1975) *and would do so again on* The Shining (1980).

Six-foot-five-inch Will Sampson (right, with Jack Nicholson) had never acted before this film.

visibly blushed (she later called this her favorite moment). Also classic is a scene where McMurphy tries to teach the towering, silent American Indian known as Chief how to dunk a basketball, and the marvelous sequence in which McMurphy

narrates a baseball game while staring at a blank television. As Nurse Ratched has forbidden the watching of Game Two of the 1963 World Series, McMurphy conjures it in his head and lifts the others to a state of joy with his description.

Cuckoo's Nest opened to critical acclaim and struck a chord with audiences, grossing over $100 million domestically and more than $160 million worldwide. It made Oscar history by becoming just the second film to win all five top categories: Best Picture, Director, Actor, Actress, and Screenplay. (*It Happened One Night* [1934] did it first, and *The Silence of the Lambs* [1991] would do it again.) Nicholson won his first Oscar, and Brad Dourif, in his debut performance, was nominated for Best Supporting Actor. The film received nine nominations, including one for Jack Nitzsche's eerie score, which makes use of a bowed saw. Fletcher won Best Actress

From left: Louisa Moritz, Danny DeVito, Marya Small, Brad Dourif. DeVito had previously played Martini in a 1971 stage revival of Cuckoo's Nest.

and later said, "It was kind of scary for a year or two: people would stop me at airports and tell me how much they hated me. Now I'm on all the 'best villain ever' lists, alongside Anthony Hopkins for Hannibal Lecter."

WHAT TO LOOK FOR

Another notable improvisation comes in the doctor's office between McMurphy and Dr. Spivey. Dean Brooks (who had never acted before and never would again) proceeds as if conducting a real interview of a new patient. Looking through McMurphy's file, he asks questions to which Nicholson improvises the answers. But Nicholson also improvises comments about the photo on Spivey's desk and slaps an imaginary fly in the middle of their exchange, spurring priceless reactions from Brooks. "I think maybe it's the best improv I ever did," Nicholson later said, adding that his twelve-year-old daughter Jennifer was visiting the set that day and he felt the urge to "show off."

HARLAN COUNTY U.S.A.

Cinema 5, 1976
Color, 103 minutes

DIRECTOR

Barbara Kopple

PRODUCER

Barbara Kopple

A coal miner

ACADEMY AWARD WINNER
BEST DOCUMENTARY FEATURE

A remarkable, passionate work. A reminder that there cannot be neutrals anywhere.
—Judith Crist, Saturday Review

ARLAN COUNTY U.S.A.
oduced and Directed by Barbara Kopple Principal Cinematography Hart Perry
Director of Editing Nancy Baker Rated PG

IMPOVERISHED COAL MINERS GO ON STRIKE IN EASTERN KENTUCKY.

In the summer of 1973, twenty-six-year-old Barbara Kopple was well into production on her first documentary. It was to be about the campaign of a labor activist and former coal miner for the presidency of the United Mine Workers of America. When Kopple heard about a miners' strike that had just begun in eastern Kentucky, she became intrigued and decided to drive there with her two-person crew and a 16-millimeter camera. Arriving in the tiny community of Brookside, in Harlan County, she thought she might incorporate what she found into her film; instead, it became the film itself, released three years later as *Harlan County U.S.A.* and recognized ever since as a landmark in documentary filmmaking.

Kopple found nearly two hundred miners striking not just over indecent wages, which forced them to live in company-supplied housing without plumbing, but over terribly unsafe working conditions. She also found a mining community made up of strong, inspiring souls maintaining their dignity despite their hardships, with the miners' wives and mothers particularly resolute. Kopple said she quickly "realized that nothing in the world was going to stop me from telling that story."

With her cinematographer, Hart Perry, and associate director, Anne Lewis, Kopple drew forth a tenacity without which she never would have finished the movie. The three were so committed that they moved to Harlan County and lived for over a year with the miners, who grew to trust them as they learned that Kopple was sympathetic to their plight. Even though Kopple, Perry, and Lewis were "hippie" New

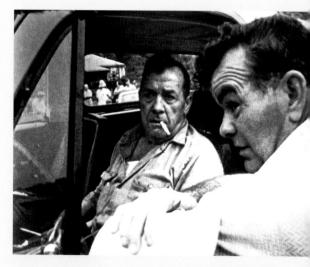

Sheriff Billy G. Williams (right) confronts the antagonistic Basil Collins.

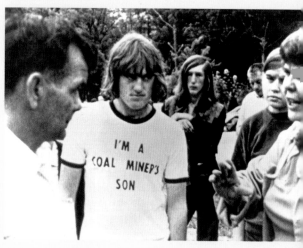

Lois Scott (right) makes a point to Sheriff Williams (left).

Yorkers, coal miner Jerry Johnson later recalled that "they kind of fit in. They looked like they were poorer than we were."

Kopple had started with just $9,000 and doggedly raised more in bits and pieces as she went along—from foundations, church groups, individuals, and even her own savings, causing her to go broke for a time. Meanwhile, in the tradition of the documentary mode of *cinema vérité*, she and her bare-bones crew followed their subjects around constantly, observing strategy sessions, filming a trip to the mine's corporate headquarters in New York, and arising before dawn when necessary to get to the picket line. On one such morning, violence broke out between strikebreaking scabs and armed, so-called "gun thugs" working for the coal company, and Kopple was there to capture the chaos. The thugs even shot at the film team, knocked over their camera, and physically assaulted them. On other days, Kopple pretended to shoot even when she didn't have film in the camera because the camera's presence helped to quell the violence.

The movie's visual approach is mostly observational, allowing real people to emerge as gripping characters who create drama and suspense. A scowling antagonist named Basil Collins intimidates and threatens the strikers (and Kopple herself), while a spirited heroine

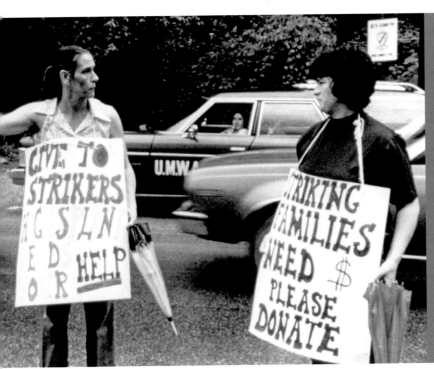

Miners' wives at work

named Lois Scott is a bundle of no-nonsense energy as she organizes women to join the picket lines and stand up for their rights. The women play an increasingly important role not just in maintaining the strike but in enriching the film itself, with their bonds and stoic humor painting a portrait of an admirable American community.

Also helping on that front are the union folk songs that Kopple works into the film, either performed on-screen or laid onto the soundtrack. All but one were written by coal miners, their wives, or their daughters, and they lend historical and social dimensions to *Harlan County U.S.A.* One song, "Whose Side Are You On?," is sung at a large gathering by Florence Reece, who had written it in the 1930s during an earlier Harlan County strike.

Kopple spent nine months in the editing room shaping her footage, with an outcome far beyond what she had originally imagined possible. The movie was accepted into the 1976 New York Film Festival, drew rave reviews as a work of profound humanism, and wound up winning the Academy Award for Best Documentary. It is now seen as an important precursor to the later explosion in social-activist documentary filmmaking. After she accepted the Oscar, Kopple phoned Lois Scott, who said everyone was driving around Harlan County and honking their horns, shouting, "We won, we won!"

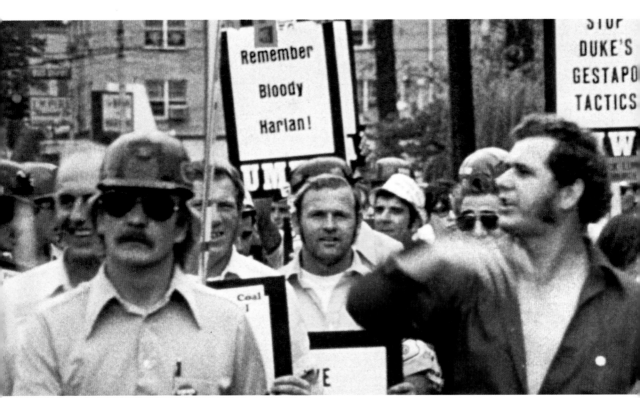

A demonstration

"It's vérité to the max, some of the things that she captures, some of the access that she gets—it's jaw-dropping [but] also intimate. You can tell that she really connected with her subjects in a way that was personal.... I really don't know how she did it. She was in her twenties, it's her first feature—it can only be explained by the word 'genius.'"

Director Barbara Kopple

WHAT TO LOOK FOR

To capture at least three candid moments, Kopple used a hidden wireless microphone. One is in a Manhattan shareholders' meeting, where a miner challenges the president of the company that owns the mine. Another is on Wall Street, where a picketing miner has a priceless exchange with a beat cop who is completely sympathetic to the cause; they commiserate about working conditions, corporate profiteering, and their respective benefits ("What about dental?" asks the cop). A third is in a courtroom, where a miner's wife, Bessie Parker, passionately tells a judge that "the laws are not made for the working people." The judge did not allow a camera in the courtroom, so Kopple "stole" the shot by hiding a wireless microphone on Parker and stationing the camera just beyond an open door in the back, with the f-stop pushed twice to compensate for the low-light conditions.

NETWORK

MGM, 1976
Color, 121 minutes

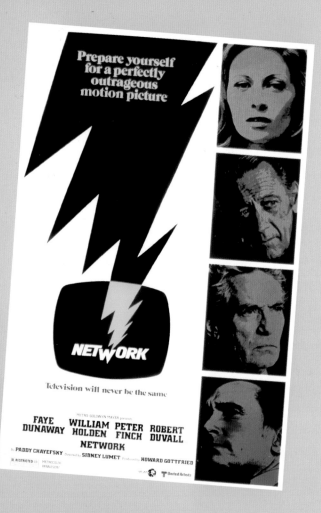

DIRECTOR

Sidney Lumet

PRODUCER

Howard Gottfried

SCREENPLAY

Paddy Chayefsky

STARRING

FAYE DUNAWAY	DIANA CHRISTENSEN
WILLIAM HOLDEN	MAX SCHUMACHER
PETER FINCH	HOWARD BEALE
ROBERT DUVALL	FRANK HACKETT
WESLEY ADDY	NELSON CHANEY
NED BEATTY	ARTHUR JENSEN
JORDAN CHARNEY	HARRY HUNTER
CONCHATA FERRELL	BARBARA SCHLESINGER
DARRYL HICKMAN	BILL HERRON
ROY POOLE	SAM HAYWOOD
WILLIAM PRINCE	EDWARD GEORGE RUDDY
BEATRICE STRAIGHT	LOUISE SCHUMACHER
MARLENE WARFIELD	LAUREEN HOBBS

FACED WITH THE LOSS OF HIS JOB, A NEWS ANCHOR HAS A NERVOUS BREAKDOWN AND RANTS ABOUT SOCIETY ON THE AIR, BECOMING SUCH A SENSATION THAT HE RECEIVES HIS OWN, INCREASINGLY OUTRAGEOUS, OPINION SHOW.

WHY IT'S ESSENTIAL

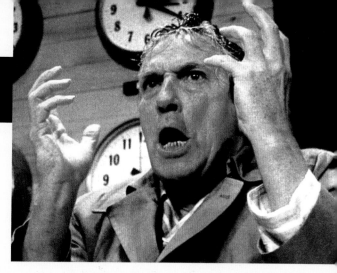

Network is one of the most prescient films ever made. A brilliant satire of the television industry and a sensation-craving public, it remains sharp and insightful to this day. Perhaps the only thing that has changed since 1976 is that what may have raised eyebrows then feels utterly commonplace now: the notion that news must be profitable and ratings-driven; the blurring of news into entertainment; the integrity of a network news division within a conglomerate that has competing interests; and the fact that anchors and reporters, more than ever, opinionize and emote to make their audiences feel a certain way.

Writer Paddy Chayefsky said he was merely reflecting reality even at the time. "I wrote a

Peter Finch delivering the Paddy Chayefsky dialogue that became a catchphrase still invoked today: "I'm as mad as hell and I'm not going to take this anymore!"

realistic drama," he said. "The industry satirizes itself." His screenplay is as darkly funny as it is astute. At the heart of the story is Howard Beale, a veteran news anchor who is told that he will be fired due to low ratings. He starts to preach angrily on the air about life and society, drawing such high ratings that the network christens him

Peter Finch (left) as Howard Beale, with William Holden as Max Schumacher

DREW BARRYMORE

"This is a perfect movie. . . . It has incredibly rich characters. Peter Finch and William Holden are so good together out of the gate, when they come stumbling out drunk. . . . It has a gladiator nature [in that] the most raw, sick, entertaining, and taboo will happen in this pulpit of a television set to get ratings— and that we as a society will also follow."

"It has such a message and depth and texture to it, and yet it's very entertaining. It's like a forecast that came true. And that's what is so terrifying about it, but what also makes the writing so brilliant. Paddy Chayefsky was an incredible genius. . . . Faye Dunaway is supreme; she never had a better part."

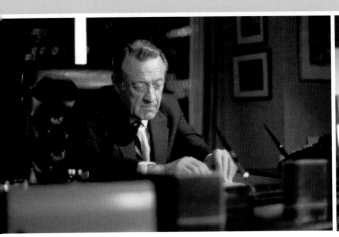

William Holden later told film critic Roger Ebert, "I thought Network had no commercial potential at all, and it made millions and millions of dollars. I only wanted to make it because of the other people involved. It sounded interesting."

Faye Dunaway as Diana Christensen, the sole female executive at the network

"the mad prophet of the airwaves" and gives him his own commentary show—even as he falls into a mental spiral. Meanwhile, the network's humane, old-school news president, Max Schumacher, and young, ratings-obsessed programming head, Diana Christensen, clash over the exploitation of Beale while starting an affair. Diana even essentially conceives of what we now know as reality television by developing a series about a domestic terrorist group that will show their actual bank robberies on the air.

Chayefsky said that *Network* began in his mind as a more straightforward comedy until

he realized, after visiting real networks and exploring the TV world, that "American people are angry and want angry shows." Anger, he decided, must be at the source of the comedy. Sure enough, the movie's defining scene is Howard Beale's "I'm as mad as hell and I'm not going to take this anymore!" rant, in which he instructs his national audience to open their windows and shout it to the world—which they do. Actor Peter Finch brought such intensity to this sequence, putting all his mental and physical strength into it, that he gave out from exhaustion halfway through the second take; director Sidney Lumet

used that take for the first half of the finished
scene, and the first take for the second half.

Despite the focus on anger, Chayefsky said
he built the script around the love story between
Max and Diana, played by William Holden and
Faye Dunaway, since they represent a primal
clash of ideas. Their scenes together are electric,
including a hilarious sex scene in which she
cannot stop talking about television. Lumet
directed Dunaway to play her character without
one ounce of vulnerability. As Diana says at one
point, "All I want out of life is a 30 share and
a 20 rating."

Network was recognized immediately as a
scathing social satire and an instant classic. It
received ten Academy Award nominations and
won four: Best Actor (Peter Finch), Actress
(Faye Dunaway), Supporting Actress (Beatrice
Straight), and Original Screenplay. William
Holden and Sidney Lumet were among the other

Robert Duvall as network executive Frank Hackett

nominees. Despite losing Best Picture to *Rocky*,
Network made quite a bit of history on Oscar
night. It is still the most recent of nine films to
receive five acting nominations, including at least
one nod in each acting category; it is one of only
two films (with 1951's *A Streetcar Named Desire*)
to win three acting awards; and it marked the
first posthumous acting Oscar in history, for
Peter Finch, who died of a heart attack while
promoting the film.

*William Holden and
Beatrice Straight in
the scene that won
Straight an Oscar*

Further, it contains two of the shortest performances ever nominated. Ned Beatty, nominated for Best Supporting Actor, is on-screen for five minutes, forty-four seconds as the demented conglomerate owner who hurls verbal fire and brimstone at Beale. Beatrice Straight, on-screen for five minutes, fifty-five seconds as Holden's wife, still holds the record for the shortest performance to actually win an Oscar. Her primary scene is with Holden, in their apartment, as he tells her that he is having an affair. She reacts with a powerful burst of emotion that flows believably among denial, anger, pain, resignation, defiance, and compassion. Lumet had her do the scene six or seven times. "She had to get past a certain point of exhaustion before she hit it right," he said. Straight's performance and Oscar victory demonstrate that the "length" of a performance, measured in screen time, does not necessarily have any bearing on its effectiveness. Hers are five of the most impressive and heartbreaking minutes of the picture, unlikely to be forgotten by anyone who experiences them.

William Holden and Faye Dunaway pose on location.

WHAT TO LOOK FOR

Sidney Lumet wrote that he and cinematographer Owen Roizman incorporated ever more rigid camera setups and artificial lighting through the story. For the opening nighttime street scene with Holden and Finch, "we started with an almost naturalistic look." Near the film's end, when network executives sit in an office deciding what to do about Howard Beale, the composition is static, framed like a still photo, and "lit like a commercial." The idea, wrote Lumet, was that as the film progressed, "the camera also had become a victim of television."

HANNAH AND HER SISTERS

Orion Pictures, 1986
Color, 107 minutes

DIRECTOR

Woody Allen

PRODUCER

Robert Greenhut

SCREENPLAY

Woody Allen

STARRING

WOODY ALLEN	MICKEY
MICHAEL CAINE	ELLIOT
MIA FARROW	HANNAH
CARRIE FISHER	APRIL
BARBARA HERSHEY	LEE
LLOYD NOLAN	EVAN
MAUREEN O'SULLIVAN	NORMA
DANIEL STERN	DUSTY
MAX VON SYDOW	FREDERICK
DIANNE WIEST	HOLLY
JULIE KAVNER	GAIL
JULIA LOUIS-DREYFUS	MARY
J. T. WALSH	ED SMYTHE
JOHN TURTURRO	WRITER
RICHARD JENKINS	DOCTOR WILKES

Mia Farrow, Barbara Hershey, and Dianne Wiest as sisters

**THREE ADULT SISTERS
EXPERIENCE ROMANTIC
HIGHS AND LOWS OVER
THE COURSE OF TWO
YEARS IN MANHATTAN.**

"Love is really unpredictable," observes Woody Allen in *Hannah and Her Sisters*, a sentiment that defines the entire film. Opening and closing with Thanksgiving dinners two years apart, the script uses several interconnecting stories to explore the ebbs and flows of romantic and familial love. Relationships begin, end, endure, and splinter—causing joy, guilt, betrayal, and reconciliation. There's no logic, the film seems to say, as to why an infatuation takes over a character's life and then withers to a vague memory, or how a horrendous first date can lead years later to a wonderful relationship; it is all simply the stuff of life, the product of being human, destined to happen time and again. It's fitting that of all the vintage music on the soundtrack, Harry James's renditions of "You Made Me Love You" and "I've Heard That Song Before" waft through the air most often. His wistful, romantic trumpet solos seem to amplify what Allen concludes to be the only knowable thing about love: that "the heart is a very, very resilient little muscle."

Woody Allen and Mia Farrow play ex-husband and wife.

One of three Thanksgiving dinner scenes that punctuate the movie. Around the table, from left: Dianne Wiest, Barbara Hershey, Maureen O'Sullivan, Mia Farrow, Michael Caine, Lloyd Nolan, Carrie Fisher

Is it any wonder that *Hannah and Her Sisters* is cherished as one of Allen's most life-affirming pictures? It presents relationships and family dynamics with honesty and humanity without sacrificing Allen's trademark comedy. Woody himself supplies much of the humor as Mickey, a hypochondriac who is convinced that he has a brain tumor—and when he learns he doesn't, is still depressed because he is going to die someday anyway. (Luckily, he realizes that any world that could produce the Marx Brothers is a world worth living in.)

Allen considered playing either of the other two lead male characters, though he admitted he could not have done so as well as Michael Caine or Max von Sydow, respectively. Caine delivers

"I just worship Mia and I think she is probably one of the fifteen greatest actors of the last fifty years. She doesn't take herself seriously at all. . . . Caine plays this love affair with Barbara Hershey like a kid at Christmastime, [with] the happiness and joy of falling in love. This is the sign of a great actor to me because one of the hardest things in movies to play is joy."

a wondrous performance as Elliot, a married man smitten with his wife's sister, expressing romantic agony in both comedy and drama scenes with aplomb. But the heart of the film lies with its women. While Mia Farrow, Dianne Wiest, and Barbara Hershey spend most of their screen time in separate stories, they are utterly believable as sisters who can be as antagonistic toward each other as they are loving. This is best seen at a tense dinner sequence in which Carlo Di Palma's complex camerawork—a series of circular tracking shots—probes their faces and heightens their performances.

Mia Farrow and Michael Caine as a married couple

Adding to the feeling of a family affair is the presence of seventy-four-year-old Maureen O'Sullivan—Mia Farrow's real-life mother— as Farrow's mother in the film. She plays a "boozy old flirt with a filthy mouth," married to fellow Hollywood veteran Lloyd Nolan, here in his final screen appearance. (He died shortly after production.)

The scenes in Hannah's apartment were shot in Mia Farrow's actual apartment on Central Park West, with her real-life children playing her kids onscreen. They continued living and sleeping at home through the weeks of filming there. Farrow later wrote: "It was strange to be shooting scenes in my own rooms— my kitchen, my pots, my own kids saying lines, Michael Caine in my bathroom, wearing a robe, rummaging through my medicine cabinet. Or me lying in my own bed kissing Michael, with Woody watching." (Farrow was involved with Allen at the time.) Caine recalled that during one rehearsal in bed things got even more surreal when he noticed Farrow's ex-husband, the composer André Previn, also watching from across the room.

Hannah was a challenging film for Allen, who found the interweaving stories difficult to balance. Unsatisfied with his original cut, he gathered the cast again and reshot 80 percent of the footage. He still was never quite satisfied with the picture, having wanted a bleaker

Hannah is full of small roles filled by actors who would later become household names, such as Julia Louis-Dreyfus, John Turturro, and Richard Jenkins. Two established actors were unbilled: Tony Roberts and Sam Waterston, who is seen here charming Dianne Wiest and Carrie Fisher.

ending until he realized that it would be *too* bleak for a film that "had not justified that level of Chekhovian sorrow." He changed the ending to something more upbeat, which is a reason the movie became his biggest box-office success to that time—although Allen, true to form, said, "I don't see it as optimistic; I see it as vaguely hopeful."

The film garnered seven Oscar nominations, including nods for Best Picture and Director as well as for Susan E. Morse's excellent film editing. It won three: Best Original Screenplay (Allen), Supporting Actress (Wiest), and Supporting Actor (Caine). Thirty-four years—and movies— later, it still stands as one of Woody Allen's most vital works.

············

"I think this is the best Woody Allen film ever, and it shows the beauty of New York City like no other—even inside the Café Carlisle, with Bobby Short at the piano. Mia Farrow, I think, is one of our very best and most underrated actresses. She makes it look so easy."

Woody Allen runs into Dianne Wiest at a record store.

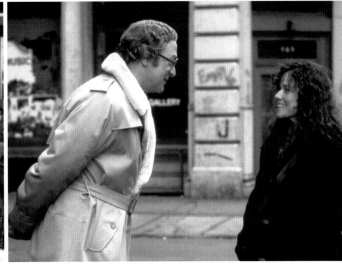

Married Michael Caine is smitten with Barbara Hershey.

WHAT TO LOOK FOR

The great Swedish actor Max von Sydow has three scenes as Barbara Hershey's much-older artist lover. He delivers some quintessentially wry Woody Allen lines, such as "You missed a very dull TV show about Auschwitz," but his finest moment comes during a heartrending breakup with Hershey. Beautifully played by both actors, the scene is made all the more intense by Allen's choice to shoot it in just two long takes. In the second shot, lasting two and a half minutes, von Sydow expresses a series of emotional transitions so powerfully that the crew applauded when he finished.

FIELD OF DREAMS

Universal, 1989
Color, 106 minutes

DIRECTOR

Phil Alden Robinson

PRODUCERS

Lawrence Gordon and Charles Gordon

SCREENPLAY

*Phil Alden Robinson, based on the
book* Shoeless Joe *by W. P. Kinsella*

STARRING

KEVIN COSTNER	RAY KINSELLA
AMY MADIGAN	ANNIE KINSELLA
JAMES EARL JONES	TERENCE MANN
TIMOTHY BUSFIELD	MARK
DWIER BROWN	JOHN KINSELLA
FRANK WHALEY	ARCHIE GRAHAM
RAY LIOTTA	SHOELESS JOE JACKSON
BURT LANCASTER	DOCTOR "MOONLIGHT" GRAHAM
GABY HOFFMANN	KARIN KINSELLA

**AN IOWA FARMER HEARS A VOICE AND SEES A VISION,
PROMPTING HIM TO BUILD A BASEBALL DIAMOND IN HIS
CORNFIELD THAT BRINGS FORTH THE 1919 CHICAGO WHITE SOX.**

WHY IT'S ESSENTIAL

Field of Dreams opened in April 1989 and became a classic sleeper hit, touching moviegoers' hearts all the way to November and securing a place as one of the most beloved baseball movies ever made. But then, the film isn't simply "about" baseball—just as baseball itself isn't only about the game. America's pastime is also about heroes and goats, comebacks and second chances, redemption, nostalgia, storytelling, fathers and sons—as well as the green of the grass, the crack of the bat, and the shifting of the light.

Field of Dreams engages all of the above. It is a fantasy drama that works beautifully because it so deeply understands what baseball means to those who experience it on the field and off. It also works all the better for never attempting to explain how or why its fantasy happens; even the long-dead baseball players who emerge out of the Iowa cornfield have no idea how they came to be there. Nor does the farmer, Ray Kinsella, understand why he heard a voice whisper in his ear, "If you build it, he will come." But after seeing a vision of a ballfield and of Shoeless Joe Jackson, one of eight players on the 1919 Chicago White Sox banned from baseball for allegedly

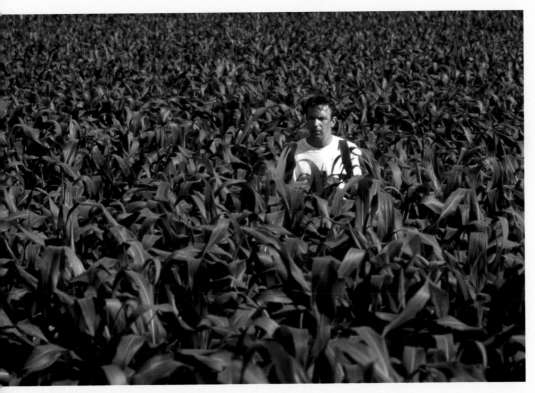

Farmer Ray Kinsella (Kevin Costner) hears a voice while walking through his cornfield.

throwing the World Series, Ray realizes that if he builds a ballpark in his cornfield, Shoeless Joe will somehow—and for some reason—show up.

The picture began as a 1982 novel, *Shoeless Joe*, by W. P. Kinsella. Filmmaker Phil Alden Robinson adapted it into a screenplay, but only after years of rejections from every studio, and the eventual involvement of brother-producers Lawrence Gordon and Charles Gordon, did Universal finally give a green light. The commercial riskiness of the project was countered by the quality of its screenplay, which was loved by seemingly everyone who read it (including those who turned it down). "It was like some fairy dust jumped off page one," recalled Timothy Busfield, who plays the antagonist of the story. "Every page was magical."

Kevin Costner jumped at the chance to play Ray even though he had just done a baseball movie, *Bull Durham* (1988). Amy Madigan came on board as Ray's wife, Annie, and the filmmakers cast Ray Liotta as Shoeless Joe because he "had a sense of danger about him," injecting some mystery as to whether the character is good or bad. Adding remarkable heft to the tale are veterans James Earl Jones, as a reclusive author who delivers one of the film's best speeches about baseball, and Burt Lancaster as "Moonlight"

James Earl Jones as Terence Mann, a fictitious writer modeled after reclusive Catcher in the Rye *author J. D. Salinger. In the novel, the character actually is Salinger, but this was changed for the film to avoid litigation.*

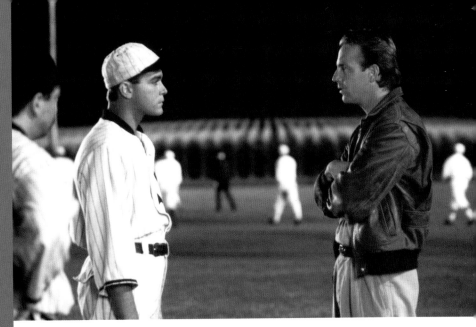

Shoeless Joe Jackson (Ray Liotta) and Ray (Kevin Costner). In a 2019 Los Angeles Times *poll of 31,544 readers,* Field of Dreams *was voted the greatest sports movie of all time.*

Graham, a small-town doctor who long ago played one inning in the major leagues but never came up to bat. This was Lancaster's final feature and he is given a perfect, poignant send-off from the silver screen.

Field of Dreams was shot on location in Dyersville, Iowa, in an existing farmhouse and on land owned by two adjacent farmers. After the ballpark sod was laid down, there was no time to wait for the grass to grow naturally green, so the crew spray-painted it. ("A field of paint," joked Robinson.) Further, a drought prevented the corn from growing that summer, forcing the production to bring in water tankers to irrigate the crop. At a certain point, the corn grew higher than Costner, who had to walk through it on a platform so he would be visible. Production was also delayed by the need to shoot many scenes at magic hour, which actually comprises only the last thirty or so minutes of sunlight each day.

Worried about marketing a baseball movie, Universal decided to sell it as a fantasy and a star vehicle for Kevin Costner, who was then riding a wave of three hits in a row. The one-sheet put

Terence will have none of Ray.

Field of Dreams gave Burt Lancaster a poignant farewell from the silver screen.

Costner front and center with the baseball and farm imagery almost hidden in the background. The title changed, too. The film had been known as *Shoeless Joe* all through production until Universal decreed that *Field of Dreams* would fare better commercially. Robinson was unhappy with the change until he broke the news to W. P. Kinsella, who said he didn't mind at all—*Shoeless Joe* had been imposed as the title by his publisher to begin with, and Kinsella had wanted to call it *The Dream Field*!

The picture was the fourth with a baseball theme to open within ten months, following the romantic comedy *Bull Durham* (1988), the period drama *Eight Men Out* (1988), and the broad comedy *Major League* (1989). *Field of Dreams*

ROBERT OSBORNE

—

"Fantasy is very difficult to do in a drama, but this one does it magnificently. I think almost every fellow in the world [would] love to have known his father as an adult if he didn't get to. That would always be a dream—maybe play ball with him, or just have a relationship with him. I never had that with my father, so it kind of affected me. . . . Kevin Costner was never cast better. It's a perfect part for him. An essential on many levels."

would outgross them all, bringing in $64 million domestically. Its poignancy especially struck a chord with male audiences, who were often left sobbing in their seats, thinking of their dads, as the lights came up. A few months later, the film

Burt Lancaster as Doc "Moonlight" Graham, with Kevin Costner and Gaby Hoffmann

drew three Oscar nominations, for Best Picture, Adapted Screenplay, and Original Score (by James Horner). In a sign of life imitating art, and art impacting real lives, people started coming to Iowa before the end of 1989 to see the farmland, ballpark included, where *Field of Dreams* had been made. Thirty years later, they have not stopped coming.

The movie's success certainly vindicated Universal's decision to change the title, but *Field of Dreams* was also an excellent choice for a deeper reason. After all, the chance to reunite with long-departed loved ones, introduce them to new family members, and perhaps play a little catch with them as the sun starts to set, is something that is only possible in two places: in our dreams and at the movies.

WHAT TO LOOK FOR

The spellbinding sequence of Ray and Shoeless Joe's first meeting, so well-written to begin with, came together thanks to some smart directing and a bit of extraordinary luck. In his first major piece of dialogue, Joe delivers a poignant speech that begins, "Getting thrown out of baseball was like having part of me amputated." Phil Alden Robinson knew that because this monologue was lengthy, there was a good chance he would be asked to trim it later on. To prevent this possibility, he shot it as a ninety-three-second master shot with both men sharing the frame—and no additional coverage.

A few moments later, Ray says, "See if you can hit my curve." In an uninterrupted take, Costner pitches, Liotta rips a line drive up the middle, the ball hits an equipment bag on the mound, and Costner falls on his rear end with a grin—all of it a lucky accident. The end of the sequence, in which Joe meets Ray's family and departs into the corn, was shot on another night. By sheer chance, a beautiful, ghostly gray fog started to roll in over the cornfield, and Robinson immediately took advantage. He shot the scene in only a few minutes, finishing just before the fog became too thick to go on.

·············

FILMS SHOWN ON *THE ESSENTIALS*

Through 2020, Turner Classic Movies has broadcast eighteen seasons of *The Essentials*. The program has spotlighted 318 "essential" films, some more than once. They are listed below, chronologically by year and alphabetically within each year. Titles that have been profiled in the two *Essentials* books—volumes 1 and 2—are indicated.

The General (1927)

Metropolis (1927) *The Essentials* book, VOL. 1

Sunrise (1927) *The Essentials* book, VOL. 2

Steamboat Bill, Jr. (1928) VOL. 2

The Wind (1928)

All Quiet on the Western Front (1930) VOL. 1

The Champ (1931)

City Lights (1931) VOL. 1

Freaks (1932) VOL. 2

Grand Hotel (1932) VOL. 1

I am a Fugitive from a Chain Gang (1932)

Love Me Tonight (1932)

The Music Box (1932)

Dinner at Eight (1933)

Duck Soup (1933) VOL. 1

Gold Diggers of 1933 (1933) VOL. 2

King Kong (1933) VOL. 1

Little Women (1933)

Sons of the Desert (1933)

It Happened One Night (1934) VOL. 1

The Merry Widow (1934)

The Thin Man (1934) VOL. 1

Twentieth Century (1934) VOL. 2

Alice Adams (1935)

Bride of Frankenstein (1935) VOL. 1

Mutiny on the Bounty (1935) VOL. 2

A Night at the Opera (1935)

Top Hat (1935) VOL. 2

Dodsworth (1936) VOL. 2

Libeled Lady (1936)

Modern Times (1936)

Mr. Deeds Goes to Town (1936)

San Francisco (1936)

Swing Time (1936) VOL. 1

Katharine Hepburn and James Stewart in The Philadelphia Story *(1940)*

.............

Alexander D'Arcy and Cary Grant in The Awful Truth *(1937)*

The Awful Truth (1937) VOL. 2

Camille (1937)

Captains Courageous (1937)

Grand Illusion (1937)

The Prisoner of Zenda (1937)

Stage Door (1937)

Stella Dallas (1937)

Topper (1937)

The Adventures of Robin Hood (1938) VOL. 2

Bringing Up Baby (1938)

Jezebel (1938)

You Can't Take It with You (1938)

The Four Feathers (1939)

Gone with the Wind (1939) VOL. 1

Gunga Din (1939)

The Hunchback of Notre Dame (1939)

Mr. Smith Goes to Washington (1939) VOL. 1

Ninotchka (1939)

Stagecoach (1939) VOL. 2

The Women (1939) VOL. 2

Wuthering Heights (1939)

The Bank Dick (1940)

Foreign Correspondent (1940)

The Great Dictator (1940) VOL. 2

His Girl Friday (1940)

The Letter (1940)

The Philadelphia Story (1940) VOL. 2

Pride and Prejudice (1940)

Rebecca (1940)

The Sea Hawk (1940)

The Shop Around the Corner (1940)

Citizen Kane (1941) VOL. 1

The Devil and Daniel Webster (1941)

Dr. Jekyll and Mr. Hyde (1941)

Here Comes Mr. Jordan (1941)

How Green Was My Valley (1941)

The Lady Eve (1941) VOL. 1

The Maltese Falcon (1941) VOL. 2

Meet John Doe (1941)

Ball of Fire (1942) VOL. 2

Casablanca (1942) VOL. 1

Cat People (1942) VOL. 2

............

The Magnificent Ambersons (1942)

The Man Who Came to Dinner (1942)

Now, Voyager (1942) VOL. 1

The Palm Beach Story (1942)

Random Harvest (1942)

Road to Morocco (1942)

Saboteur (1942)

Sullivan's Travels (1942) VOL. 2

To Be or Not to Be (1942)

Woman of the Year (1942)

Yankee Doodle Dandy (1942) VOL. 2

Cabin in the Sky (1943)

The More the Merrier (1943)

Arsenic and Old Lace (1944)

Double Indemnity (1944) VOL. 1

Gaslight (1944)

Laura (1944) VOL. 2

Lifeboat (1944)

Meet Me in St. Louis (1944) VOL. 1

The Miracle of Morgan's Creek (1944)

Murder, My Sweet (1944)

Thirty Seconds Over Tokyo (1944)

To Have and Have Not (1944)

Brief Encounter (1945) VOL. 2

Leave Her to Heaven (1945) VOL. 1

The Lost Weekend (1945)

Mildred Pierce (1945) VOL. 2

The Picture of Dorian Gray (1945)

Spellbound (1945)

They Were Expendable (1945)

Anna and the King of Siam (1946)

Beauty and the Beast (1946)

The Best Years of Our Lives (1946) VOL. 1

The Big Sleep (1946)

The Blue Dahlia (1946)

Gilda (1946)

A Matter of Life and Death (1946)

My Darling Clementine (1946)

Notorious (1946) VOL. 2

The Postman Always Rings Twice (1946)

The Razor's Edge (1946)

The Spiral Staircase (1946)

Black Narcissus (1947)

The Ghost and Mrs. Muir (1947) VOL. 2

Miracle on 34th Street (1947)

Out of the Past (1947) VOL. 1

The Bicycle Thief (1948) VOL. 1

The Fallen Idol (1948)

Force of Evil (1948)

A Foreign Affair (1948)

Fort Apache (1948)

I Remember Mama (1948)

Key Largo (1948)

The Lady from Shanghai (1948)

..............

Red River (1948)

The Red Shoes (1948) VOL. 1

The Snake Pit (1948)

Sorry, Wrong Number (1948)

The Treasure of the Sierra Madre (1948) VOL. 2

Adam's Rib (1949) VOL. 1

Battleground (1949)

Champion (1949)

Kind Hearts and Coronets (1949)

A Letter to Three Wives (1949)

The Third Man (1949) VOL. 1

White Heat (1949) VOL. 1

All About Eve (1950) VOL. 1

The Asphalt Jungle (1950) VOL. 2

Born Yesterday (1950)

Gun Crazy (1950) VOL. 1

Harvey (1950)

Rashomon (1950) VOL. 2

Sunset Boulevard (1950) VOL. 1

Winchester '73 (1950) VOL. 1

Ace in the Hole (1951)

The African Queen (1951)

An American in Paris (1951) VOL. 2

A Place in the Sun (1951) VOL. 2

The Red Badge of Courage (1951)

Strangers on a Train (1951)

A Streetcar Named Desire (1951)

The Bad and the Beautiful (1952)

High Noon (1952) VOL. 2

The Importance of Being Earnest (1952)

The Quiet Man (1952) VOL. 2

Singin' in the Rain (1952) VOL. 1

The Band Wagon (1953)

From Here to Eternity (1953)

How to Marry a Millionaire (1953)

It Should Happen to You (1953)

Mogambo (1953)

Roman Holiday (1953) VOL. 1

Stalag 17 (1953)

The Wild One (1953)

The Caine Mutiny (1954)

Dial 'M' for Murder (1954)

On the Waterfront (1954) VOL. 1

Rear Window (1954) VOL. 1

Seven Brides for Seven Brothers (1954)

Seven Samurai (1954) VOL. 1

A Star is Born (1954)

Bad Day at Black Rock (1955)

Diabolique (1955)

East of Eden (1955)

Guys and Dolls (1955)

Kiss Me Deadly (1955) VOL. 2

La Pointe Courte (1955)

Marty (1955)

.............

The Night of the Hunter (1955) VOL. 2

Pather Panchali (1955) VOL. 2

Rebel Without a Cause (1955) VOL. 2

Summertime (1955)

Bus Stop (1956)

Friendly Persuasion (1956)

Giant (1956)

Invasion of the Body Snatchers (1956) VOL. 1

The Searchers (1956) VOL. 1

The Bridge on the River Kwai (1957) VOL. 2

A Face in the Crowd (1957) VOL. 2

Fear Strikes Out (1957)

Paths of Glory (1957)

Sweet Smell of Success (1957) VOL. 2

3:10 to Yuma (1957)

Written on the Wind (1957)

Auntie Mame (1958)

The Defiant Ones (1958)

Gigi (1958)

The Long Hot Summer (1958)

No Time for Sergeants (1958)

Some Came Running (1958)

Touch of Evil (1958)

Vertigo (1958) VOL. 2

Witness for the Prosecution (1958)

Ben-Hur (1959) VOL. 1

Lillian Gish and director Charles Laughton on the set of The Night of the Hunter *(1955)*

Black Orpheus (1959)

The Diary of Anne Frank (1959)

Imitation of Life (1959)

The Mouse That Roared (1959)

North by Northwest (1959) VOL. 1

The Nun's Story (1959)

Pillow Talk (1959) VOL. 2

Some Like It Hot (1959) VOL. 1

The Apartment (1960) VOL. 2

Breathless (1960) VOL. 1

Elmer Gantry (1960)

Inherit the Wind (1960)

The Magnificent Seven (1960)

Psycho (1960) VOL. 2

Spartacus (1960)

Breakfast at Tiffany's (1961)

Fanny (1961)

The Guns of Navarone (1961)

The Hustler (1961)

Judgment at Nuremberg (1961)

The Misfits (1961)

Splendor in the Grass (1961)

West Side Story (1961)

Birdman of Alcatraz (1962)

Hud (1962)

Lawrence of Arabia (1962) VOL. 1

Lolita (1962)

The Loneliness of the Long Distance Runner (1962)

The Man Who Shot Liberty Valance (1962)

The Manchurian Candidate (1962)

The Music Man (1962)

Mutiny on the Bounty (1962)

Ride the High Country (1962) VOL. 2

That Touch of Mink (1962)

To Kill a Mockingbird (1962) VOL. 1

What Ever Happened to Baby Jane? (1962)

The Great Escape (1963)

The Haunting (1963)

It's a Mad Mad Mad Mad World (1963)

The Pink Panther (1963)

Tom Jones (1963)

Dr. Strangelove (1964) VOL. 1

Fail-Safe (1964)

A Hard Day's Night (1964)

My Fair Lady (1964)

Cat Ballou (1965)

Doctor Zhivago (1965)

The Battle of Algiers (1966) VOL. 2

Who's Afraid of Virginia Woolf? (1966)

Belle de Jour (1967)

Bonnie and Clyde (1967) VOL. 1

Cool Hand Luke (1967)

The Dirty Dozen (1967)

The Graduate (1967) VOL. 1

In the Heat of the Night (1967) VOL. 1

The Producers (1967) VOL. 2

Bullitt (1968)

Funny Girl (1968)

I Love You Alice B. Toklas (1968)

The Lion in Winter (1968)

2001: A Space Odyssey (1968) VOL. 2

Butch Cassidy and the Sundance Kid (1969)

Once Upon a Time in the West (1969) VOL. 1

Take the Money and Run (1969)

The Wild Bunch (1969)

Klute (1971)

The Candidate (1972)

Sounder (1972)

American Graffiti (1973)

The Day of the Jackal (1973)

Paper Moon (1973)

Papillon (1973)

Serpico (1973)

The Sting (1973) VOL. 2

A Warm December (1973)

The Way We Were (1973)

Claudine (1974)

The Sugarland Express (1974)

Alice Doesn't Live Here Anymore (1975)

Dog Day Afternoon (1975)

Jaws (1975) VOL. 1

The Man Who Would Be King (1975)

One Flew Over the Cuckoo's Nest (1975) VOL. 2

Harlan County U.S.A. (1976) VOL. 2

Network (1976) VOL. 2

Rocky (1976) VOL. 1

Annie Hall (1977) VOL. 1

Close Encounters of the Third Kind (1977)

The Goodbye Girl (1977)

The Meetings of Anna (1978)

The Black Stallion (1979)

Kramer vs. Kramer (1979)

Norma Rae (1979)

Coal Miner's Daughter (1980)

Ashes and Embers (1982)

Diner (1982)

Gandhi (1982)

Losing Ground (1982)

Tootsie (1982)

The Big Chill (1983)

Silkwood (1983)

This is Spinal Tap (1984) VOL. 1

Kiss of the Spider Woman (1985)

Lost in America (1985)

Hannah and Her Sisters (1986) VOL. 2

Stand by Me (1986)

Field of Dreams (1989) VOL. 2

Daughters of the Dust (1991)

............

BIBLIOGRAPHY

In addition to the sources listed, information came from production files, clippings, studio publicity notes, and trade paper reviews held at the Academy of Motion Picture Arts and Sciences' Margaret Herrick Library.

BOOKS

Agel, Jerome. *The Making of Kubrick's 2001*. New York: Signet, 1970.

Astaire, Fred. *Steps in Time*. New York: Harper & Brothers, 1959.

Astor, Mary. *A Life on Film*. New York: Delacorte Press, 1971.

Backus, Jim. *Rocks on the Roof*. New York: G. P. Putnam's Sons, 1958.

Bansak, Edmund G. *Fearing the Dark: The Val Lewton Career*. Jefferson, N.C.: McFarland, 1995.

Basinger, Jeanine. *I Do and I Don't*. New York: Alfred A. Knopf, 2012.

Basinger, Jeanine. *The Star Machine*. New York: Alfred A. Knopf, 2007.

Basinger, Jeanine. *A Woman's View: How Hollywood Spoke to Women, 1930-1960*. New York: Alfred A. Knopf, 1993.

Basinger, Jeanine, John Frazer, and Joseph W. Reed, Jr., eds. *Working with Kazan*. Middletown, Conn.: Wesleyan Film Program, 1973.

Bazin, Andre. *What Is Cinema? Volume 2*. Translated by Hugh Gray. Berkeley: University of California Press, 1971.

Beauchamp, Cari, and Mary Anita Loos (editors). *Anita Loos Rediscovered*. Berkeley: University of California Press, 2003.

Behlmer, Rudy. *Behind the Scenes*. Hollywood: Samuel French, 1990.

Bell, Douglas. *An Oral History with Philip Dunne*. Oral History Program, Margaret Herrick Library. Academy of Motion Picture Arts and Sciences, 1991.

Bellamy, Ralph. *When the Smoke Hit the Fan*. Garden City, N.Y.: Doubleday, 1979.

Benson, Michael. *Space Odyssey: Stanley Kubrick, Arthur C. Clarke, and the Making of a Masterpiece*. New York: Simon & Schuster, 2019.

Berg, A. Scott. *Kate Remembered*. New York: Putnam, 2003.

Berg, A. Scott. *Goldwyn*. New York: Alfred A. Knopf, 1989.

Bergman, Ingrid. *Ingrid Bergman: My Story*. New York: Delacorte Press, 1980.

Bergreen, Laurence. *As Thousands Cheer: The Life of Irving Berlin*. New York: Viking, 1990.

Bogdanovich, Peter. *Who the Devil Made It*. New York: Alfred A. Knopf, 1997.

Bosworth, Patricia. *Montgomery Clift: A Biography*. New York: Harcourt Brace Jovanovich, 1978.

Bowman, Manoah. *Natalie Wood: Reflections on a Legendary Life*. Philadelphia: Running Press, 2016.

Brady, John. *The Craft of the Screenwriter*. New York: Simon & Schuster, 1981.

Brownlow, Kevin. *David Lean*. New York: St. Martin's Press, 1996.

............

Brownlow, Kevin. *Hollywood: The Pioneers.* New York: Alfred A. Knopf, 1979.

Brownlow, Kevin. *The Parade's Gone By. . .* New York: Alfred A. Knopf, 1968.

Buford, Kate. *Burt Lancaster.* New York: Alfred A. Knopf, 2000.

Cagney, James. *Cagney by Cagney.* Garden City, N.Y.: Doubleday, 1976.

Caine, Michael. *What's It All About?* New York: Turtle Bay Books, 1992.

Canutt, Yakima, with Oliver Drake. *Stunt Man.* New York: Walker, 1979.

Caron, Leslie. *Thank Heaven.* New York: Viking Penguin, 2009.

Carroll, Brendan G. *The Last Prodigy: A Biography of Erich Wolfgang Korngold.* Portland, Ore.: Amadeus Press, 1997.

Celli, Carlo. *Gillo Pontecorvo: From Resistance to Terrorism.* Lanham, Md.: Scarecrow Press, 2005.

Chandler, Charlotte. *Ingrid Bergman: A Personal Biography.* New York: Simon & Schuster, 2007.

Chandler, Charlotte. *Not the Girl Next Door: Joan Crawford, A Personal Biography.* New York: Simon & Schuster, 2008.

Chaplin, Charles. *My Autobiography.* New York: Simon & Schuster, 1964.

Couchman, Jeffrey. *The Night of the Hunter: Biography of a Film.* Evanston , Ill.: Northwestern University Press, 2009.

Croce, Arlene. *The Fred Astaire and Ginger Rogers Book.* New York: Outerbridge and Lazard, 1972.

Crowe, Cameron. *Conversations with Wilder.* New York: Alfred A. Knopf, 1999.

Curtis, Tony, with Peter Golenbock. *American Prince: A Memoir.* New York: Harmony Books, 2008.

Davis, Ronald L. *Zachary Scott: Hollywood's Sophisticated Cad.* Jackson: University Press of Mississippi, 2006.

DeCamp, Rosemary. *Tigers in My Life.* Baltimore: Midnight Marquee Press, 2000.

Dickerson, Gary E. *The Cinema of Baseball.* Westport, Conn.: Meckler, 1991.

Dunne, Philip. *Take Two: A Life in Movies and Politics.* New York: McGraw-Hill, 1980.

Eisner, Lotte H. *Murnau.* Berkeley: University of California Press, 1973.

...blicity photo of Ginger Rogers in Gold Diggers of 1933 *(1933)*

Erickson, Hal. *The Baseball Filmography 1915 Through 2001*. 2nd edition. Jefferson, N.C.: McFarland, 2002.

Everson, William K. *American Silent Film*. New York: Oxford University Press, 1978.

Everson, William K. *The Detective in Film*. Secaucus, N.J.: Citadel Press, 1972.

Everson, William K. *Love in the Film*. Secaucus, N.J.: Citadel Press, 1979.

Eyman, Scott. *Five American Cinematographers*. Metuchen, N.J.: Scarecrow Press, 1987.

Eyman, Scott. *John Wayne: The Life and Legend*. New York: Simon & Schuster, 2014.

Eyman, Scott. *Print the Legend: The Life and Times of John Ford*. New York: Simon & Schuster, 1999.

Fleming, Kate. *Celia Johnson*. London: Weidenfeld and Nicolson, 1991.

Frankel, Glenn. *High Noon: The Hollywood Blacklist and the Making of an American Classic*. New York: Bloomsbury, 2017.

Frascella, Lawrence, and Al Weisel. *Live Fast, Die Young: The Wild Ride of Making Rebel Without a Cause*. New York: Simon & Schuster, 2005.

Frayling, Christopher. *The 2001 File: Harry Lange and the Design of the Landmark Science Fiction Film*. London: Reel Art Press, 2015.

Fujiwara, Chris. *Jacques Tourneur: The Cinema of Nightfall*. Baltimore: Johns Hopkins University Press, 2000.

Galbraith IV, Stuart. *The Emperor and the Wolf*. London: Faber and Faber, 2001.

Gehring, Wes D. *Leo McCarey*. Lanham, Md.: Scarecrow Press, 2005.

Griffin, Mark. *All That Heaven Allows: A Biography of Rock Hudson*. New York: Harper, 2018.

Grobel, Lawrence. *The Hustons*. New York: Charles Scribner's Sons, 1989.

Hamlisch, Marvin, with Gerald Gardner. *The Way I Was*. New York: Charles Scribner's Sons, 1992.

Harris, Warren G. *Clark Gable*. New York: Harmony Books, 2002.

Harvey, James. *Romantic Comedy in Hollywood from Lubitsch to Sturges*. New York: Alfred A. Knopf, 1987.

Harvey, Stephen. *Directed by Vincente Minnelli*. New York: Harper & Row, 1989.

Head, Edith, and Jane Kesner Ardmore. *The Dress Doctor*. Boston: Little, Brown and Company, 1959.

Hepburn, Katharine. *Me: Stories of My Life*. New York: Alfred A. Knopf, 1991.

Higham, Charles, and Joel Greenberg. *The Celluloid Muse: Hollywood Directors Speak*. London: Angus & Robertson, 1969.

Higham, Charles. *Hollywood Cameramen*. Bloomington: Indiana University Press, 1970.

Horton, Andrew. *The Films of George Roy Hill*. Jefferson, N.C.: McFarland, 2005.

Horton, Andrew. *Henry Bumstead and the World of Hollywood Art Direction*. Austin: University of Texas Press, 2003.

Hotchner, A. E. *Doris Day: Her Own Story*. New York: William Morrow and Company, 1976.

Huff, Theodore. *An Index to the Films of F. W. Murnau*. Sight and Sound Index Series 15. London: BFI, 1948.

Huff, Theodore. *Charlie Chaplin*. New York: Henry Schuman, 1951.

Huston, John. *An Open Book*. New York: Alfred A. Knopf, 1980.

Itzkoff, Dave. *Mad as Hell: The Making of Network and the Fateful Vision of the Angriest Man in Movies*. New York: Henry Holt and Company, 2014.

Jacobs, Diane. *Christmas in July: The Life and Art of Preston Sturges*. Berkeley: University of California Press, 1992.

............

Jaeckle, Jeff, and Susan Ryan, eds. *The Films of Barbara Kopple*. Edinburgh: Edinburgh University Press, 2019.

Jones, Preston Neal. *Heaven & Hell to Play With: The Filming of The Night of the Hunter*. New York: Limelight, 2002.

Kazan, Elia. *A Life*. New York: Alfred A. Knopf, 1988.

Kemp, Philip. *Lethal Innocence: The Cinema of Alexander Mackendrick*. London: Methuen, 1991.

Knight, Vivienne. *Trevor Howard: A Gentleman and a Player*. London: Muller, Blond & White, 1986.

Knox, Donald. *The Magic Factory: How MGM Made An American in Paris*. New York: Praeger, 1973.

Krefft, Vanda. *The Man Who Made the Movies: The Meteoric Rise and Tragic Fall of William Fox*. New York: Harper, 2017.

Kurosawa, Akira. *Something Like an Autobiography*. New York: Alfred A. Knopf, 1982.

Lake, Veronica, with Donald Bain. *Veronica*. London: W. H. Allen, 1969.

Lambert, Gavin. *On Cukor*. New York: Rizzoli, 2000.

Lax, Eric. *Woody Allen*. New York: Alfred A. Knopf, 1991.

Leigh, Janet, with Christopher Nickens. *Psycho: Behind the Scenes of the Classic Thriller*. New York: Harmony Books, 1995.

Leopold, David. *Irving Berlin's Show Business*. New York: Harry N. Abrams, 2005.

Levy, Emanuel. *George Cukor: Master of Elegance*. New York: William Morrow and Company, 1994.

Levy, Emanuel. *Vincente Minnelli: Hollywood's Dark Dreamer*. New York: St. Martin's Press, 2009.

MacHale, Des. *Picture The Quiet Man*. Belfast: Appletree Press, 2004.

Mackendrick, Alexander. *On Film-Making*. New York: Faber & Faber, 2004.

Madsen, Axel. *Stanwyck*. New York: Harper-Collins, 1994.

Malone, Aubrey. *Maureen O'Hara*. Lexington: University Press of Kentucky, 2013.

Maltin, Leonard. *Carole Lombard*. New York: Pyramid, 1976.

Marill, Alvin H. *Samuel Goldwyn Presents*. South Brunswick, N.J.: A. S. Barnes and Company, 1976.

McCabe, John. *Cagney*. New York: Alfred A. Knopf, 1997.

McCarthy, Todd. *Howard Hawks: The Grey Fox of Hollywood*. New York: Grove Press, 1997.

McGilligan, Patrick. *Alfred Hitchcock: A Life in Darkness and Light*. New York: Regan Books, 2003.

McGilligan, Patrick. *Funny Man: Mel Brooks*. New York: Harper, 2019.

Mellen, Joan. *Filmguide to The Battle of Algiers*. Bloomington: Indiana University Press, 1973.

Neal, Patricia, with Richard Deneut. *As I Am*. New York: Simon & Schuster, 1988.

Newquist, Roy. *Conversations with Joan Crawford*. Secaucus, N.J.: Citadel Press, 1980.

Oakie, Jack. *Jack Oakie's Double Takes*. San Francisco: Strawberry Hill Press, 1980.

O'Hara, Maureen, with John Nicoletti. *'Tis Herself*. London: Simon & Schuster, 2005.

Phillips, Gene D. *Beyond the Epic: The Life and Films of David Lean*. Lexington: University Press of Kentucky, 2006.

Pike, Bob, and Dave Martin. *The Genius of Busby Berkeley*. Reseda, Calif.: Creative Film Society Books, 1973.

Powell, Michael. *Million Dollar Movie*. New York: Random House, 1995.

Preminger, Otto. *Preminger: An Autobiography*. Garden City, N.Y.: Doubleday, 1977.

Ray, Nicholas. *I Was Interrupted: Nicholas Ray on Making Movies*. Edited by Susan Ray. Berkeley: University of California Press, 1993.

Ray, Satyajit. *Our Films, Their Films*. New York: Hyperion, 1994.

Richie, Donald. *The Films of Akira Kurosawa*. Third edition. Berkeley: University of California Press, 1996.

Richie, Donald. *Focus on Rashomon*. Englewood Cliffs, N.J.: Prentice-Hall, 1972.

Richie, Donald. *George Stevens: An American Romantic*. New York: Museum of Modern Art, 1970.

Riese, Randall. *The Unabridged James Dean*. New York: Random House, 1994.

Riese, Randall, and Neal Hitchens. *The Unabridged Marilyn*. New York: Congdon & Weed, 1987.

Robinson, Andrew. *Satyajit Ray: A Vision of Cinema*. London: I. B. Tauris, 2005.

Robinson, David. *Chaplin: His Life and Art*. New York: McGraw-Hill, 1985.

Rode, Alan K. *Michael Curtiz: A Life in Film*. Lexington: University Press of Kentucky, 2017.

Rollyson, Carl. *Hollywood Enigma: Dana Andrews*. Jackson: University Press of Mississippi, 2012.

Rossellini, Isabella, and Lothar Schirmer. *Ingrid Bergman: A Life in Pictures*. Munich: Schirmer/ Mosel, 2013.

Russell, Rosalind, and Chris Chase. *Life Is a Banquet*. New York: Random House, 1977.

Schickel, Richard. *Elia Kazan*. New York: Harper-Collins, 2005.

Dana Andrews and Gene Tierney in Laura *(1944)*

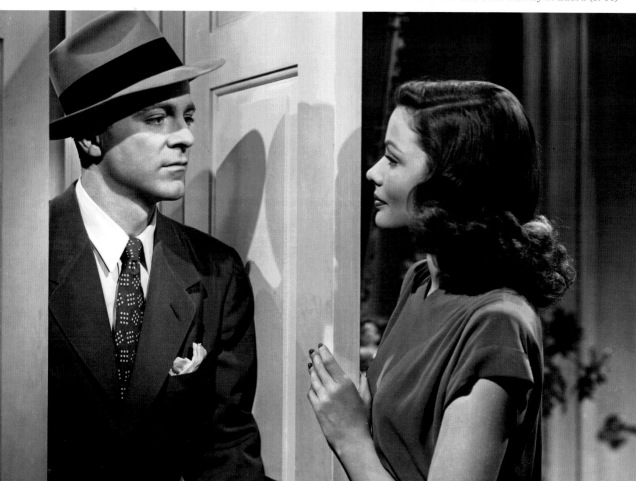

Server, Lee. *Robert Mitchum: Baby, I Don't Care*. New York: St. Martin's Press, 2001.

Server, Lee. *The Thieves' Market: A. I. Bezzerides in Hollywood*. New York: Carroll & Graf, 1998.

Seydor, Paul. *Peckinpah: The Western Films, A Reconsideration*. Chicago: University of Illinois Press, 1996.

Sherman, Dale. *Mel Brooks FAQ*. Lanham, Md.: Applause, 2018.

Siegel, Joel E. *Val Lewton: The Reality of Terror*. New York: The Viking Press, 1973.

Sikov, Ed. *On Sunset Boulevard: The Life and Times of Billy Wilder*. New York: Hyperion, 1998.

Simmons, Garner. *Peckinpah: A Portrait in Montage*. New York: Limelight, 1998.

Singer, Kurt. *The Laughton Story*. Philadelphia: John C. Winston Company, 1954.

Sinyard, Neil. *Fred Zinneman: Films of Character and Conscience*. Jefferson, N.C.: McFarland, 2003.

Sinyard, Neil. *George Stevens*. Jefferson, N.C.: McFarland, 2019.

Skal, David J., and Elias Savada. *Dark Carnival: The Secret World of Tod Browning*. New York: Anchor Books, 1995.

Slide, Anthony, ed. *Directing: Learn from the Masters*. Lanham, Md.: Scarecrow Press, 1996.

Smith, Steven C. *A Heart at Fire's Center: The Life and Music of Bernard Herrmann*. Berkeley: University of California Press, 1991.

Solomons, Jason. *Woody Allen: Film by Film*. Revised edition. London: Carlton Books, 2018.

Spivak, Jeffrey. *Buzz: The Life and Times of Busby Berkeley*. Lexington: University Press of Kentucky, 2011.

Spoto, Donald. *Madcap: The Life of Preston Sturges*. Boston: Little, Brown, and Company, 1990.

Taylor, Elizabeth. *Elizabeth Taylor*. New York: Harper & Row, 1964.

Thomas, Bob, editor. *Directors in ACTION*. Indianapolis: The Bobbs Merrill Company, 1973.

Thomas, Bob. *Thalberg: Life and Legend*. New York: Doubleday, 1969.

Thomas, Tony, Jim Terry, and Busby Berkeley. *The Busby Berkeley Book*. Greenwich, Conn.: New York Graphic Society, 1973.

Thomas, Tony. *Joel McCrea: A Film History*. Burbank, Calif.: Riverwood Press, 2013.

Tierney, Gene, and Mickey Herskowitz. *Self-Portrait*. New York: Wyden Books, 1979.

Truffaut, Francois. *Hitchcock*. New York: Simon & Schuster, 1983.

Vieira, Mark A. *Irving Thalberg: Boy Wonder to Producer Prince*. Berkeley: University of California Press, 2010.

Weddle, David. *"If They Move, Kill 'Em!": The Life and Times of Sam Peckinpah*. New York: Grove Press, 1994.

Welles, Orson, and Peter Bogdanovich. *This Is Orson Welles*. New York: HarperCollins, 1992.

Winters, Shelley. *Shelley*. New York: William Morrow and Company, 1980.

Winters, Shelley. *Shelley II*. New York: Simon & Schuster, 1989.

Zinneman, Fred. *A Life in the Movies*. New York: Charles Scribner's Sons, 1992.

ARTICLES

American Film. George Cukor interview. February 1978.

Associated Press. "Screen Star Dame Celia Dies at 73." *Albuquerque Journal*, April 27, 1982.

Astor, Mary. "Bogie Was for Real." *New York Times*, April 23, 1967.

············

Bachmann, Gideon. "How I Make Films: An Interview with John Huston." *Film Quarterly*, Fall 1965.

Bergstrom, Janet. "William Fox Presents F. W. Murnau and Frank Borzage." *Murnau, Borzage and Fox*. DVD supplement. Twentieth Century Fox Home Entertainment, 2008.

Bodeen, DeWitt. "Val Lewton." *Films in Review*, April 1963.

Bontemps, Jacques, and Richard Overstreet. "Measure for Measure: Interview with Joseph L. Mankiewicz. *Cahiers du Cinema in English*, February 1967.

Bue, James. Interview with Satyajit Ray. *Film Comment*, Summer 1968.

Catsos, Gregory J. M. "Priceless: A Farewell Interview with Vincent Price." *Filmfax*, December 1993/January 1994.

Chaplin, Charles. "Mr. Chaplin Answers His Critics." *New York Times*, October 27, 1940.

Chiasson, Dan. "Anybody There?" *New Yorker*, April 23, 2018.

Child, Ben. "How We Made... Michael Phillips and David S. Ward on 'The Sting.'" *Guardian*, June 4, 2012.

Cimons, Marlene. "Feminists Dissect 'Women.'" *Los Angeles Times*, October 18, 1971.

Das Gupta, Chidananda. "Satyajit Ray: The Indian Genius of the Cinema." *Asia Magazine*, August 5, 1962.

"Dialogue on Film: Fred Zinneman." *American Film*, January-February 1986.

Drew, Bernard. "John Huston: At 74 No Formulas." *American Film*, September 1980.

Ebert, Roger. "William Holden at Supersonic Speed." *Chicago Sun-Times*, June 18, 1978.

Ford, Dan. "A Talk with John Huston." *Action*, September-October 1972.

"Freaks." *Time Out* review. Accessed online: https://www.timeout.com/london/film/freaks June 8, 2015.

Gillett, John, and James Blue. "Keaton at Venice." *Sight and Sound*, Winter 1965-66.

Hammond, Pete. "Ann Blyth: Doing It All." *TCM Classic Film Festival Program*, 2013.

Hoberman, J. "It's Always 'High Noon' at the White House." *New York Times*, April 25, 2004.

Hood, Phil. "Michael Douglas: How We Made 'One Flew Over the Cuckoo's Nest.'" *Guardian*, April 11, 2017.

Klawans, Stuart. "Lessons of the Pentagon's Favorite Training Film." *New York Times*, January 4, 2004.

Kleinhans, Chuck. "Barbara Kopple Interview." *Jump Cut: A Review of Contemporary Media*, 1977.

Maltin, Leonard. "Going to the Source." *Leonard Maltin's Movie Crazy*, Spring 2003.

Maltin, Leonard. "Remembering Forgotten Men." *Leonard Maltin's Movie Crazy*. Summer 2007.

Medjuck, Joe. "Carl Foreman." *Take One*, January-February 1972.

Mitchell, Houston. "And the Best Sports Movie Is..." *Los Angeles Times*, February 25, 2019.

Moffitt, Jack. "'Pillow Talk': Hilarious, Sophisticated, Surefire." *Hollywood Reporter*, August 12, 1959.

Murray, William. "Playboy Interview: Sam Peckinpah." *Playboy*, August 1972.

Pellett, Gail. "The Making of 'Harlan County U.S.A.'" *Radical America*, March-April 1977.

Pond, Steve. "Blending Fantasy and Reality in 'Field of Dreams.'" *Premiere*, May 1989.

Pontecorvo, Gillo. "'The Battle of Algiers': An Adventure in Filming." *American Cinematographer*, April 1967.

Ramnarayan, Gowri. Interview with Satyajit Ray. *Interview*, June 1992.

Silke, James. "Stevens Talks About Movies." *Cinema*, December 1964-January 1965.

Sweeney, Louise. "John Huston." *Christian Science Monitor*, July 26, 1973.

United Press International. "Dame Celia Johnson, 73, Is Dead." *New York Times,* April 27, 1982.

Van Gelder, Robert. "Chaplin Draws a Keen Weapon." *New York Times Magazine*, September 8, 1940.

Vermilye, Jerry. "Charles Laughton." *Films in Review*, May 1963.

Walker, Alexander. "Woody Allen." *Cinema Papers*, July 1986.

Weide, Robert. "Quiet on the Set!" *DGA Quarterly*, Summer 2012.

Wise, Damon. "The Making of 'The Producers.'" *Guardian*, August 15, 2008.

VIDEO/AUDIO

Bacon, Jim, director. *From Father to Son.* DVD supplement to *Field of Dreams.* Universal, 2004.

Brownlow, Kevin, and Michael Kloft, directors. *The Tramp and the Dictator.* Turner Classic Movies, 2002.

Bouzereau, Laurent, producer. *The Making of Network.* Turner Entertainment, 2006.

Bouzereau, Laurent, director. *The Making of The Producers.* MGM Home Entertainment, 2002.

Ciment, Michel. *Portrait of a 60% Perfect Man.* Billy Wilder Interview. YLE, 1982.

Facing the Past. Documentary about *A Face in the Crowd.* Warner Home Video, 2005.

Feldman, Gene, and Suzette Winter, directors. *Cary Grant: A Celebration of a Leading Man.* Janson Media, 1988.

Halperin, Jonathan, producer. *The Making of One Flew Over the Cuckoo's Nest.* Saul Zaentz Company, 2002.

Heeley, David, director. *The Adventures of Errol Flynn.* Turner Entertainment, 2005.

Heeley, David, director. *Katharine Hepburn: All About Me.* Turner Pictures, 1991.

Kelly, Gene, Saul Chaplin, and Leslie Caron. Comments on DVD commentary track of *An American in Paris.* Warner Home Video, 2008.

Kiselyak, Charles, producer. *The Art of The Sting.* Universal Studios Home Video, 2005.

Kurtti, Jeff, director. *Discovering Treasure: The Story of The Treasure of the Sierra Madre.* Warner Home Video, 2003.

Ling, Van, director. *Field of Dreams: A Scrapbook.* DVD supplement to *Field of Dreams.* MCA Home Video, 1996.

Nicholson, Jack. Comments on *One Flew Over the Cuckoo's Nest. AFI's Night at the Movies.* American Film Institute, 2007.

Plomly, Roy. Interview with Natalie Wood. *Desert Island Discs.* BBC, May 16, 1980.

Rust, John, director. *Let Freedom Sing: The Story of Yankee Doodle Dandy.* Warner Home Video, 2003.

Schiller, Johanna, producer. *The Making of Harlan County U.S.A.* The Criterion Collection, 2006.

Thompson, David, director. *Ennio Morricone.* BBC, 1995.

Wallace, Mike. Interview with Mel Brooks. *60 Minutes.* CBS, April 15, 2001.

ONLINE DATABASES

Turner Classic Movies: www.tcm.com

William K. Everson Collection: www.nyu.edu/projects/wke/index.php

INDEX

Page numbers in italics indicate photographs or their captions.

.............

............

.............

ACKNOWLEDGMENTS

First and foremost, I thank my Running Press editor Cindy Sipala, who guided this project with intelligence and patience, just as she did our first *Essentials* book and *Christmas in the Movies*. Her love of classic cinema also helps to make hard work fun. When Cindy went on maternity leave (welcome to the world, Frankie Leo!), editor Jess Riordan stepped in to oversee the book's design stages. Thank you, Jess.

As the primary host for ten of *The Essentials'* first sixteen seasons, the late Robert Osborne set a standard for astute, accessible conversations with his cohosts before and after each film. TCM's primetime host Ben Mankiewicz has since stepped into the role with aplomb, bringing his unique personality to the job and generating illuminating discussions with, so far, filmmakers Ava DuVernay and Brad Bird. Ben is also a pal and fellow baseball fanatic, and I thank him for contributing this book's foreword. Here's to many more seasons of *The Essentials*, Ben.

Turner Classic Movies is a national treasure, and I'm proud to have been associated with TCM since 2003, when I began contributing to its website. In an era in which vintage movies are becoming alarmingly harder to see—because DVDs and Blu-rays are being usurped by streaming services that greatly ignore older titles—the TCM network, website, annual film festival, peripheral events, and overall brand are more valuable than ever to those who love classic film. None would be possible without a small army of devoted programmers, executives, talent coordinators, hosts, writers, editors, and production personnel. Many were supportive of this book in direct and indirect ways, starting with John Malahy and Heather Margolis, who were the immediate Turner liaisons. My thanks to them, as well as to TCM general manager Pola Changnon, former general manager Jennifer Dorian, Genevieve McGillicuddy, Charles Tabesh, Stephanie Thames, Scott McGee, Steven Denker, Susana Zepeda, Dori Stegman, Quatoyiah Murry, and Kristen Welch. A special shout-out to Melissa Yocom, who found and compiled past transcripts and videos of *Essentials* host introductions.

My gratitude also extends to Eileen Flanagan at Warner Media, who provided intrepid help in procuring photos, and to photo editor Mark A. Vieira. Mark is a writer and photographer who specializes in digital restoration, and we all have him to thank for the beautiful look of the images in this book.

............

Writing is mostly solitary work; sounding boards are essential. Several friends kindly read drafts of essays in this book along the way—none more so than Mark Cantor. Mark is a longtime friend as well as a music and film historian, and his feedback, ranging from very specific to overarching, was always helpful and stimulating. Thanks so much, pal! Other friends who gave thoughtful suggestions and were down to talk, text, or e-mail about movies at all hours included Isabella Sanders Miller, Sam Wasson, Owen Renfroe, Louis Maggiotto, Steven C. Smith, Leonard Maltin, and Jeanine Basinger. Jeanine was my professor at Wesleyan University and has remained a friend for over thirty years; I can never thank her enough for her inspiring and insightful teaching, which has never stopped.

This book was written in Los Angeles, Lake Placid, and Washington D.C. In L.A., my home away from home was the Margaret Herrick Library at the Academy of Motion Picture Arts and Sciences. The Herrick is an invaluable resource, impeccably staffed, and I want to specifically thank Elizabeth Youle, Rachel Bernstein, Genevieve Maxwell, Kristine Kreuger, Kevin Wilkerson, Louise Hilton, Jeff Miller, Benjamin Friday, Andrea Battiste, Jacki Brazzeal, Marisa Duron, Libby Wertin, and Francesca Krampe.

For support and help in ways great and small I also thank Diane Baker, Barbara Kopple, Susan Landesmann, Tamsen Wolff, Patricia Ward Kelly, Veronica Chandler, Wyatt McCrea, Gael Arnold, David Arnold (for the additional dialogue), Melissa Palarea, Jonathan Arnold, Stephanie Arnold, Alice Arnold, Farrah Boutia, Ronald V. Borst, Donald Bogle, Ned Comstock at USC's Cinematic Arts Library, Scott Wiper, Alan K. Rode, Katherine Kendall, Sloan de Forest, Karin Andersson at Stay Ready, Kristen Terry, and Enigma Coffee.

Finally, my thanks to Aaron Spiegeland at Parham Santana, book designers Susan Van Horn and Corinda Cook, publicist Seta Zink, and Running Press publisher Kristin Kiser.

.............

Set of The Women *(1939)*